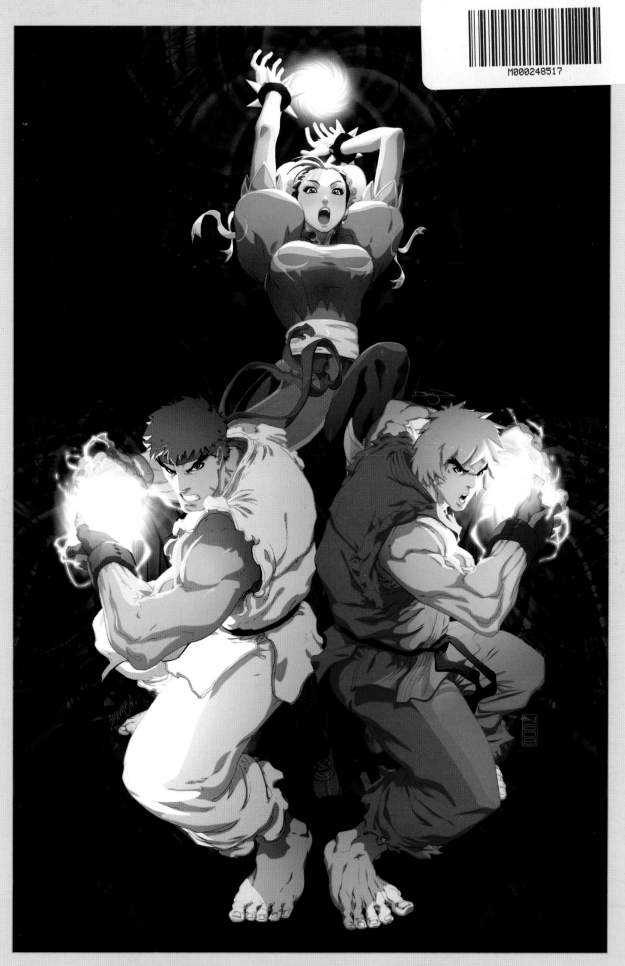

STREET FIGHTER TRIBUTE

"You can't be a true
martial artist
without showmanship!"
-Dan Hibiki

FOREWORDS

The Eternal Challenge of the World Warriors!

It seems like only yesterday that we put together a proposal trying to convince different publishers to obtain the Street Fighter comic book license with UDON at the artistic helm. When those publishers waited too long to make a decision, we decided to sign the license ourselves and started UDON along the road of self publishing. Without Capcom and Street Fighter, we would never be the company we are now.

After all these years and hundreds of story pages dedicated to our favorite fighting game, I've had the chance to work with some of the best artists in the comic, video game and illustration fields. These artists, along with our in-house crew at UDON, have inspired me in so many ways. Every day I look forward to new pieces of art arriving in my in-box.

This special tribute book pushes the artistic boundary even further, with artists from all over the world sending in their art celebrating the 20th anniversary of STREET FIGHTER, the fighting game that started it all! Seeing this book come together is quite possibly the most satisfying experience I've ever had as an art director!

Now we're truly ready for the 25th, 30th and many more years to come!

Erik Ko
Chief of Ops
UDON Entertainment
May 2008

The Art of Fighting

It is only fitting that Udon publishes this Tribute Book, jam-packed with the most incredible collection of artistic talent that has ever been assembled in Street Fighter's twenty year legacy, for Street Fighter - the game, has become "art" in every aspect of the word. Chun-Li, Ken, Ryu and the rest of the cast of oh-so familiar characters have become icons of video game history.

In addition to raising fighting games to an unprecedented level of sophistication, Street Fighter II demonstrated that video games can transcend the arcade and home consoles to become a worldwide cultural phenomenon. Each colorful character has cultivated their own rabid fan following whether onscreen, in manga, as collectibles, or even dressing up in cosplay. Nowhere is the extent of self-expressionism more distinct than in the field of art where millions of professional and fan renderings of favorite Street Fighter characters have appeared in print, online, as street art, or just doodles in the margins of textbooks, notebooks, and sketchbooks.

Just as there are a million different combinations and moves to master your opponents in the game, the following pages demonstrate that there is an infinite palette of colors and styles to render Street Fighter as art. Let the artists within take you on their personal journeys of color, motion, and imagination to inspire you to your own expressions of the joy of Street Fighter. Round One, FIGHT!

Francis Mao
Senior Director of Creative Services
CAPCOM
Summer 2008

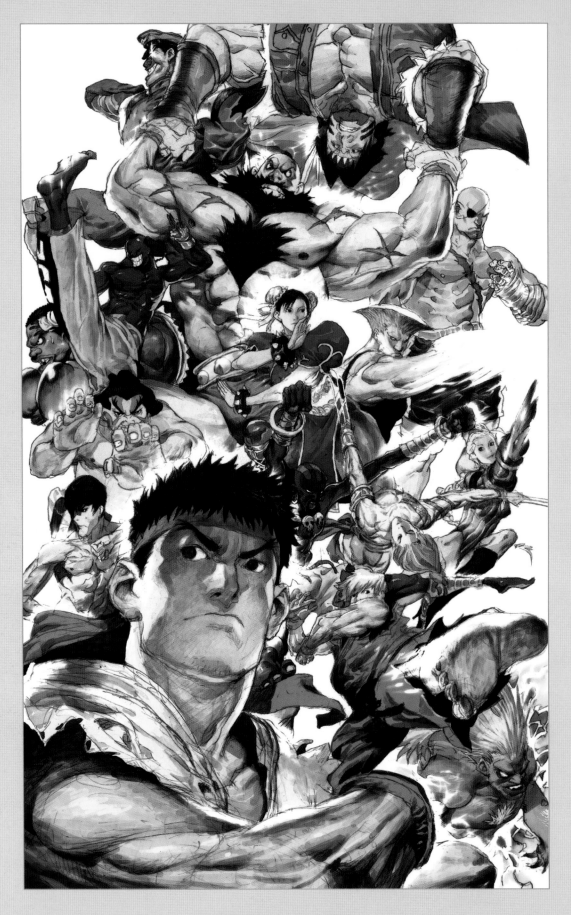

HUANG JIA WEI
GUANGDONG, CHINA
COMIC ARTIST / ILLUSTRATOR

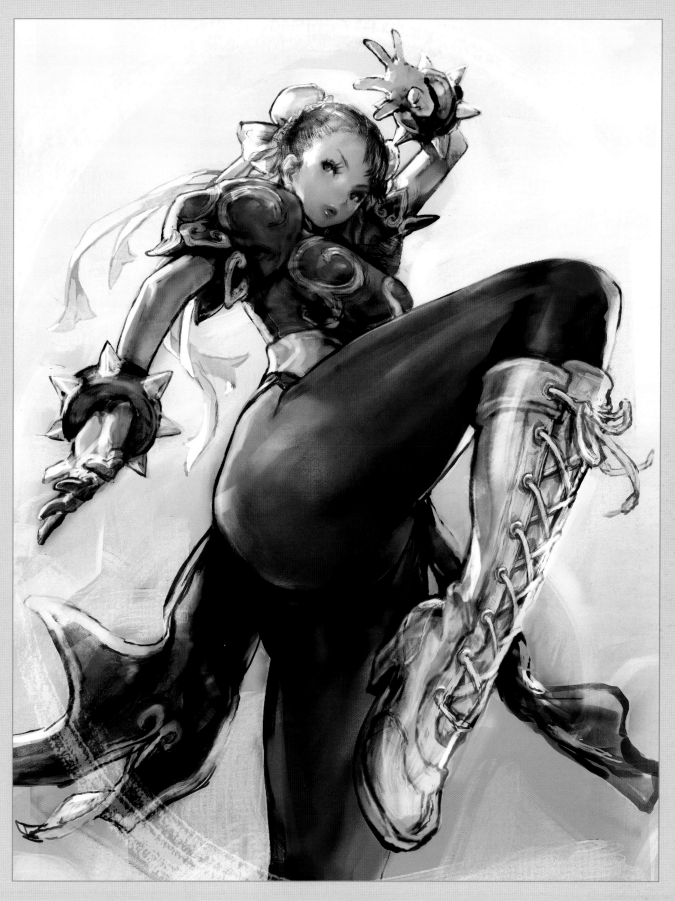

LEE MIN-PIYO [M.P]
SOUTH KOREA
MPBLUE.EGLOOS.COM
ILLUSTRATOR
[NCSOFT]

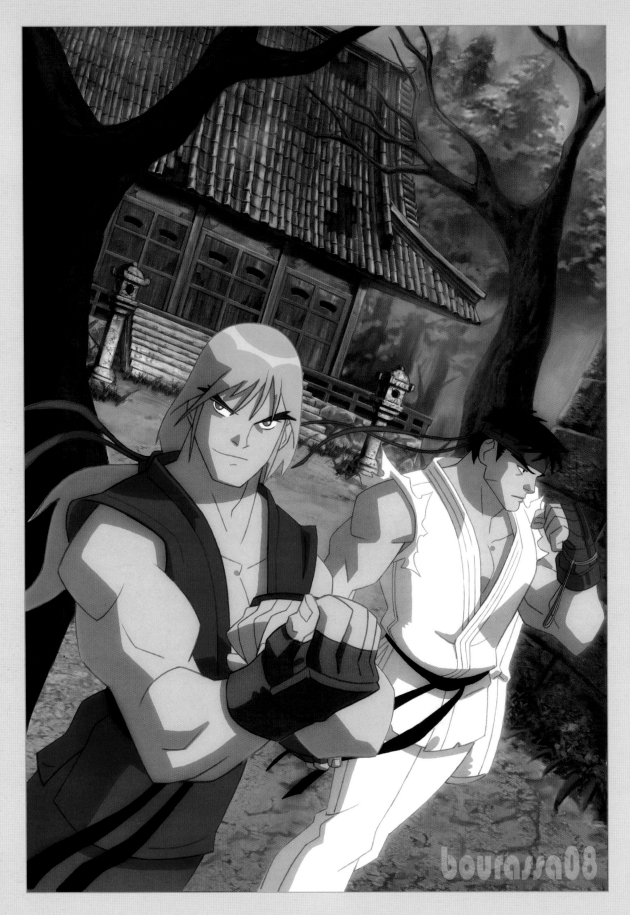

PHIL BOURASSA
LOS ANGELES, CALIFORNIA, USA
PHILLYBEE.DEVIANTART.COM
CHARACTER DESIGNER/COMIC ARTIST
[THOR: SON OF ASGARD, BEN 10, FIRST WORLD]

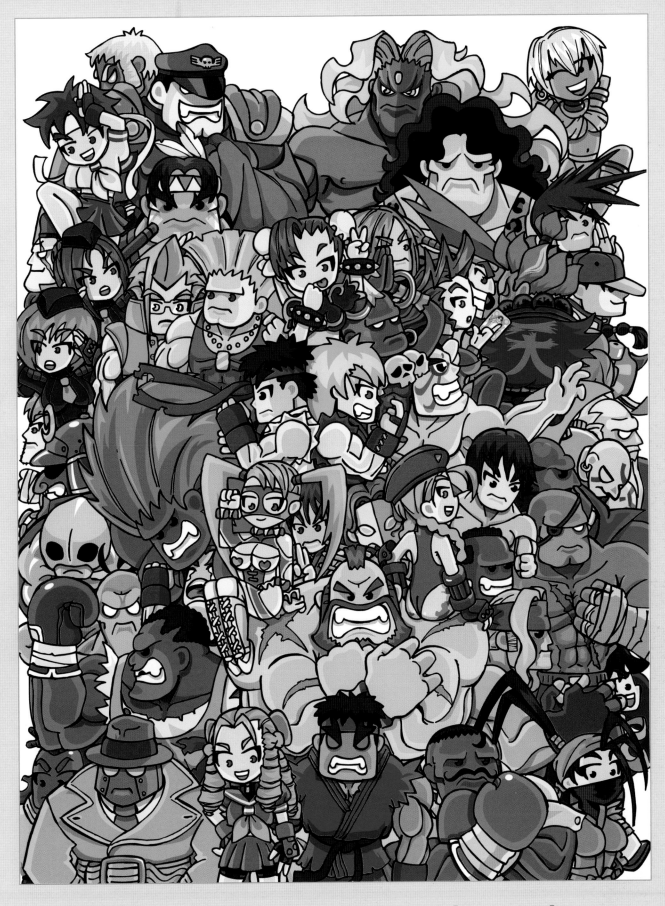

VICTOR MANUEL BOGGIANO CHAVEZ [BOGGIANO]
LIMA, PERU
GALLERYLLUSTRATA.BLOGSPOT.COM
PROFESSIONAL ILLUSTRATOR

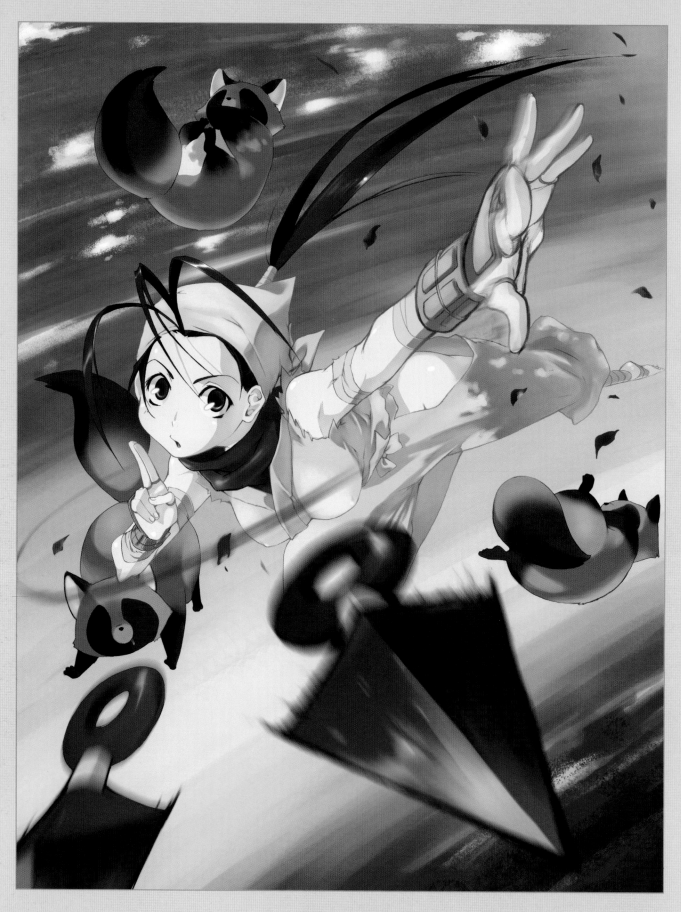

JUDY JONG
BURNABY, BRITISH COLUMBIA, CANADA
JOODLEZ.DEVIANTART.COM
FREELANCE ILLUSTRATOR

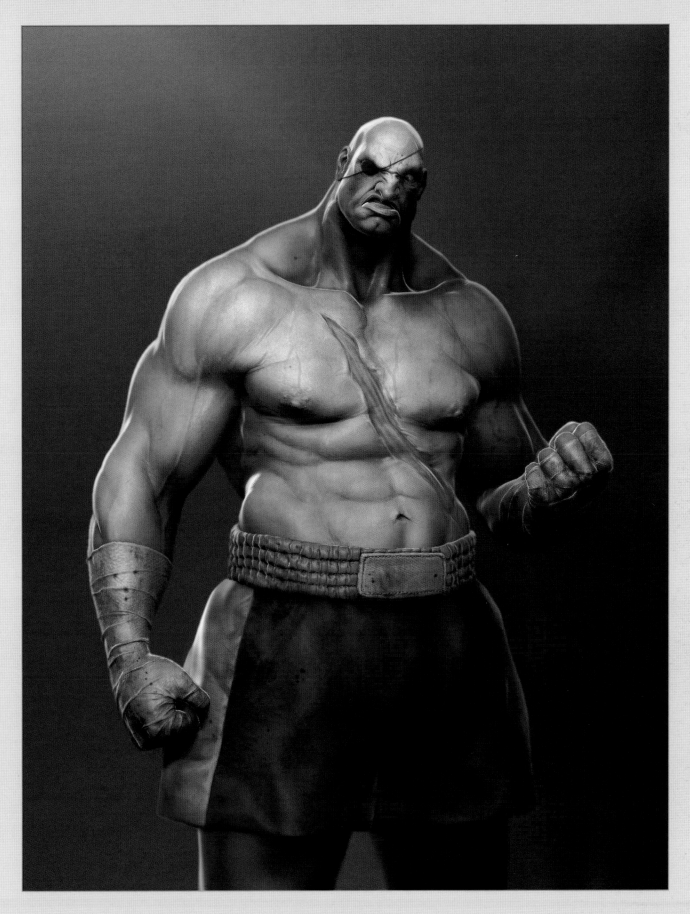

DOE
WWW.DOEMAN.ORG
ARTIST

OMAR DOGAN

My memories from Street Fighter are more related to the artistic side of it. From the range of style to the ability of Capcom's design team, I always found something in the Street Fighter concept art that I could learn and apply to my own art. Since about 1995 I have been drawing and sketching Sakura, and I find a lot of myself in her as far as personality goes. She seemingly doesn't have much to work with at first glance as a fighter, however it is her determination that wins the match against all odds. That, and she's cute!

This picture is based off the comic 'Street Fighter Legends: Sakura' with all of her main opponents. Each of her enemies represents an aspect she has to fight; Karin represents dirty fighting or cheating, Zangief stands for oppressive strength, and Dan is delusions of grandeur or misplaced confidence. R. Mika is there to show that along the way she has friends who will help her. The hand alerting Sakura to the fight ahead is that of her best friend Kei.

Sakura has a very strong tomboyish aspect to her, and I dressed her in blue to accentuate that, but a pink strawberry flavoured Pocky lets you know she is still a girl.

Sakura is the definitive schoolgirl of the world of fighting games, period.

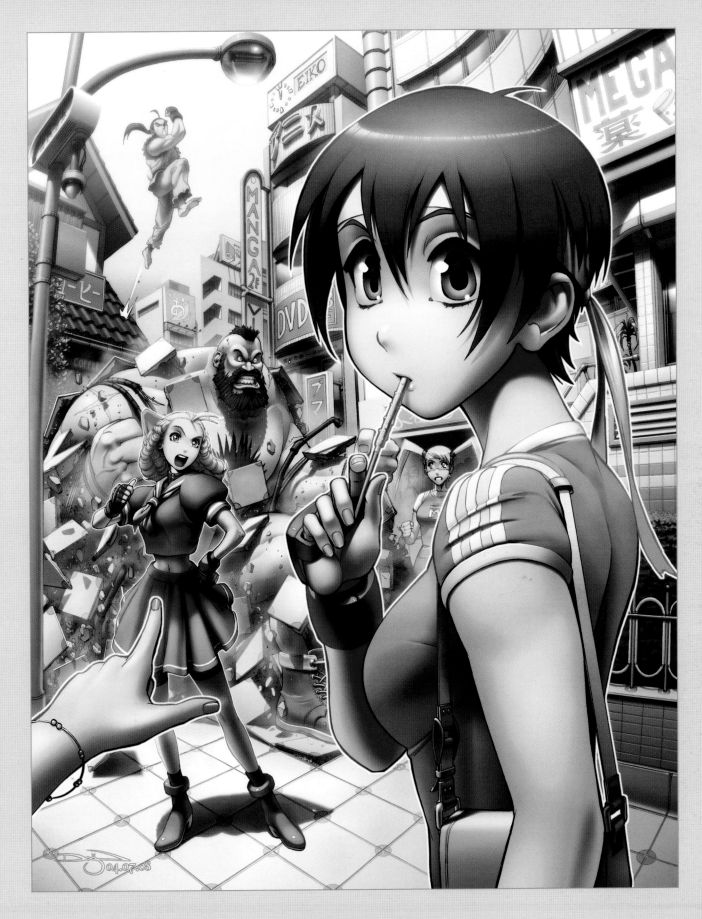

OMAR DOGAN
MISSISSAUGA, ONTARIO, CANADA
OMAR-DOGAN.DEVIANTART.COM
ILLUSTRATOR
[UDON'S STREET FIGHTER COMICS, STREET FIGHTER HD, KONAMI'S NEW INTERNATIONAL TRACK & FIELD]

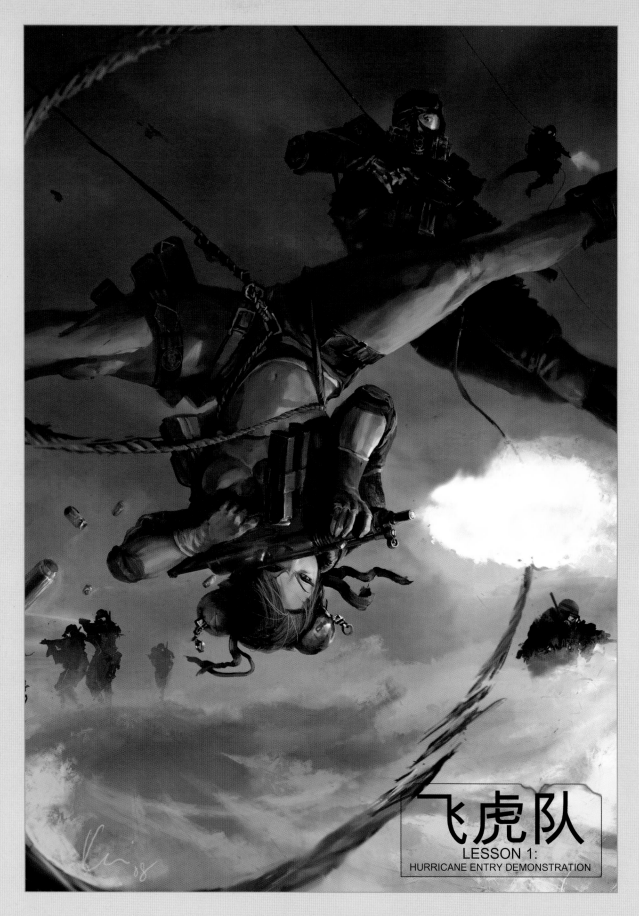

飞虎队
LESSON 1:
HURRICANE ENTRY DEMONSTRATION

LIM RI KAI
SINGAPORE
WWW.IMAGINARYFS.COM - UKITAKUMUKI.DEVIANTART.COM
SENIOR ART DIRECTOR
[IMAGINARY FRIENDS STUDIOS]

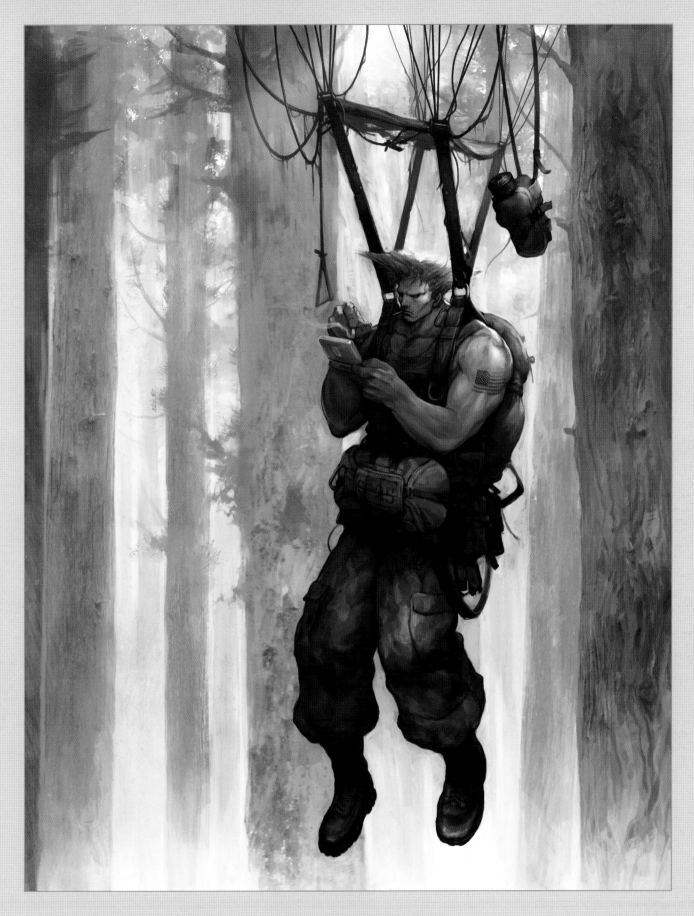

LEE CHANG-WOO
SOUTH KOREA
BLOG.NAVER.COM/83SHO
ILLUSTRATOR
[CRONOS, RIDING STAR]

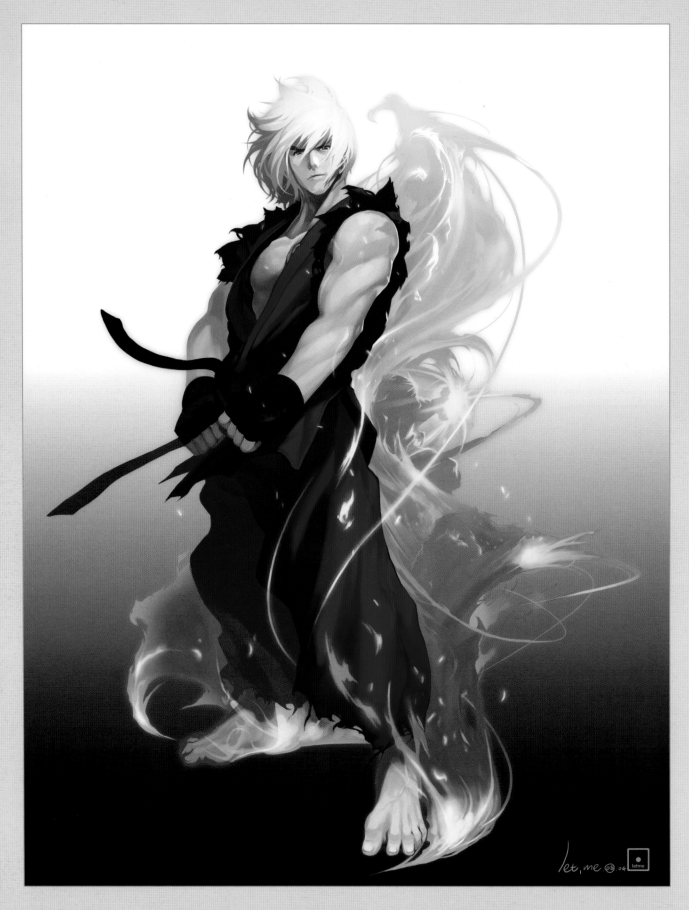

JUNG YONG-SICK [LETME]
SOUTH KOREA
HTTP://BLOG.NAVER.COM/LETME0306
CONCEPT ARTIST/ILLUSTRATOR
[KNIGHT ONLINE, PARFAIT SITUATION, DUNGEON & FIGHTER]

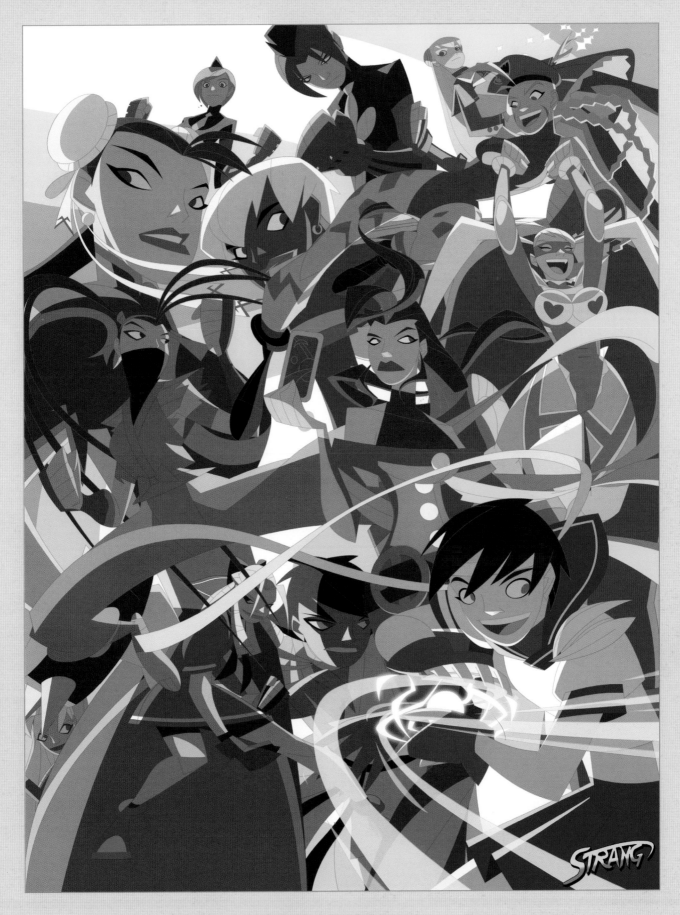

BOB STRANG
SOMERSET, PENNSYLVANIA, USA
VONTOTEN.DEVIANTART.COM
ARTIST
[ATTACK OF THE MONSTROLOGY "THE CREEPS"]

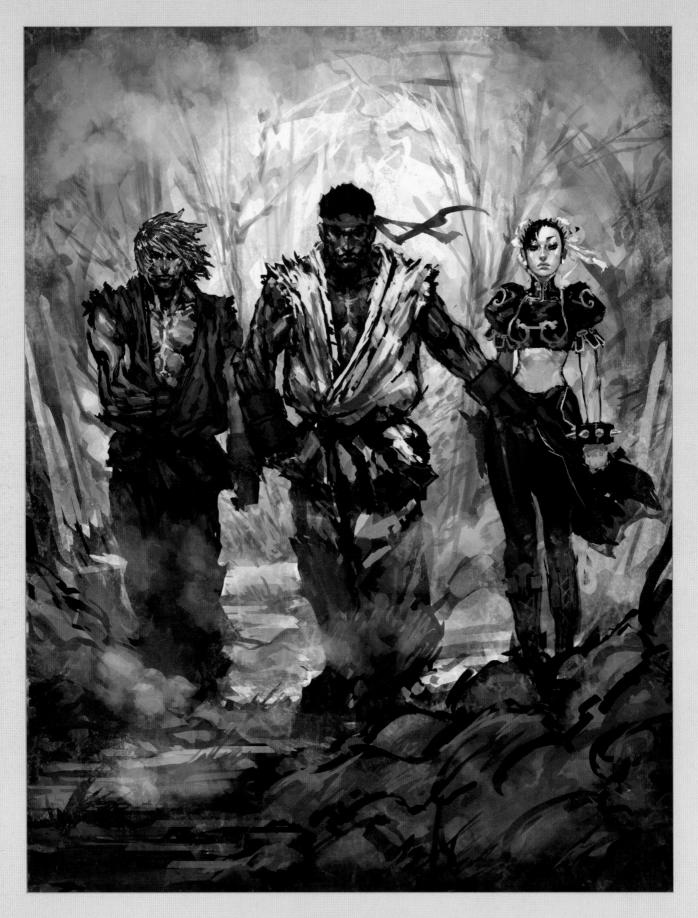

ANDRE MINA
WWW.GAIAONLINE.COM
CONCEPT ARTIST
[GAIA ONLINE]

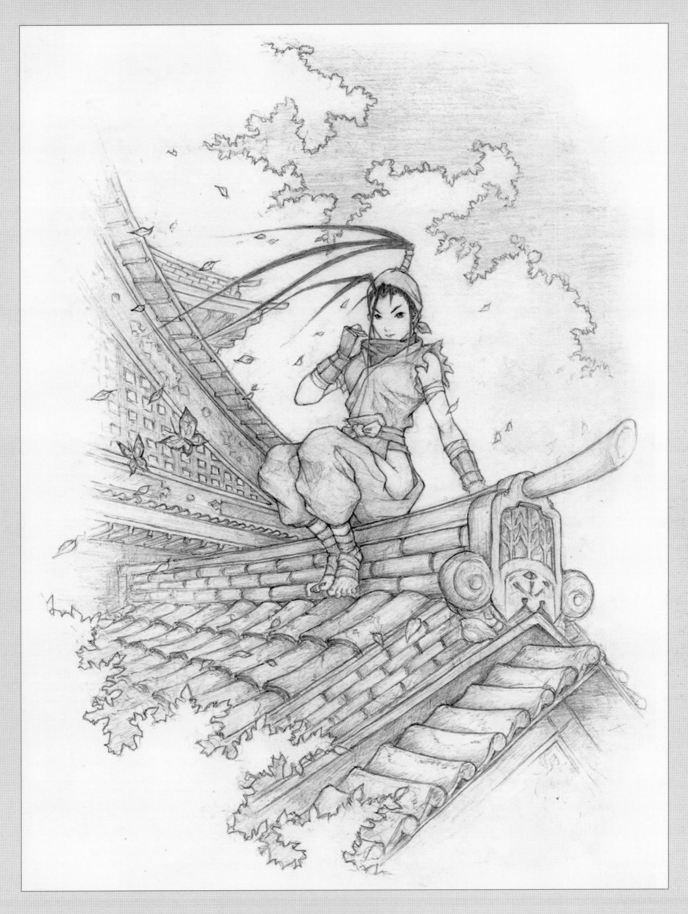

GERTRUIDA
BANDUNG, INDONESIA
ACOLYTE ILLUSTRATION SCHOOL

JEFFREY "CHAMBA" CRUZ

The earliest memory I have of the original Street Fighter game was back at a mate's joint, playing it on his Amiga 500 computer. It was a super old console with super old graphics but I guess since I was so young it kept me entertained. Thinking back now, I realize how dodgy it was, but it was one of a kind in those days.

A few years later, in Primary School, Street Fighter II came out in arcades. When it was released on both the SNES and Mega Drive I finally had a chance to play it. It had advanced so far beyond the original game. As the years passed by, newer and better versions of SF were released, like Street Fighter II Turbo and a whole slew of the Alpha/Zero games. All those releases were preparing me... preparing me for the pinnacle of Street Fighter games: the Street Fighter III series.

Capcom had stepped it up, as any one would expect from the epitome of 2D fighting games. It included some of the wildest designs, including one of my favourite characters out of the entire SF cast.

The one who stood out for me was Q. He was such an odd character and so difficult to play but he was worth the challenge of controlling well. The fact that his v was so obscure and had me questioning what he was supposed to be was enough reason for me to draw him.

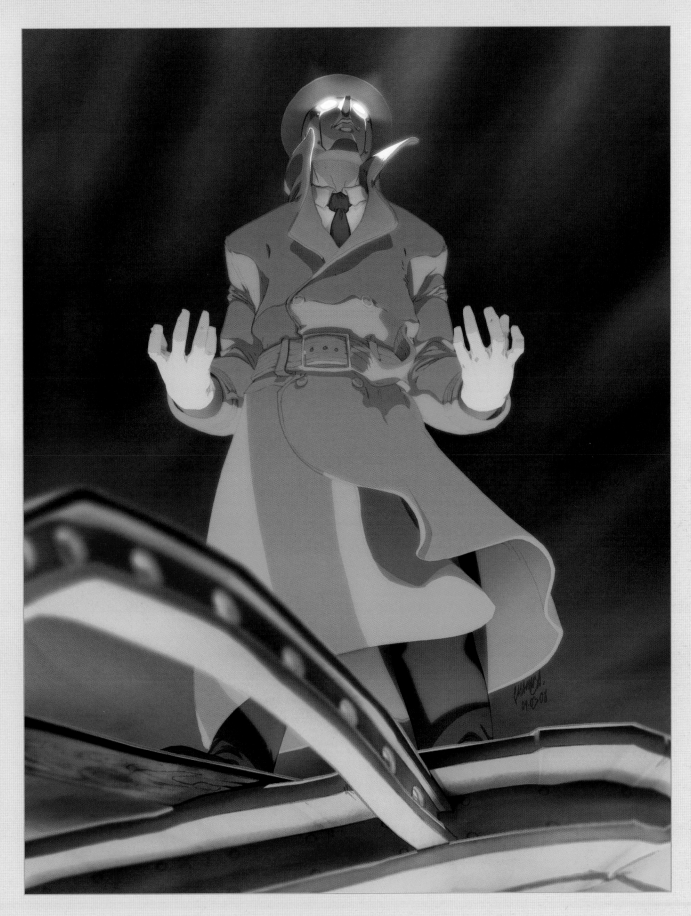

JEFFREY "CHAMBA" CRUZ
MELBOURNE, AUSTRALIA
LASTSCIONZ.DEVIANTART.COM - CHAMBA-LANG-ITO.BLOGSPOT.COM
ILLUSTRATOR
[10TH MUSE, SINBAD: ROGUE OF MARS, STREET FIGHTER II TURBO]

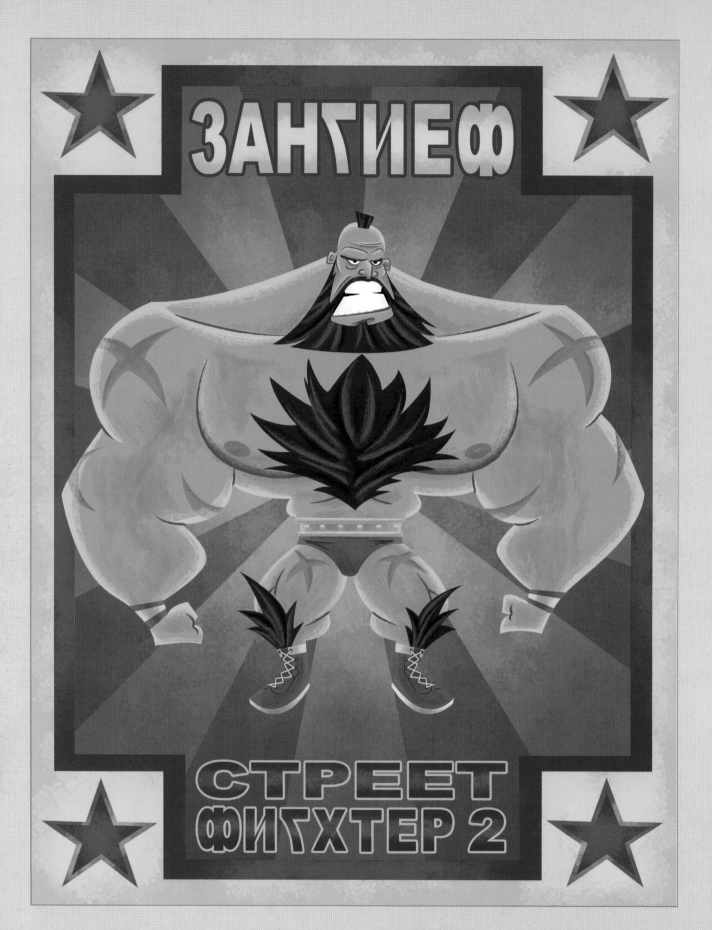

ЗАНГИЕФ

СТРЕЕТ ФИГХТЕР 2

ERIC "THE GUTE" GONZALEZ
RIVERSIDE, CALIFORNIA, USA
ERICGONZALEZ.BLOGSPOT.COM

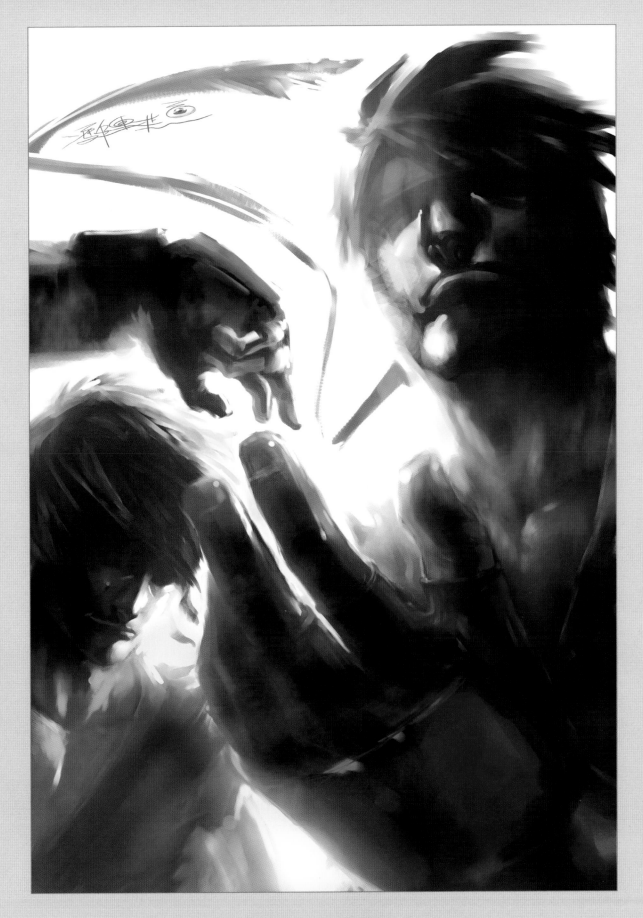

FUNG KIN CHEW
KUALA LUMPUR, MALAYSIA
FKCSANTACLAUS.DEVIANTART.COM
FKCSANTACLAUS.CGSOCIETY.ORG/GALLERY
COMIC ARTIST / CONCEPT ARTIST

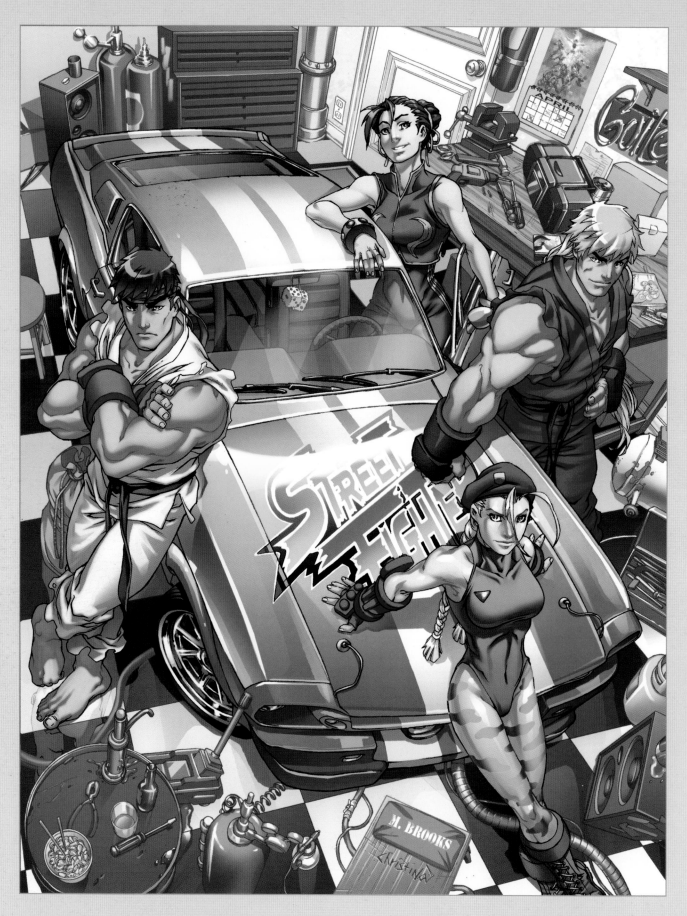

MARK BROOKS
ATLANTA, GEORGIA, USA
DIABLO2003.DEVIANTART.COM
ARTIST
[SPIDER-MAN, FANTASTIC FOUR, NEW X-MEN,
AVENGERS, CABLE/DEADPOOL]

CHRISTINA STRAIN
LOS ANGELES, CALIFORNIA, USA
CEECEELUVINS.DEVIANTART.COM
COLORIST
[SPIDER-MAN LOVES MARY JANE,
RUNAWAYS, AVENGERS]

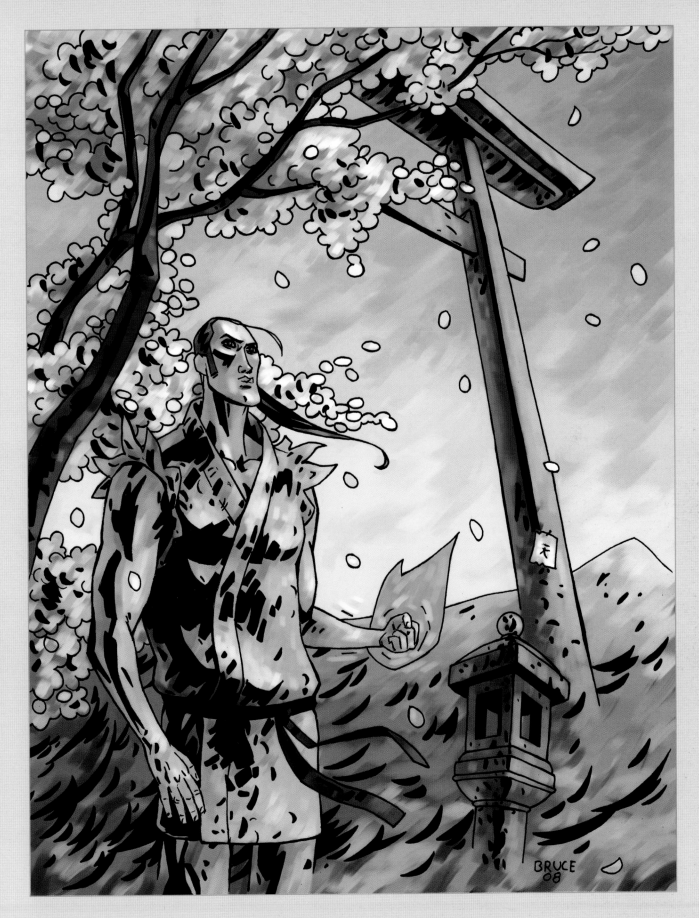

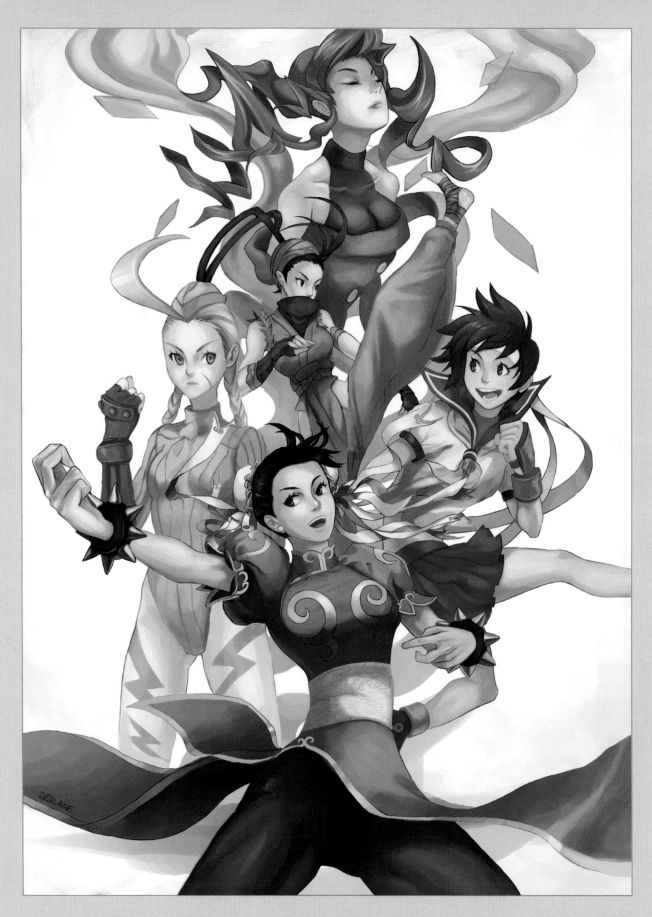

DERLAINE
WWW.GAIAONLINE.COM
CONCEPT ARTIST
[GAIA ONLINE]

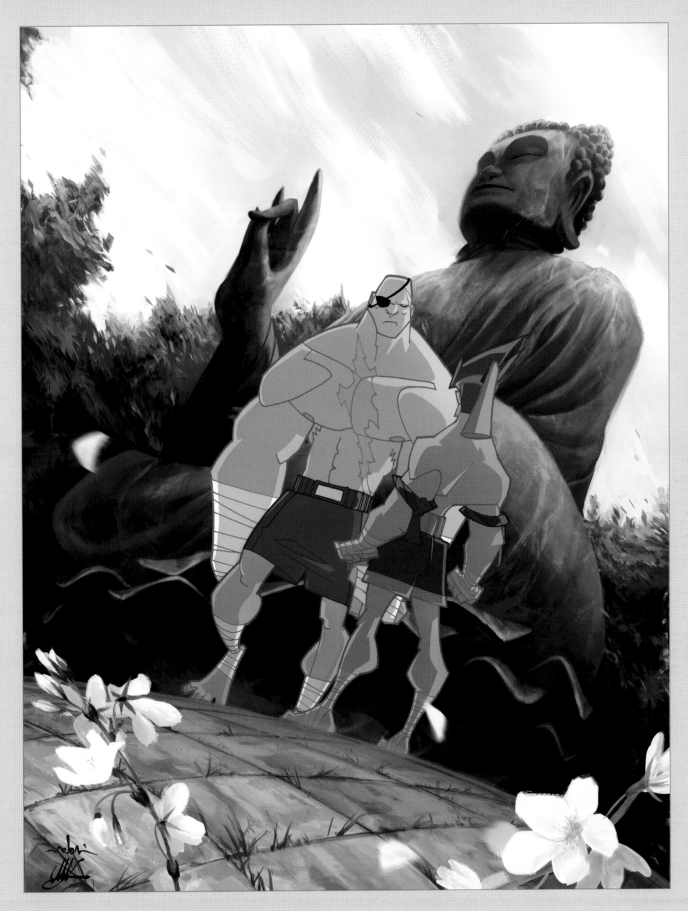

MATTEO SCALERA
PARMA, ITALY
MATTEOSCALERA.DEVIANTART.COM
MATTEOSCALERA.BLOGSPOT.COM
ORIGINAL CONCEPT & CHARACTER ARTIST
[HYPERKINETIC, IMAGE COMICS]

ANDREA MELONI
SETTIMO TORINESE (TO), ITALY
WWW.H1CKS.BLOGSPOT.COM
BACKGROUND ARTIST &
FREELANCE ILLUSTRATOR

ストリートファイタートリビュート | 27

ANDREW HOU

I've loved Street Fighter since I was a little kid. I remember sneaking into the arcade at the convenience store near my house after school. I also remember getting caught by my Mom for not going home after school. She pulled me out of the arcade by the ear.

Street Fighter was more than just an art thing for me, it was part of my childhood. I used countless quarters just to practice doing triple shoryukens and the jump kick, low medium, fireball - dizzy combo. I remember when Akuma made his first appearance and I fell in love with the design. I don't even know what it was about him. He was probably the first character that just screamed "BAD ASS".

Down the road when I was able to officially work on Street Fighter, it was like a dream come true. I remember when I first started drawing 6-7 years ago, I'd draw Akuma all the time. It wasn't until working on this new SF Tribute art book, while deciding what character to draw, that I realized I hadn't drawn him for a long time.

Illustrating Akuma brings back so many memories of my life and the paths I've traveled as an artist.

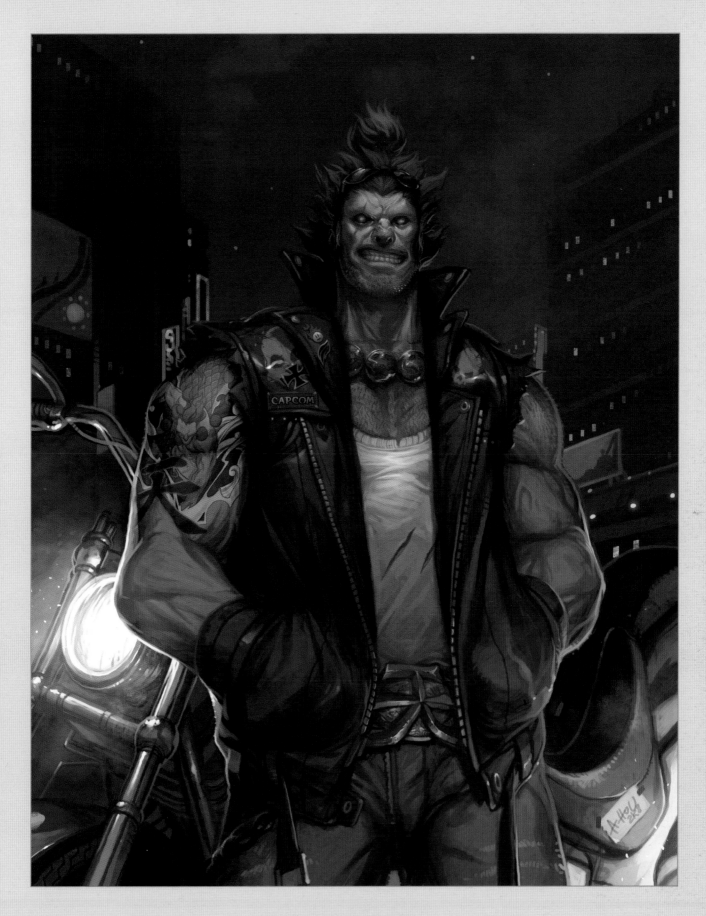

ANDREW HOU
WWW.ANDREWHOU.COM
ILLUSTRATOR/CONCEPT ARTIST
[STREET FIGHTER, DUNGEONS AND DRAGON]

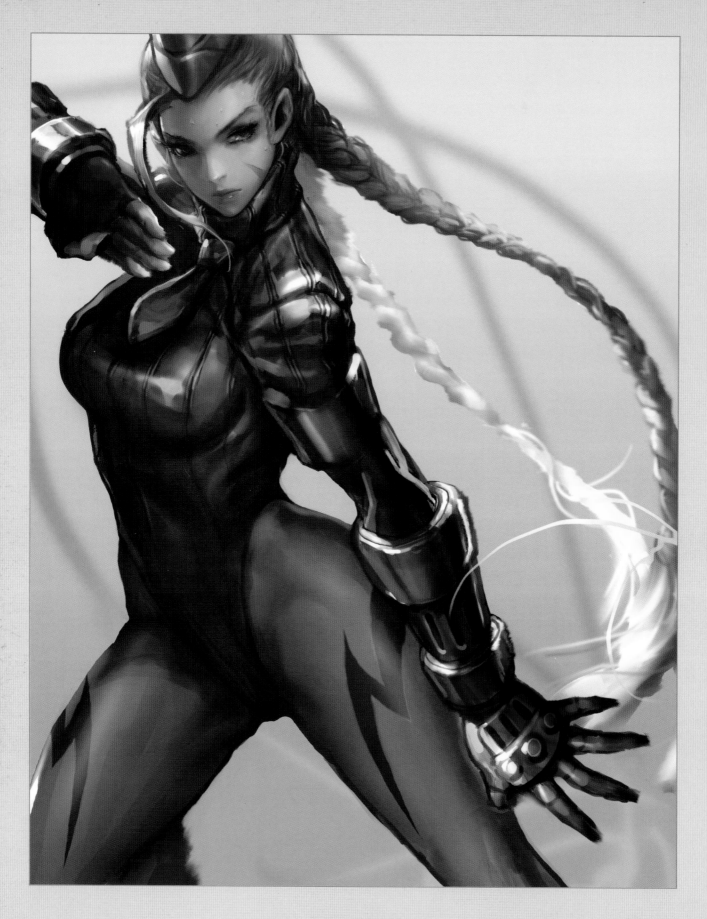

LIM JONG-HEE [JJ]
SOUTH KOREA
JX2COMICS.EGLOOS.COM
ART DIRECTOR [NCSOFT INC]
ILLUSTRATOR/CONCEPT ARTIST [LINEAGE II]

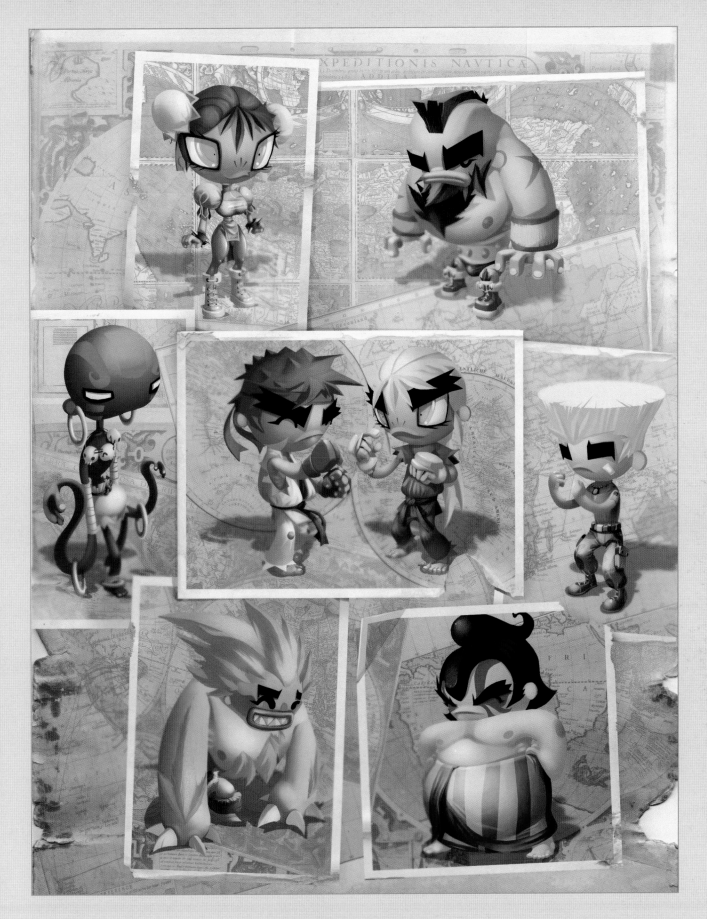

ANDREW WILSON
SAN DIEGO, CALIFORNIA, USA
ANDREWANDDAVID.BLOGSPOT.COM
ILLUSTRATOR/ART DIRECTOR
[THE FORGOTTEN KINGDOM, SO NOW WHAT DO WE DO?,
ROCKSTAR SAN DIEGO: MIDNIGHT CLUB SERIES]

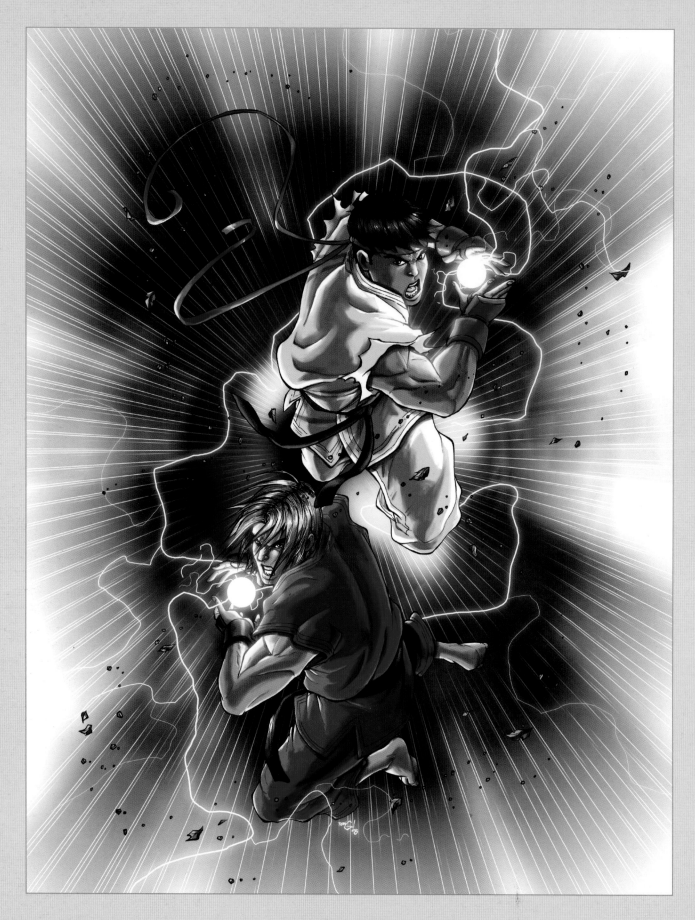

ANDIE TONG
LONDON, ENGLAND
WWW.DEEMONPRODUCTIONS.COM
ARTIST
[SPECTACULAR SPIDER-MAN UK, BATMAN STRIKES]

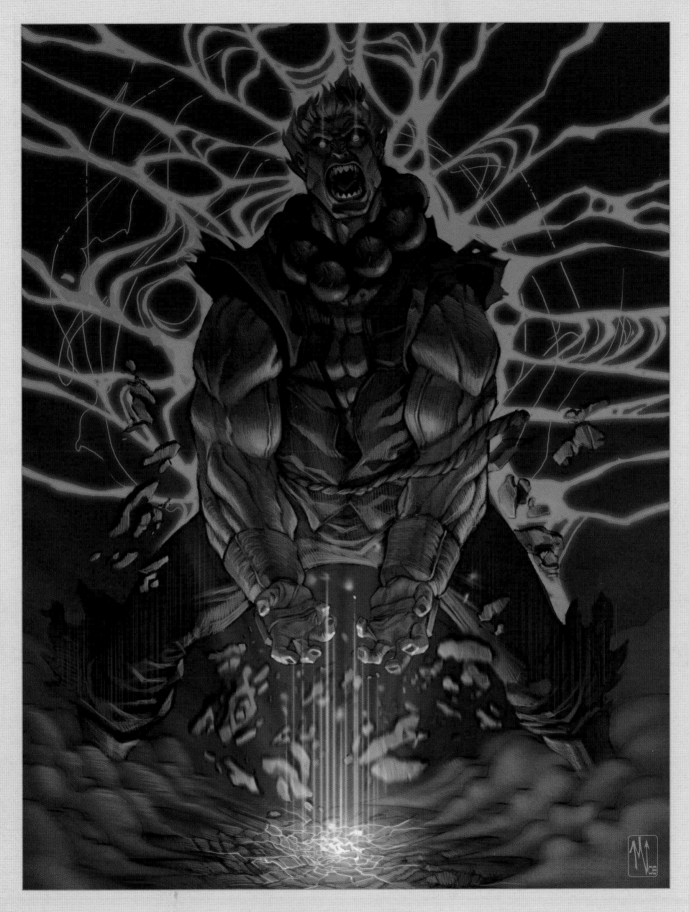

JORGE MOLINA
MÉRIDA, YUCATÁN MEXICO
WWW.ZURDOM.COM
ZURDOM.DEVIANTART.COM
ILLUSTRATOR

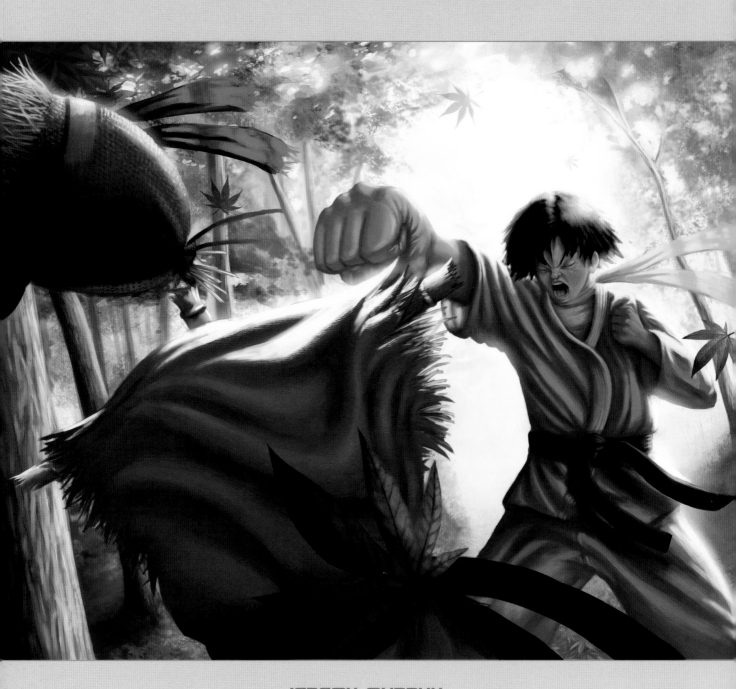

JEREMY MURPHY
KINGSTON, MASSACHUSETTS, USA
WWW.INFEHNITEDESIGN.COM
FREELANCE ILLUSTRATOR

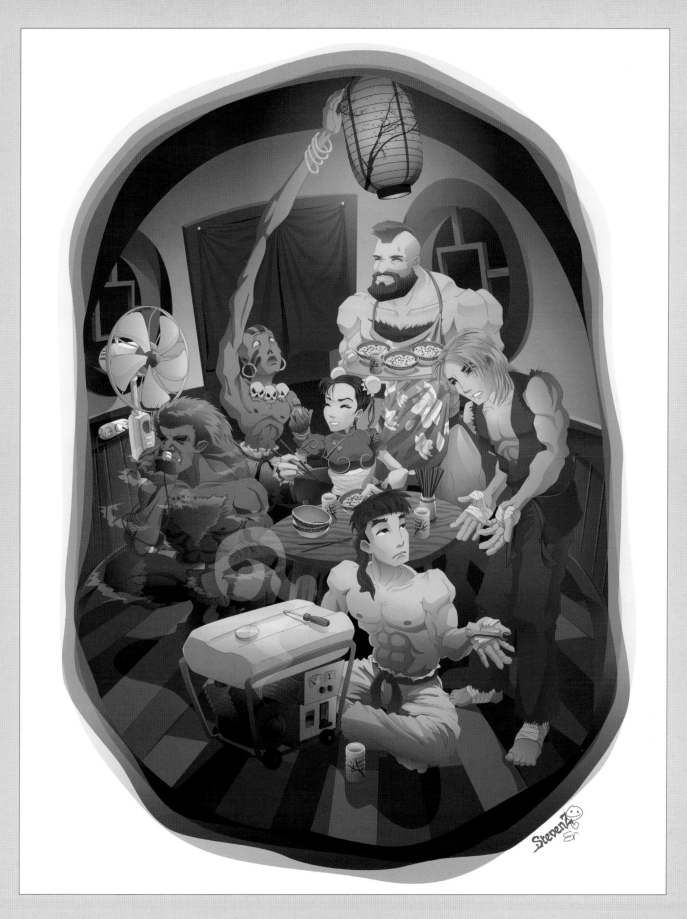

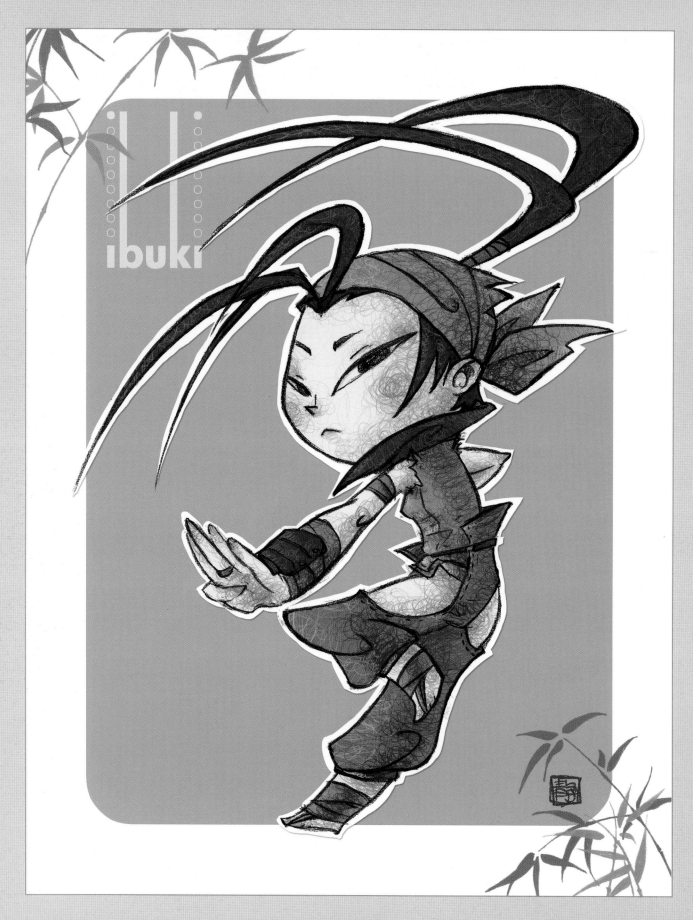

ibuki

JING TEO
SINGAPORE, SINGAPORE
JINGSTER.DEVIANTART.COM

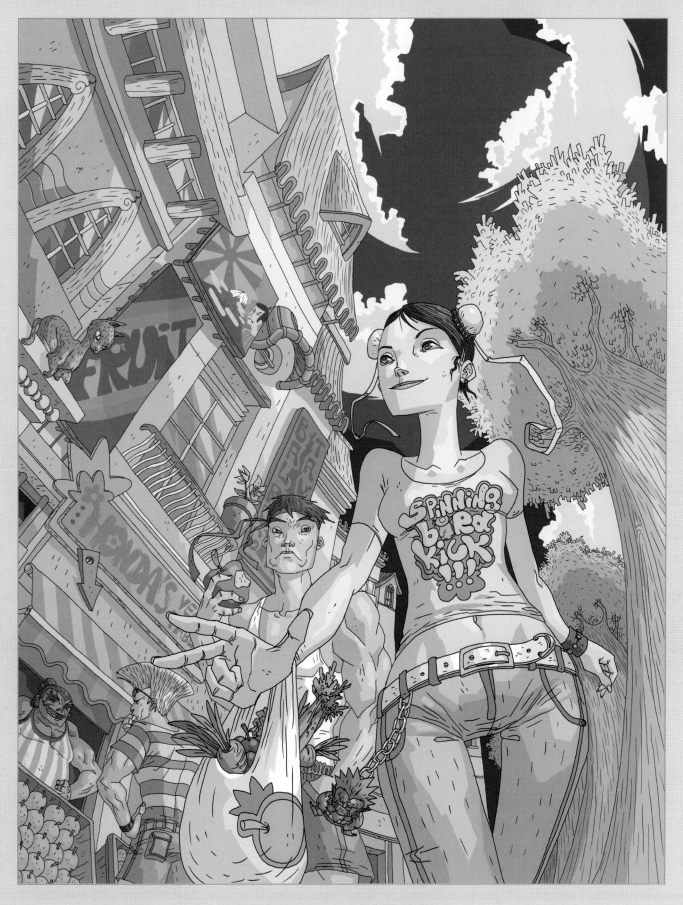

ANCOR GIL HERNÁNDEZ
SANTA CRUZ DE TENERIFE, SPAIN
GREAT-OHARU.DEVIANTART.COM
FREELANCE ILLUSTRATOR / COMIC ARTIST
[POPGUN]

ARNOLD TSANG

Although my first love was for comics, there is no other body of artwork that has influenced me more than the works from Street Fighter. I think I speak for many artists of my generation when I say that Street Fighter's artwork sparked a revolution in not only the then-budding field of game concept art, but in popular illustration as a whole.

Did I mention that it's an awesome game too? If something could be on par with the flair and creativity in Street Fighter's art, it's definitely the gameplay. Punch for punch, hadouken for hadouken, a harmony in ass-kicking art and ass-kicking fun. Beating up your friends and family has never looked so good.

Street Fighter, you've ravaged my thumb with many shoryuken blisters but what you've given me is worth so much more!

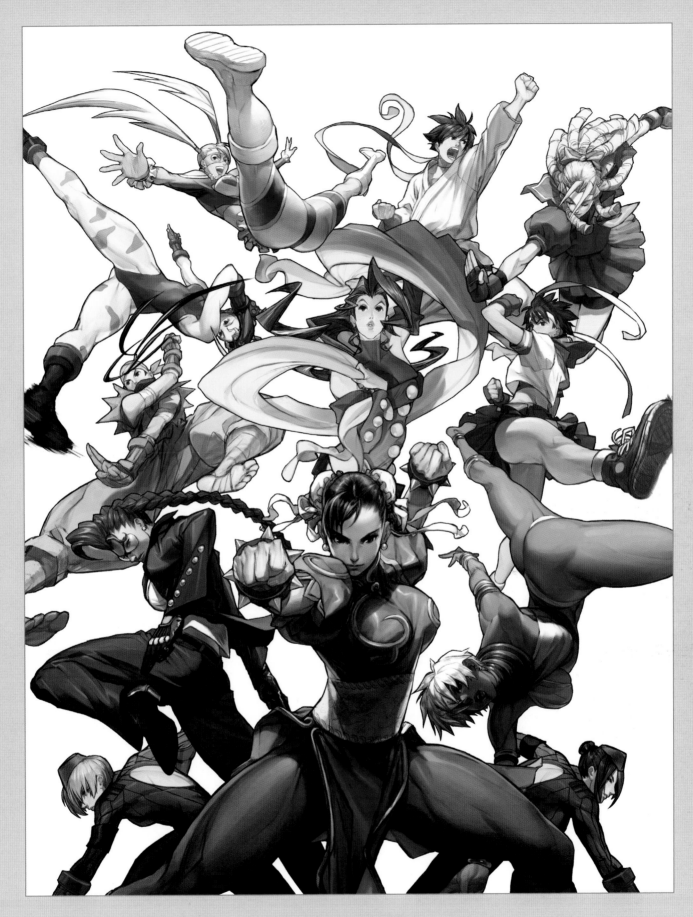

ARNOLD TSANG
SHANGHAI, CHINA
WWW.WEEWUNG.COM/ARN/PORTFOLIO
ILLUSTRATOR / CONCEPT ARTIST
[STREET FIGHTER, APB]

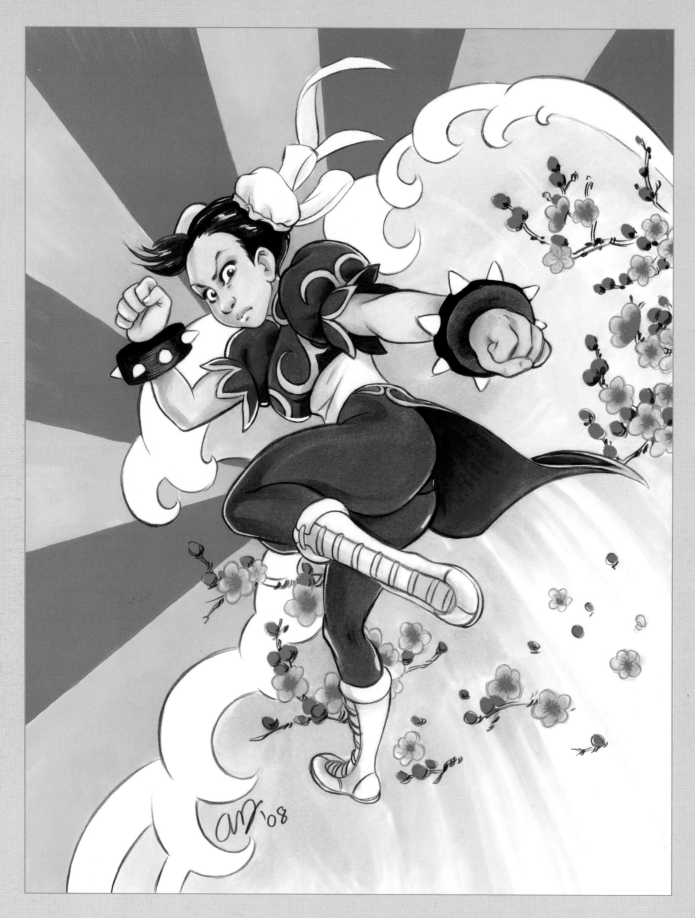

AIMEE MAJOR STEINBERGER
BURBANK, CALIFORNA, USA
WWW.AIMEEMAJOR.COM
COMIC ARTIST [JAPAN AI]
ANIMATION ARTIST [FUTURAMA, THE SIMPSONS, DISNEY INTERACTIVE]

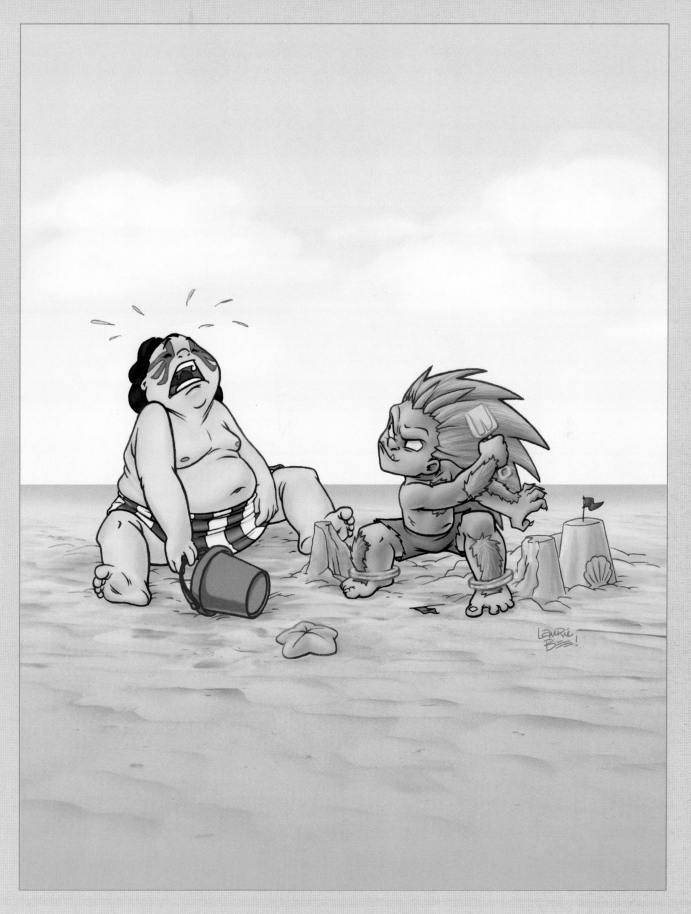

LAURIE BREITKREUZ
ARTOFLAURIEB.BLOGSPOT.COM
ANIMATOR/ILLUSTRATOR

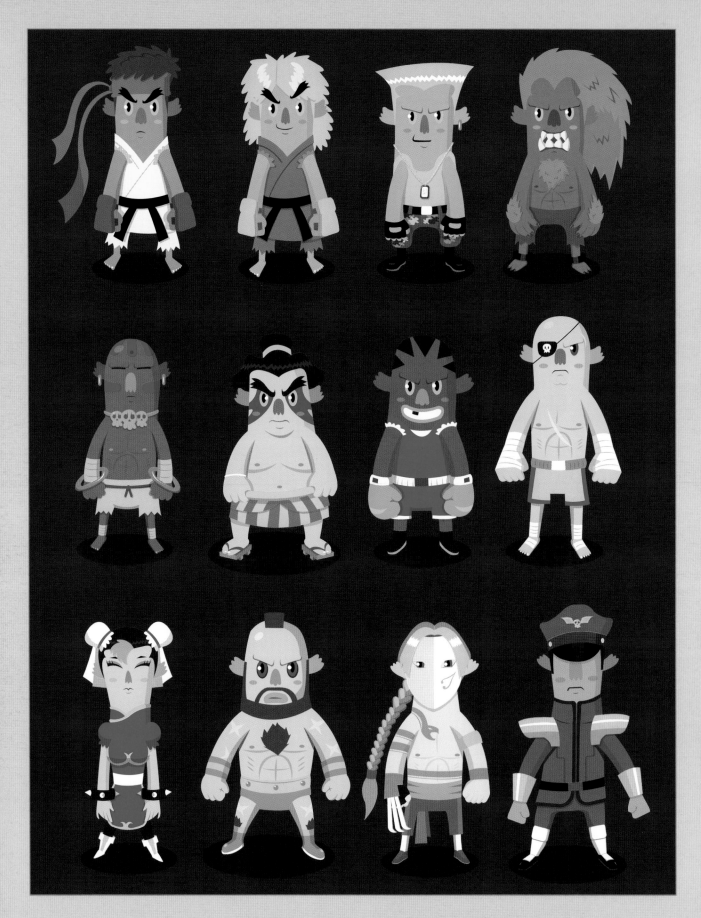

KENJI CHAI VUI YUNG [BLACK FRYDAY]
KUALA LUMPUR, MALAYSIA
TODAYISBLACKFRYDAY.BLOGSPOT.COM

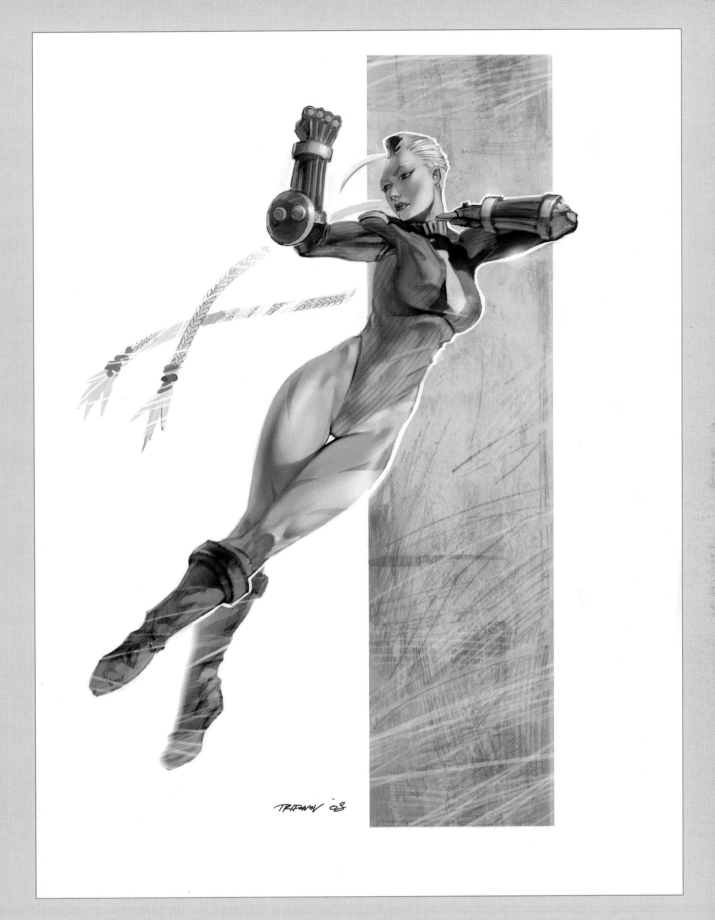

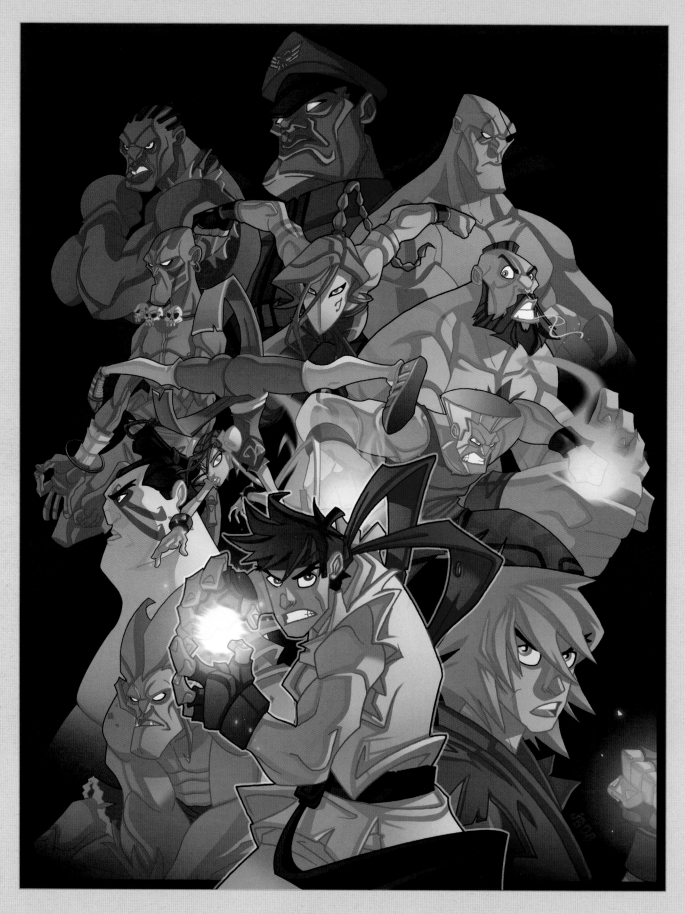

JAVIER BURGOS
MADRID, SPAIN
JAVASB.BLOGSPOT.COM
FREELANCE ARTIST

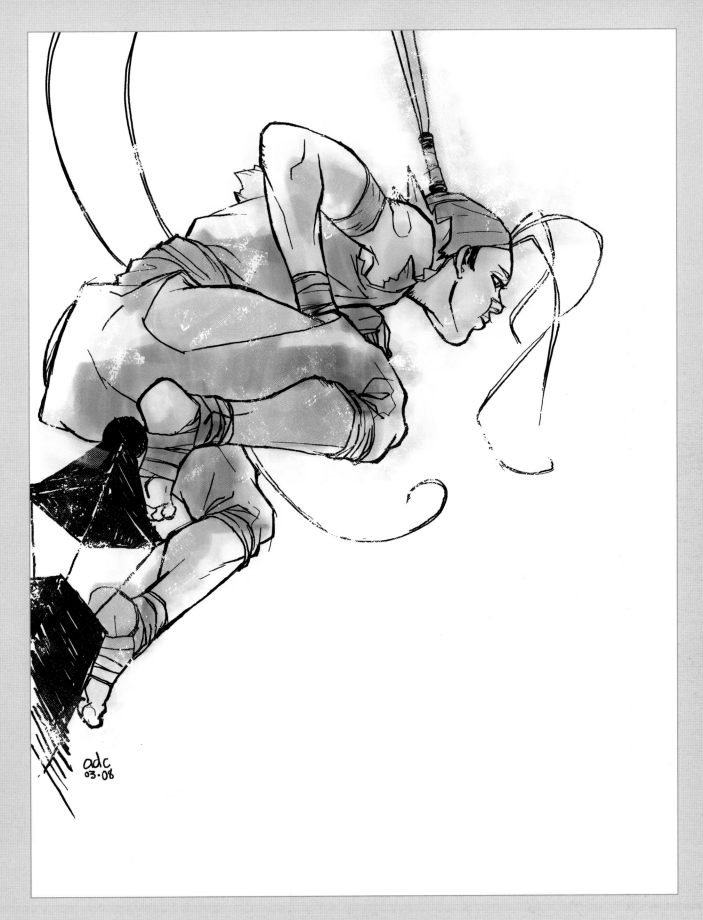

ARTHUR DELA CRUZ
TORONTO, ONTARIO, CANADA
WWW.KISSINGCHAOS.COM
CREATOR OF KISSING CHAOS
FREELANCE WRITER/ARTIST [ONI PRESS, IMAGE COMICS, DC COMICS, 360E.P.]

CHRISTINE CHOI

When I was young my parents would frequently throw dinner parties with their friends. Being eight and knowing we would be going to a potluck meant one thing: Street Fighter. All us kids would huddle around a little television and become sucked into the Street Fighter realm. The outside world (including the calls to come for dinner) would be blocked out in anticipation of the next epic "Street Fighter moment".

A "Street Fighter moment" is that perfectly timed combo, or immaculate block. It is the feeling when you have finally won after a 5-loss streak or when a total button-mashing noob kicks your can to the curb. It is the inevitable debate of Ryu vs. Ken superiority - and the eventual conclusion that the best is, in fact, Chun-Li. It is the shout of victory. It is admitting defeat. It is showing your Street Fighter blisters with pride.

I whole-heartedly share in the love of Street Fighter. The ability for it to touch gamers and non-gamers alike is what makes Street Fighter more than just a game. It is a community.

Hold, make, share your Street Fighter moments — it is what allows the legacy of Street Fighter to continue.

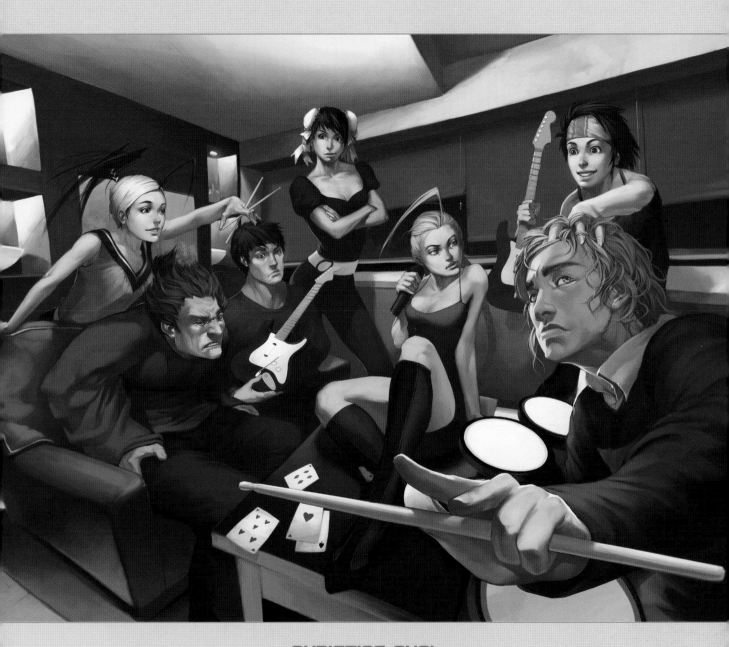

CHRISTINE CHOI
TORONTO, ONTARIO, CANADA
PAINTER [UDON]

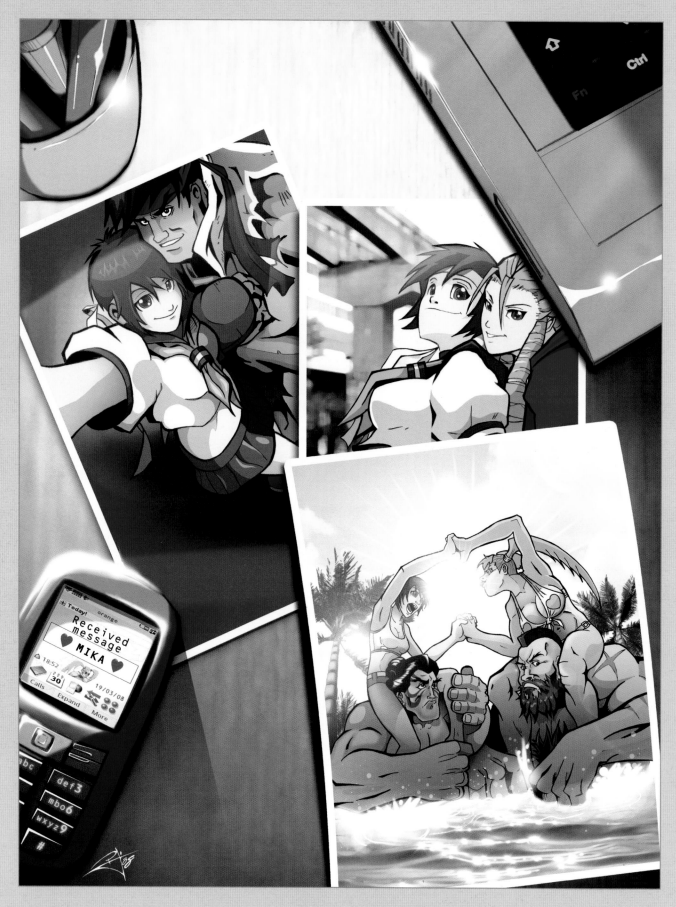

PERICLES JÚNIOR
VITÓRIA, BRAZIL
WWW.PJARTS.NET
ILLUSTRATOR / COMIC ARTIST

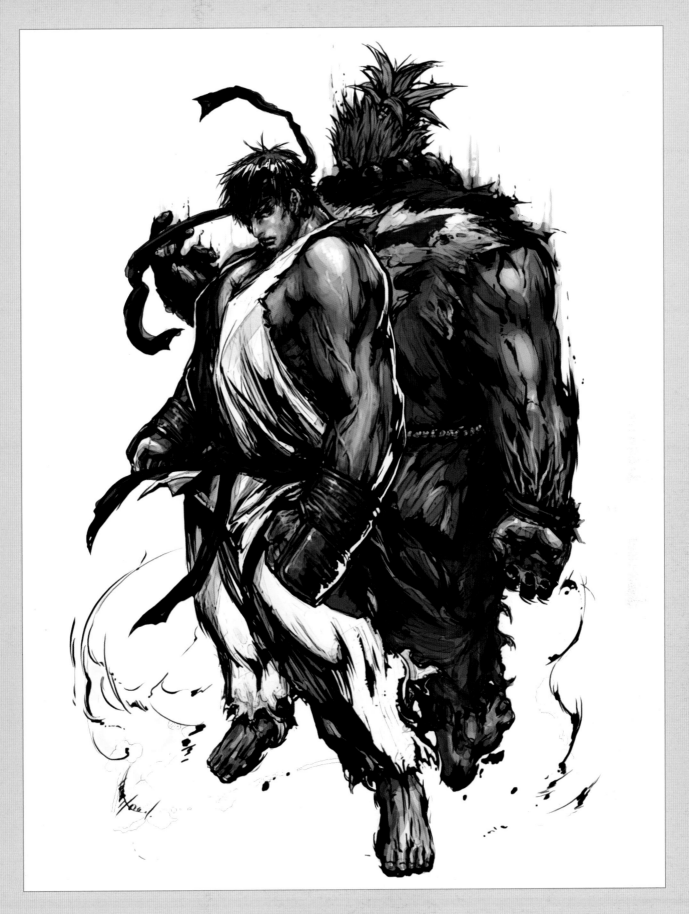

LEE JUNG-MYUNG
SOUTH KOREA
ILLUSTRATOR

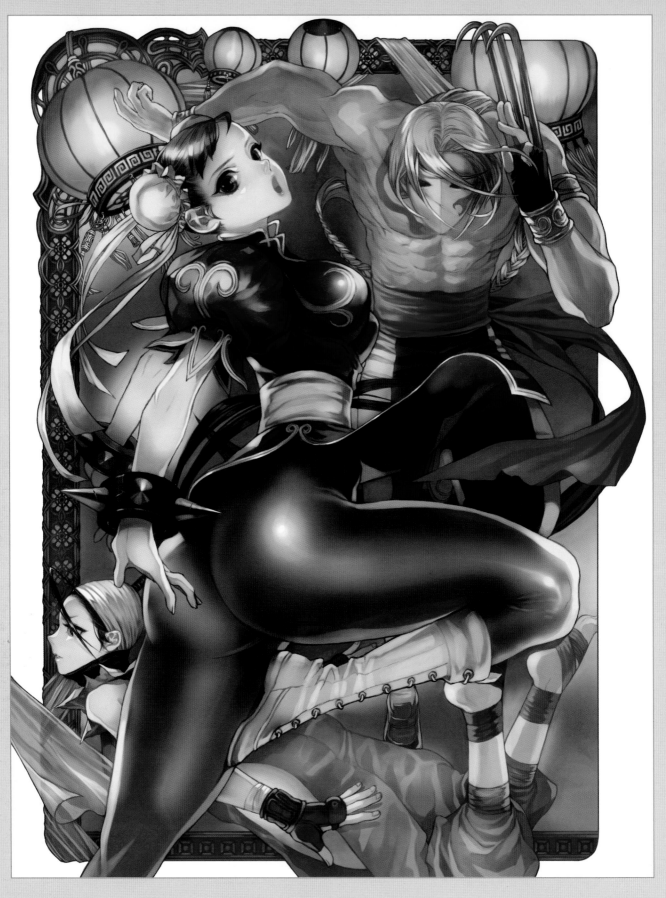

AN JEONG-WON [MAGGI]
SOUTH KOREA
ILLUSTRATOR

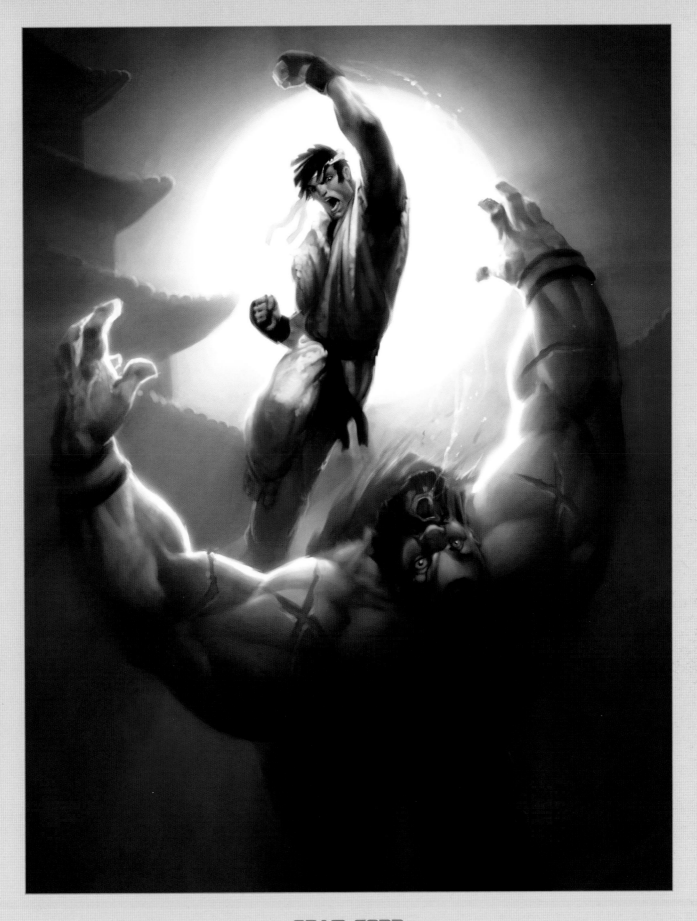

ADAM FORD
EAGLE MOUNTAIN, UTAH, USA
ADAMSCREATION.BLOGSPOT.COM

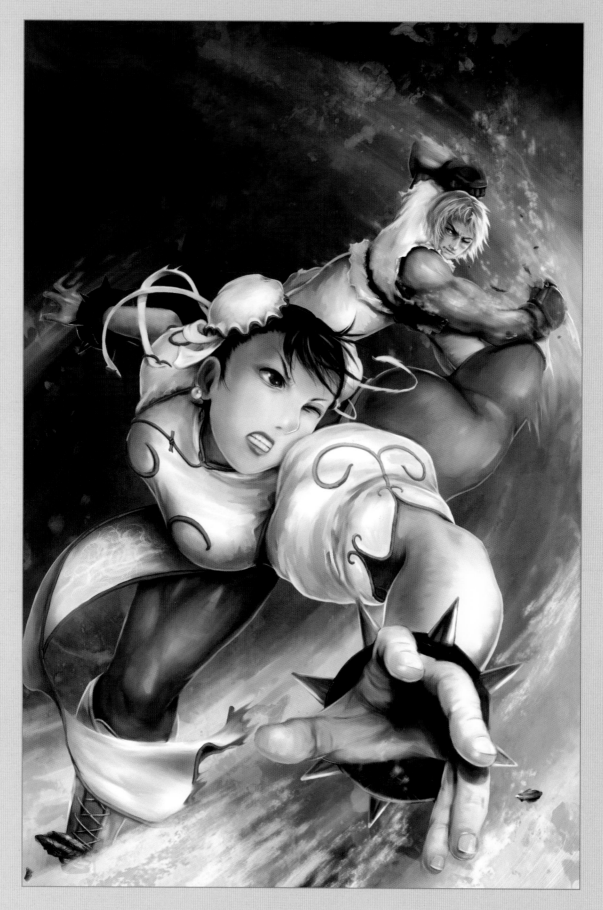

GARY YEUNG
TORONTO, ONTARIO, CANADA
ARTIST, COLORIST
[MEGA MAN X COLLECTION COVER, STREET FIGHTER, DARKSTALKERS]

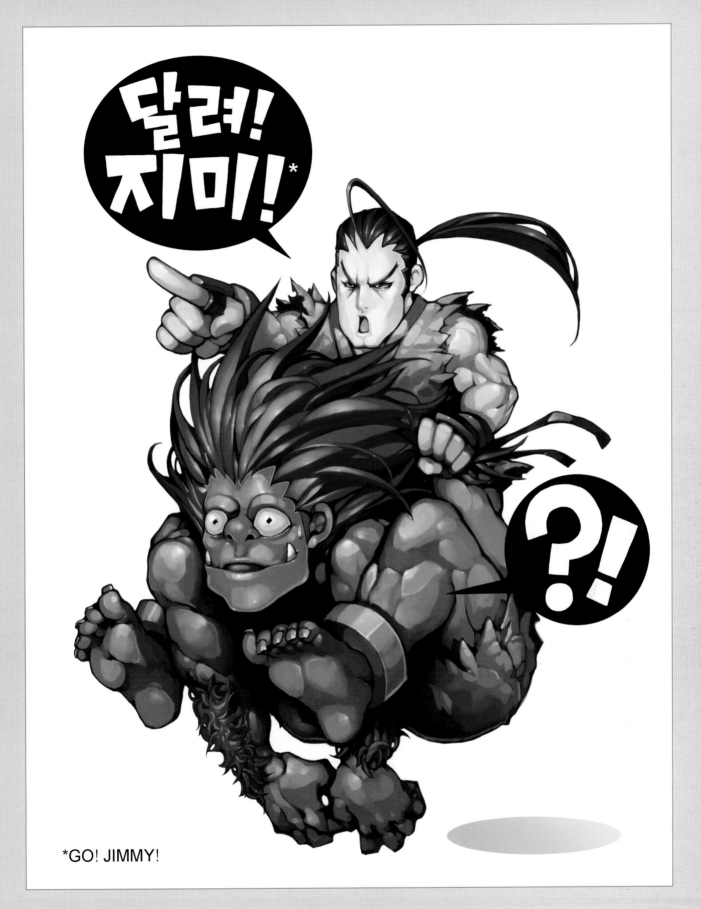

*GO! JIMMY!

LEE, MYEONG-UN [FUFUHOL]
SOUTH KOREA
BLOG.NAVER.COM/FUFUHOL
CONCEPT ARTIST

ADAM HUGHES

I feel sorry for all the young kids who have to discover all these great Capcom games via modern venues.... XBOX Live downloads and retro video game collections.

Street Fighter II... the only way you should learn to play it is in an arcade; a mall arcade, thick with sweat like a locker room after a team sport. Depending on where you lived, maybe there was an inversion layer of cigarette smoke hovering over you like the next player waiting their turn. The jangle and toll of antique video games, the angry thump of losing fists on unforgiving fiberglass cases, the cacophony of quarters filling bowls as change is made... the sounds were the only thing thicker than the air.

If you could get close enough to lay your quarters in the edge of the screen (the time-honored tradition for making a gaming reservation), then you might get a chance to play Street Fighter II. It was so popular, such an instant success, that you always knew if a new arcade had it because you simply couldn't SEE it. There was always a crowd around the machine.

I'd love to say that this was the time and place where I learned to love Street Fighter. I'd love to, but I can't. I could never get close enough to the game to actually get a chance to play. It was THAT popular.

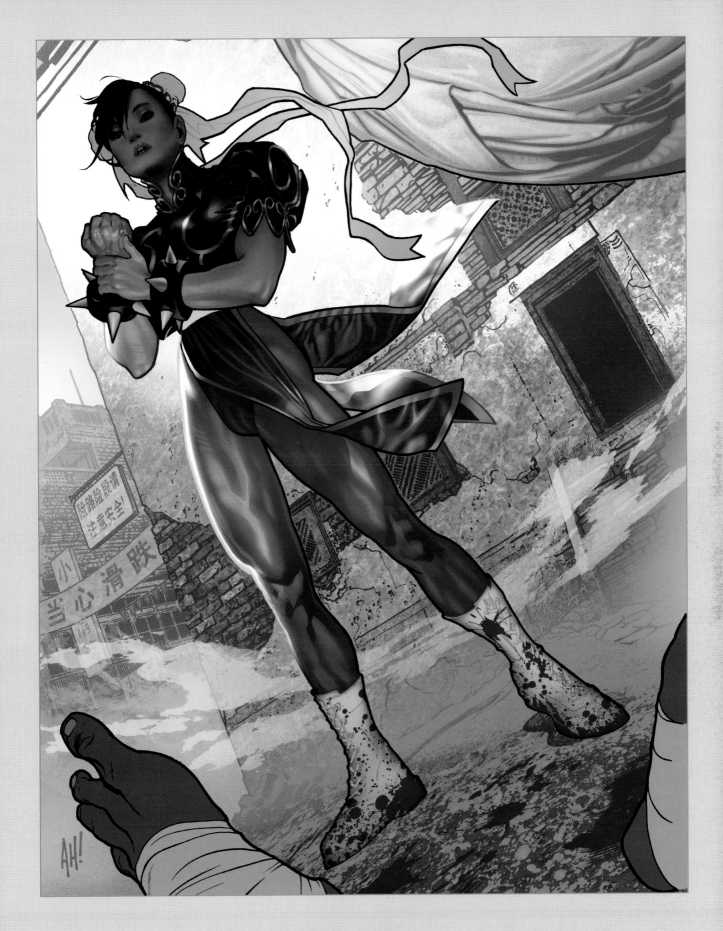

ADAM HUGHES
ATLANTA, GEORGIA, USA
WWW.JUSTSAYAH.COM
ARTIST - WRITER
[CATWOMAN, WONDER WOMAN, STAR WARS, STAR TREK, GEN-13, GHOST]

MARY CAGLE
TEXAS, USA
SHIKAKUSUIKA.DEVIANTART.COM

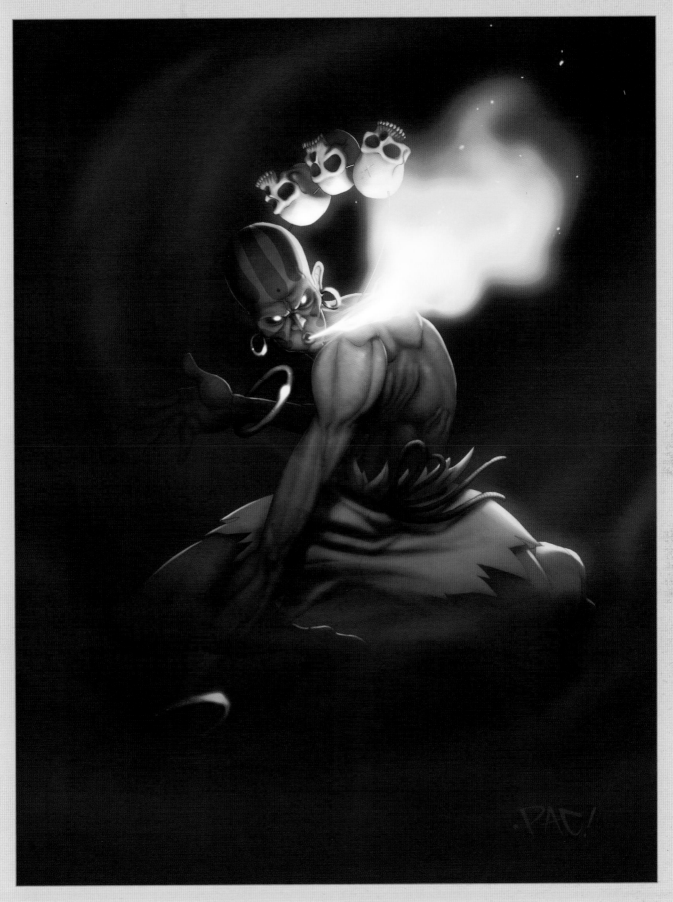

FRANCISCO PEREZ [PAC23]
MIAMI, FLORIDA, USA
PACMAN23.GUTTERSPACED.COM
ILLUSTRATOR/COLORIST
[VIRGIN AMERICA AIRLINES, LEVITICUS CROSS]

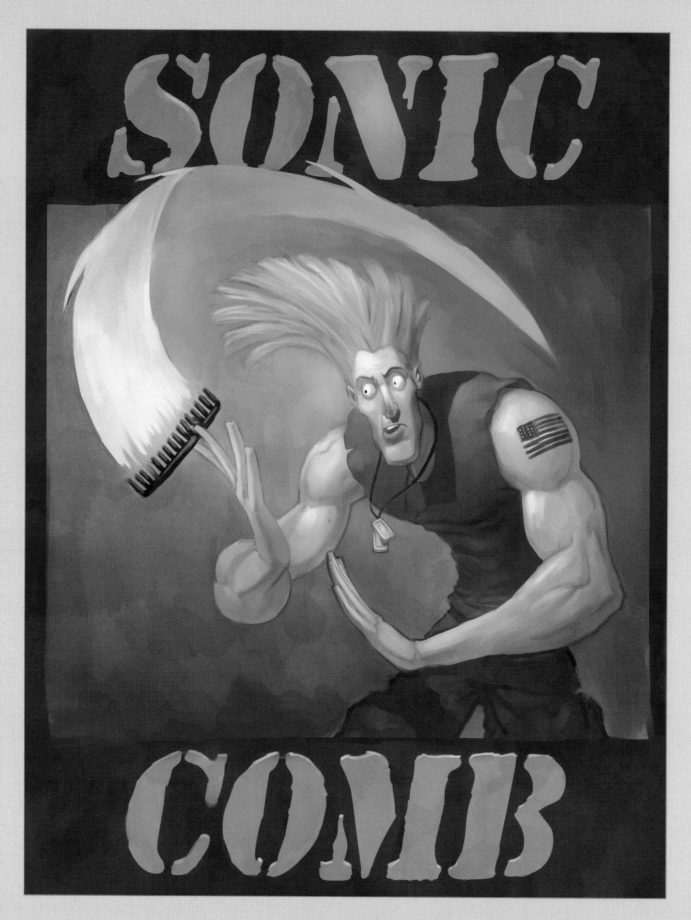

SONIC COMB

ERIC HENZE
TUSTIN, CALIFORNIA, USA
ERASERFOOT.BLOGSPOT.COM
LEAD ANIMATOR - CARBINE STUDIOS

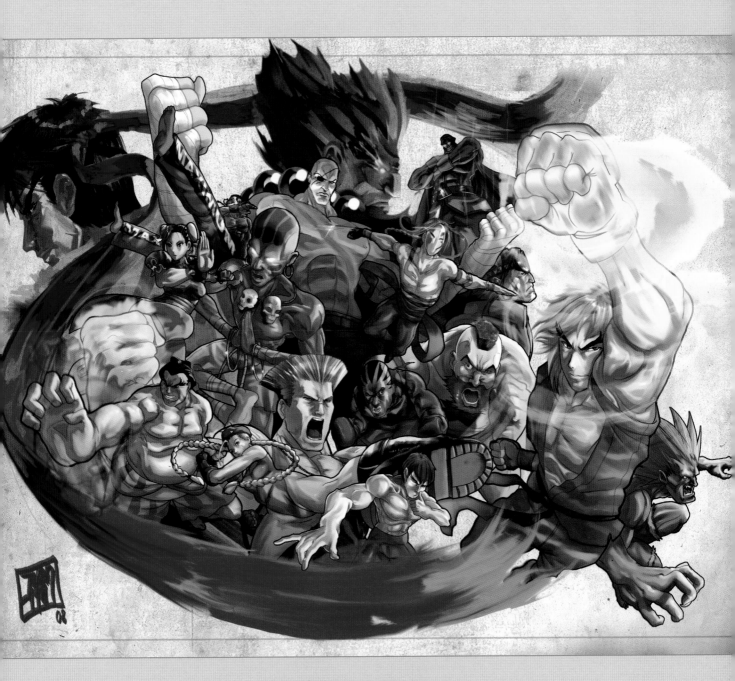

JUAN MANUEL OCHOA
MEDELLIN, COLOMBIA
ARMYCOM.DEVIANTART.COM

ALVIN LEE

My memories of Street Fighter are fond ones. It started out as a young boy playing at local arcades dumping countless quarters into machines from my allowance money. It later became an obsession, not so much towards the game itself but the artwork that accompanied it. I remember a friend of mine approached me with a Ken Masters diamond cut trading card (illustrated by Nishimura Kinu) in grade school and asked me if I could draw in this style.

I replied with a hesitant, "Yeah, I think so." Soon, after repeated attempts to draw different characters in the Street Fighter style, I realized how difficult this was. The same friend approached me later that same week and asked if I could show him what I had done.

I responded with a sheepish, "No, I can't do it."

At that moment in time I never could have imagined that I would one day be drawing this coveted Street Fighter Style professionally. Not only as the lead penciller for the comic book series but also providing art for the recent re-release of the video game itself.

To even be mentioned under the same breath as some of Capcom Japan's great artists is an incredible honor. I have learned so much from the likes of Edayan, Ikeno, Kinu, Akiman and Bengus that I am forever grateful for this transcendent property's existence. The opportunities that have opened up for me as a result of Street Fighter are countless. I think it's safe to say that Street Fighter truly has changed my life.

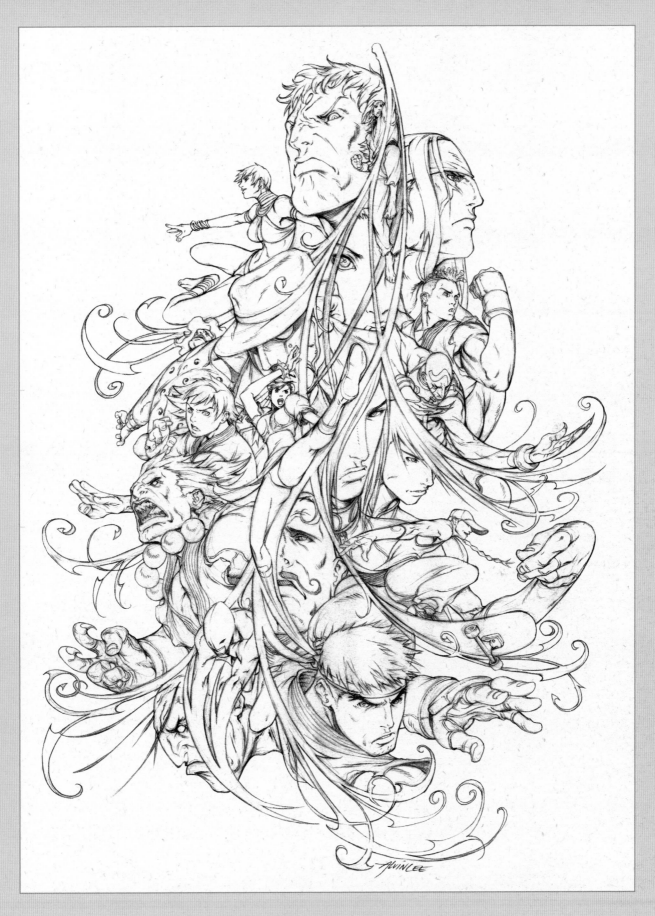

ALVIN LEE
TORONTO, ONTARIO, CANADA
WWW.ALVINLEEART.COM
PENCILLER
[STREET FIGHTER I AND II COMIC BOOK SERIES,
MARVEL ADVENTURES SUPERHEROES, AGENT-X, DEADPOOL]

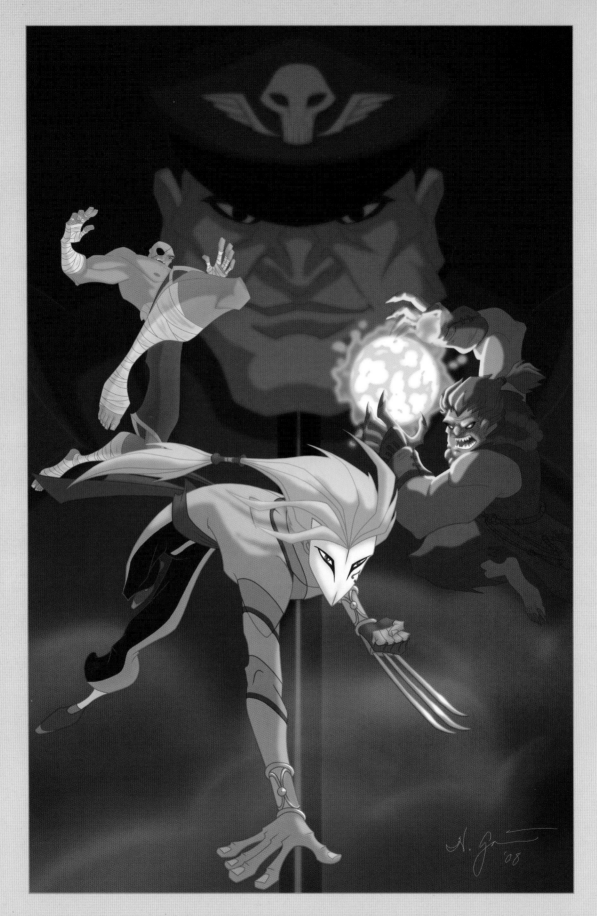

WALTER GATUS
WOODLAND HILLS, CALIFORNIA, USA
WWW.WALTERGATUS.COM
CHARACTER DESIGNER/ ANIMATION ARTIST
[SPECTACULAR SPIDER-MAN, HYDRO ATTACK, BLOKHEADZ FEATURE]

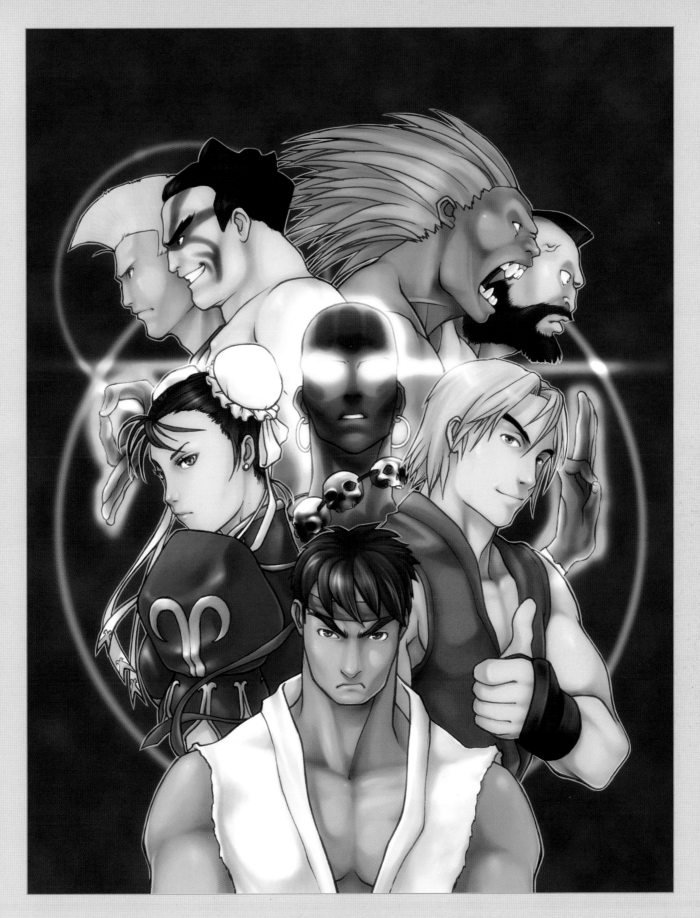

EMILIO PILLIU
DOMUSNOVAS, CARBONIA-IGLESIAS, ITALY
EXEMI.DEVIANTART.COM
ITALIAN MANGAKA

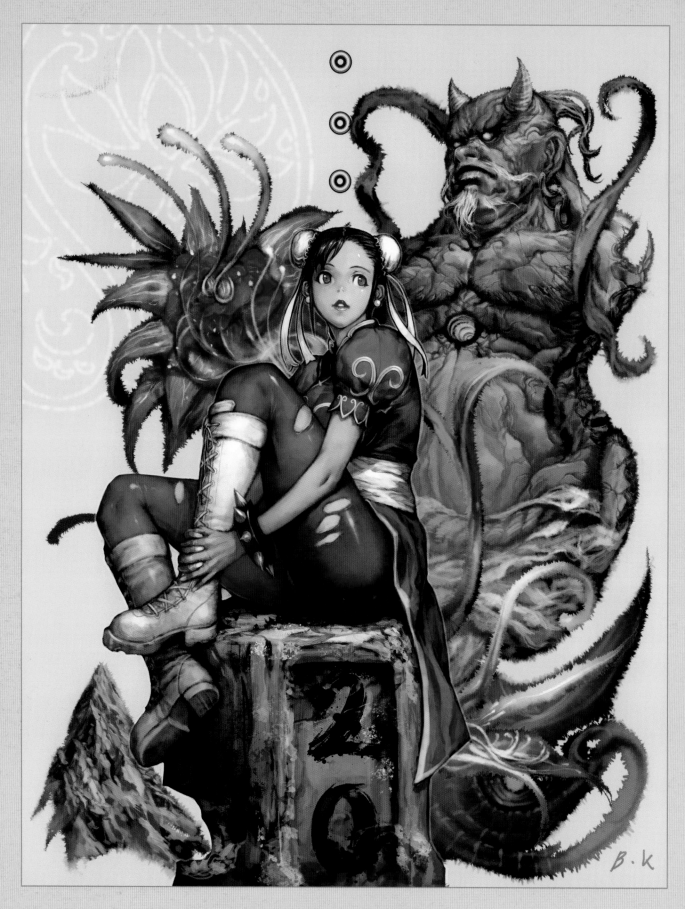

HAM SUNG-CHUL [BRAVEKING]
SOUTH KOREA
WWW.BRAVEKING.CO.KR
CHARACTER & CONCEPT DESIGNER
[EVAN ONLINE, AION, RFC, LEGEND OF HEROS]

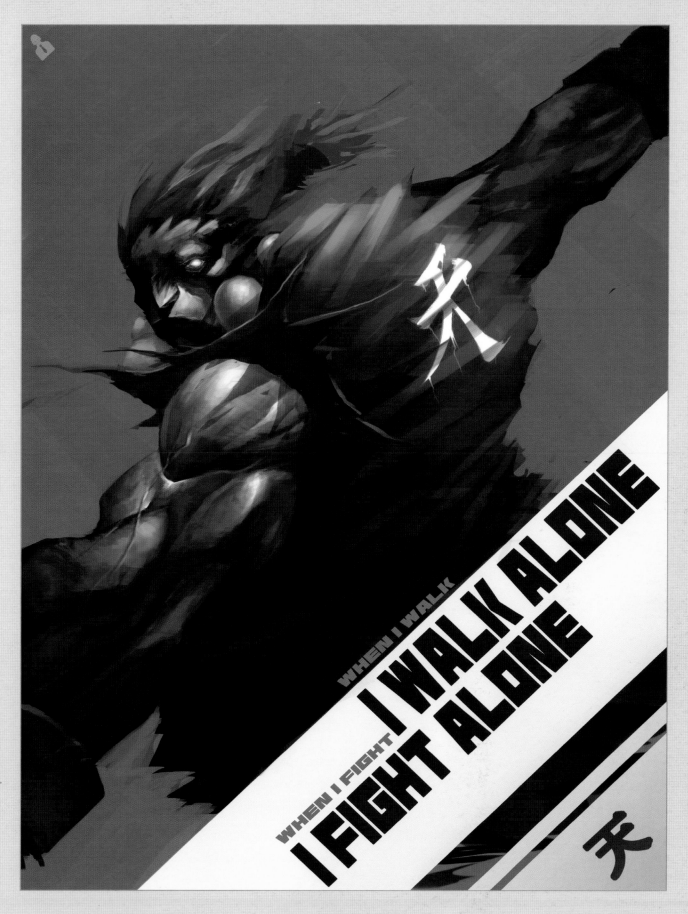

WHEN I WALK I WALK ALONE

WHEN I FIGHT I FIGHT ALONE

STEFAN ATANASOV
SOFIA, BULGARIA
WI-FLIP-FF.DEVIANTART.COM
CONCEPT ARTIST
[WI-FLIP-FF WIFLP]

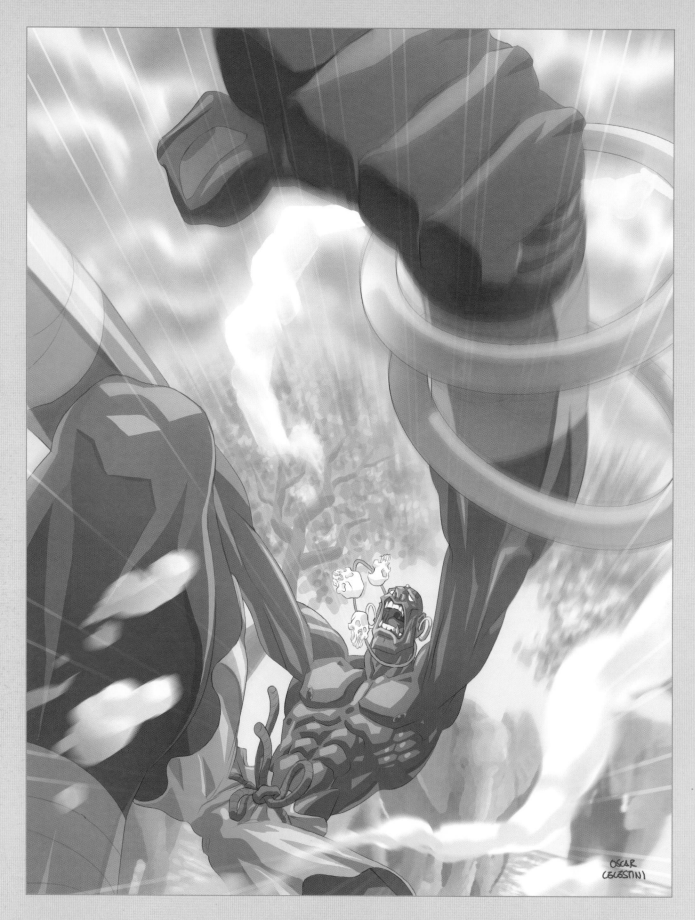

OSCAR CELESTINI

VITERBO, ITALY

WWW.OSCARCELESTINI.ALTERVISTA.ORG - OSK-STUDIO.DEVIANTART.COM

ILLUSTRATOR

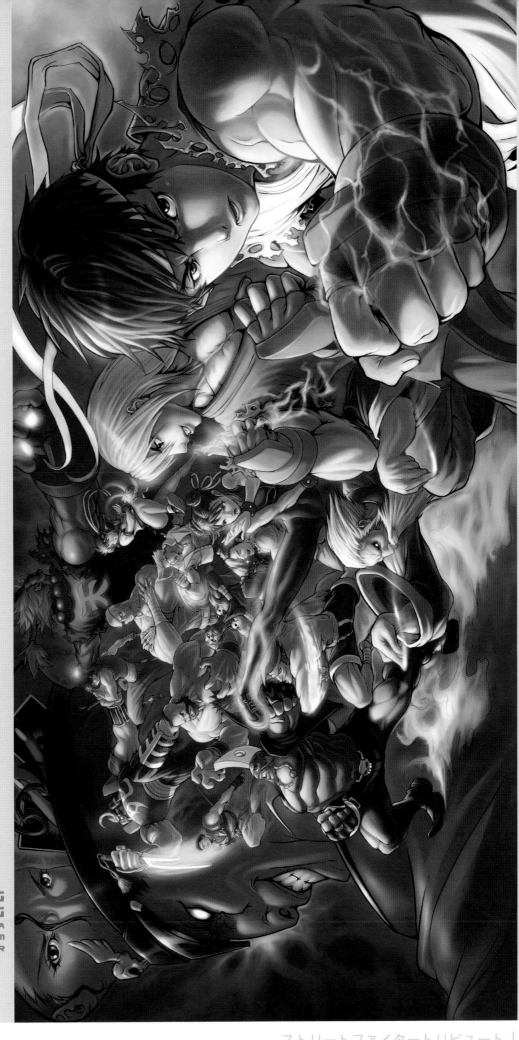

CHRIS NG
FHZE YANG
JOHOR, MALAYSIA
CHRISNFY85.DEVIANTART.COM
ILLUSTRATOR

AKI

Hello all! This is Aki, from Hong Kong.

I'm thankful that UDON put together this tribute book so I could draw some Street Fighter!

I actually had a hard time deciding which character to illustrate. Street Fighter was the first fighting game I played as a kid, so I really wanted to draw a lot of the characters.

I finally settled on Chun-Li, since she's the signature heroine of the series. I think almost every girl who plays Street Fighter dreams of being Chun-Li! She's beautiful and also an incredible fighter - that's the dream, right there!

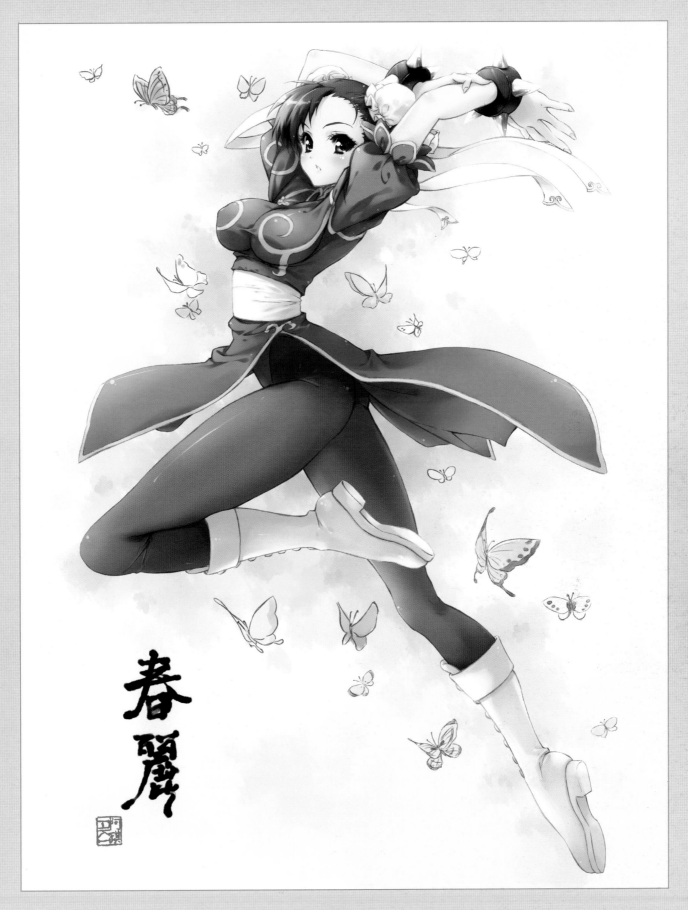

AKI
HONG KONG
MECHDOLL.BLOG.SHINOBI.JP
CHARACTER DESIGNER
[FIREDOG STUDIO- CUPID BISTRO]

ストリートファイタートリビュート |

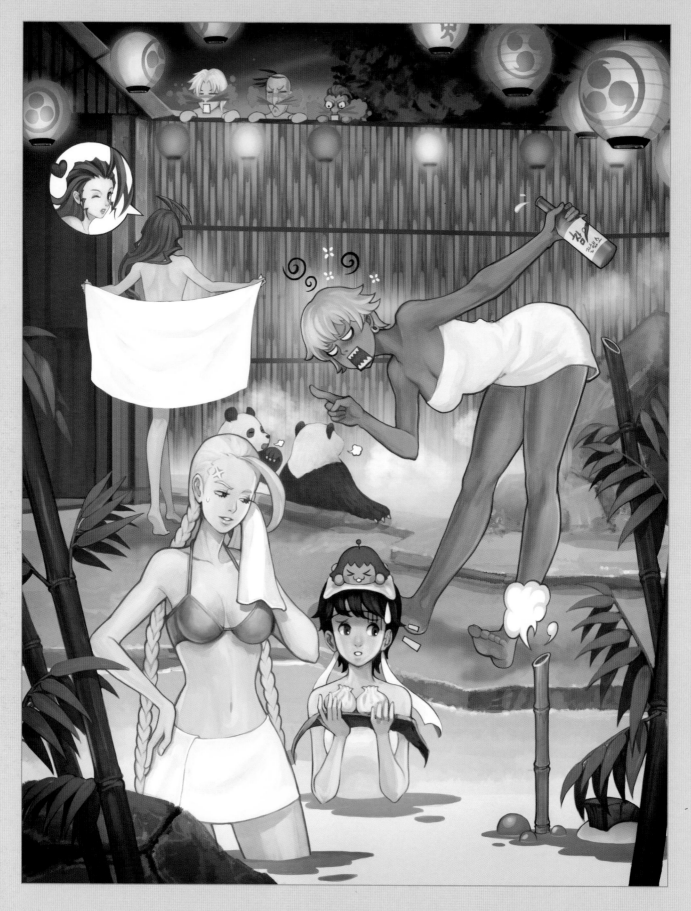

SONG HYUN-JUNG [GAYA]
SOUTH KOREA
WWW.ARAGAYA.NET
ILLUSTRATOR
[DRAGONGEM, KNIGHT ONLINE, NED ONLINE,
CHANGCHUN ONLINE, FANTASY MASTERS, MEMORY OF ARIA]

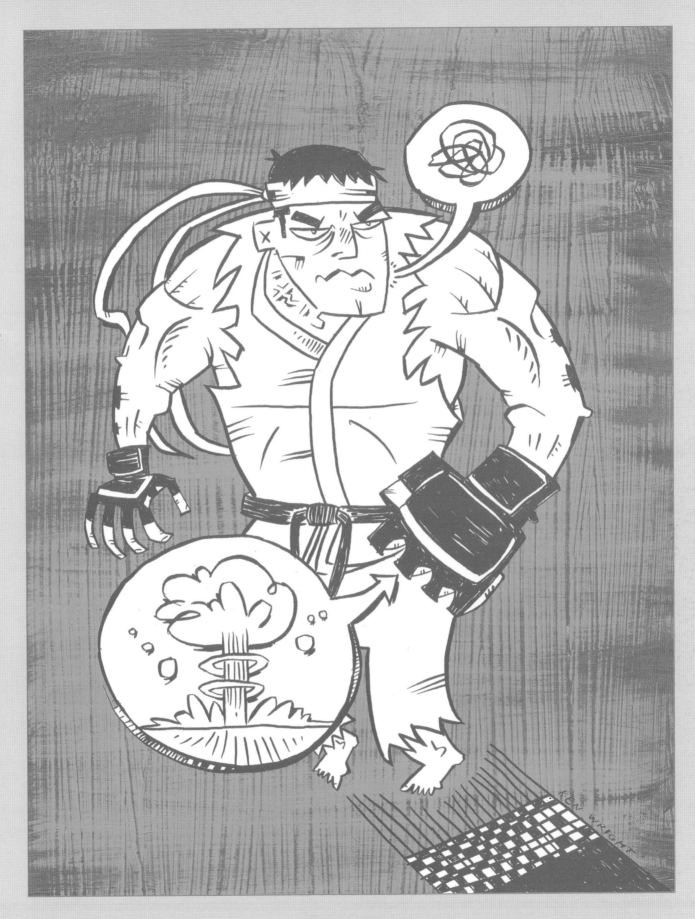

KEN WRIGHT
TUCSON, ARIZONA
WWW.KENWRIGHTONLINE.COM

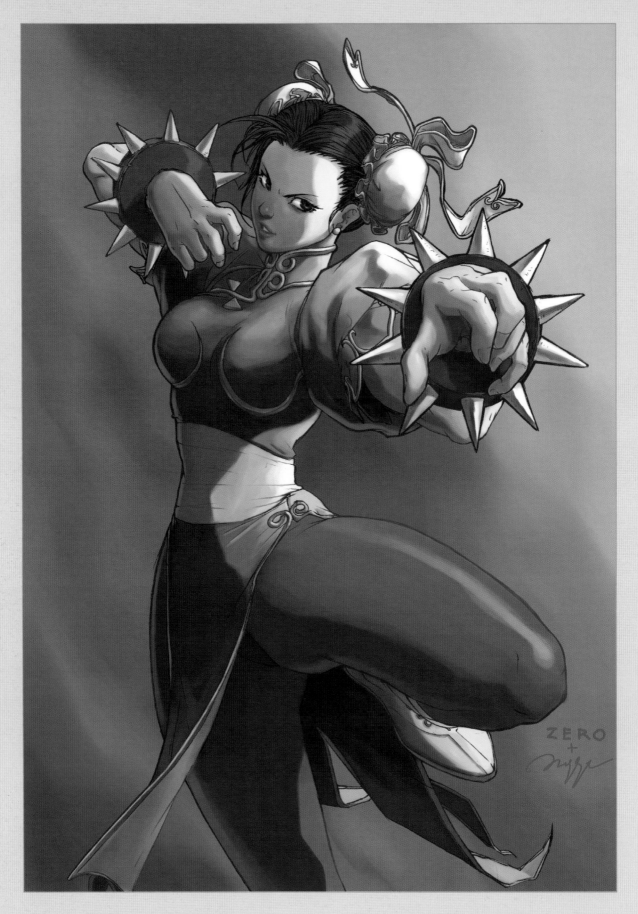

HENDRY PRASETYA
JAKARTA, INDONESIA
HENDRYZERO.DEVIANTART.COM
ILLUSTRATOR
[IMAGINARY FRIENDS STUDIOS]

ANGGA SATRIOHADI
ANGGASATRIOHADI.DEVIANTART.COM

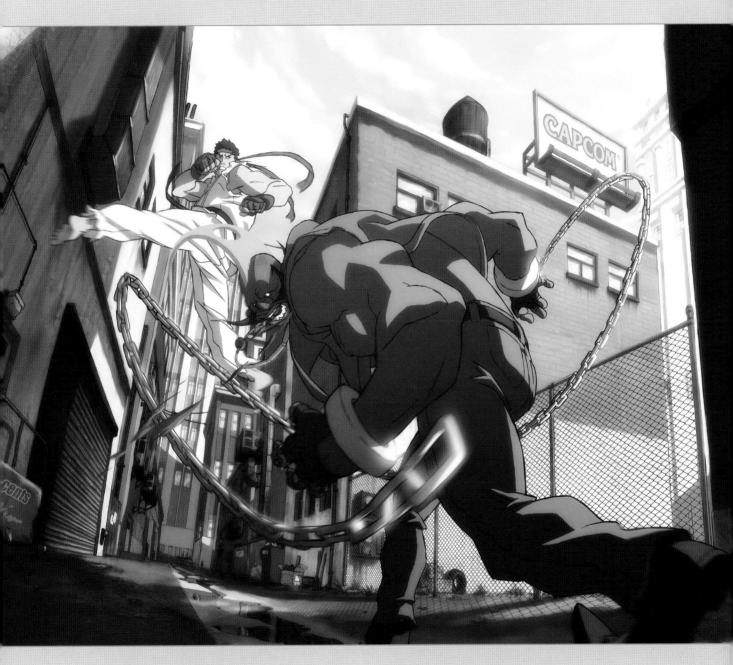

JOAQUIM DOS SANTOS
LOS ANGELES, CALIFORNIA, USA
2-CENTS.DEVIANTART.COM
J-2CENTS.BLOGSPOT.COM
DIRECTOR
[AVATAR: THE LAST AIRBENDER,
JUSTICE LEAGUE UNLIMITED]

HYE-JUNG KIM
LOS ANGELES, CALIFORNIA, USA
WWW.HYEKIM.COM
HYEJUNGKIM.BLOGSPOT.COM
COLOR SUPERVISOR
[AVATAR: THE LAST AIRBENDER]

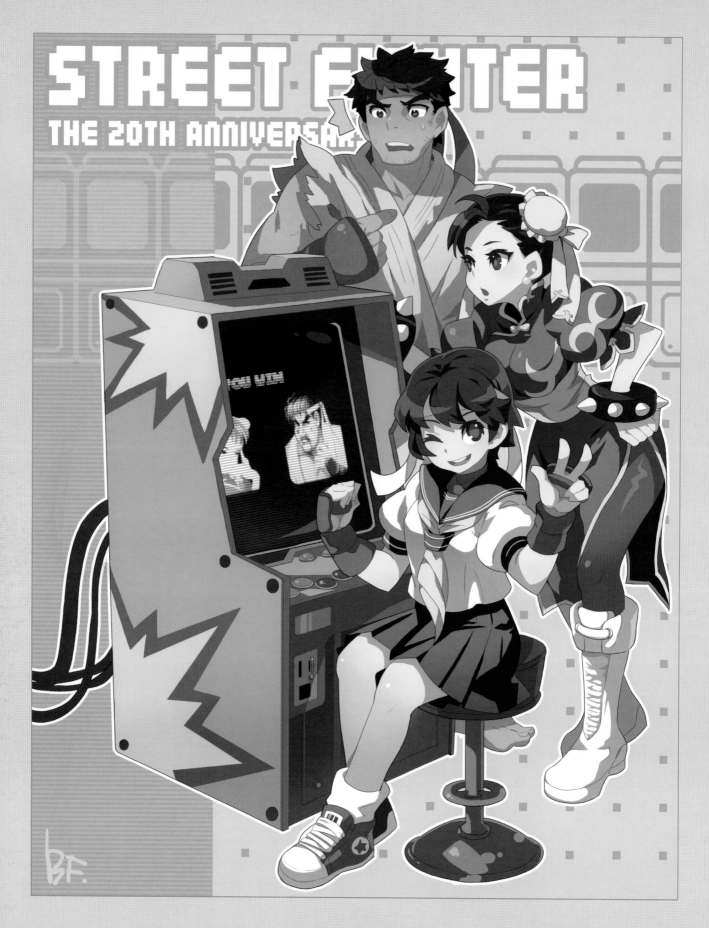

KIM HYE-LIN
SOUTH KOREA
BF81.EGLOOS.COM
ILLUSTRATOR
[LA TALE, EZ2DJ, ASGARD, DJMAX PORTABLE 2]

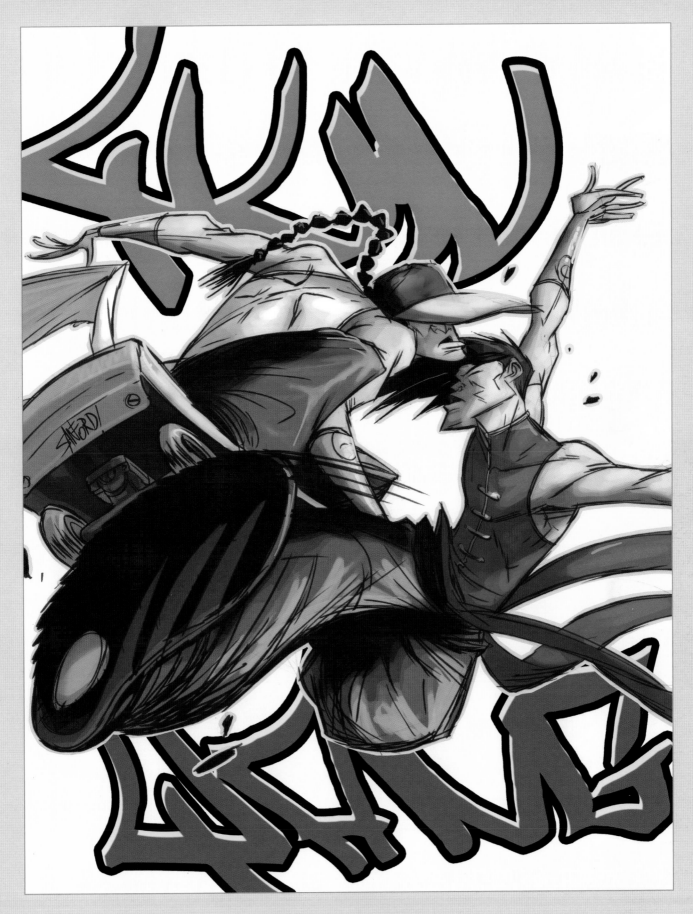

SANFORD GREENE
COLUMBIA, SOUTH CAROLINA, USA
WWW.SANFORDGREENE.COM
ILLUSTRATOR
[WONDER GIRL, BATMAN STRIKES, SONIC COVER ARTIST, METHOD MAN/WU TANG GN]

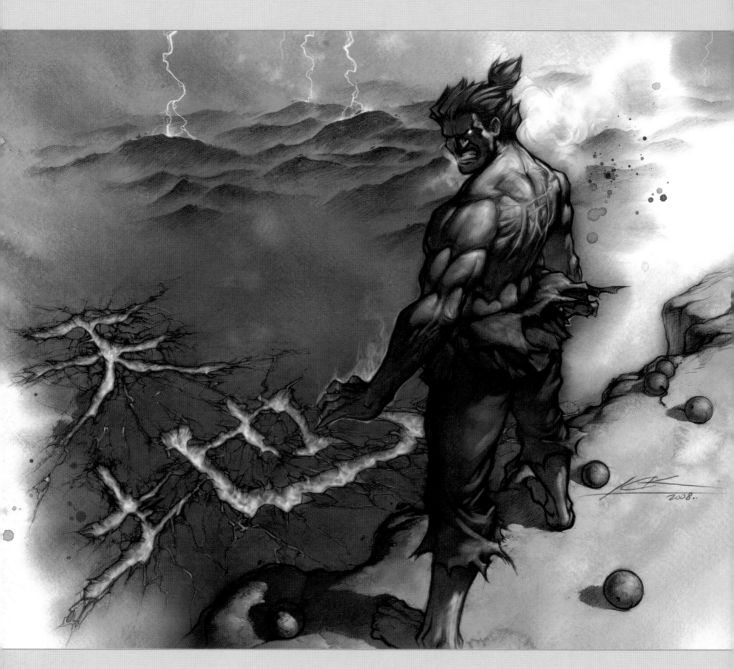

LUM CHOON KIAT
MALAYSIA
CKLUM.DEVIANTART.COM

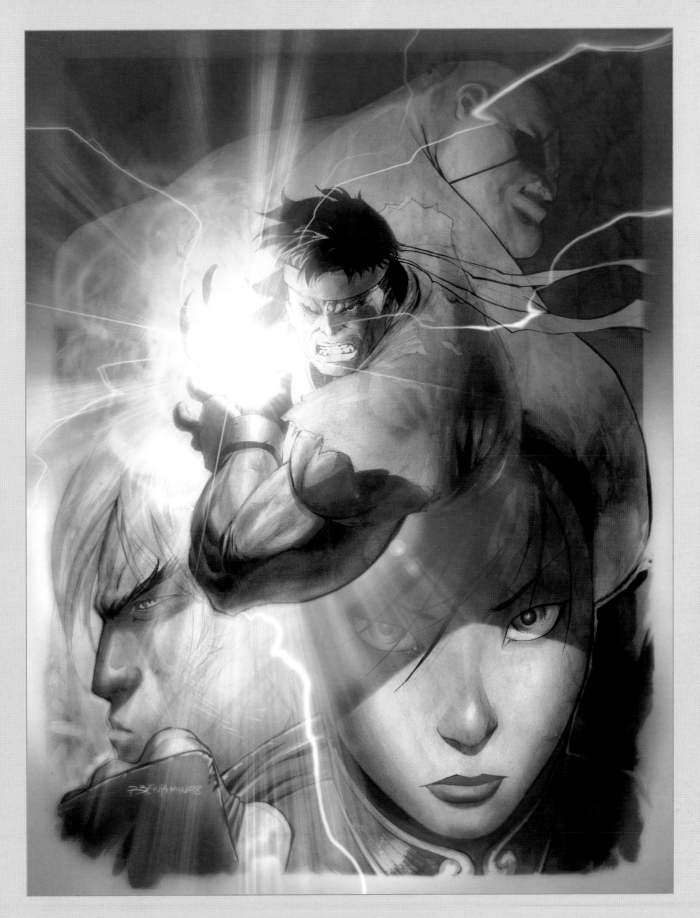

RYAN BENJAMIN
SAN DIEGO, CALIFORNIA, USA
WWW.RYANBENJAMIN.COM - RYANBNJMN.DEVIANTART.COM
COMIC BOOK ILLUSTRATOR / ANIMATOR

J. AXER

I grew up playing the original Street Fighter at the local pizza joint. Once Street Fighter II came out I would spend far too much time in the arcade playing Chun-Li or Guile. The style and fun of the Street Fighter series has remained through the years and I am hard pressed to come across someone unfamiliar with it. Enough time was spent playing various incarnations of the game between myself and my friends that it easily contributed to who I am today; a guy who runs around punching people into submission.

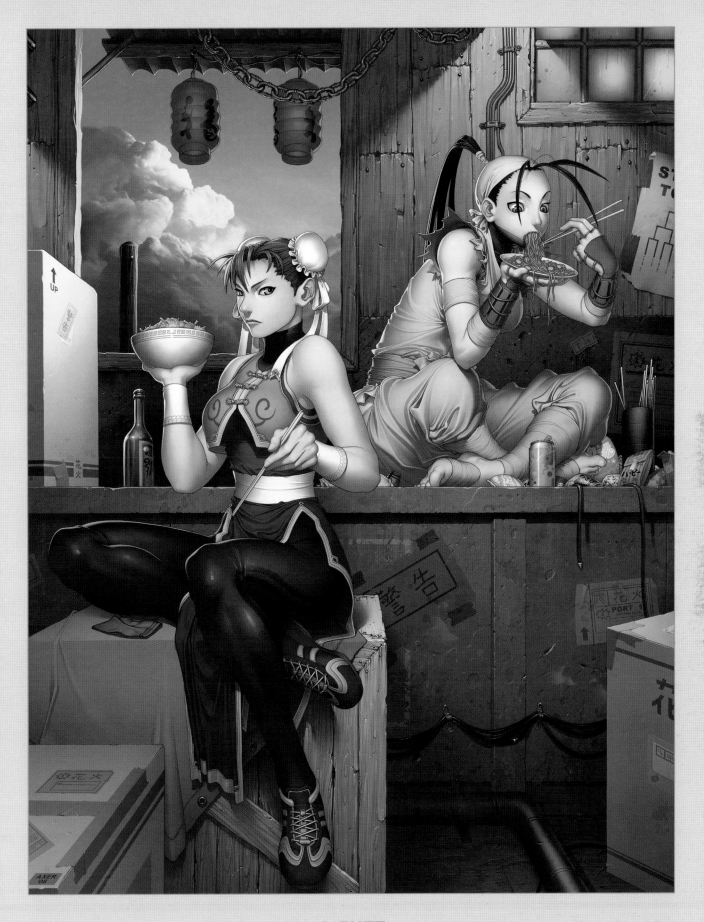

J. AXER
ALBANY, OREGON, USA
WWW.AXERINDUSTRIES.COM
DESIGNER & ILLUSTRATOR

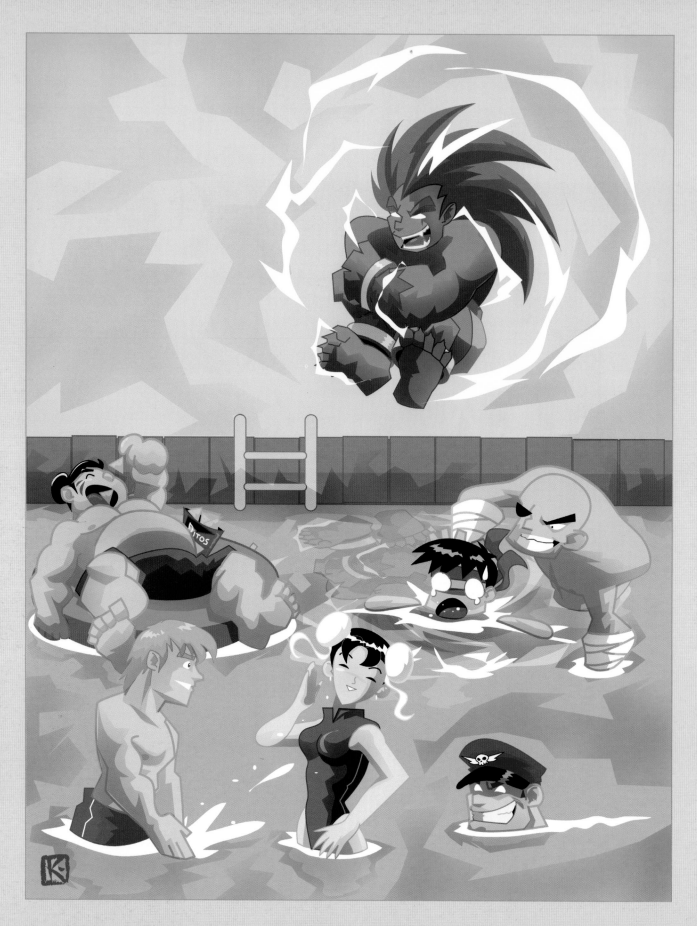

AUGUSTO SASA
[CESAR AUGUSTO SANCHEZ SANDOVAL]
WWW.AUGUSTOSASA.COM
MONTERREY, MEXICO
ILLUSTRATOR, CARTOONIST

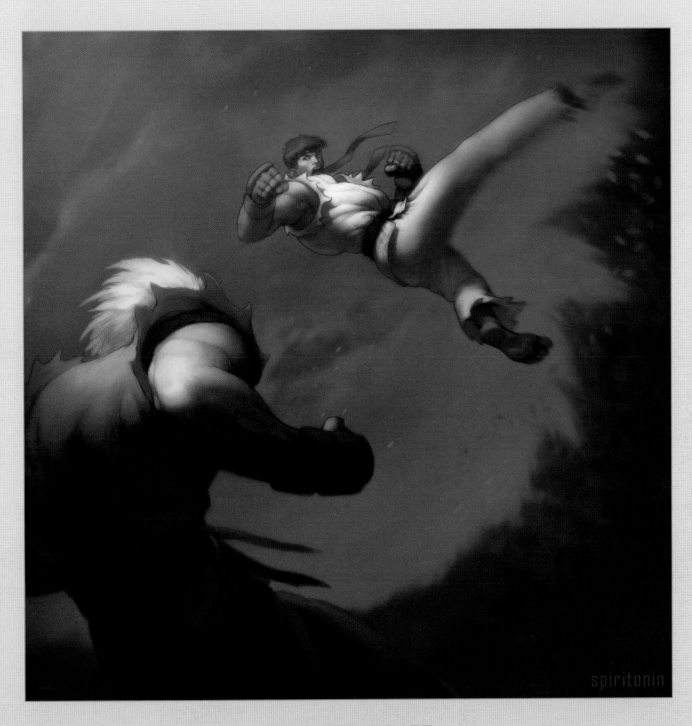

SCOTT STODDARD
SALT LAKE CITY, UTAH, USA
WWW.SPIRITONIN.COM
GAME DEVELOPER
[CAPOEIRA FIGHTER 3, GUARDIANS OF ALTARRIS]

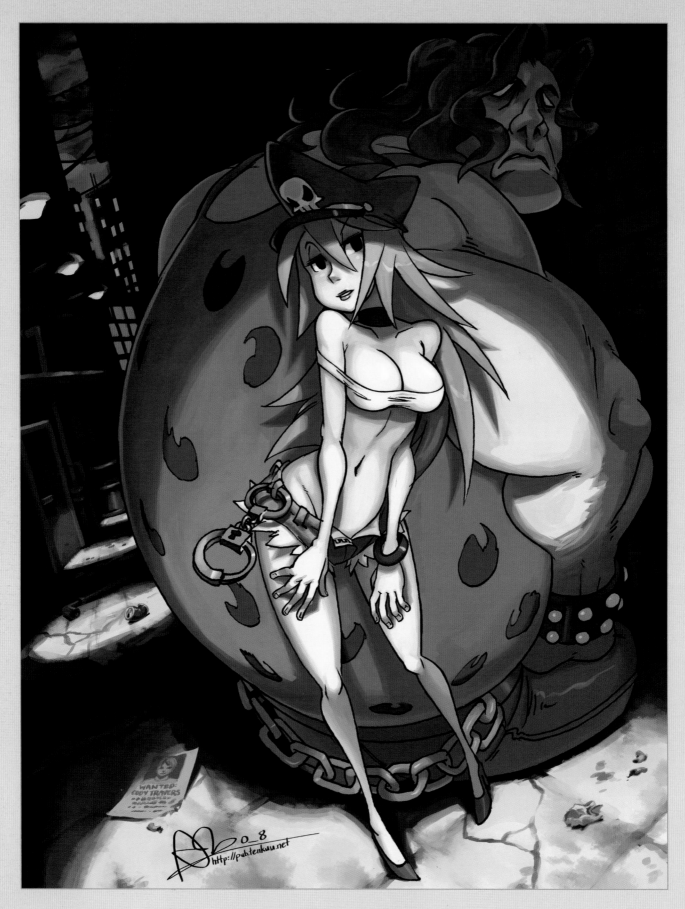

ALEX AHAD [OH8]
FREMONT, CALIFORNIA, USA
PUB.TENKUU.NET - OH8.DEVIANTART.COM
CONCEPT ARTIST
[GAIA INTERACTIVE, SKULLGIRLS]

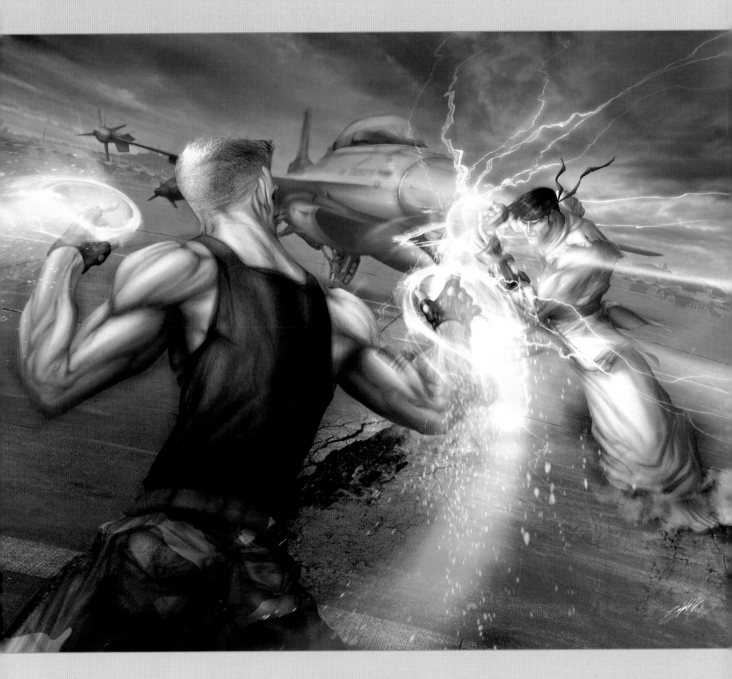

JOHN GIANG
SAN FRANCISCO, CALIFORNIA, USA
WWW.ORBITALHARVEST.COM
CONCEPT ARTIST
[INDUSTRIAL LIGHT & MAGIC: IRON MAN, INDIANA JONES 4, NATIONAL TREASURE 2]
COMIC ARTIST
[ZECTA, TALES OF THE MOONLIGHT CUTTER]

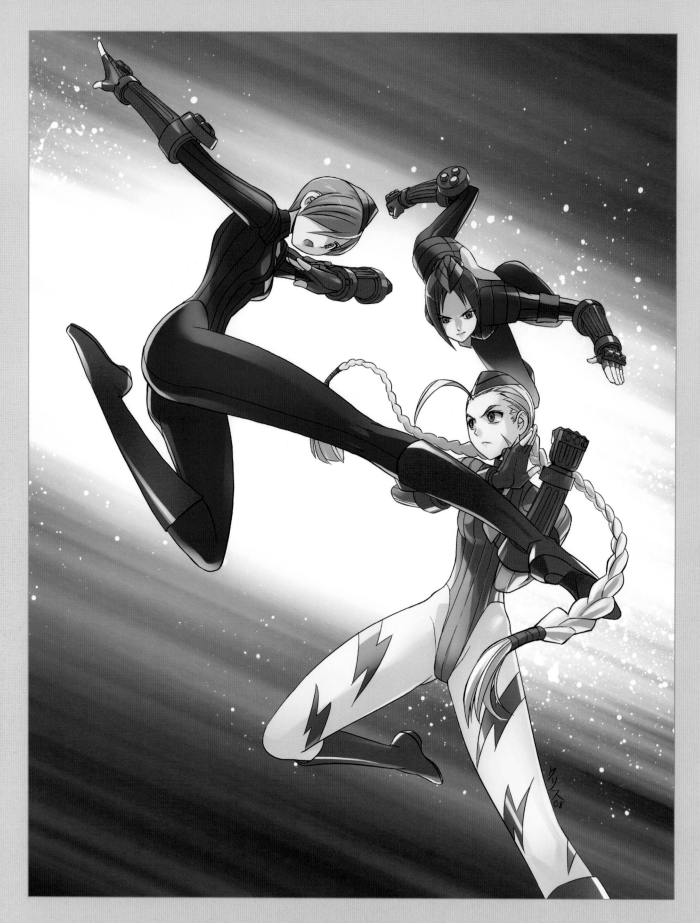

KRISS SISON
MANILA, PHILIPPINES
WWW.GROUNDBREAKERS.COM.PH - WWW.ELTINIDORDEDIYABLO.DEVIANTART.COM
SENIOR GRAPHIC ARTIST [MANGAHOLIX]
ARTIST [LAST HOPE & NINJA GIRL KO]

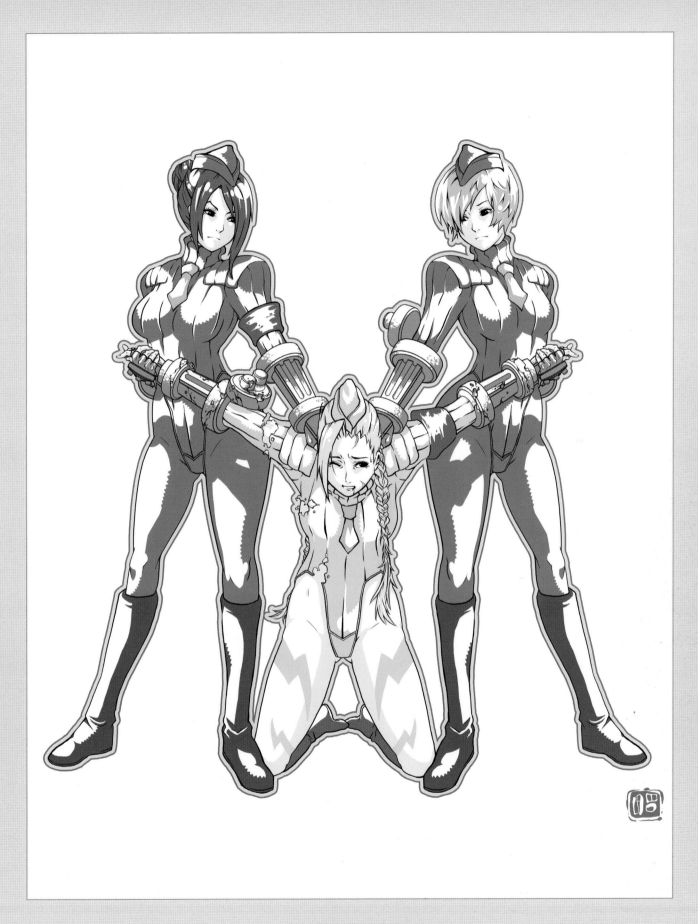

JORBY ALANO
SILVERDALE, WASHINGTON, USA
RAKUGAKINGDOM.COM
ILLUSTRATOR

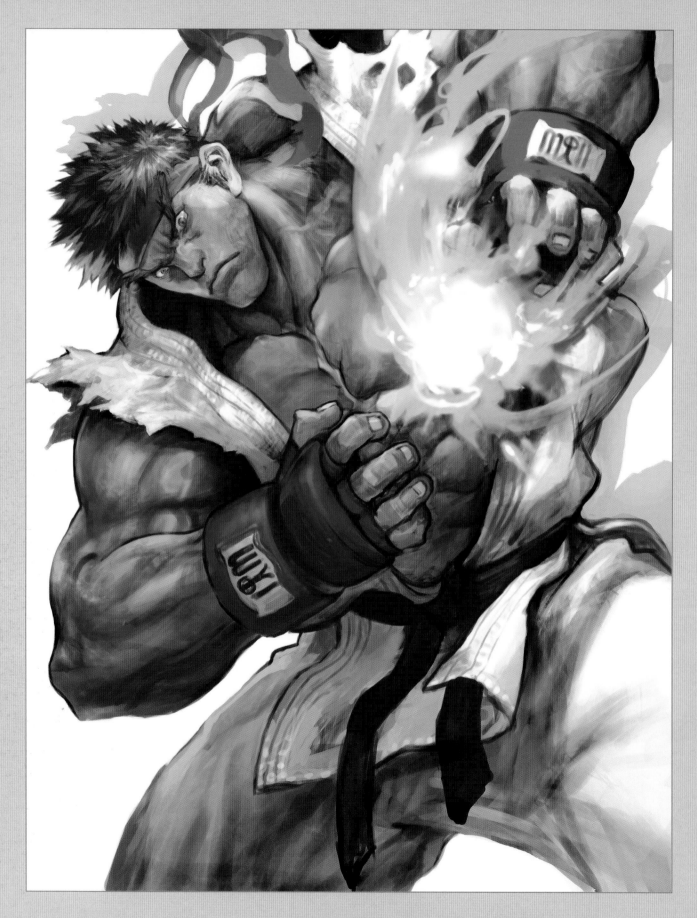

SUNG HEE-JUNG [SAGA]
SOUTH KOREA
HOMEPAGE;SHJBANANA.EGLOOS.COM
ILLUSTRATOR
[DARK EDEN 2, PRIUS, NED ONLINE]

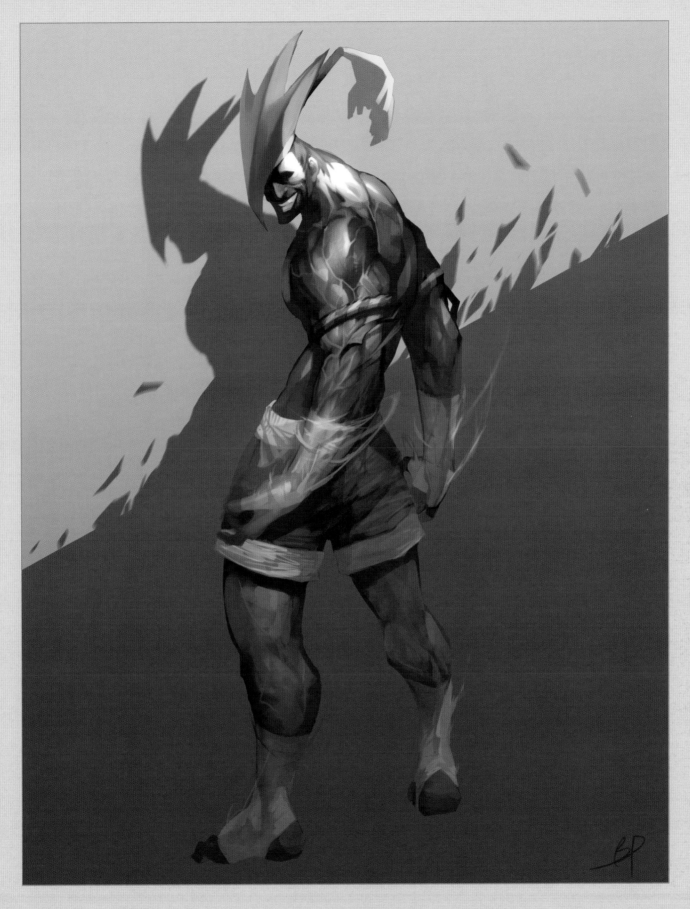

KIM GANG-SAN [BP]
SOUTH KOREA
WWW.MANAGER-BP.COM
ILLUSTRATOR
[NCSOFT]

KEVIN CONVERSE

I chose Crimson Viper as my subject after seeing her being played on the test units here in the Capcom offices. Of the new characters she was the most interesting to me. I really enjoyed the idea of her various gadgets and her use of technology. She has a fun James Bond feel. I hope you enjoy my take on Crimson Viper.

To create the image I first sketched out the idea on an 11" x 17" bristol board. I got the layout and details of the outfit mostly worked out in pencil and then scanned the pencils into the computer. Using Photoshop, I went over all of the pencils and created the black "ink" work for the art. I used the pen tool in Photoshop so I could vary line weights and add dimension. After the line work was done I started in on the colors.

The first step with the color work was to lay down broad flat tones in all of the major areas. Once I had the color palette I started going in and creating the layered cuts of color to add to the shape and depth of the picture. I finished off the clothing first before working on the skin and eventually finishing with Crimson Viper's hair.

Last I added in the background and computer screens to round out the picture. The background uses a painted texture I had scanned into the computer. I colored and adjusted it in Photoshop for use in this picture. The screens were created as separate files and then brought into the main piece as individual layers.

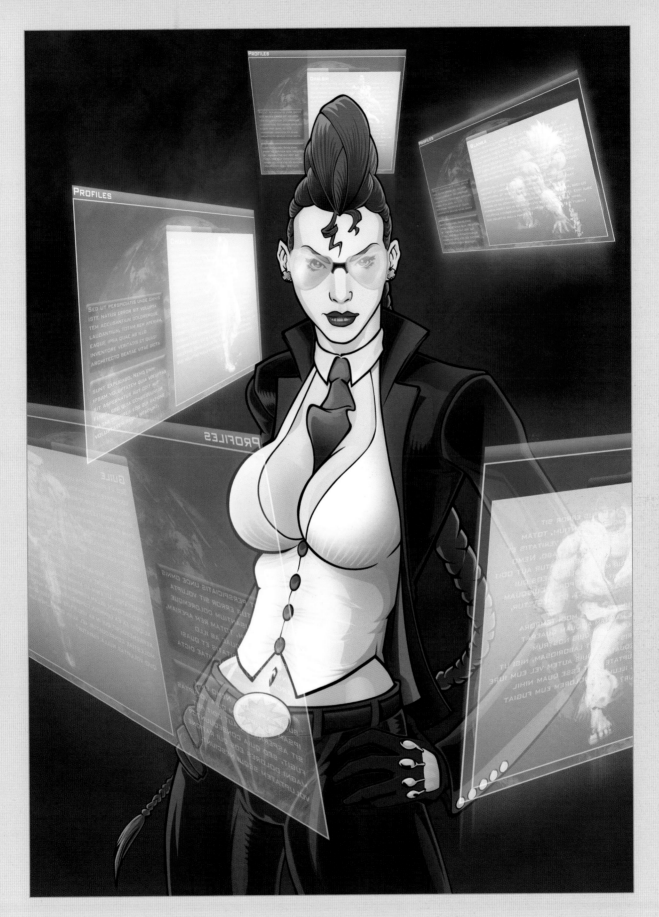

KEVIN CONVERSE
OAKLAND, CALIFORNIA, USA
WWW.INDUSTRIALANGELS.COM
ILLUSTRATOR, DIGITAL ARTIST, PHOTOGRAPHER

BRYAN GREEN
BROOKLYN, NEW YORK, USA
WWW.PAPERFOLDABLES.COM

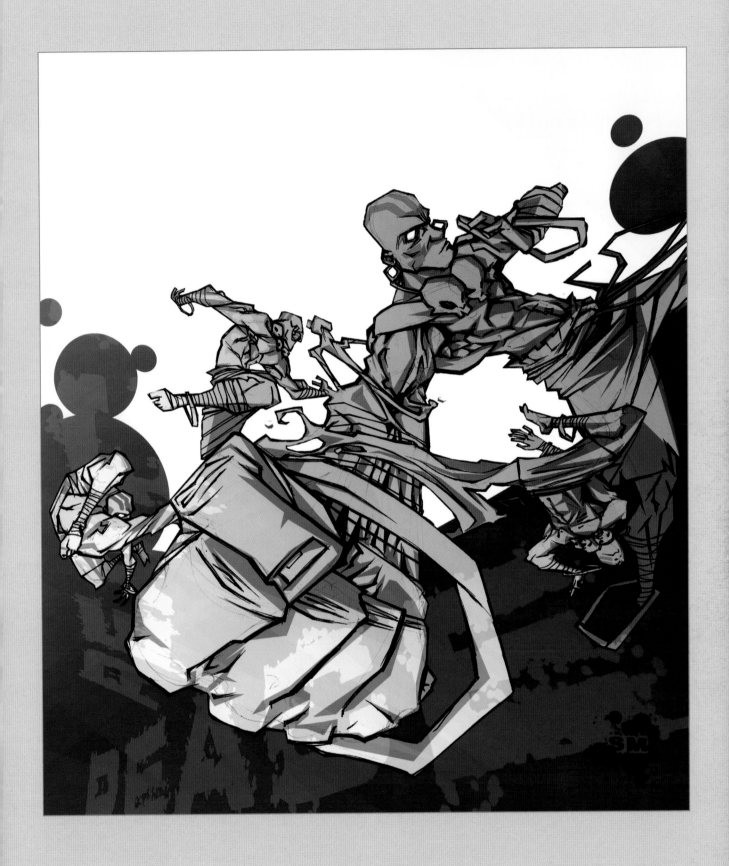

SHAWNA MILLS
NEW YORK, NEW YORK, USA
WWW.FREEWEBS.COM/LAZYMILLS1986

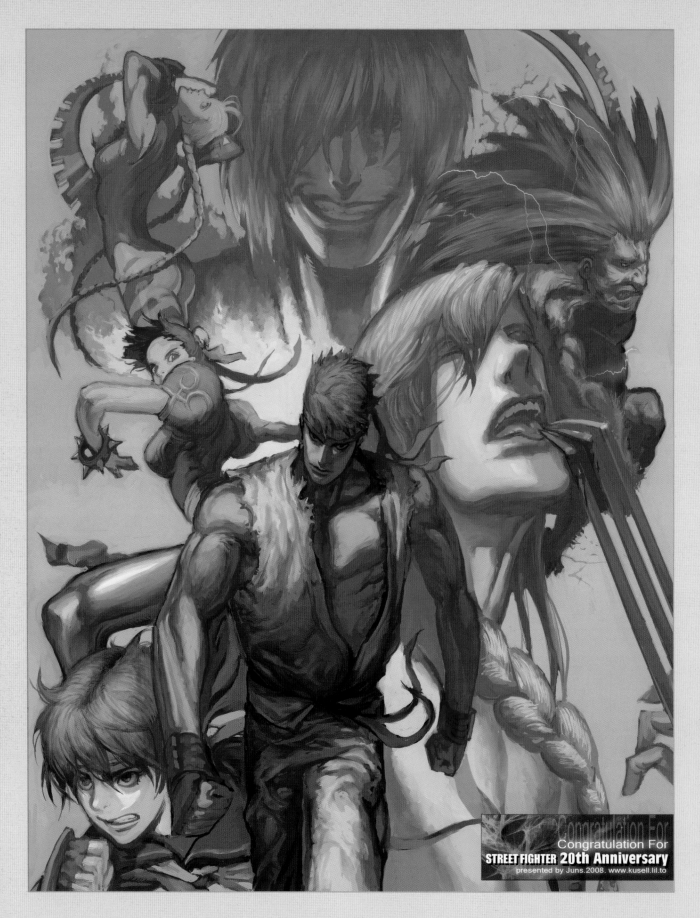

Congratulation For
STREET FIGHTER 20th Anniversary
presented by Juns.2008. www.kusell.lil.to

JUN HYUN-JUNG
SOUTH KOREA
KUSELL.LIL.TO
ANIMATOR
[BRITNEY SPEARS: BREAK THE ICE MUSIC VIDEO]

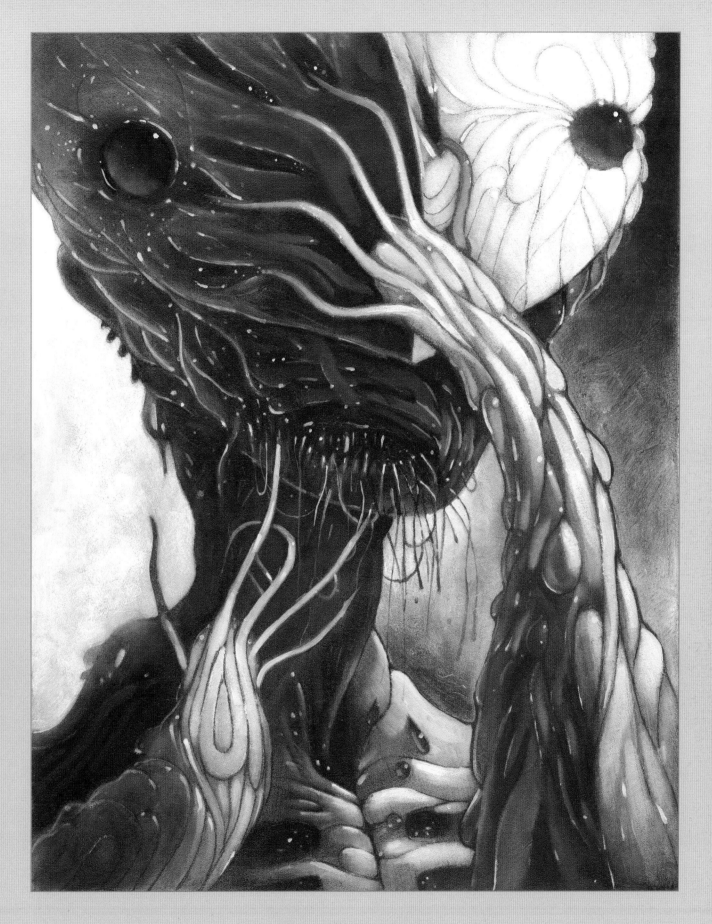

CHARLIE IMMER
PROVIDENCE, RHODE ISLAND, USA

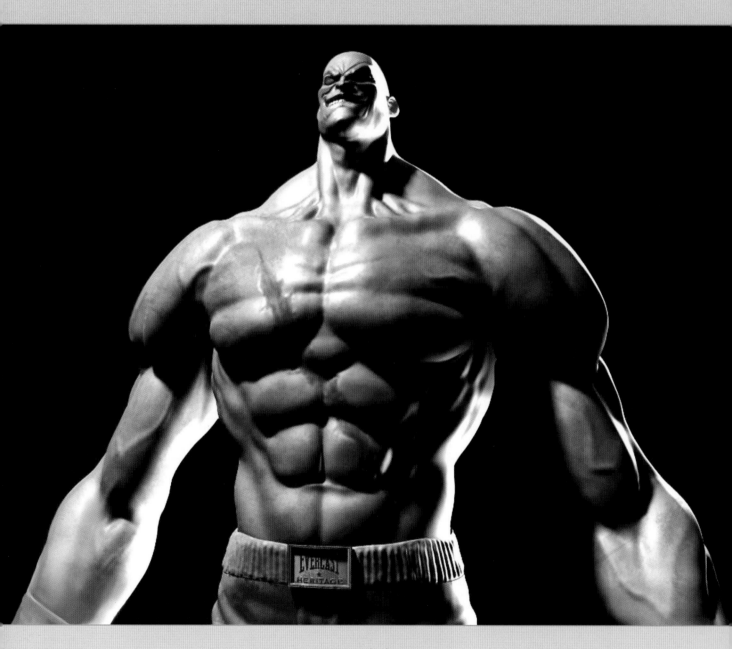

DIEGO MAIA
SÃO PAULO, BRAZIL
MAIA3D.BLOGSPOT.COM
3D MODELER AND CONCEPT ARTIST
[VETOR ZERO, VIGIL GAMES]

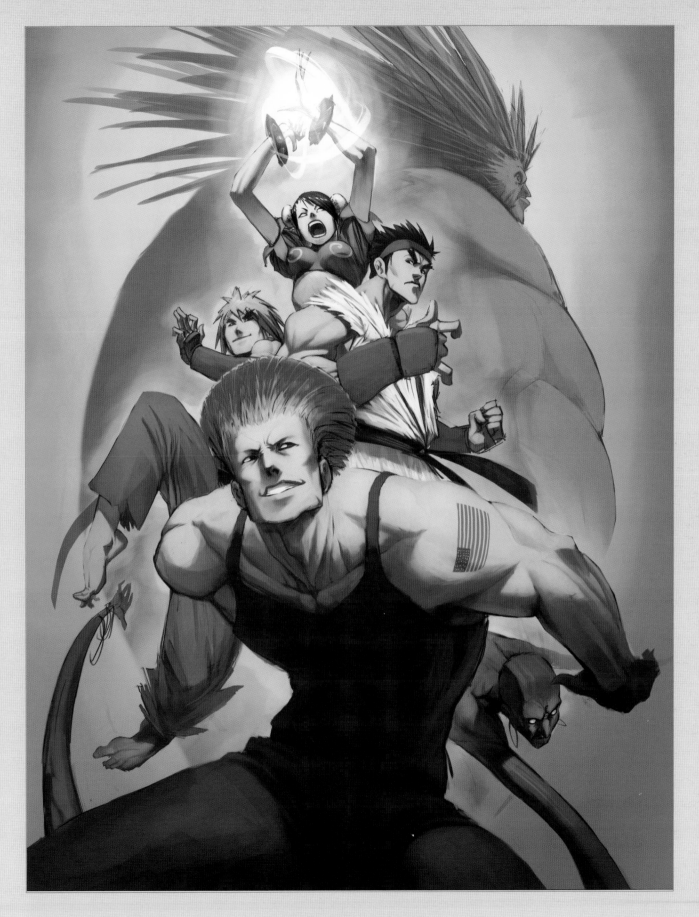

MATTHEW LAU
TORONTO, ONTARIO, CANADA
NINGYEE7.BLOGSPOT.COM
SHERIDAN INSTITUTE

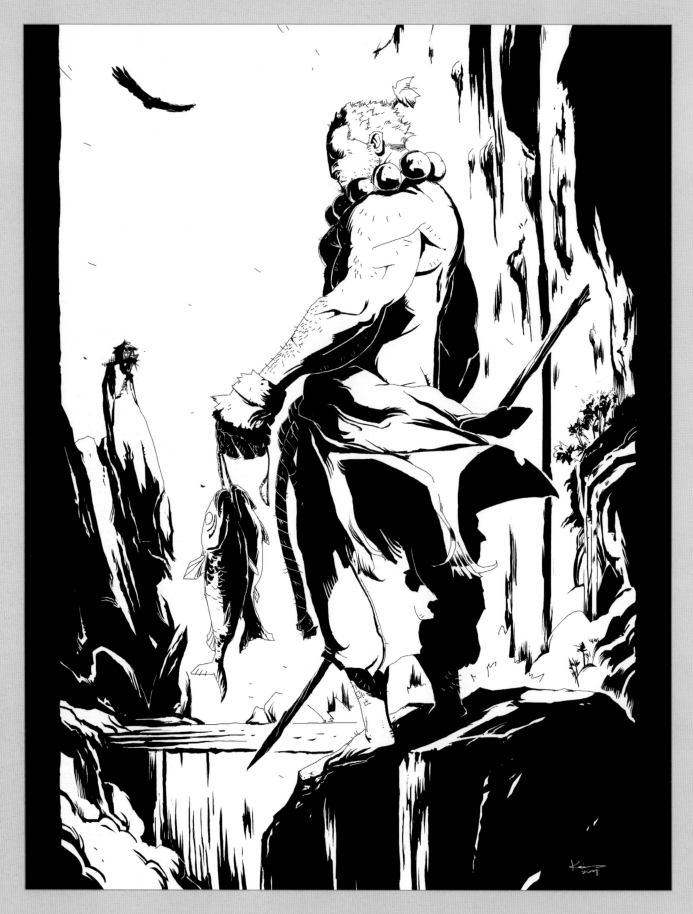

NG SHI KIAN
SINGAPORE
KIAN02.DEVIANTART.COM
CONCEPT ARTIST

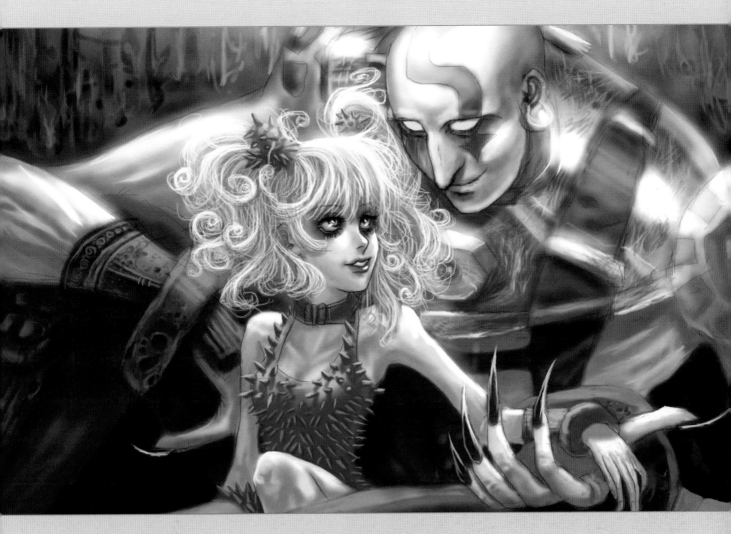

EMILY NGUYEN
ONTARIO, CALIFORNIA, USA
RINOATILMITT.DEVIANTART.COM

CHRIS STEVENS

I sucked. It's the truth and I'm not afraid to admit it. I loved it, but I hardly ever won. My friends (and strangers) would lay waste to me with seeming ease, but it never stopped me from playing it every day at the gas station near my high school. I eventually got better at it, but I was never feared around the arcade like some guys.

The cool thing about SFII was how deceptively complex it was. It seemed simple enough, but once you dug deeper you could see how much depth there was to each character and it became a true source of pride when you became seriously effective with any of them...although I still think Blanka was cheap.

Ken was my choice most days (Guile when Ken wasn't working for me). I was deadly with the Dragon Punch... on the right side at least. If I got flipped to the left, I was in trouble and I'd just fireball and hurricane kick you to death. Hopefully, I'd hurricane kick back over to the right side and then it was Dragon Punch time again.

Like I said, I was never that great at it but I sure loved it. To this day, I've never obsessed more about a game or had as much fun playing one. After all these years, it still holds up remarkably well. That's the truest mark of a masterpiece. It's timeless.

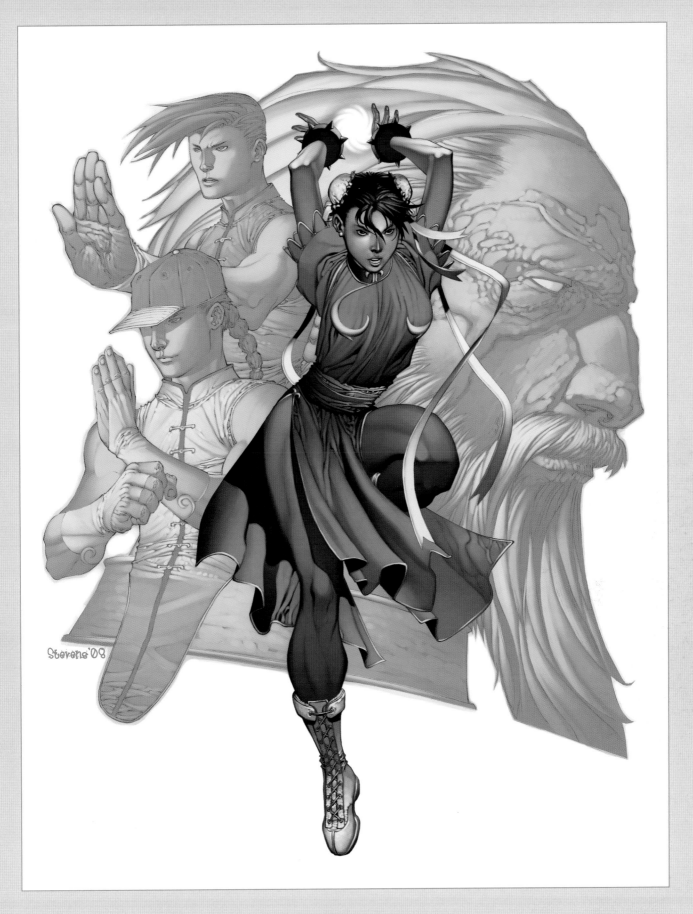

CHRIS STEVENS
WINTERVILLE, NORTH CAROLINA, USA
CHRISS2D.DEVIANTART.COM
ILLUSTRATOR
[UDON]

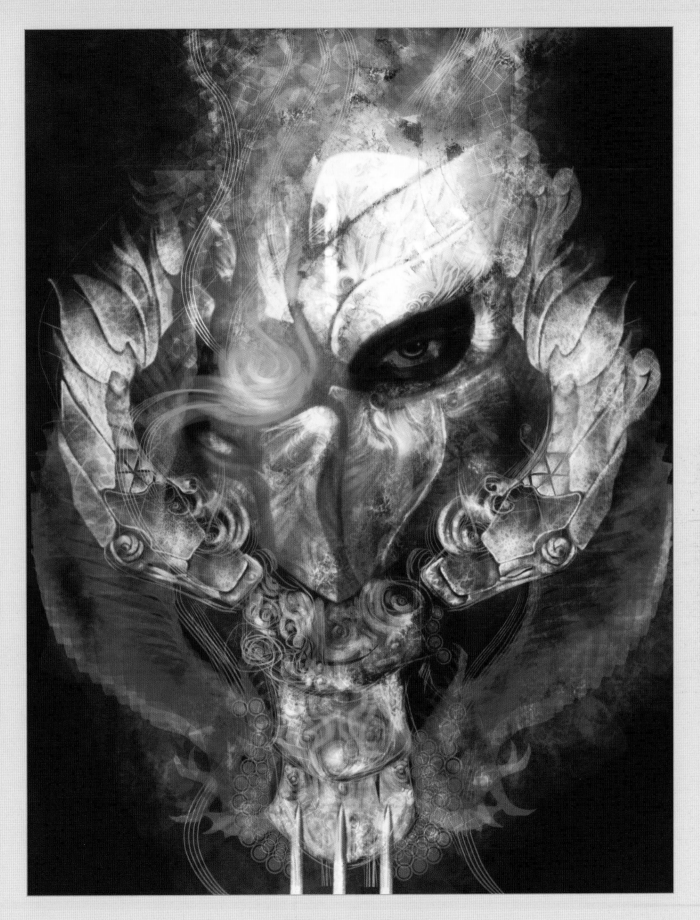

TIMOTHY TERRENAL
PASAY CITY, PHILIPPINES
BALASA.CGSOCIETY.ORG/GALLERY
BOYBALASA.DEVIANTART.COM

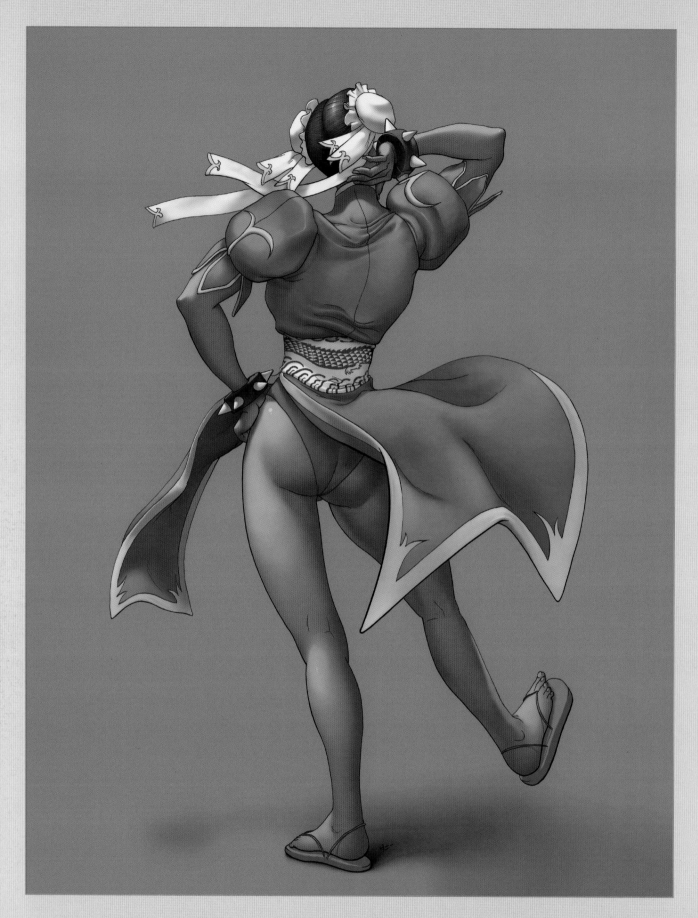

DANIMATION
WWW.DANDOJO.COM
COLORIST
[VOLTRON, MARVEL AGE SPIDER-MAN, SON OF VULCAN, IRON AND THE MAIDEN]

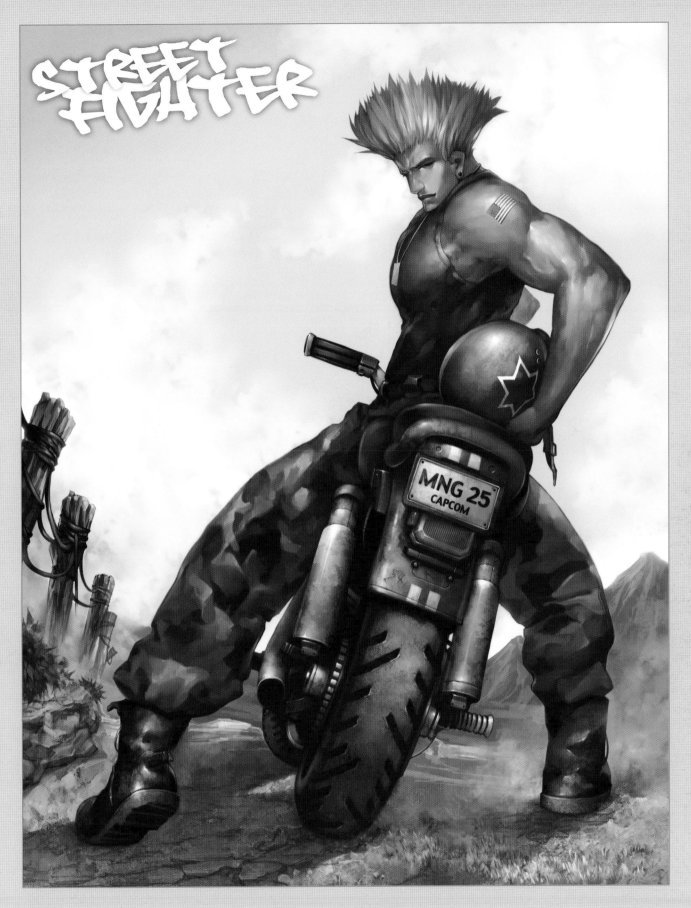

STREET FIGHTER

LEE DAE HOON [MANAGA]
SOUTH KOREA
WWW.MANAGA.NAME
CONCEPT ARTIST
[DARK EDEN 2, NED ONLINE]

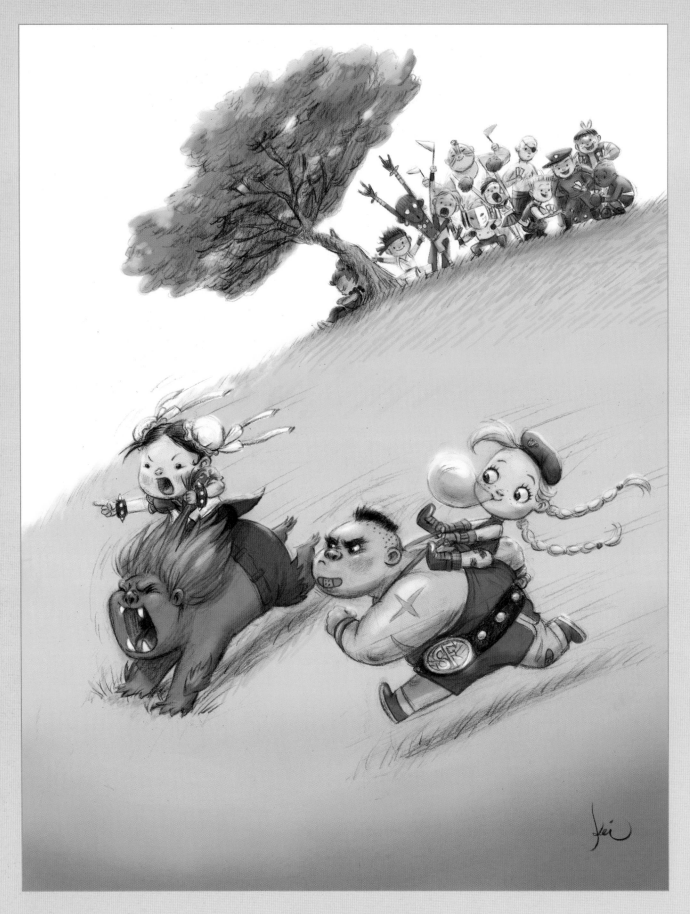

KEI ACEDERA
TORONTO, ONTARIO, CANADA
WWW.IMAGINISMSTUDIOS.COM
ILLUSTRATOR / VISUAL DEVELOPMENT

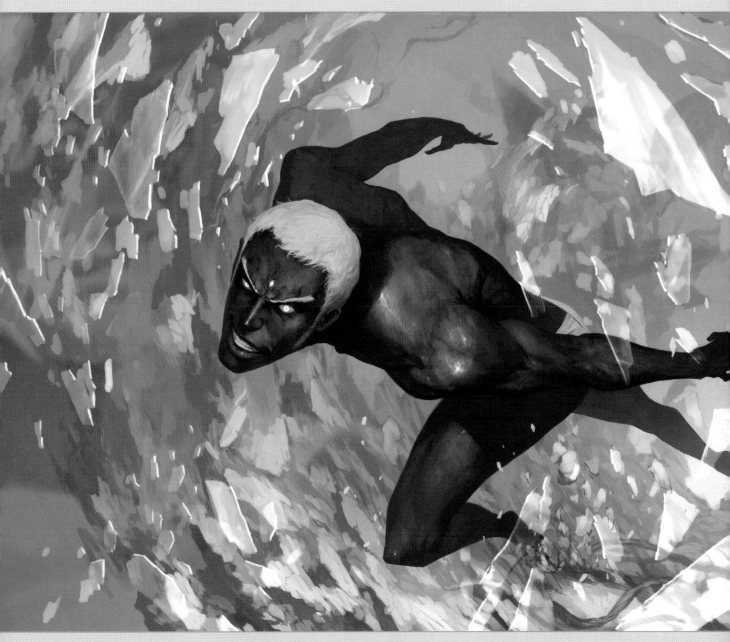

SKAN SRISUWAN [FIDUCIOSE]
SINGAPORE
WWW.FIDUCIOSE.NET - WWW.IMAGINARYFS.COM
ART DIRECTOR
[IMAGINARY FRIENDS STUDIOS - CALIBER, HERCULES,
DUNGEONS & DRAGONS, UFS]

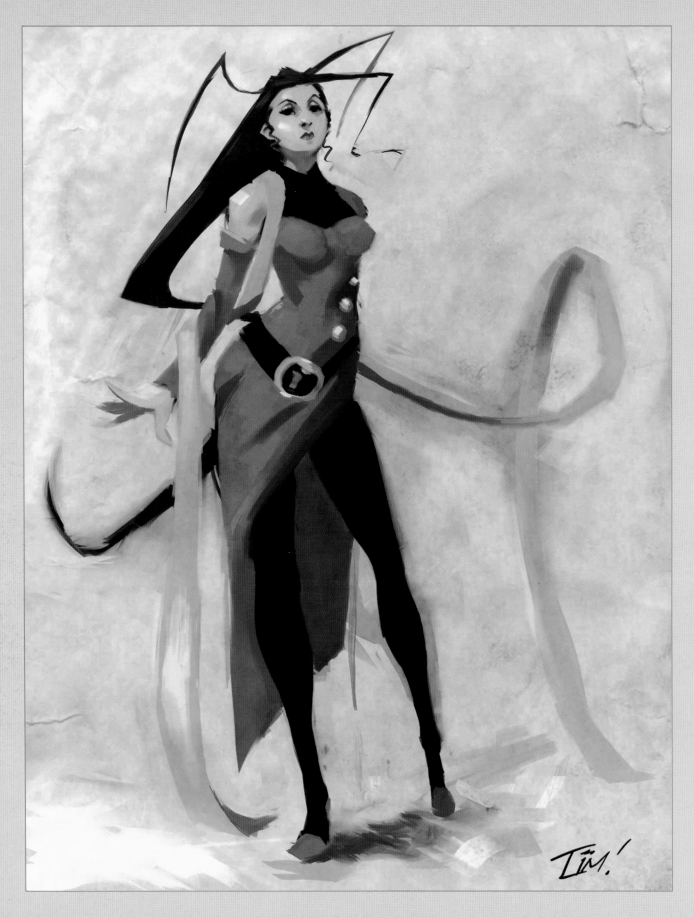

TIMOTHY J. LIM
LITTLE ROCK, ARKANSAS, USA
NINJAINK.DEVIANTART.COM
STUDENT, FREELANCE ARTIST

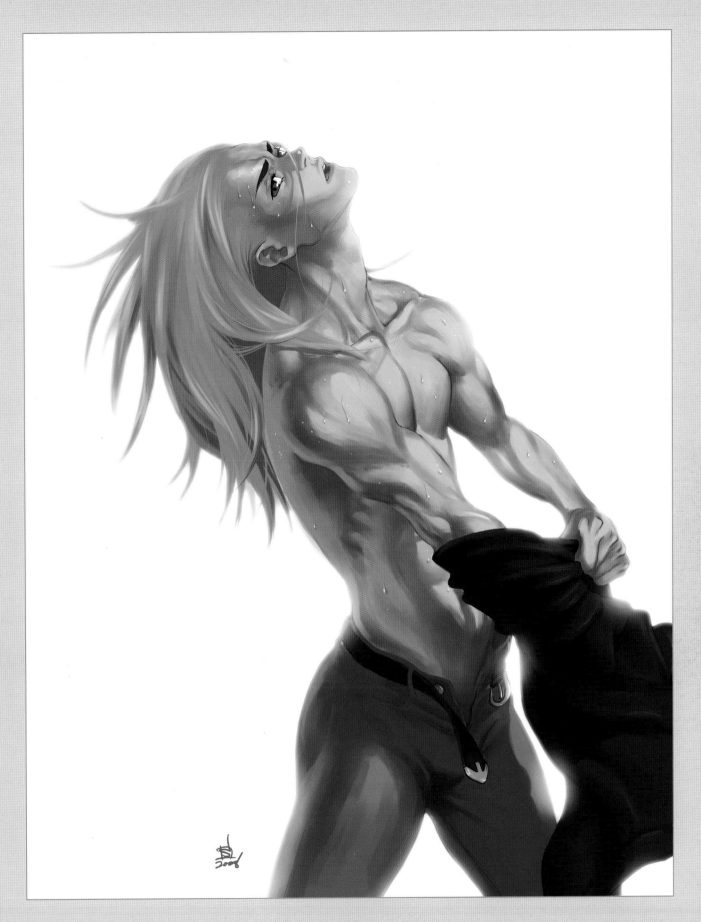

SAKA
WWW.GAIAONLINE.COM
CONCEPT ARTIST
[GAIA ONLINE]

KALMAN ANDRASOFSZKY

It was October 1991 and I was in grade 11. I'd finally found myself a group of friends the previous year, which meant I didn't walk with my head down so much, and didn't have to eat lunch in the library anymore. We bonded over a shared love of video games (even so, they were Nintendo people and I was a SEGA guy, but you let these things slide.)

One Monday, Darryl turned up in math class, excited, claiming he'd seen, and played Street Fighter II over the weekend at a strip mall variety store. I'd played the original Street Fighter once, in an amusement park arcade, and I hadn't been terribly impressed. These guys had been obsessed with it though, so this was big news to all of them.

You need to understand that this was grade 11. Someone was always going on about how they'd seen Super Mario 7 in Chinatown or that they watched Akira 2 at their cousin's house and Darryl's story had the tang of B.S. about it. More suspicious still, Darryl would be unable to join us after school to go play it, as he had a dentist appointment or something.

Regardless, at 3:45 my friend Brad and I trekked out to said strip mall. In the rain. But it was there, right where he'd said. It was real. Brad had cold feet, so I stepped up. Dazzled by all the characters, I chose Guile. "Do a fireball" Brad said. There were fireballs? Clearly I had missed a few things while playing SF1. "It's down + forward + punch."

I spent all the money I had that day, quarter by quarter, trying to do fireballs with Guile, all the while getting my ass royally kicked by Ken, in front of some very majestic looking steamboats.

That was far from the last time I'd spend all the money I had on that machine, and, of course, far from the last time I'd get my ass royally kicked.

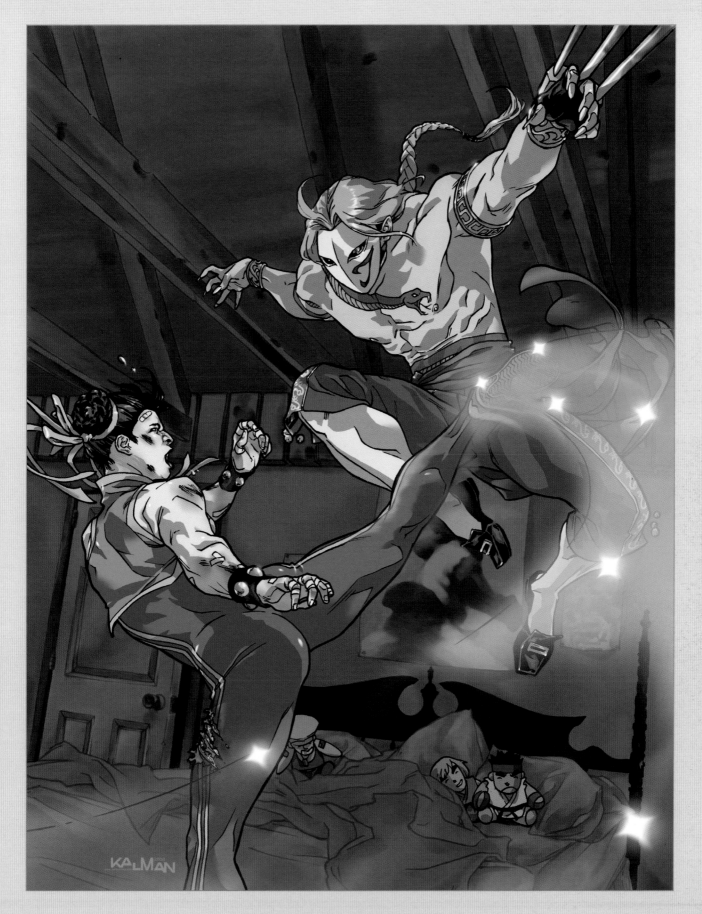

KALMAN ANDRASOFSZKY
TORONTO, ONTARIO, CANADA
WWW.IAMKALMAN.COM
ILLUSTRATOR [NYX, LEGION OF MONSTERS: SATANA]
COVER ARTIST [CHECKMATE, ION, ACTION COMICS]

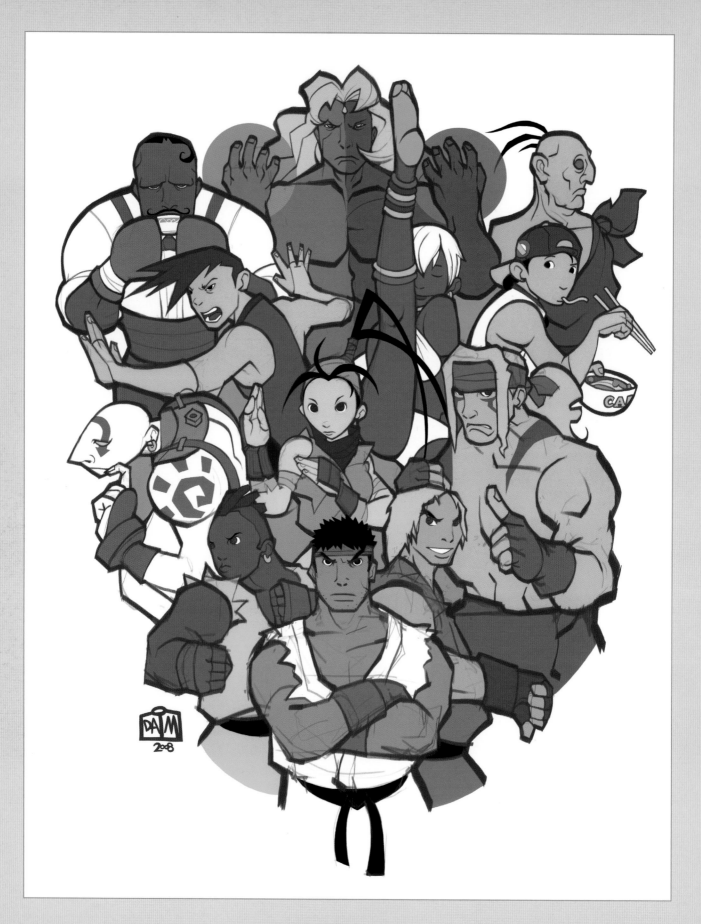

DAIM DZIAUDDIN
KUALA LUMPUR, MALAYSIA
WWW.DAIMATION.COM
ANIMATOR / ILLUSTRATOR

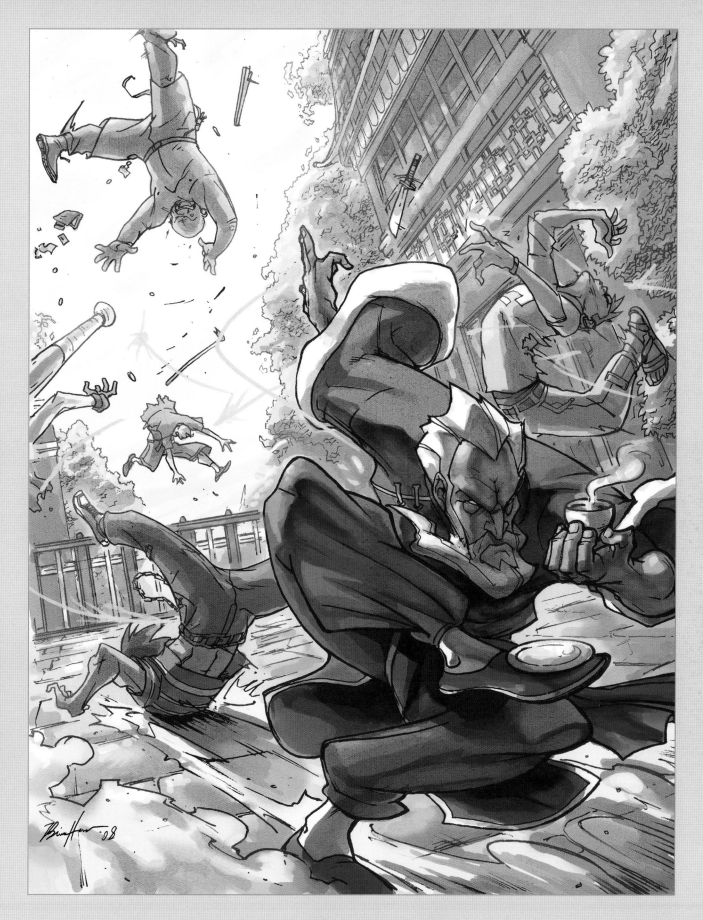

BRIAN HARDISON
ALPHARETTA, GEORGIA, USA
WWW.ALTERED-EGO.COM/BRIAN
FREELANCE ARTIST
[TERMINUS MEDIA, REYOMI PUBL, BOLCHAZY-CARDUCCI PUBL]

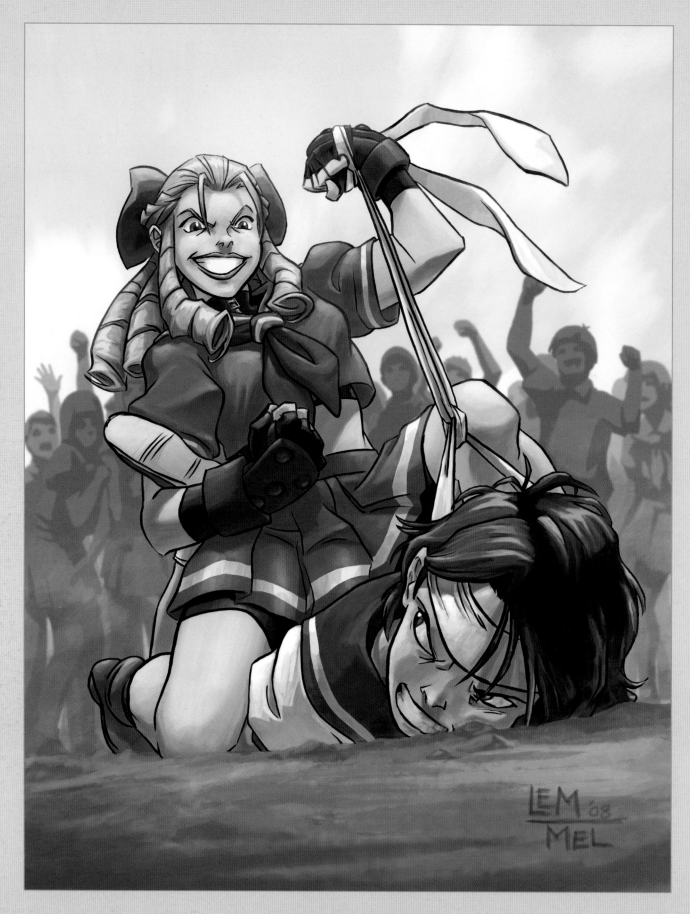

LAUREN MONTGOMERY
LOS ANGELES, CALIFORNIA, USA
LAURENMONTGOMERY.BLOGSPOT.COM
DIRECTOR
[SUPERMAN: DOOMSDAY, WONDER WOMAN]

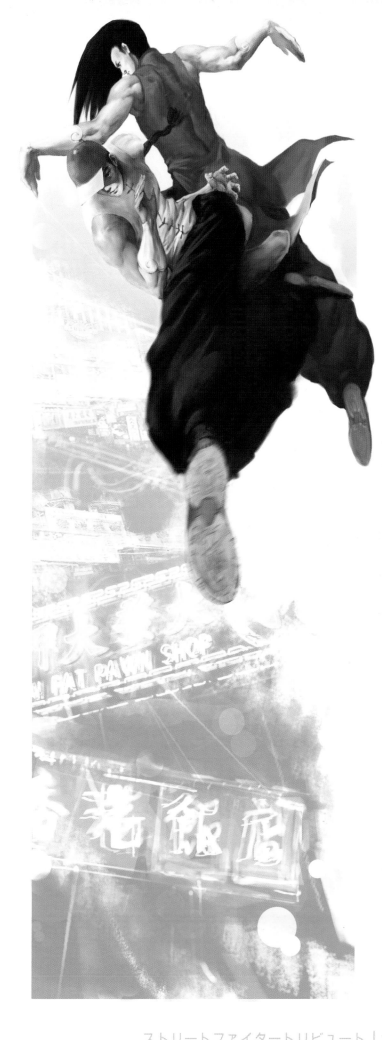

CARMEN CHOW
SAN FRANCISCO, CALIFORNIA, USA
WWW.OCUBETEAM.COM/CARGUIN
VISUAL DEVELOPMENT ARTIST

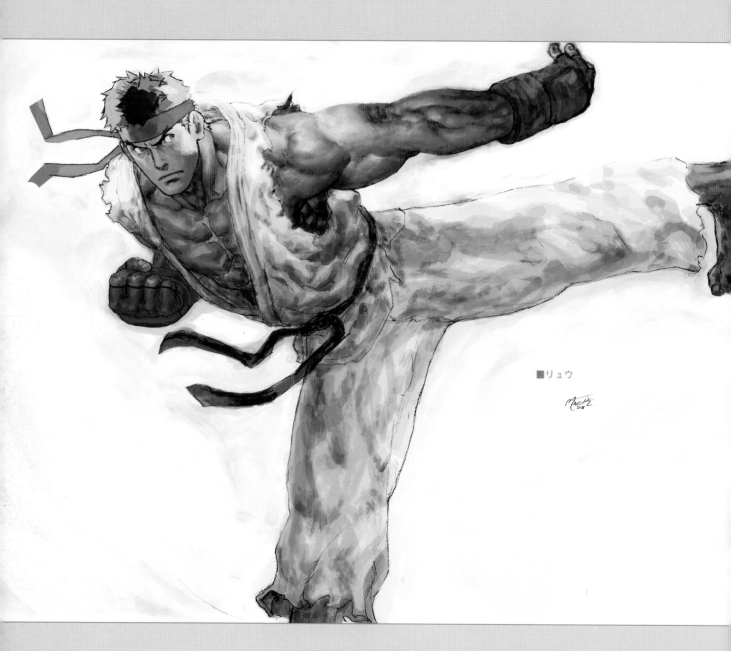

■リュウ

STEVE MACK
PHILADELPHIA, PENNSYLVANIA, USA
CONCEPT ARTIST
[KANDOKEN]

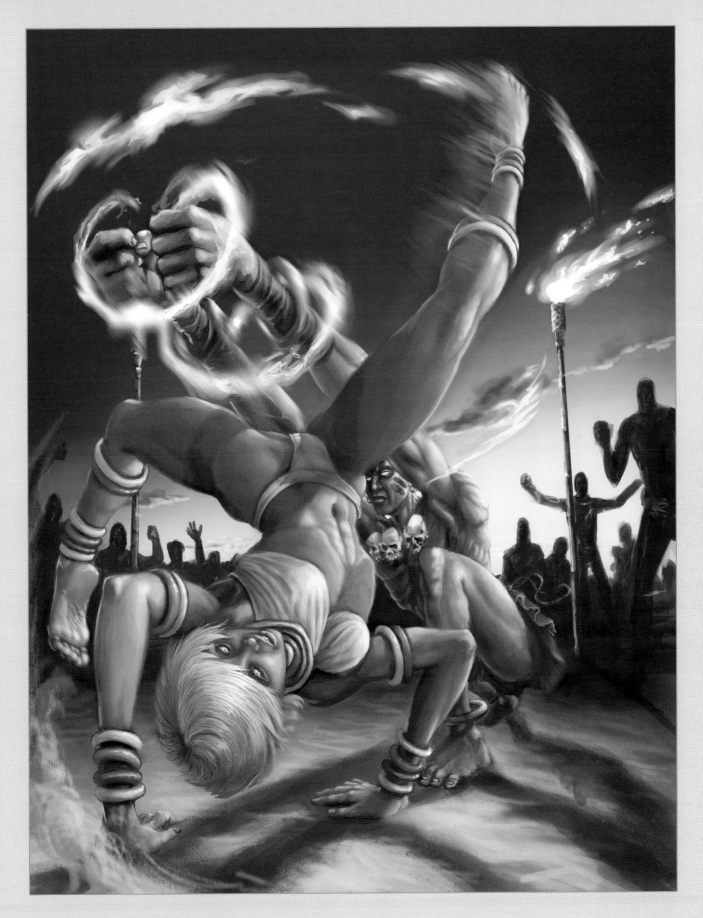

LEO LINGAS
TORONTO, ONTARIO, CANADA
WWW.LEOILLUSTRATOR.COM
JUDGEFANG.DEVIANTART.COM
ILLUSTRATOR

ERIC VEDDER

I remember my friend and I scrounging through our change jars just to afford a few rounds of Street Fighter II when it first arrived at the local 7-11. I logged so many hours playing that game and the sequels, starting off with Guile then switching permanently to Ryu. Sprinkled in between were my favorite ladies - Ibuki, Chun-Li, Cammy, Sakura, Karin, Hokuto and many other fine females from various other Capcom games.

Along with the killer games came the awe-inspiring artwork. Most notably early Alpha, courtesy of Bengus, followed by the jaw-dropping perfection of Street Fighter III, from none other then Kinu.

This pin-up is my attempt to thank those artists using a collection of my favourite Street Fighter characters, including Crimson Viper, as I eagerly await playing her in SF4.

It's truly an honour to be invited to this tribute book as the game and its characters have been a huge part of my life for over 15 years.

Thank you Capcom and thank you Udon!

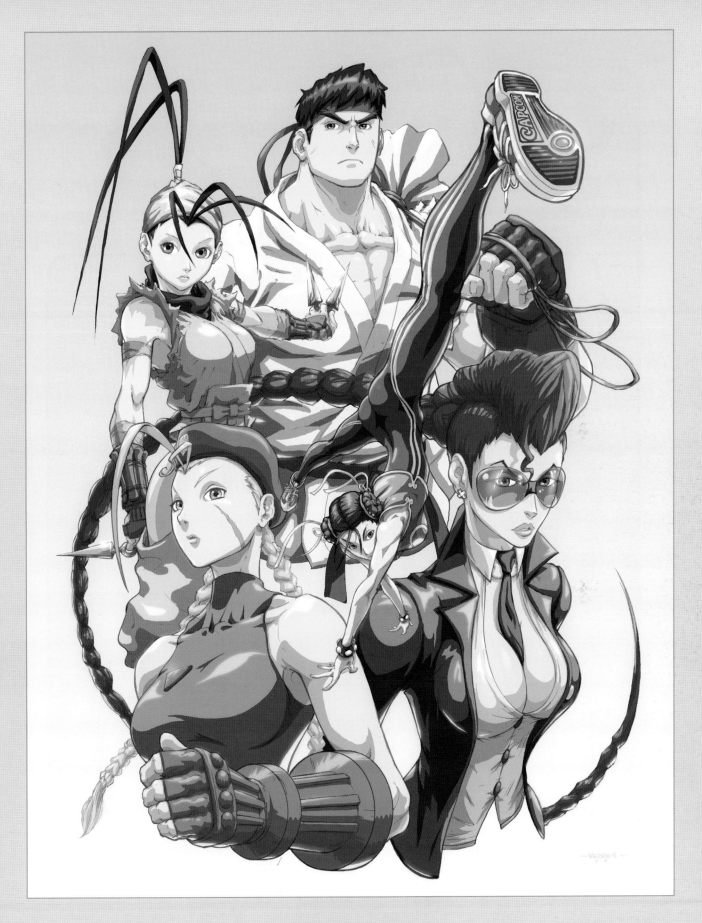

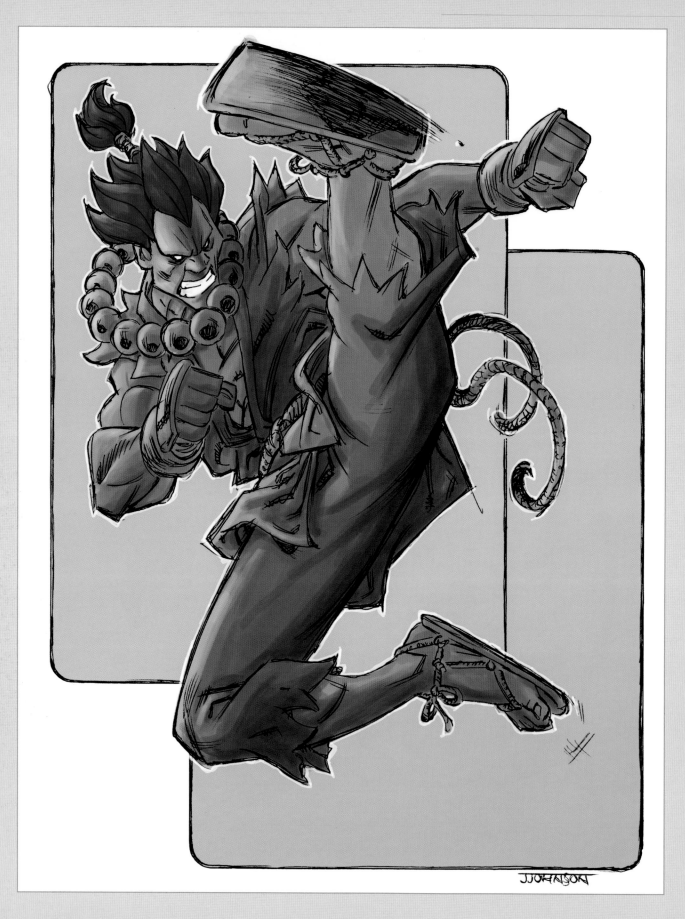

JEFF JOHNSON
LOS ANGELES, CALIFORNIA, USA
JOHNSONVERSE.BLOGSPOT.COM
ILLUSTRATOR
[SPIDER-MAN, GREEN LANTERN, WAY OF THE RAT, BOONDOCKS, WONDERMAN]

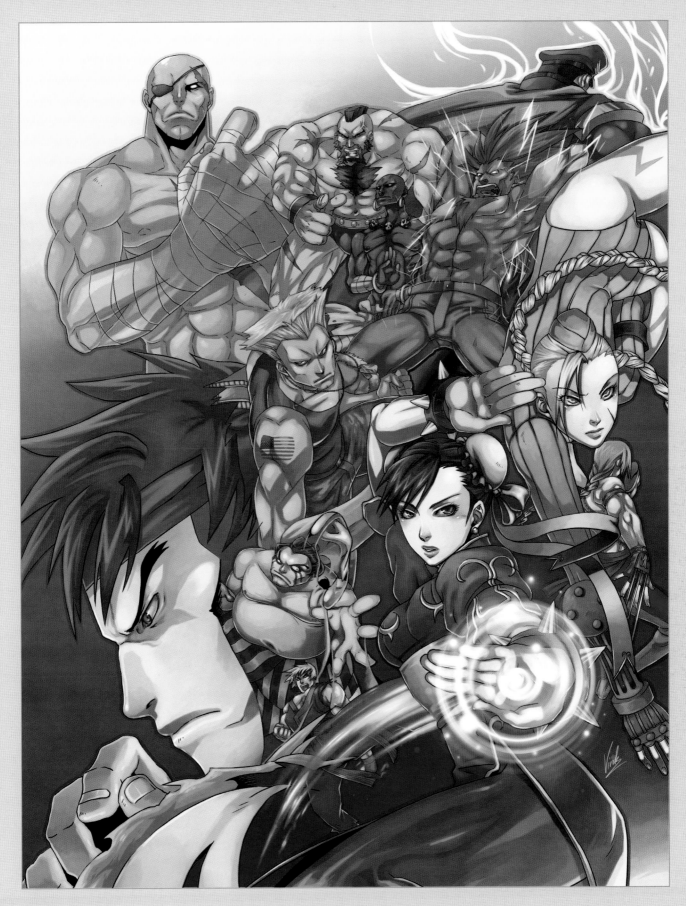

JEANNE KONGPHENGTA [VIRAK]
MARSEILLE, FRANCE
VIRAK.FREE.FR
FREELANCE ILLUSTRATOR AND COMICS ARTIST
[LE CIEL D'EDEN]

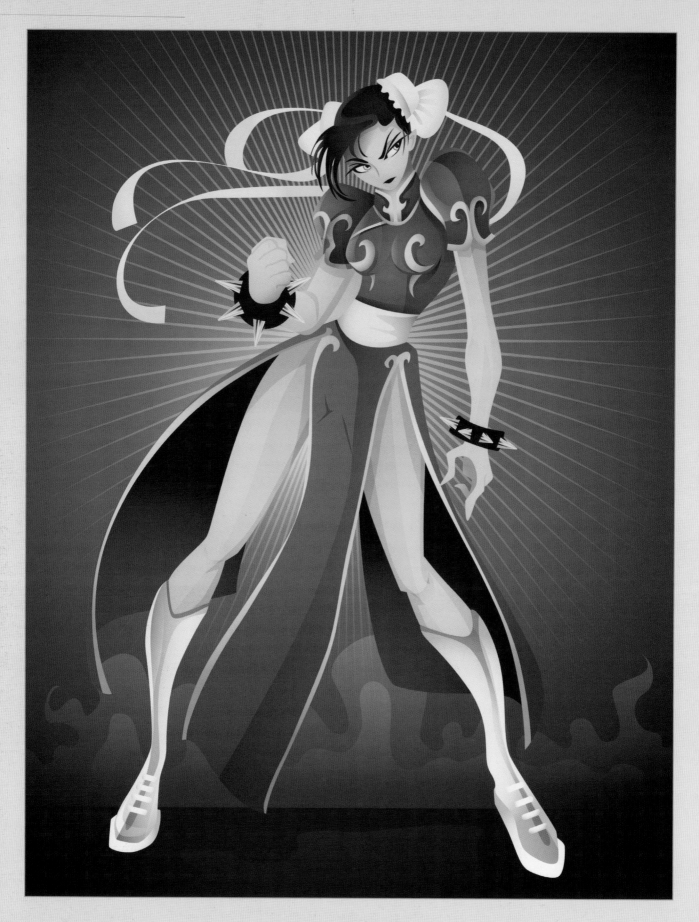

CHARLENE CHUA
TORONTO, ONTARIO, CANADA
WWW.CHARLENECHUA.COM
ILLUSTRATOR

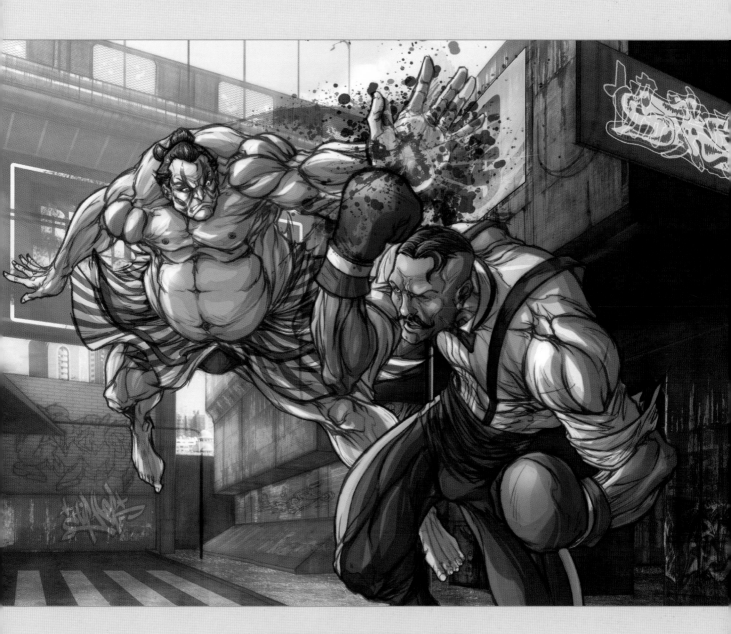

ANDRES MONTEALEGRE
BOGOTÁ, COLOMBIA
WWW.TELEFONO4.COM
CONCEPT ARTIST / ILLUSTRATOR
[CELLFACTOR: IGNITION, MONSTER NADNESS, SHOCK, CROMOS]

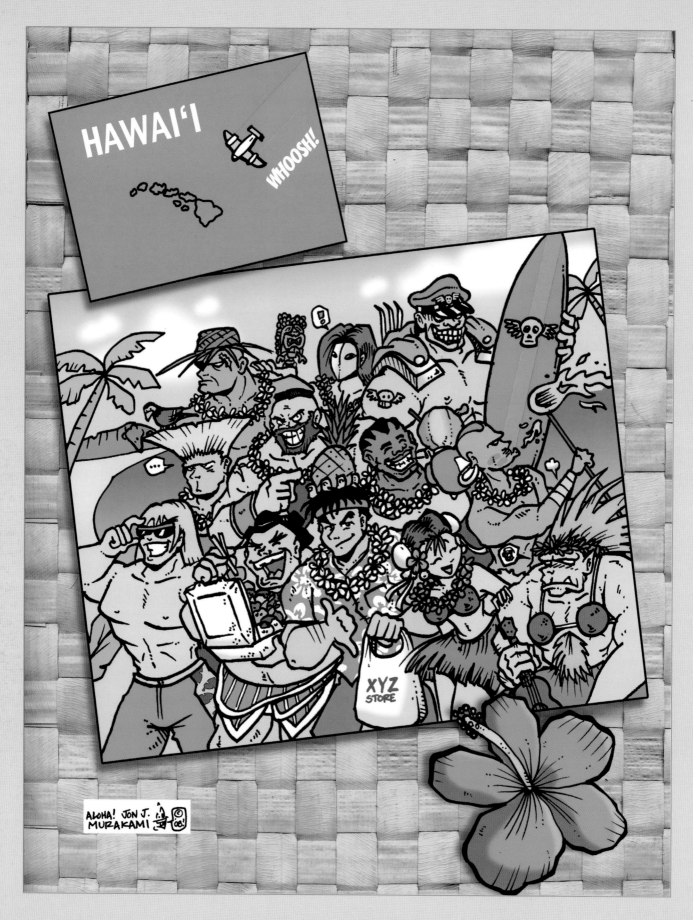

JON J. MURAKAMI
PEARL CITY, HAWAII, USA

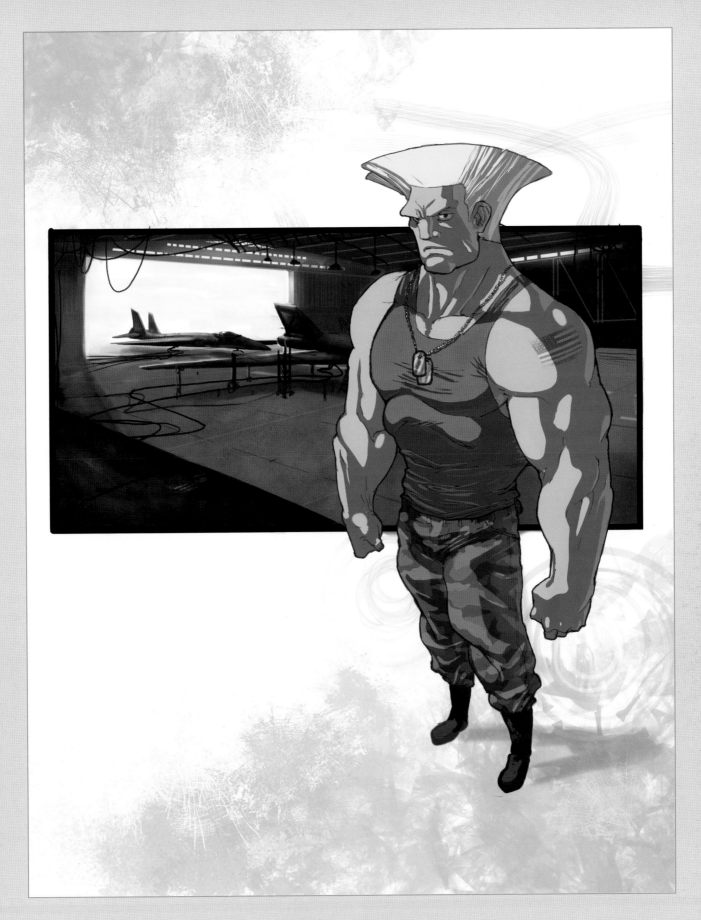

DANNY ARAYA
ARLINGTON, VIRGINIA, USA
UNLEADEDETHIOPIAN.DEVIANTART.COM
ART STUDENT

EDGAR DELGADO

Where I lived, mastering Street Fighter was a sign of respect.

I spent the entire last year of high school trying to beat this guy who was a monster with Ryu. I used every character on him and no one was a match until I started using Chun-Li (we didn't select her 'cause, you know, she was a girl...) and my whole world changed.

The day I knocked him out with her super lightning kicks was the day we became friends. It was an awesome time of my life.

J. SCOTT CAMPBELL

I always thought Cammy was hot.

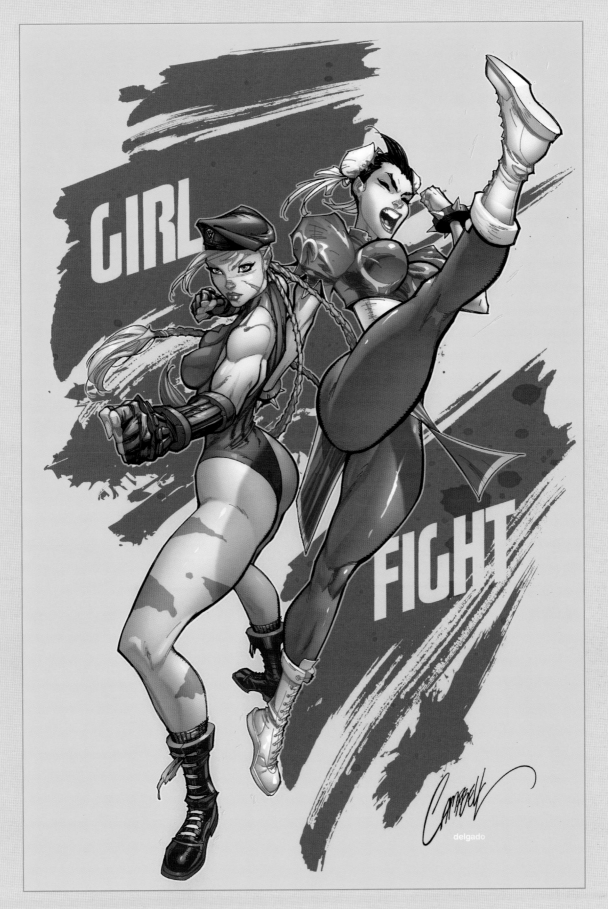

J. SCOTT CAMPBELL
ORANGE COUNTY, CALIFORNIA, USA
JSCOTTCAMPBELL.COM
ILLUSTRATOR
[DANGER GIRL, WILDSIDERZ, SPIDER-MAN, GEN 13]

EDGAR DELGADO
MEXICO
EDGARDELGADO.NET
COLORIST
[MARVEL, DC, TOP COW]

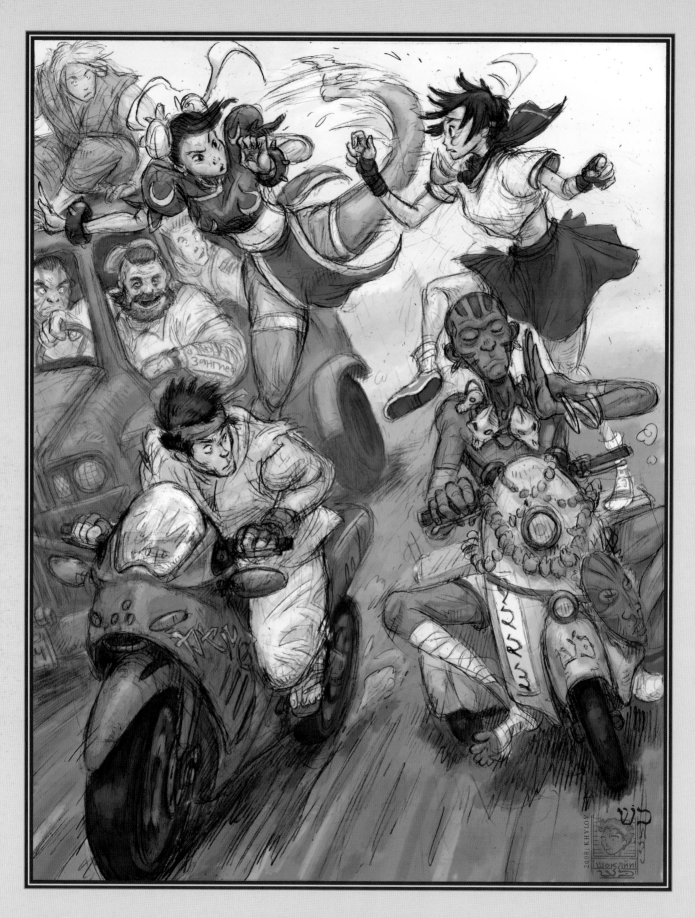

KYLE SHOCKLEY
CENTRAL COAST, CALIFORNIA, USA
KHYLOV.BLOGSPOT.COM
STORYBOARD ARTIST / CHARACTER DESIGNER [PIXAR, SIX POINT HARNESS, CUBE 5 PRODUCTIONS, HAYASA PICTURES]
CALIFORNIA INSTITUTE OF THE ARTS [CALARTS]
BEZALEL ACADEMY OF ART AND DESIGN [JERUSALEM]

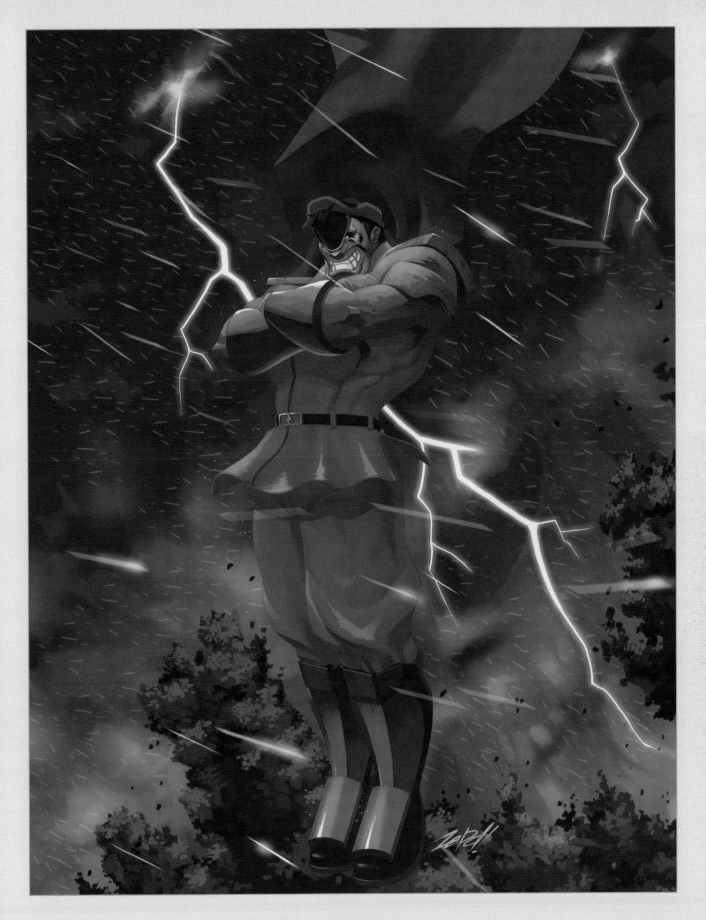

ZEDD
[MUHAMMAD FARIZ ZULKIPLI]
KUALA LUMPUR, MALAYSIA
Z3DD.DEVIANTART.COM
COLORIST / ILLUSTRATOR

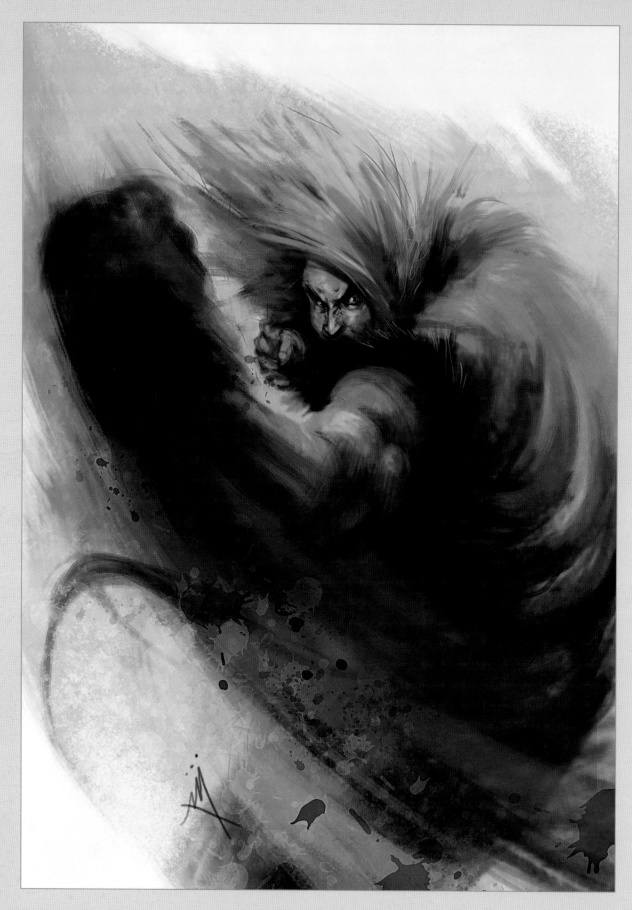

KEVIN CHIN [KINGMONG]
SINGAPORE

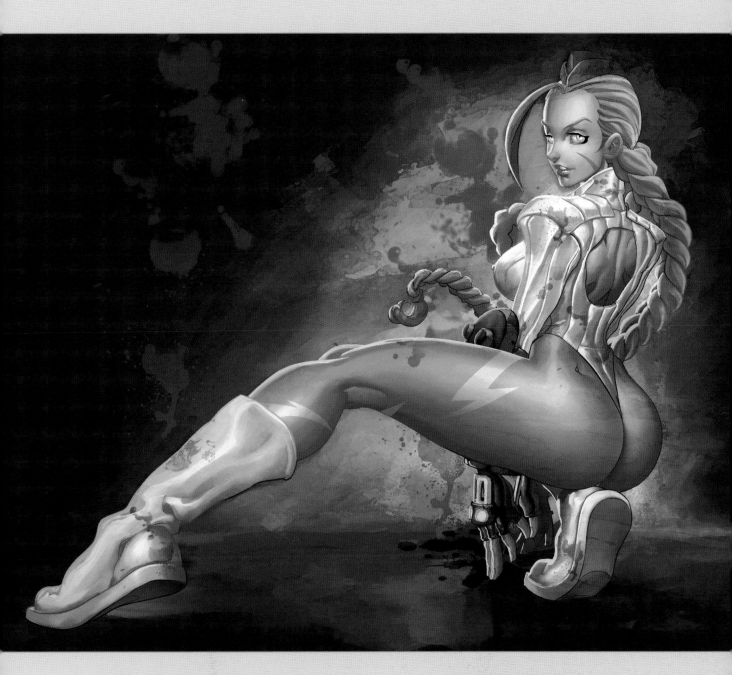

MARK ANTHONY O. TADURAN
PHILIPPINES
MARKOVAH.DEVIANTART.COM

RAINIER BEREDO
PHILIPPINES
SUMMERSET.DEVIANTART.COM

JIM ZUBKAVICH

I remember playing Street Fighter II in arcades, corner stores and the local pizza place down the road from my high school. The game had a hold on my friends and I like nothing else — constant discovery, competition and adrenaline. When it made the leap to Super Nintendo home consoles, we feverishly practiced the moves, trying to perfect our street fighting craft. I had a cross-shaped callus on my left thumb for most of my teenage years thanks to the power of the Dragon Punch. It healed up for a while after I left home for college, but then Street Fighter Alpha was released on the original Playstation in my 2nd year and I was back to tearing skin and crushing combos.

In 2003 I would end up at UDON just as the studio began working on their Street Fighter comic series. I've been fortunate enough to see the studio grow and our relationship with Capcom strengthen as the years go by.

I still remember having dinner with Kinu and Ikeno, two of the original Street Fighter designers. I told them about playing Street Fighter as a teenager and competing with my friends; so many quarters spent on match after match.

Then I had a flash of insight.

"Now I have a chance to be involved with Street Fighter and I'm ecstatic. It's a childhood dream to contribute to the franchise..."

I smiled.

"...and I finally get some of my quarters back!"

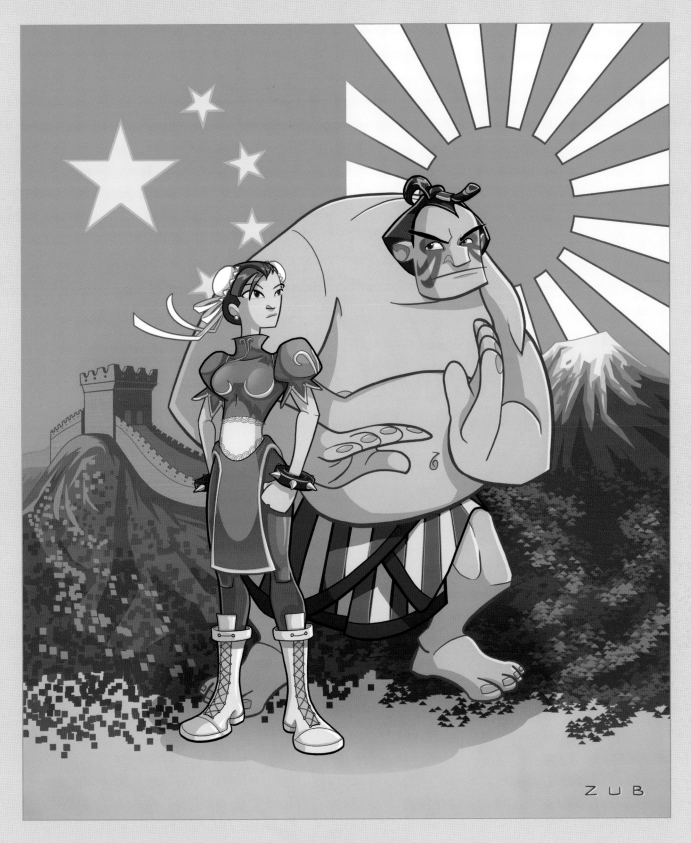

JIM ZUBKAVICH
TORONTO, ONTARIO, CANADA
WWW.MAKESHIFTMIRACLE.COM - ZUBBY.DEVIANTART.COM
WRITER/ARTIST [MAKESHIFT MIRACLE]
PROJECT MANAGER [UDON]

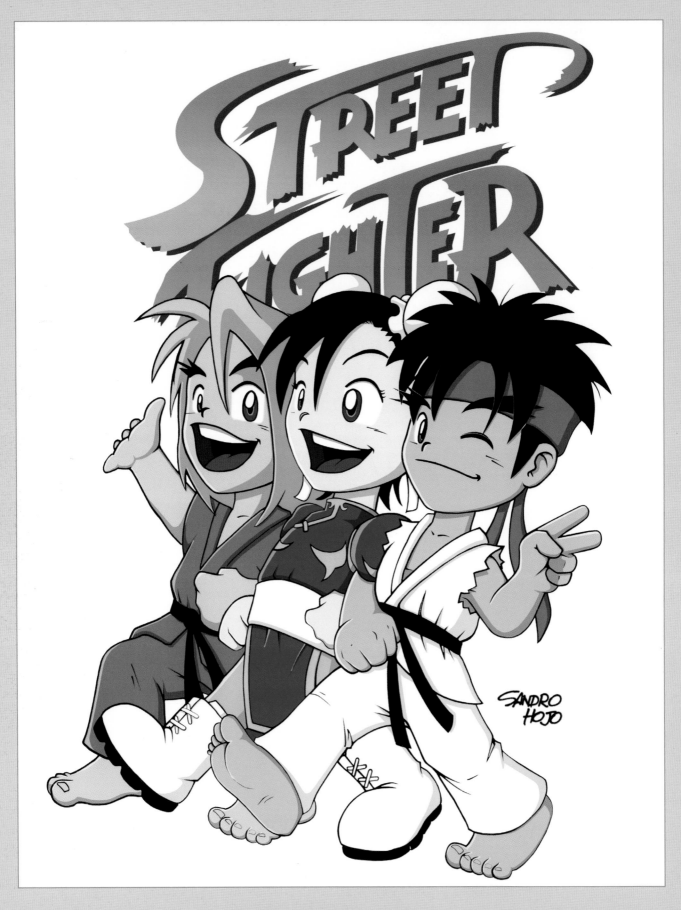

SANDRO NORI HOJO
SÃO PAULO, BRAZIL
NORI-HOJO.DEVIANTART.COM
CHARACTER DESIGNER

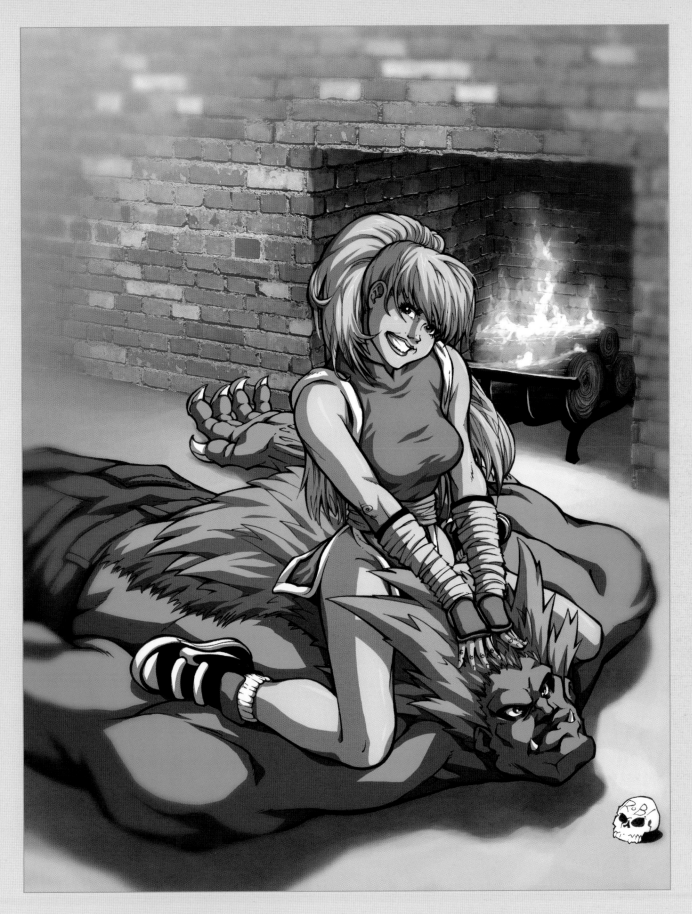

ROBBIE ARMSTRONG
TORONTO, ONTARIO, CANADA
ILLUSTRATOR / INKER
[TRANSFORMERS G1 VOL 1 & 2, ARMADA,
X-MEN/FANTASTIC FOUR, SUPERMAN/BATMAN]

STUART NG
VANCOUVER, BRITISH COLUMBIA, CANADA
WWW.GENESOUL.NET
CONCEPT ARTIST [TUROK, ARMY OF TWO, CANDY FACTORY]
COLORIST [WARLANDS AGE OF ICE, SANDSCAPE, MEGA MAN]

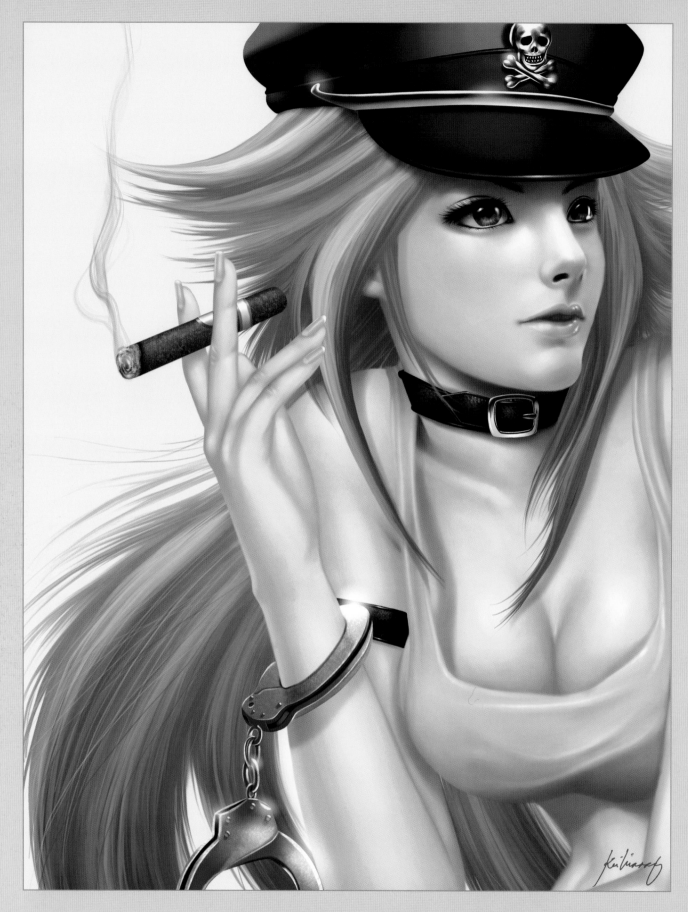

ANNA KATRINA LIWANAG
MAKATI CITY, PHILIPPINES
KEI03.DEVIANTART.COM
DIGITAL ARTIST

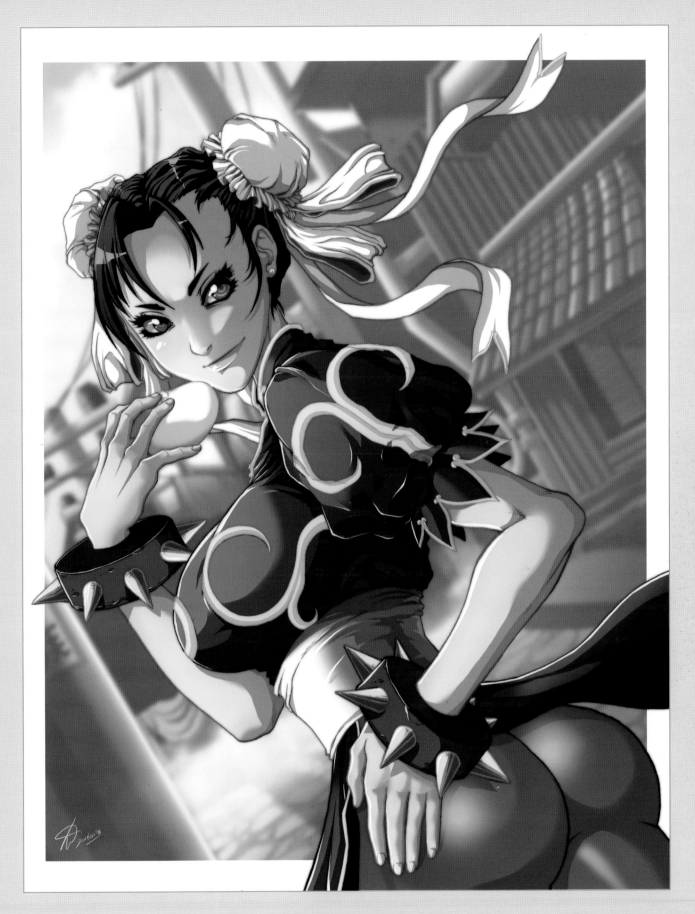

ROCIO ZUCCHI
BUENOS AIRES, ARGENTINA
DEWNOIR.DEVIANTART.COM
CONCEPT ARTIST / MANGA ARTIST
[MIND:CODE NEON, TIME:S]

ALEXANDER DIOCHON
TORONTO, ONTARIO, CANADA
WWW.DIOCHON.COM - STPLMSTR.DEVIANTART.COM
ILLUSTRATOR
[CUPPA COFFEE, HALLMARK CHANNEL, RKPUBLISHING, SPIKE TV]

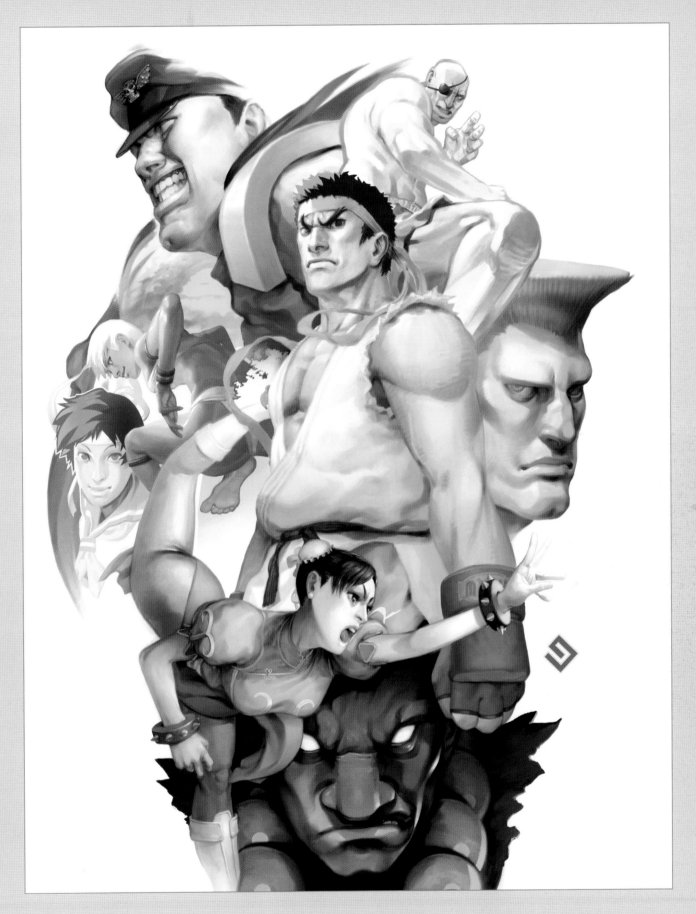

CHAD WALKER
BRENTWOOD, TENNESSEE, USA
GAMMON.DEVIANTART.COM
TEXTURE ARTIST
[PREY MOBILE, GUITAR HERO MOBILE, STAND DOWN]

ARTGERM

I remember Street Fighter, the original version with 2 huge pressure sensitive buttons, as the highlight of my secondary school days. I spent almost all of my pocket money in the arcade after school, sometimes even skipping classes just to kick my classmates' butts in the game.

We became so good at playing Street Fighter that we actually traveled around town to different arcade shops just to find better challengers. The Street Fighter series were my official arcade games for many years until they were ported to the consoles. I still play Street Fighter III: Third Strike in my studio every day on the PS2 and it's just as great.

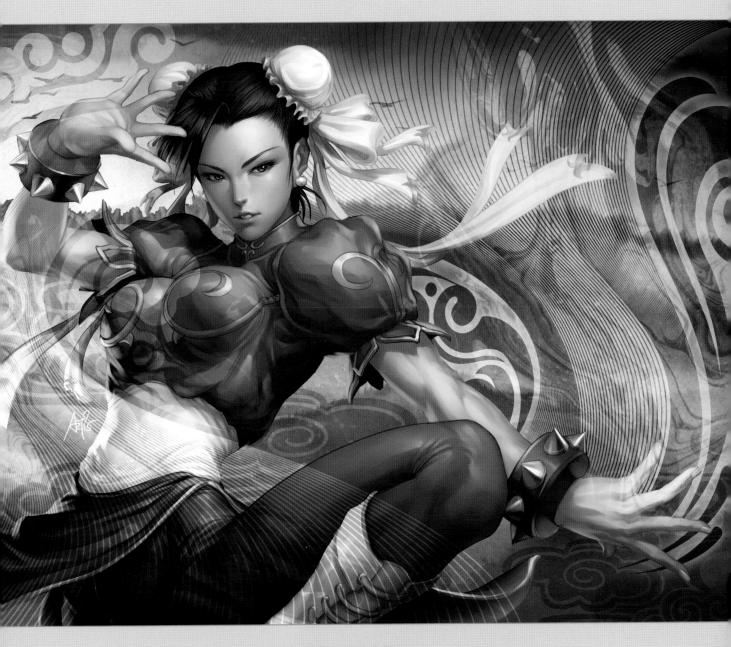

ARTGERM
ARTGERM.DEVIANTART.COM
CREATIVE DIRECTOR
[IMAGINARY FRIENDS STUDIOS]

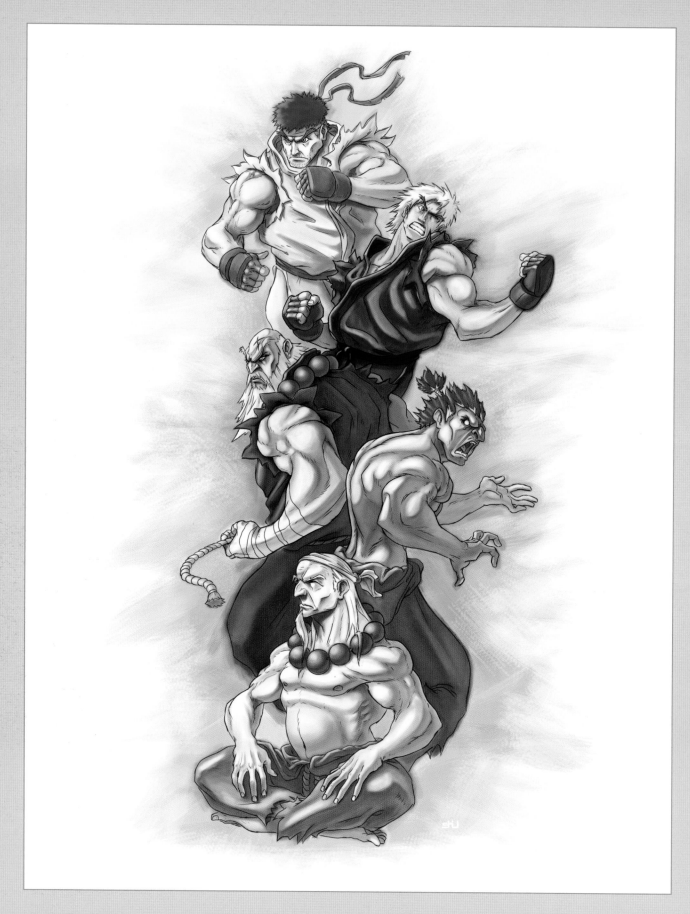

SHYH CHAI
VANCOUVER, BRITISH COLUMBIA, CANADA
SHUCHAI.BLOGSPOT.COM
CHARACTER DESIGNER
[ESCAPE FROM PLANET EARTH, CLASS OF THE TITANS, VIVA PINATA]

ストリートファイター

リュウ　　　ケン・マスターズ　　　チュンリー　　　ガイル

ザンギエフ　　　ダルシム　　　ブランカ　　　エドモンド本田

マイク・バイソン　　　バルログ　　　サガット　　　ベガ

ANTHONY AGUINALDO 2008

ANTHONY AGUINALDO
LOS ANGELES, CALIFORNIA, USA
THISISANTON.DEVIANTART.COM
COLORIST/VECTOR ARTIST

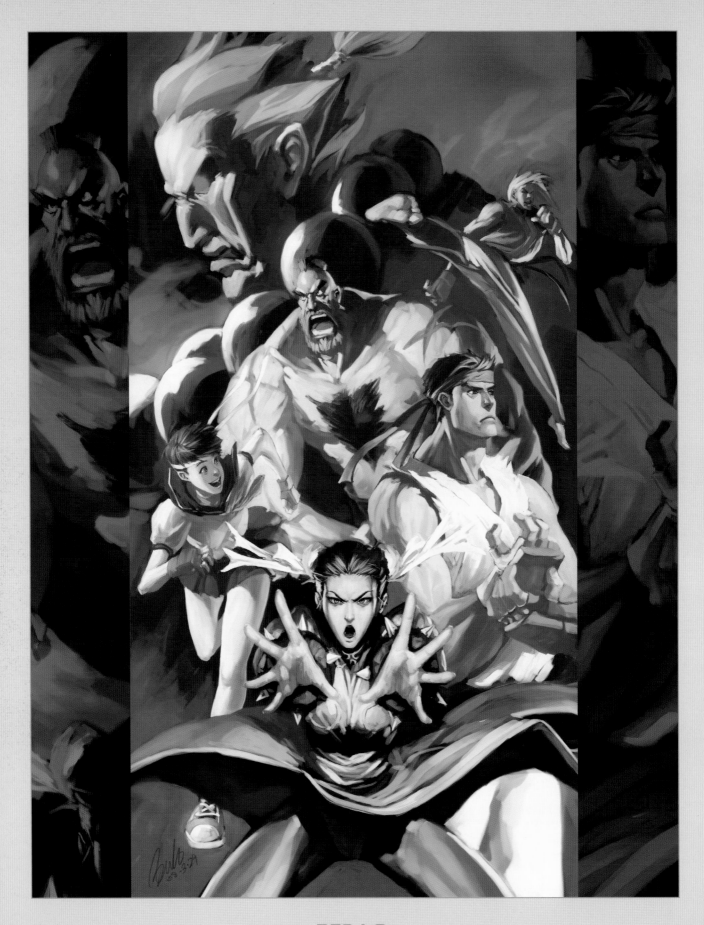

BEN LO
TORONTO, ONTARIO, CANADA
BENLO.DEVIANTART.COM
ANIMATION STUDENT AT SHERIDAN INSTITUTE

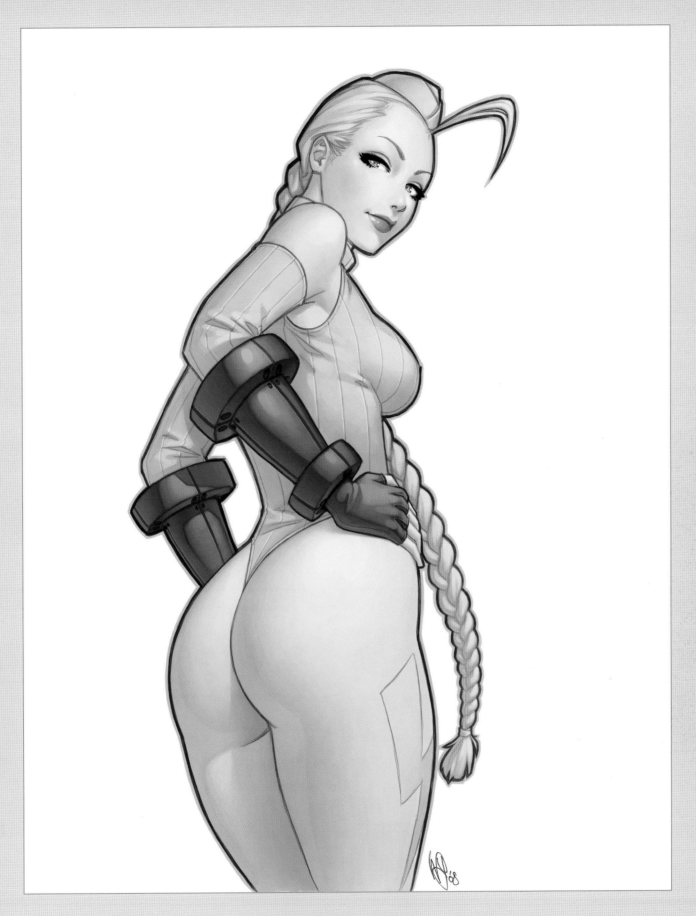

WARREN LOUW
JOHANNESBURG, SOUTH AFRICA

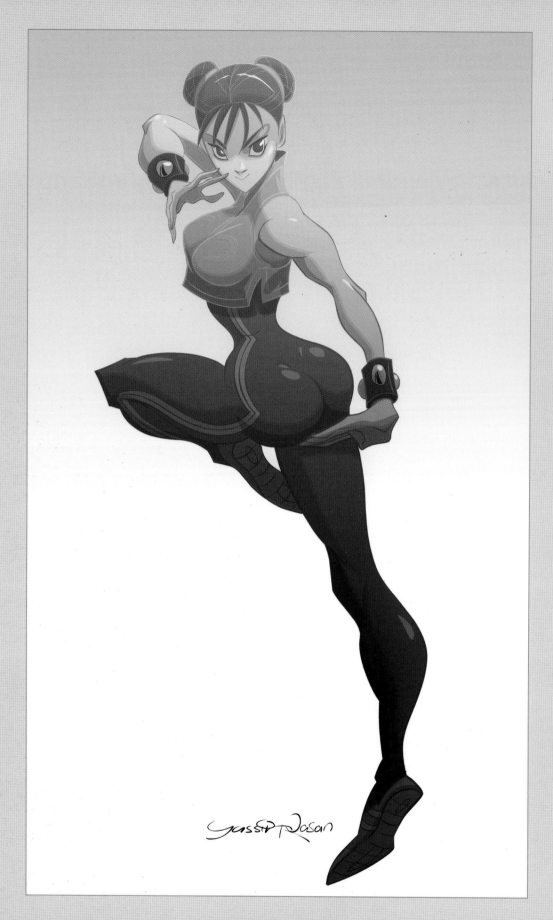

YASSIR S.RASAN
TURKEY / ISTANBUL
SEESOZD.DEVIANTART.COM
ILLUSTRATOR

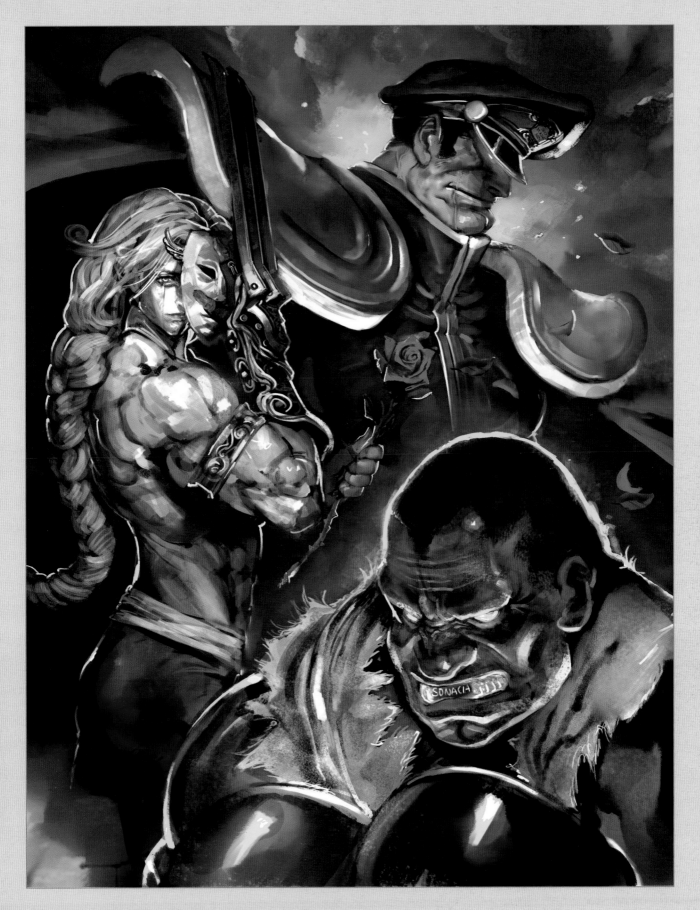

SEO YOUNG-min [SONACIA]
SOUTH KOREA
WWW.SONACIA.COM
ILLUSTRATOR
[GRANADOESPATA, STILLLIVE, ROOMS]

FRANCIS MAO

In the early 90's, just as Street Fighter II was taking the world by storm and changing video game culture forever, I was super-fortunate to have a personal Street Fighter II arcade machine to play anytime I wanted to. I was working as the Art Director for GamePro magazine and Capcom sent us a unit to do "research" on the official strategy guide we were creating for them. Needless to say the editors and I put that arcade machine to good use 24/7 and we were always "late" with our deadlines, because we kept doing "research" and not producing the guide.

I was mesmerized by the gorgeous artwork and uniqueness of all the different characters, and although Chun-Li, M. Bison, and others had more popularity, my favorite was always Dhalsim. The first time I made him pull some of his crazy moves stretching his body like wacky taffy, I was hooked. Maybe he appealed to the oddball geek inside me, but the mysteriousness and exoticness of his look and moves always appealed to me. Can't wait to play him in SF4!

FRANCIS MAO
SAN MATEO, CALIFORNIA, USA
SR. DIRECTOR CREATIVE SERVICES
[CAPCOM]

LOUIS CHAMPAGNE
OTTAWA, ONTARIO, CANADA
LOUISCHAMPAGNE.BLOGSPOT.COM
SUPERVISING ANIMATOR
[GERALD MCBOING BOING, WORLD OF QUEST, TOOT AND PUDDLE]

MIKE NGUYEN
TORONTO, ONTARIO, CANADA
ARTIST
[WARNER BRO.'S HAPPY FEET MOBILE GAME, CAPYBARA GAME'S PILLOW FIGHT]

UPON
WASHINGTON, D.C., USA
WWW.BURRITOCHAN.NET
UPONTHOUFAIRCAT.DEVIANTART.COM

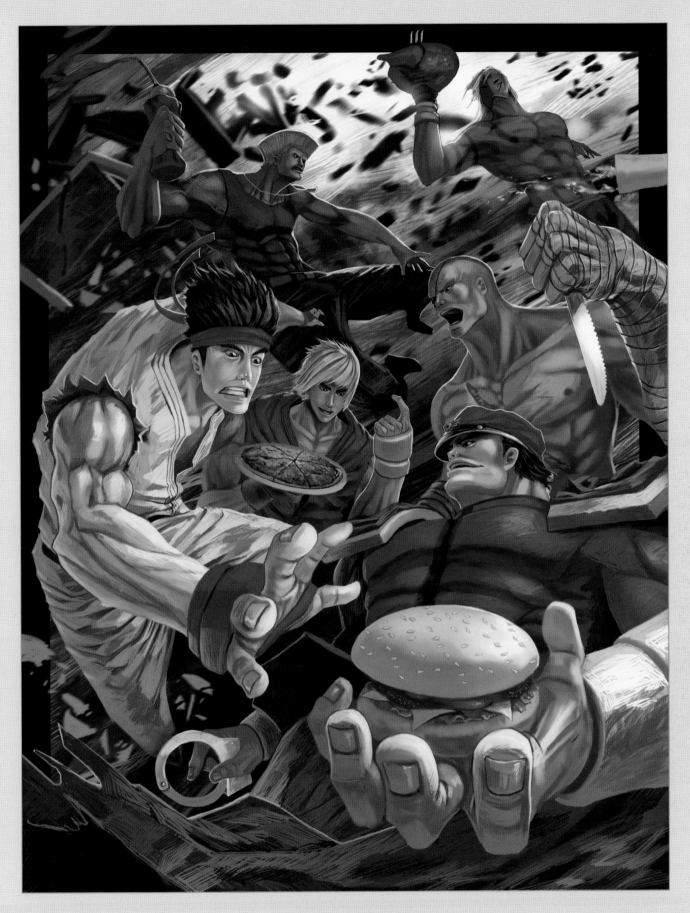

JESSADA SUTTHI
UDONTHANI, THAILAND
JESSADA-NUY.DEVIANTART.COM
ILLUSTRATOR

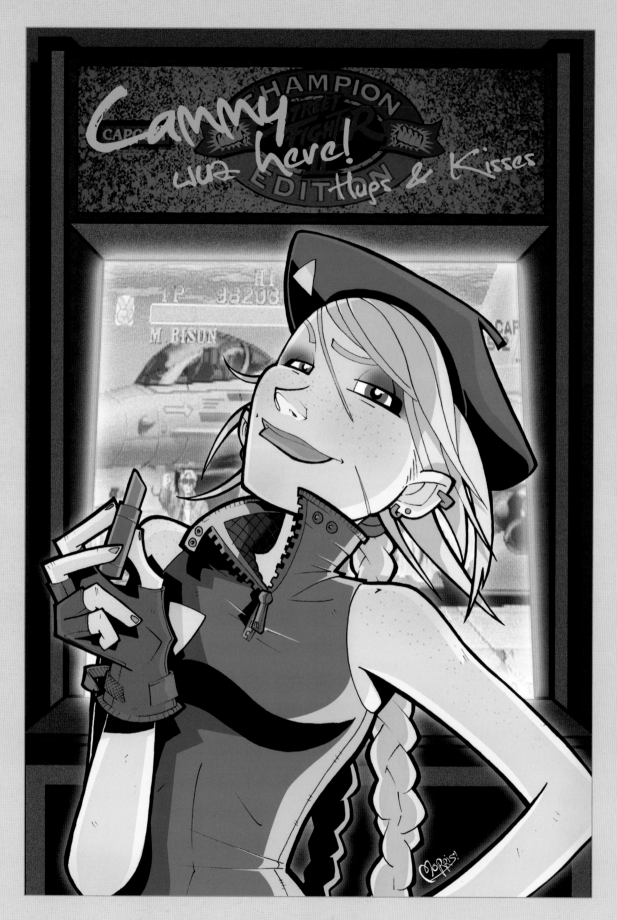

KEITH MORRIS
TORONTO, ONTARIO, CANADA
ILUSTRATOR / GRAPHIC DESIGNER
[TEEN CRIME ACADEMY]

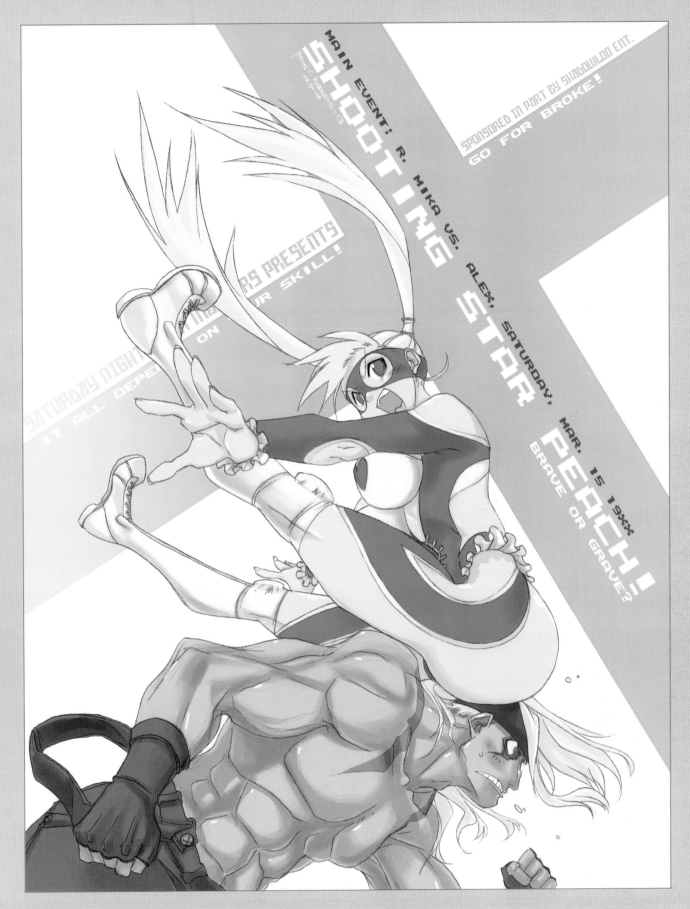

SHOOTING STAR

MAIN EVENT! R. MIKA VS. ALEX, SATURDAY, MAR. 15 19**

PEACH! BRAVE OR GRAVE?

SATURDAY NIGHT ...RS PRESENTS IT ALL DEPE... ON ...IR SKILL!

SPONSORED IN PART BY SHADOWLOO ENT.

GO FOR BROKE!

JASON ROBINSON [CRYBRINGER]
BELTSVILLE, MARYLAND, USA
WWW.ANGRYVIKINGPRESS.COM - CRYBRINGER.DEVIANTART.COM
COMIC CREATOR [THE DEMON MAGES]
WEBCOMIC ARTIST [CHISUJI]

RYAN ODAGAWA

My first memory of Street Fighter was after high school with kids putting their quarters down on the arcade machine, which translated to: "I'm next to play". The different combinations of moves were challenging to get down, not to mention trying to get a Dragon Punch out while going up against a skilled player. My thumbs are still calloused from playing the home version.

Art wise, I remember being blown away when I came across the first Capcom art book. Everyone wanted to have one, and several people I knew asked me to pick them up a copy. The artwork of Bengus, Akiman, Kinu Nishimura, etc. were a big influence on my own work from then on.

Happy Anniversary Street Fighter!

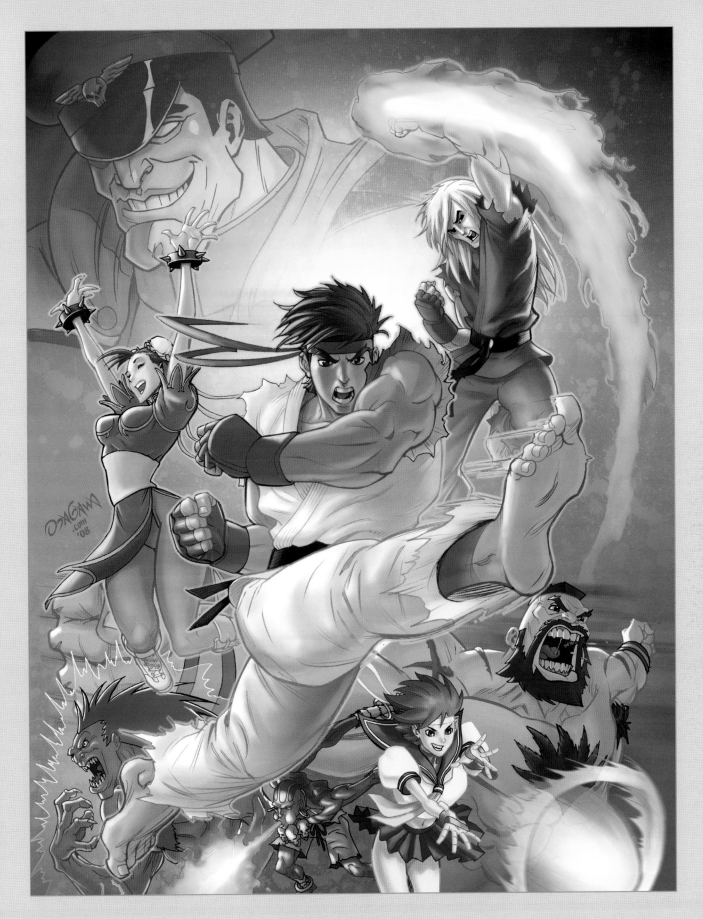

RYAN ODAGAWA
ROSEMEAD, CALIFORNIA, USA
WWW.ODAGAWA.COM
RM0120.DEVIANTART.COM
ILLUSTRATOR [HEROES ONLINE COMIC]

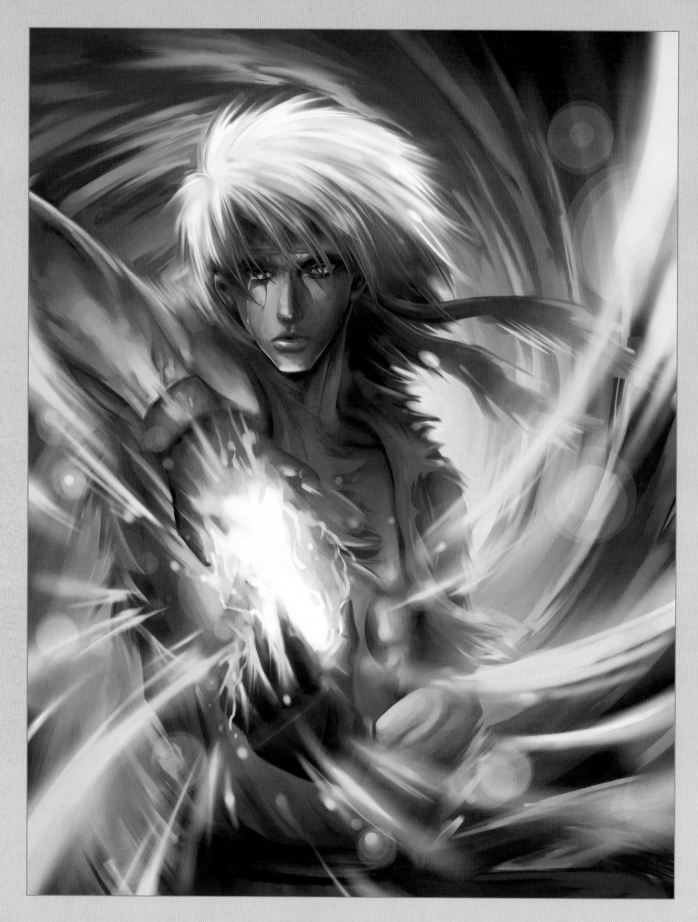

YAP JIA XING
KUALA LUMPUR, MALAYSIA

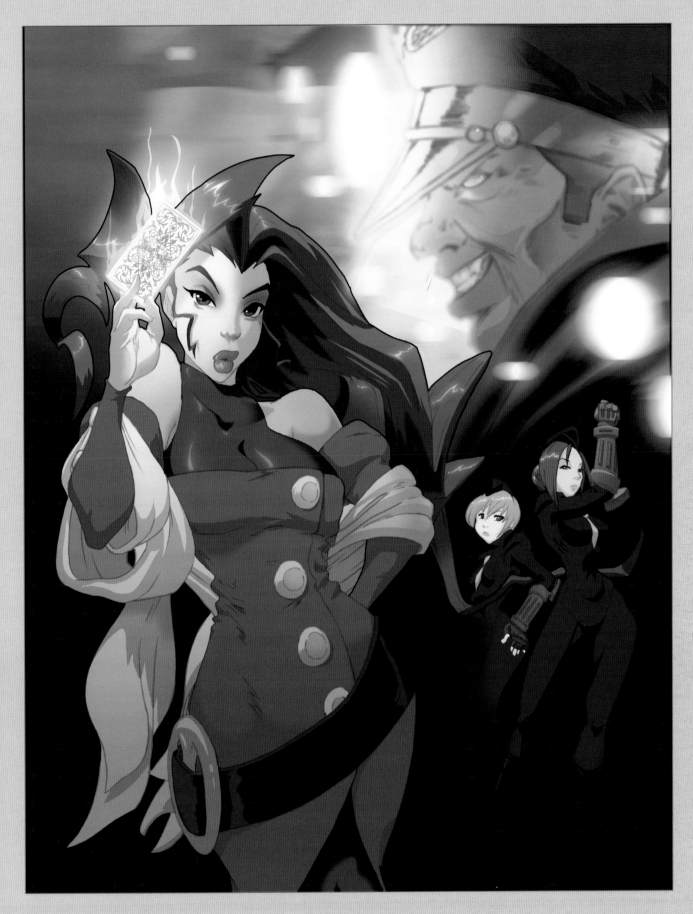

ROBAATO
ILLINOIS, USA
WWW.ROBAATO.COM
ILLUSTRATOR

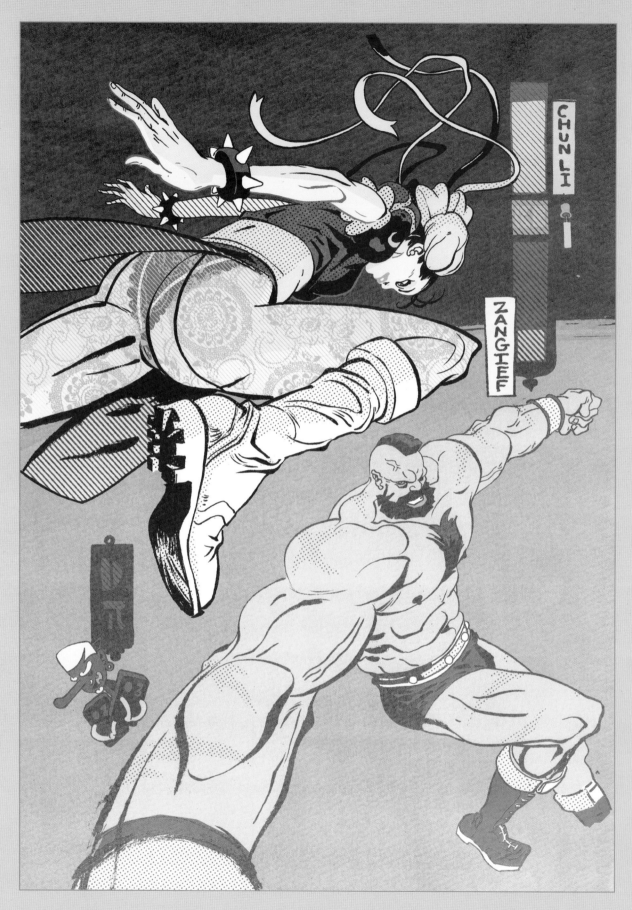

D π
BROOKLYN, NY
WWW.D-PI.COM
GRAPHIC ARTIST/NOVELIST
[PRINCE OF CATS, GRATUITOUS NINJA, MEATHAUS: SOS]

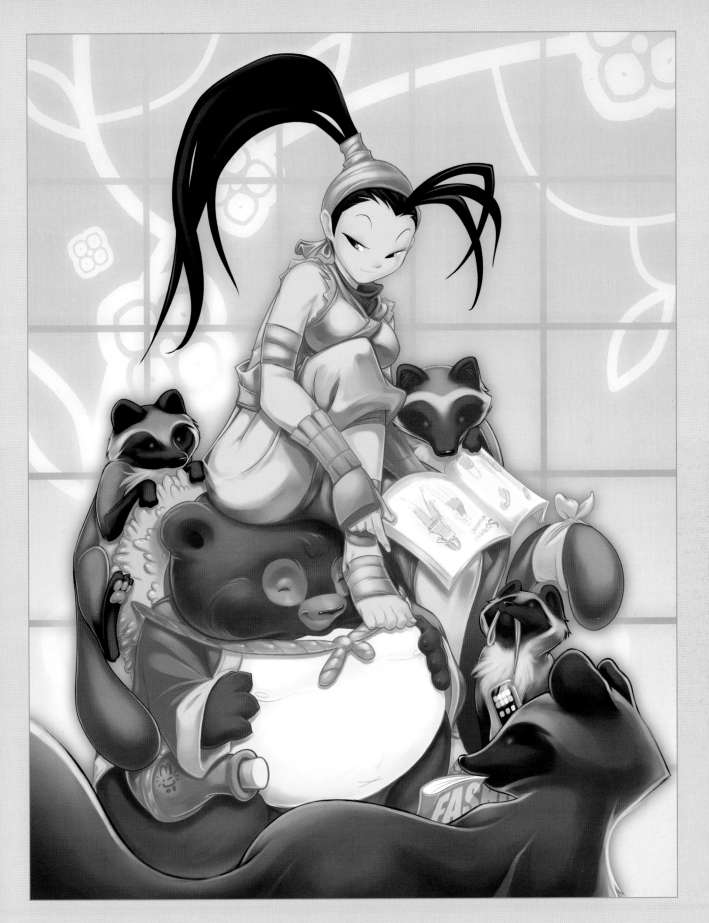

MIU
BAKERSFIELD, CALIFORNIA, USA
COOKINGPEACH.DEVIANTART.COM
ILLUSTRATOR/COMIC WRITER

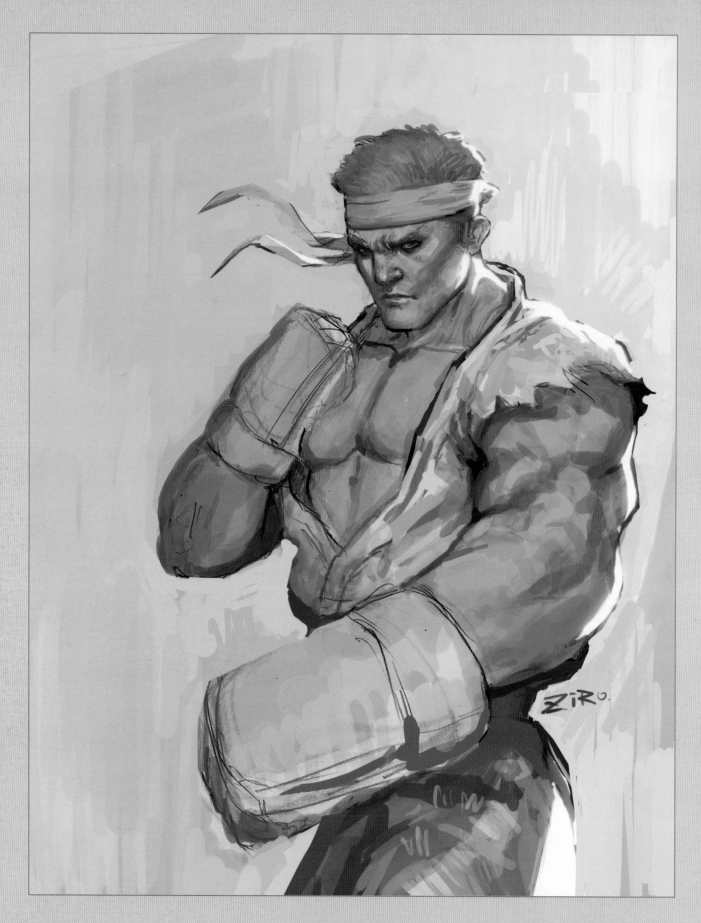

AHN JUNG-SIK
SOUTH KOREA
ZIRO.EGLOOS.COM
ART DIRECTOR
[LAPELZ MMORPG]

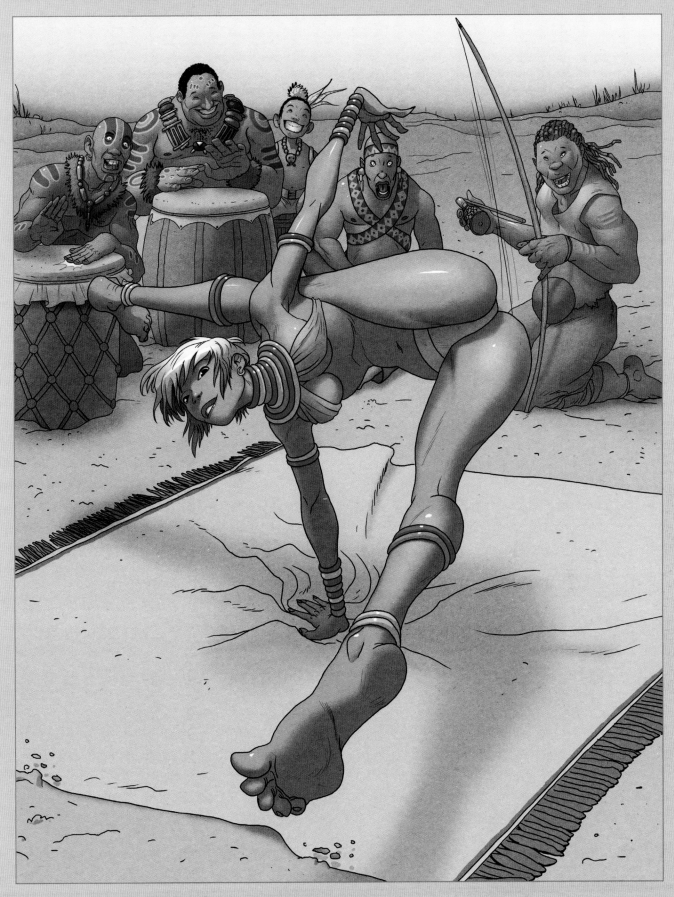

RAÚL TREVIÑO
MONTERREY, MÉXICO
WWW.TREVINOART.COM
GRAPHIC NOVEL ARTIST
[LA DANZA DE LA CONQUISTA, PROTOBUNKER STUDIO]

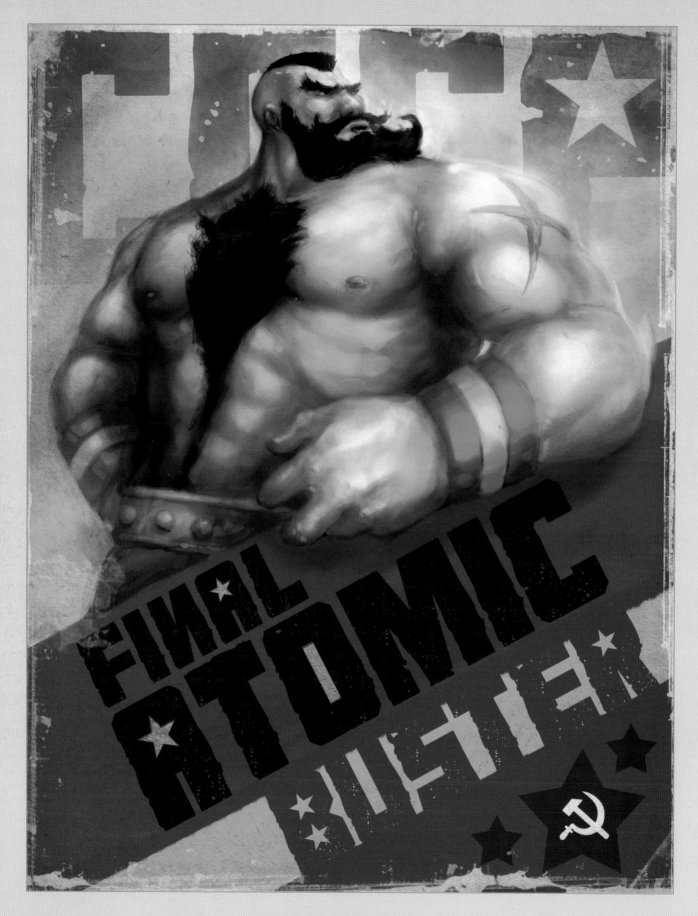

FINAL ATOMIC FIGHTER

DIEGO SANCHES
SÃO PAULO, BRAZIL
WWW.DIEGOSANCHES.COM
ILLUSTRATOR/COLORIST
[24-SEVEN VOL.2, ROLLING STONE BRASIL, SUPERINTERESSANTE, QUATRO RODAS]

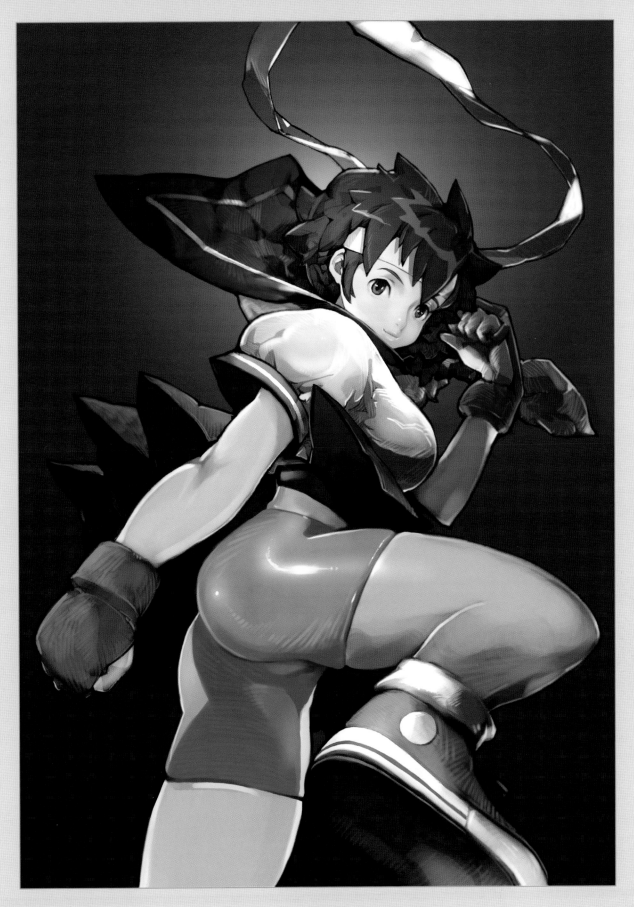

KIM DONG SOOK [ARTKIKI]
SOUTH KOREA
ARTKIKI.EGLOOS.COM
CONCEPT ARTIST
[SUNONLINE]

BOBBY CHIU

I was playing against a skinny 10 year old boy with glasses. He was probably a mouse on the playground, but on the Street Fighter machine, he was a lion. His character was Guile and he worked the controls like a piano virtuoso.

I was pretty good at Street Fighter myself. My buddies, Mike, Richard, and I each had "our" characters: at the time mine was Dhalsim; they were always Blanka and E. Honda, respectively.

Against this kid, my Dhalsim traded shots with his Guile until we were both down to two or three strikes from defeat. I kept him at a distance with Dhalsim's medium toe kick and endless Yoga Fire.

I thought I had him. But then he did a combo that shook the machine. On the screen, Guile went through the throwing motion. Correspondingly, Dhalsim went through the motion of being grabbed and launched through the air— from the other side of the screen! Game over.

I stared in disbelief. After a few seconds, I asked, "How did you do that invisible throw?"

The kid looked nervously at me and, after making sure that I wouldn't shove him or something, he demonstrated on his computer opponent. I was amazed! Learning Guile's glitch invisible throw was like discovering superpowers!

The kid finished the game and left. I popped in another quarter and reclaimed the controls. I called out to Mike and Richard at the other side of the arcade, "Hey, come check this out! I wanna show you something!"

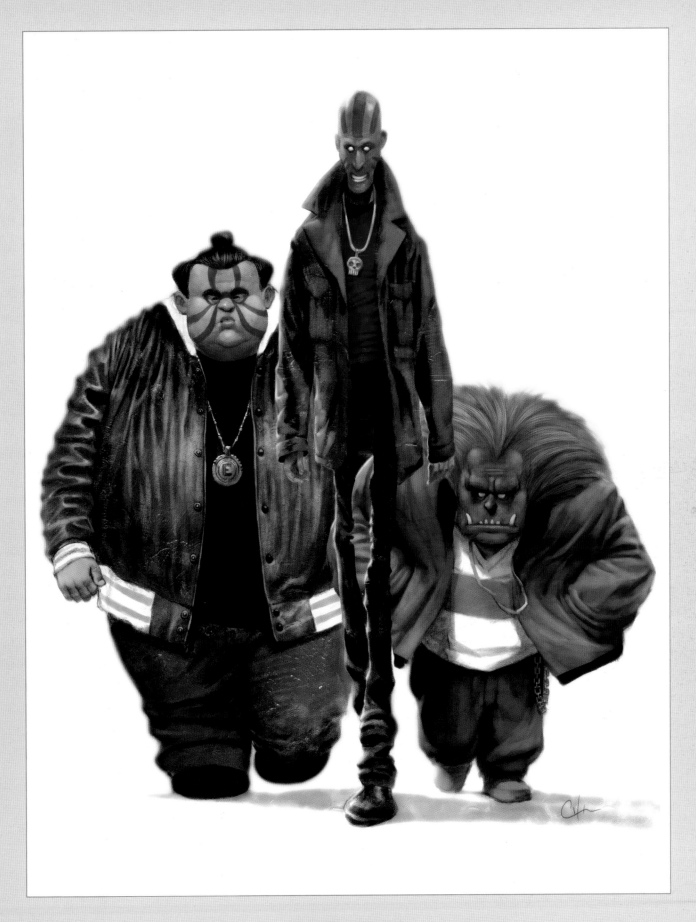

BOBBY CHIU
TORONTO, ONTARIO, CANADA
WWW.IMAGINISMSTUDIOS.COM
ILLUSTRATOR / VISUAL DEVELOPMENT

GORDON MCMILLAN
SMYRNA, TENNESSEE, USA

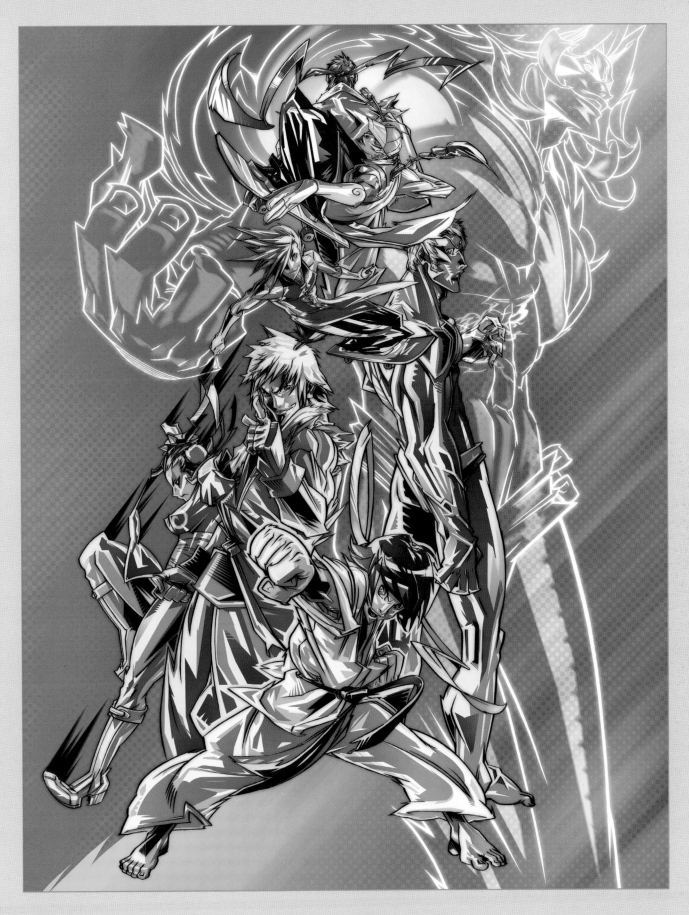

LARRY D. WARREN JR.
HALTOM CITY, TEXAS, USA
L-DAWB.DEVIANTART.COM

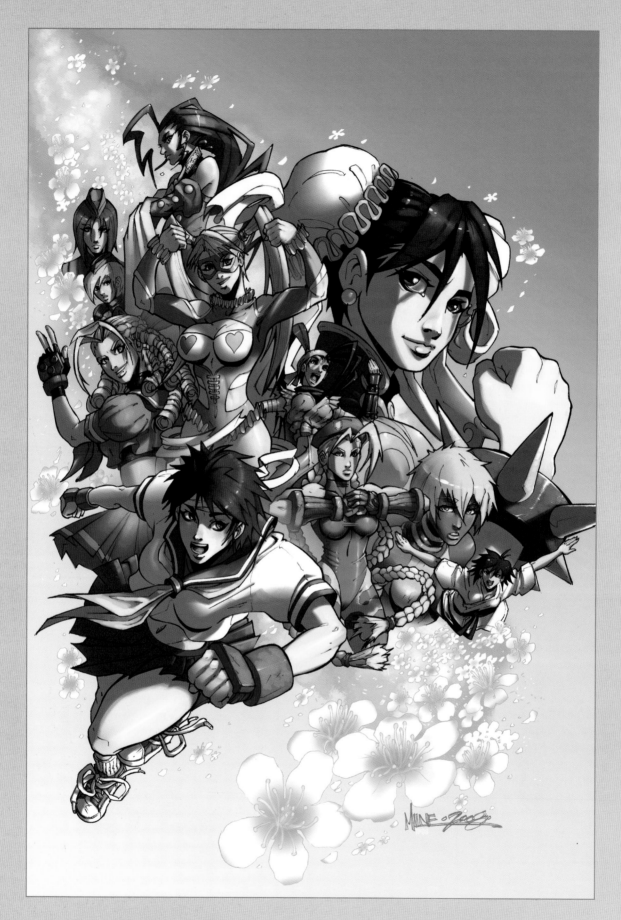

ALEX MILNE
TORONTO, ONTARIO, CANADA
MARKERGURU.DEVIANTART.COM
COMIC ARTIST
[TRANSFORMERS MOVIE ADAPTATION,
MEGATRON: ORIGINS, CYBERFORCE]

JOSH PEREZ
KILLEEN, TEXAS, USA
DYEMOOCH.DEVIANTART.COM
COLORIST
[MEGATRON: ORIGINS,
TRANSFORMERS SPOTLIGHT]

AVIV ITZCOVITZ
BINYAMINA, ISRAEL
WWW.IAVIV.COM
ARTIST AND ILLUSTRATOR

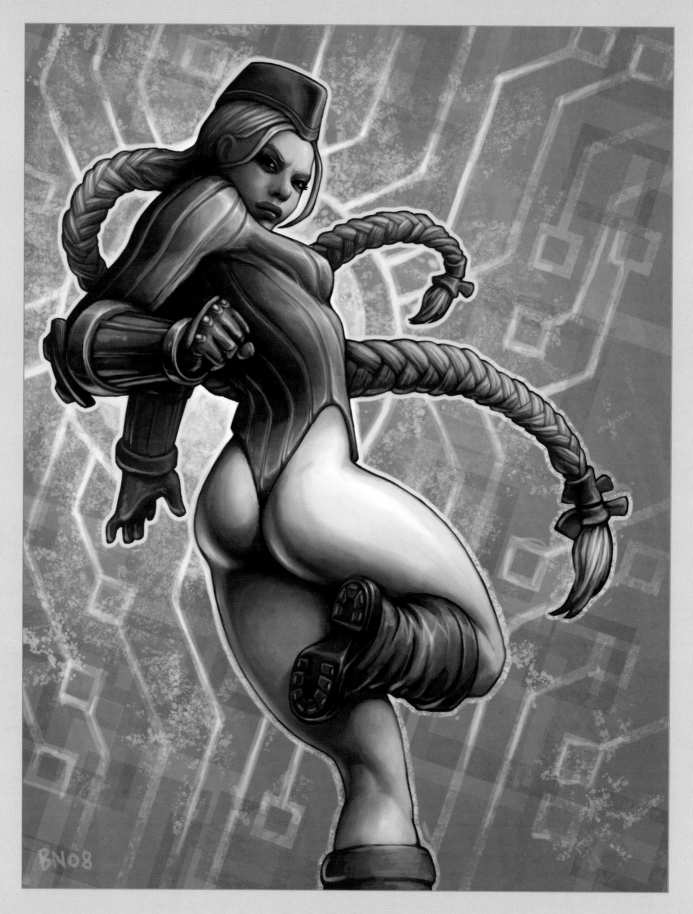

BEN NEWMAN
OXFORD, UK
BENNEWMANART.BLOGSPOT.COM
ILLUSTRATOR

I MADE MARTHANA YUSA
BALI, INDONESIA
ANGELMARTHY.DEVIANTART.COM
2D ARTIST

JOE VRIENS

My fondest memories as a little brat...er kid were filled with jumping off the roof of my garage into our in-ground swimming pool, from early morning through to sundown. All my school friends would show up unannounced (we wouldn't have answered the phone anyways) with or without their own towels around their necks. My mom became the neighbourhood nanny, serving triple-decker sandwiches and Tang to feed our empty bellies during those sun soaked summers.

As the sun set, some of my friends would go home for dinner but a handful would retire into the basement. The fun continued with the trusty-rusty NES hooked up to our 13 inch crapola TV. This is where my love for video games flourished... the graphics and music on the NES were so awesome!

The most amazing games artistically were the gems released by Capcom - Ghost'n'Goblins, Mega Man and Bionic Commando! "Wow," I thought "this stuff can't get any better". That is, of course... until Street Fighter II showed up in arcade form at my local Towers store.

HOLY CRAP! Street Fighter II blew my mind!! The characters were huge on the screen and animated better than anything else out there! The floor was even pseudo-3D! Seeing that game was the moment that solidified my ultimate goal of making 'my own games/comics' and 'trying to draw like Capcom'.

I continue to have the utmost respect for the Capcom artists and their whacked out original art that pushes the envelope in so many ways.

Thank you Capcom, for not sucking like so many others!

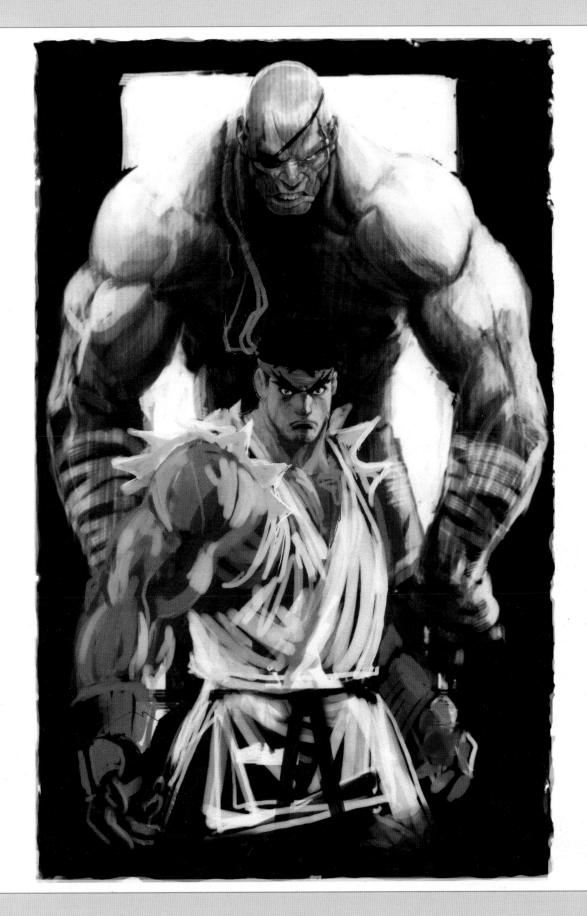

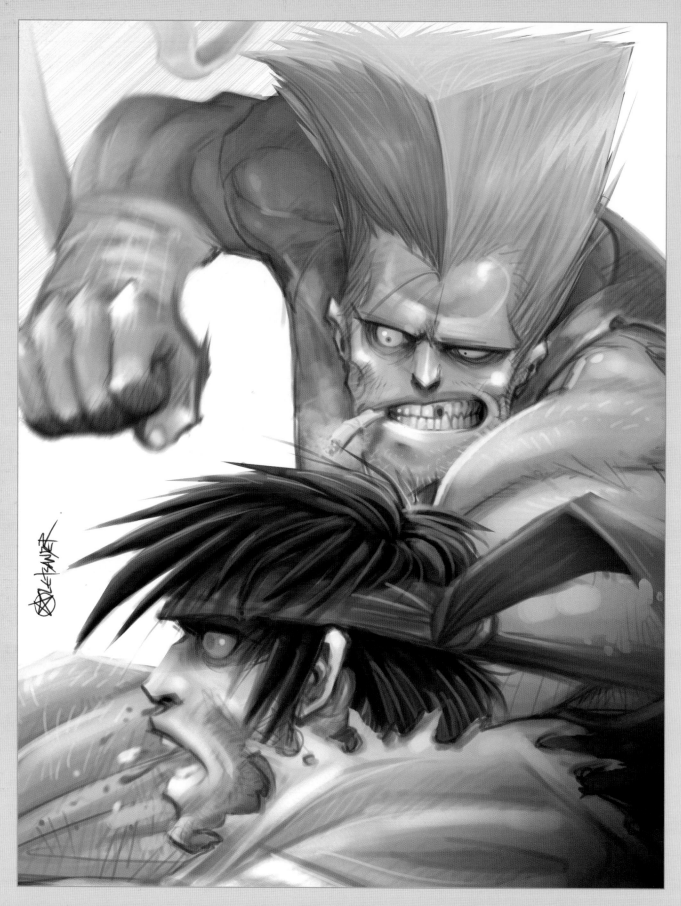

ALEXSANDER PATIÑO DE LA HOZ
MEDELLIN, COLOMBIA
ALETSANDER.DEVIANTART.COM
ILLUSTRATOR

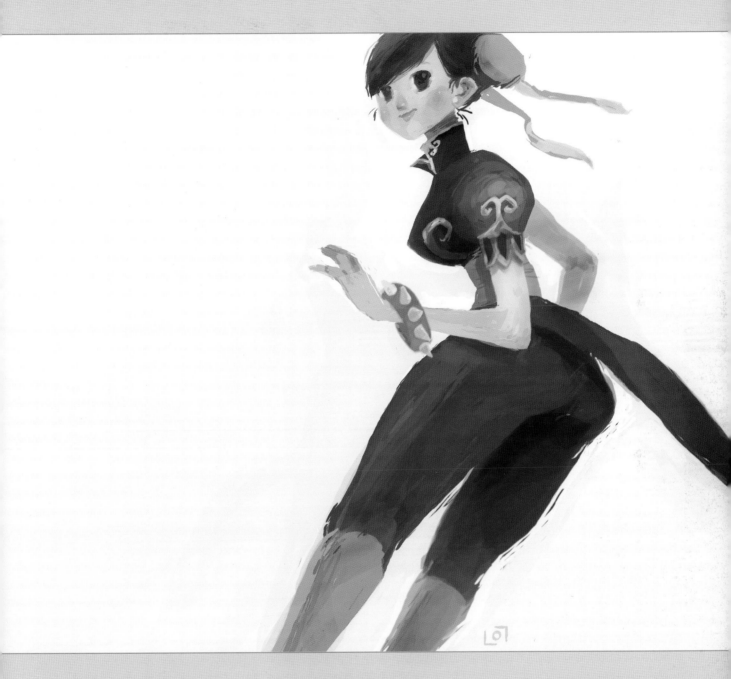

LETTIE LO
TORONTO, ONTARIO, CANADA
LETTIELO.BLOGSPOT.COM

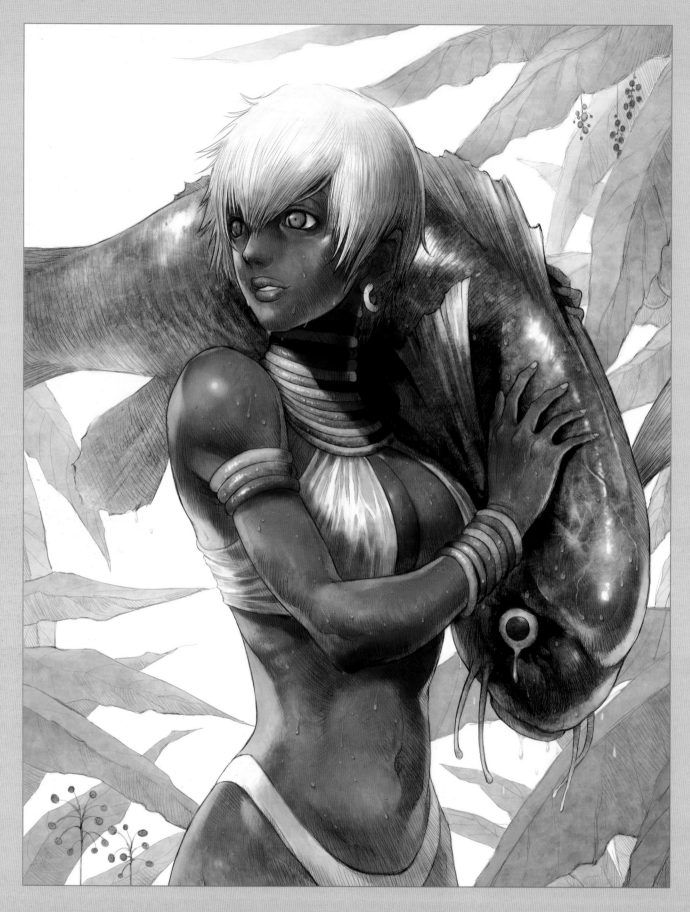

KIM KYOUNG-HWAN [TAHRA]
SOUTH KOREA
WWW.TAHRAART.COM
ILLUSTRATOR/CHARACTER DESIGNER
[ECTOZESOFT, DJMAX PORTABLE, HYUN EON SOFT]

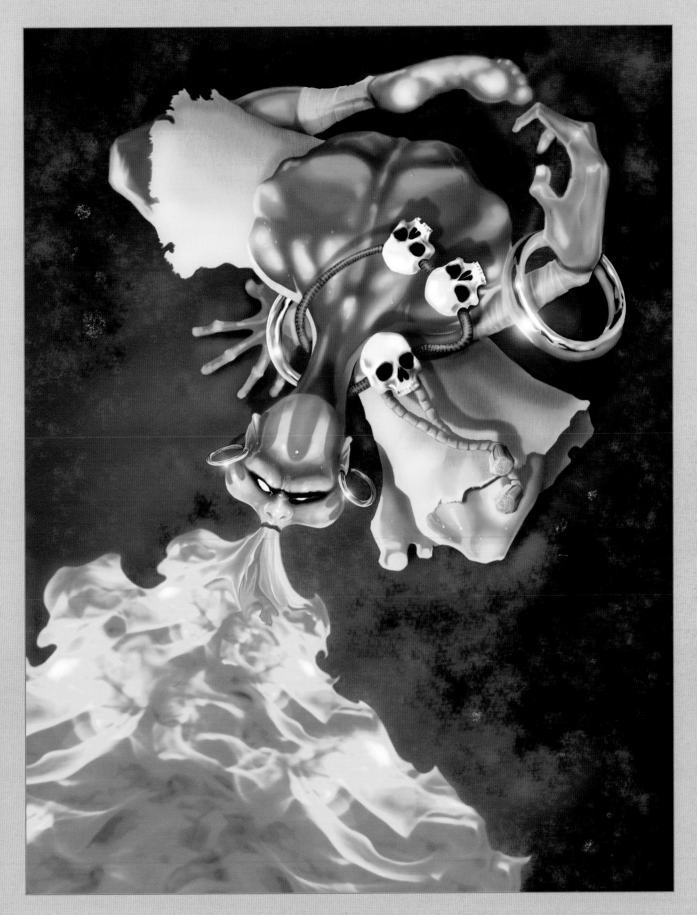

YACU MALIK
MELBOURNE, FLORIDA, USA

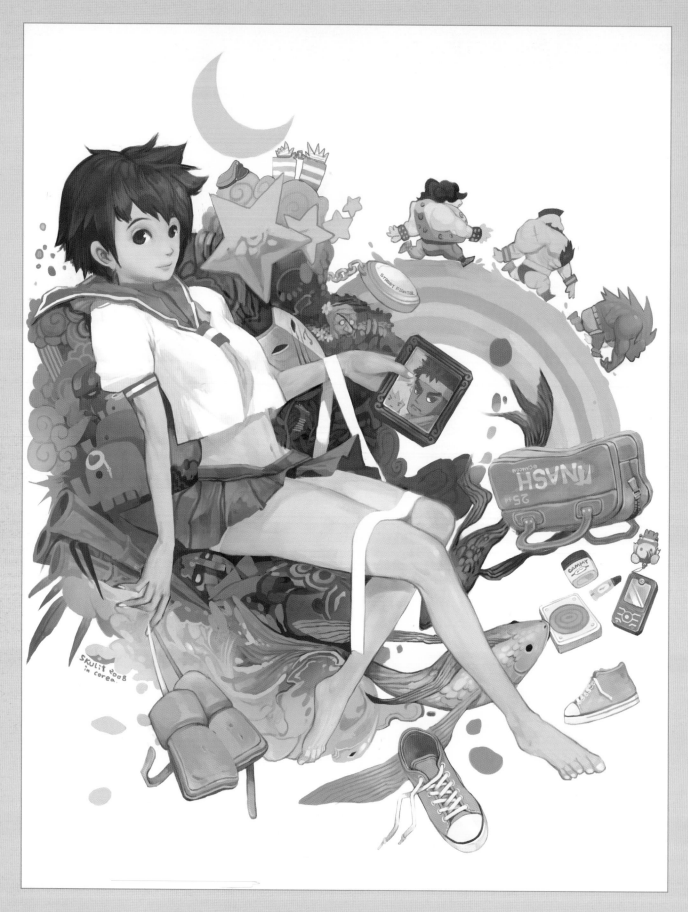

LEE SEUNG-CHAN [SKULIT]
SOUTH KOREA
SKULIT.EGLOOS.COM
CONCEPT ARTIST
[WEBZEN]

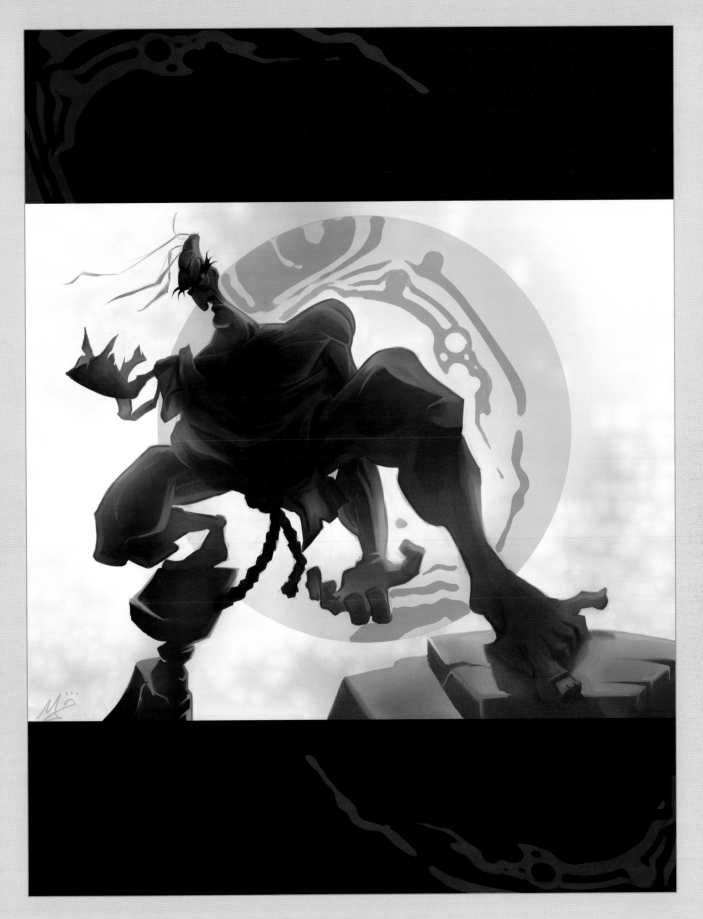

MATT MOCARSKI
ALISO VIEJO, CALIFORNIA, USA
VIDEO GAME ARTIST
[SOUL REAVER, WORLD OF WARCRAFT, DAXTER]
COMIC BOOK CREATOR [CORPORATE NINJA]

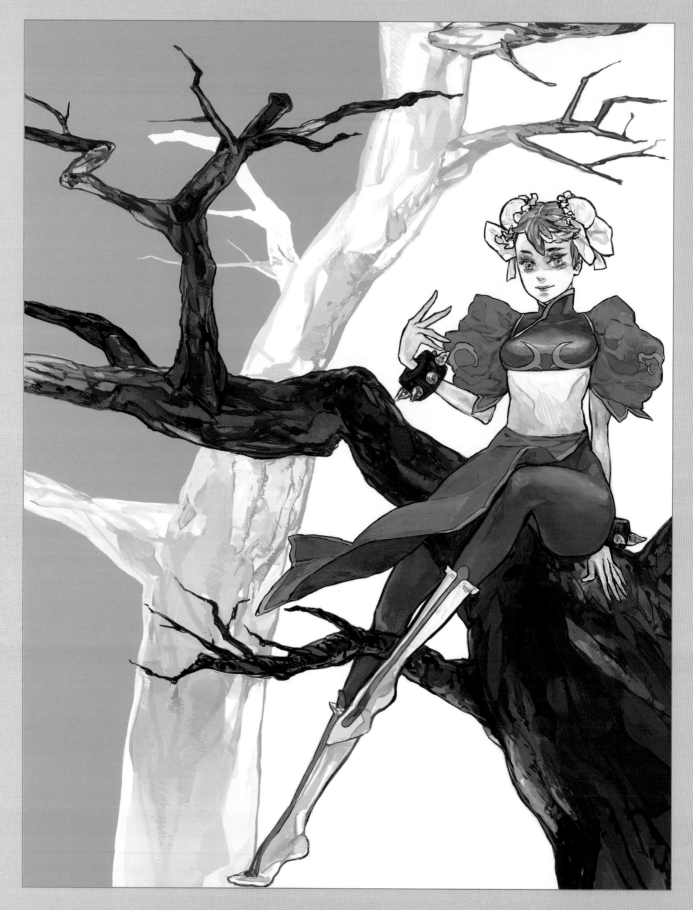

KIKKER
BREMEN, GERMANY

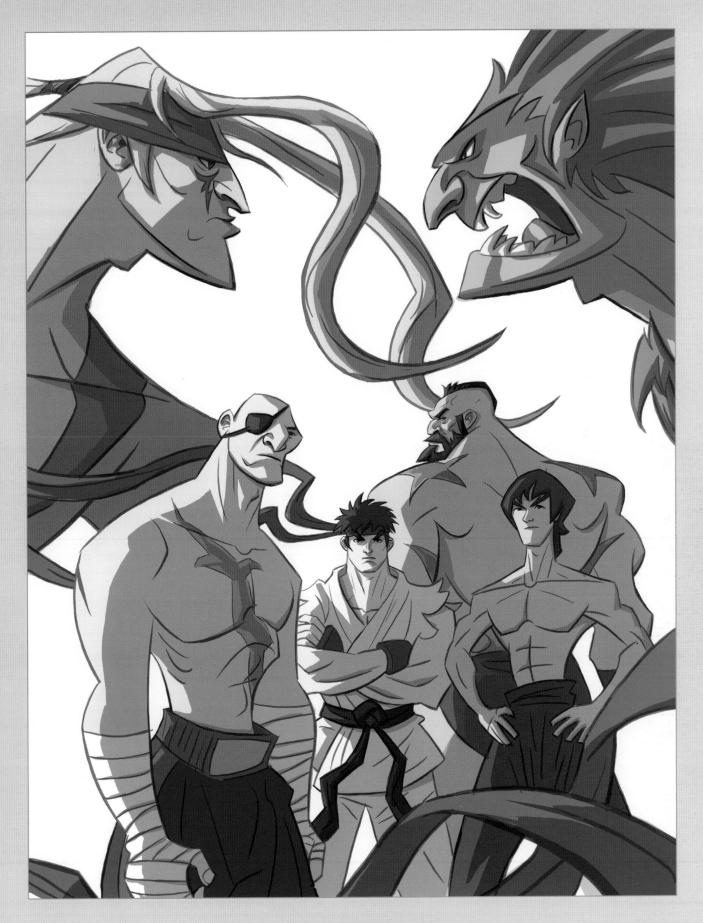

R'JOHN BERNALES
VANCOUVER, BRITISH COLUMBIA, CANADA
RJOHNB.BLOGSPOT.COM
CONCEPT ARTIST

SCOTT HEPBURN

I was a decidedly lazy kid, a chubby, C-level student with a perpetually messy room and very little motivation to change. I liked the idea of beating people up-- it looked pretty satisfying when Daniel-San finally laid a crane kick upside that smug, Cobra Clan, Nazi-Youth-looking jerk face-- but all that fence-painting and car-waxing wasn't really in keeping with my lifestyle.

So when Street Fighter II for Super NES finally arrived, I knew I'd found the perfect outlet. It played to all my strong suits: sitting, watching TV, and swearing under my breath so my mom wouldn't hear.

Thank you, Street Fighter, for giving my 12-year-old self the means to rise above his doughy existence. You were the first to give me something worth fighting for.

Long live Sonic Boom.

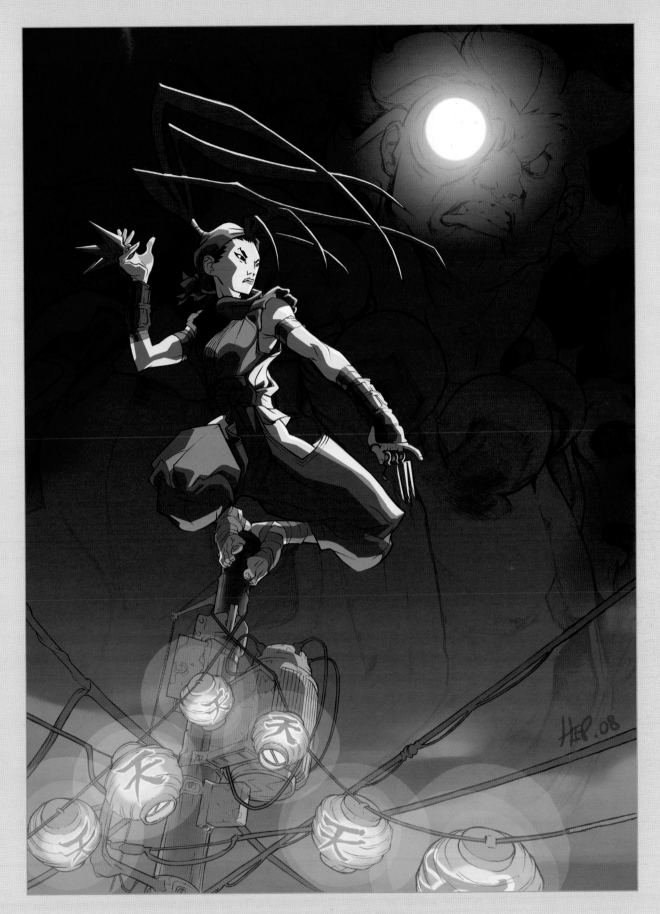

SCOTT HEPBURN
TORONTO, ONTARIO, CANADA
WWW.TRANSMISSION-X.COM
ILLUSTRATOR
[KNIGHTS OF THE OLD REPUBLIC, THE PORT, SENTINEL]

SODOM
STREET FIGHTER ALPHA

ELECTRONICS
CAUTION:
USE ONLY UNDER SUPERVISION
NOT RECOMMENDED FOR CHILDREN

ROOM99
KUALA LUMPUR, MALAYSIA
ROOM-99.BLOGSPOT.COM

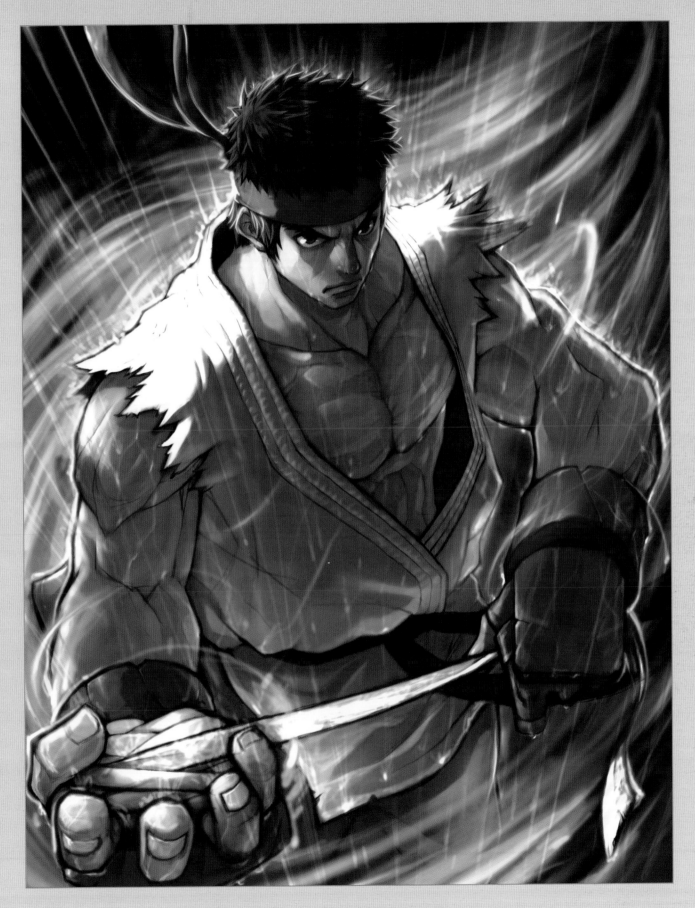

SHIN TAE-HWAN [LENN]
SOUTH KOREA
BLOG.NAVER.COM/HIYASE
ILUSTRATOR
[BARON, DUNGEON & FIGHTER TCG]

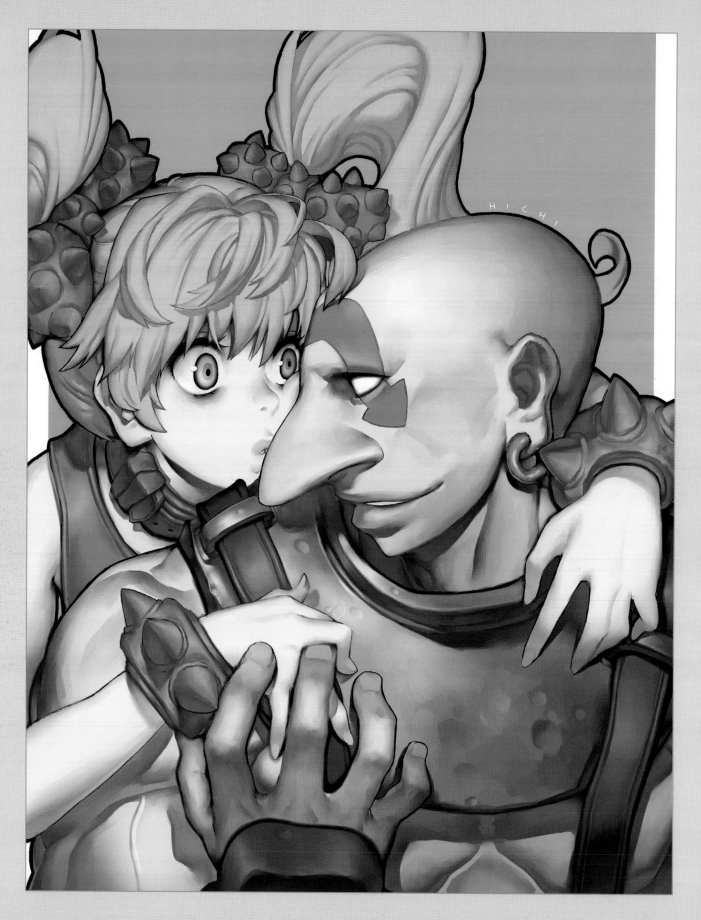

AN HEE-CHEOL [HICHI]
SOUTH KOREA
WWW.HICHIBOX.COM
ILLUSTRATOR
[NCSOFT]

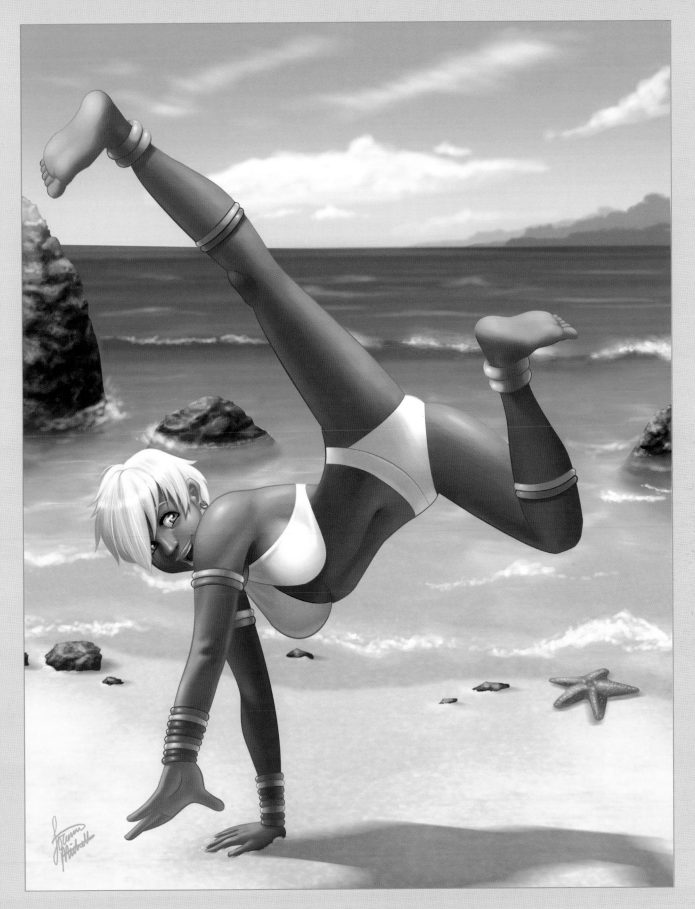

MICHELLE SONEJA
MAKATI CITY, PHILIPPINES
SH3LLY.DEVIANTART.COM
DIGITAL ARTIST

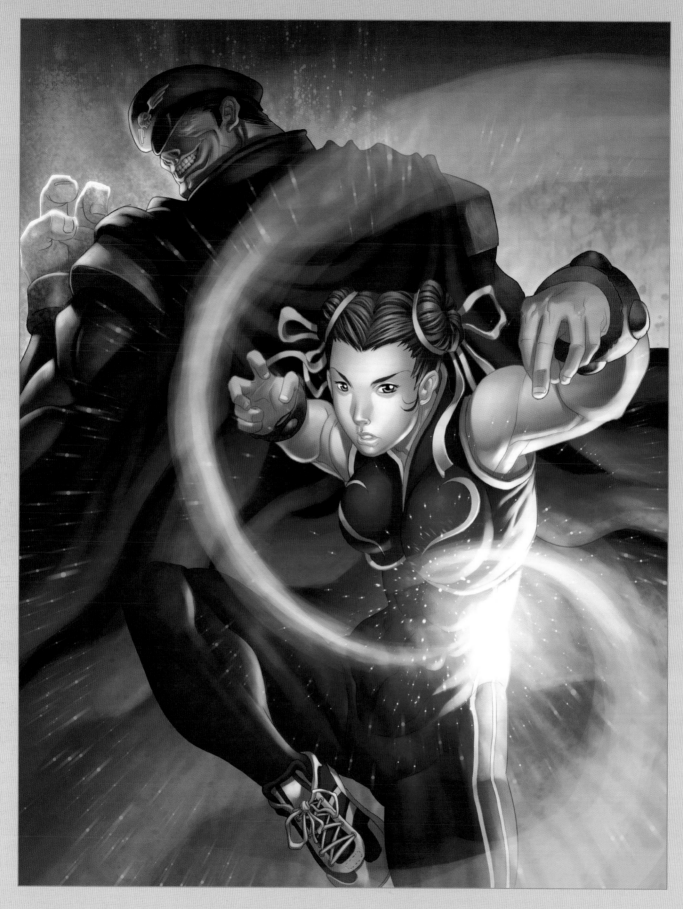

SAMUEL V. DONATO
QUEZON CITY, PHILIPPINES

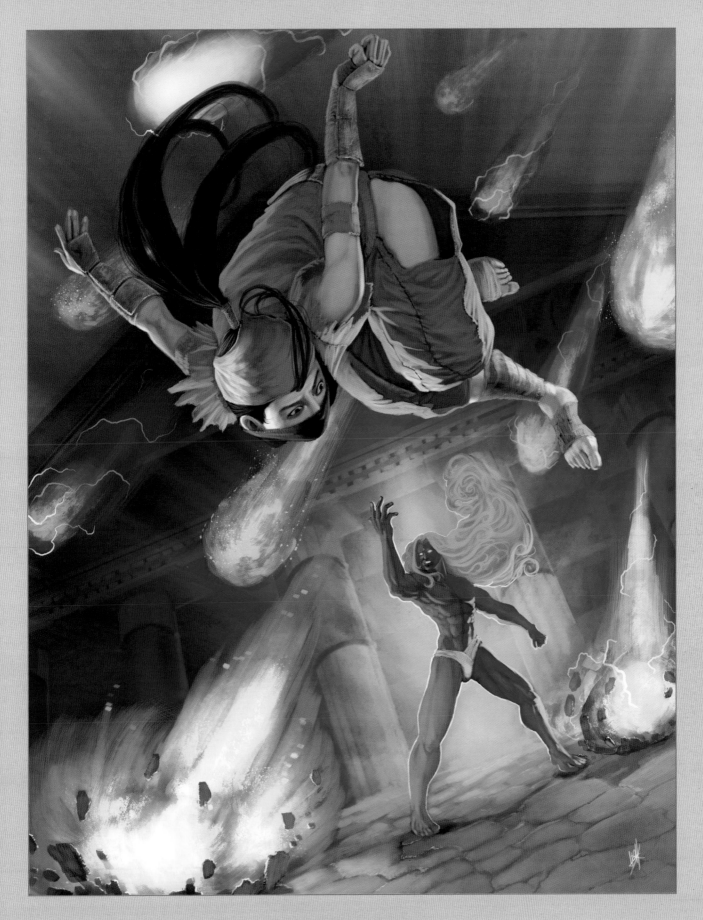

DAN HOWARD
ATLANTA, GEORGIA, USA
KUROITORA.DEVIANTART.COM - WWW.MIASAUTOANDBODY.COM
FREELANCE ILLUSTRATOR

CAMERON STEWART

Like most Street Fighter fans, I was first introduced to the characters in the summer of 1994. Kurt Cobain had performed an ultimate act of self-critique, the planet Jupiter was pummelled by fragments of comet Shoemaker-Levy 9 for six nerve wracking days, and Steven E. de Souza's film "Street Fighter" starring Jean Claude Van Damme shattered box office records worldwide and became a cultural phenomenon. Clamouring for more exciting adventures of Col. William F. Guile and his UN task force, a desperate public demanded a sequel but the untimely death of Raul Julia (who portrayed General M. Bison in a career-defining role) unfortunately halted plans for "Street Fighter II."

In the absence of a proper sequel, a form of outdoor urban combat derived from the film, dubbed "street fighting", swept the nation and hospitals became dangerously overcrowded as broken limbs, concussion and third degree burns rose to epidemic levels. The "street fighting" fad eventually declined in popularity but nearly 15 years later the film retains its visceral power and social relevance, and is a perennial inclusion on critical "Top Ten" lists everywhere.

Supposedly there were some video games too, but I never saw them.

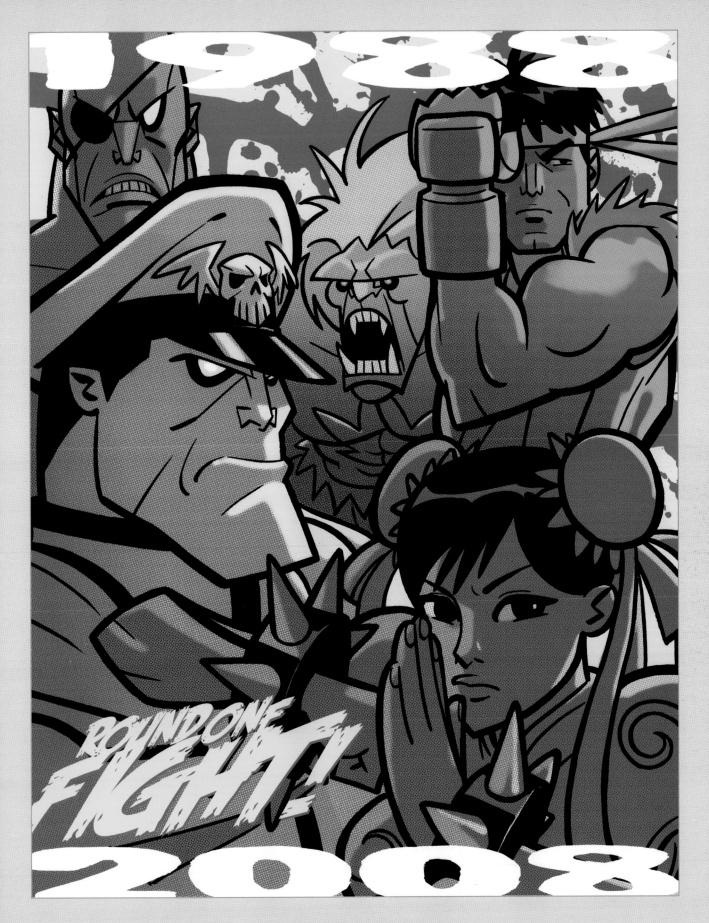

CAMERON STEWART
TORONTO, ONTARIO, CANADA
WWW.CAMERON-STEWART.COM - WWW.SINTITULOCOMIC.COM
COMIC ARTIST
[CATWOMAN, SEAGUY, THE OTHER SIDE, SIN TITULO, THE APOCALIPSTIX]

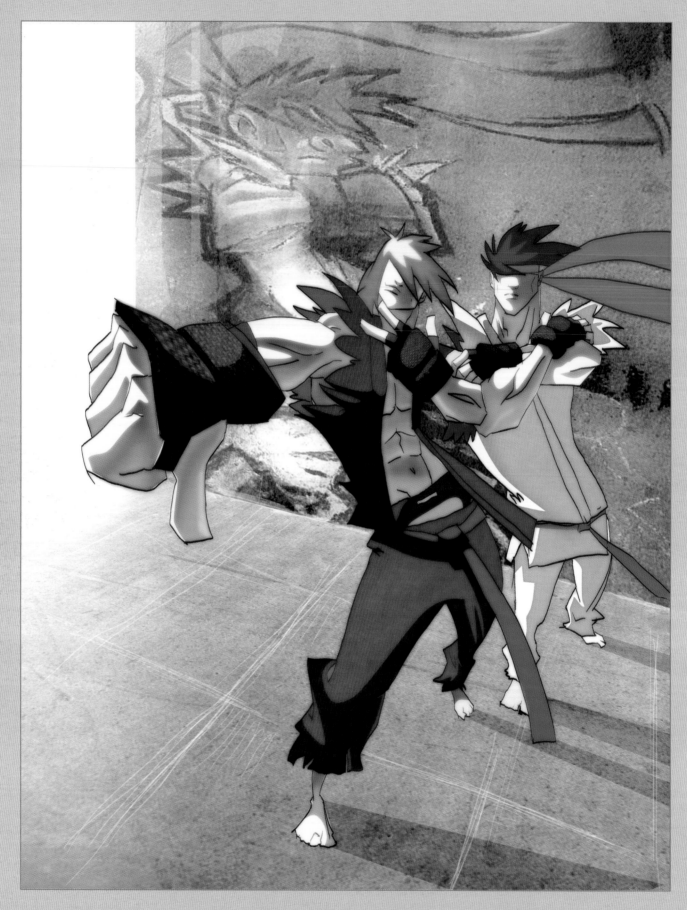

AMÉRICO ANDRADE
SOYA CITY, EL SALVADOR
MEK0.DEVIANTART.COM
FREELANCER

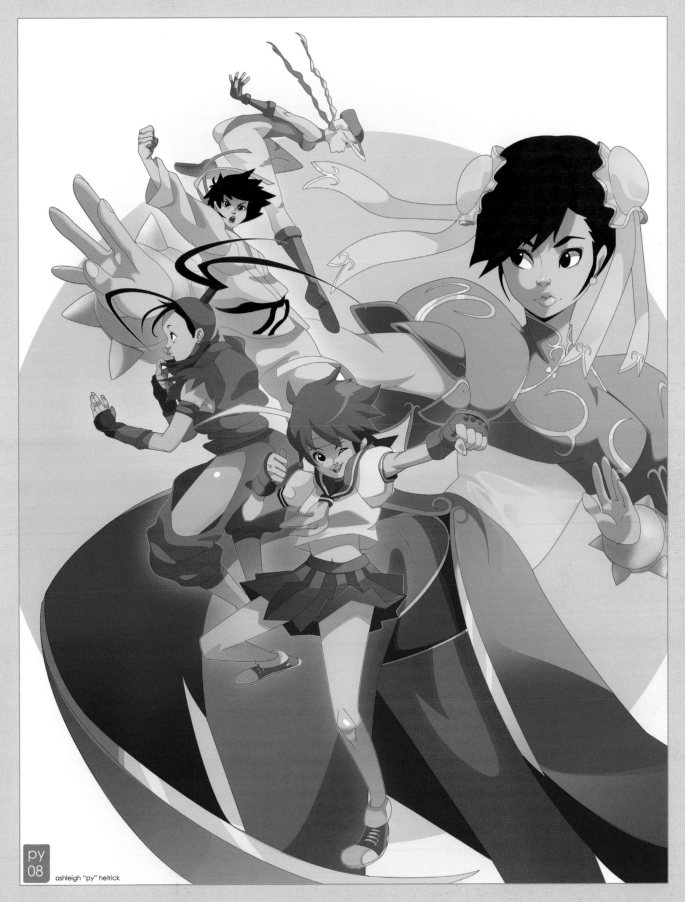

py
08
ashleigh "py" hetrick

ASHLEIGH HETRICK [PY]
WWW.SAISEKI.ORG
ANIMATOR

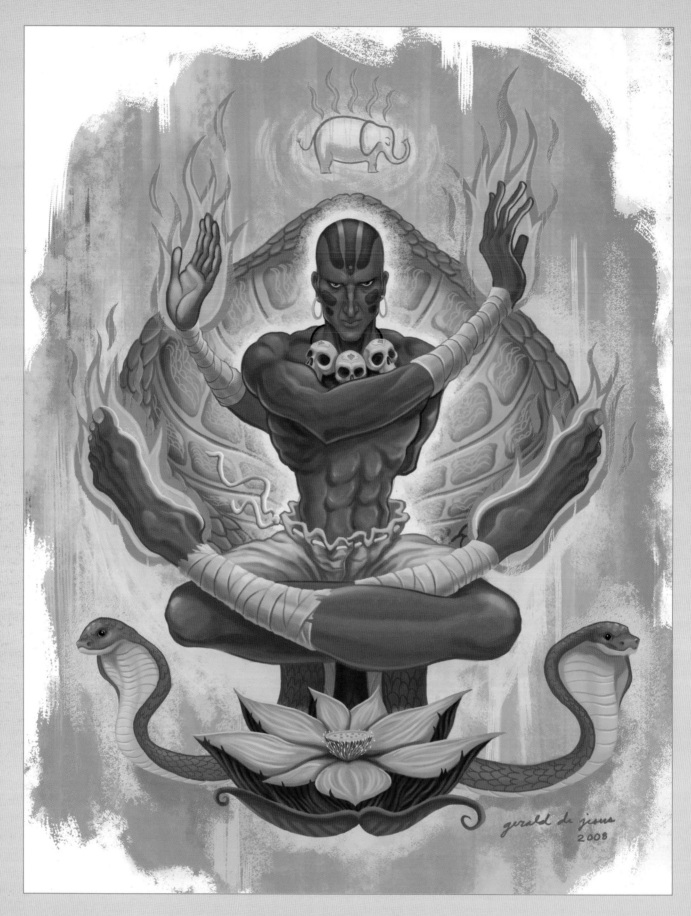

GERALD DE JESUS
GLENDALE, CALIFORNIA, USA
WWW.GERALDDEJESUS.COM
ILLUSTRATOR

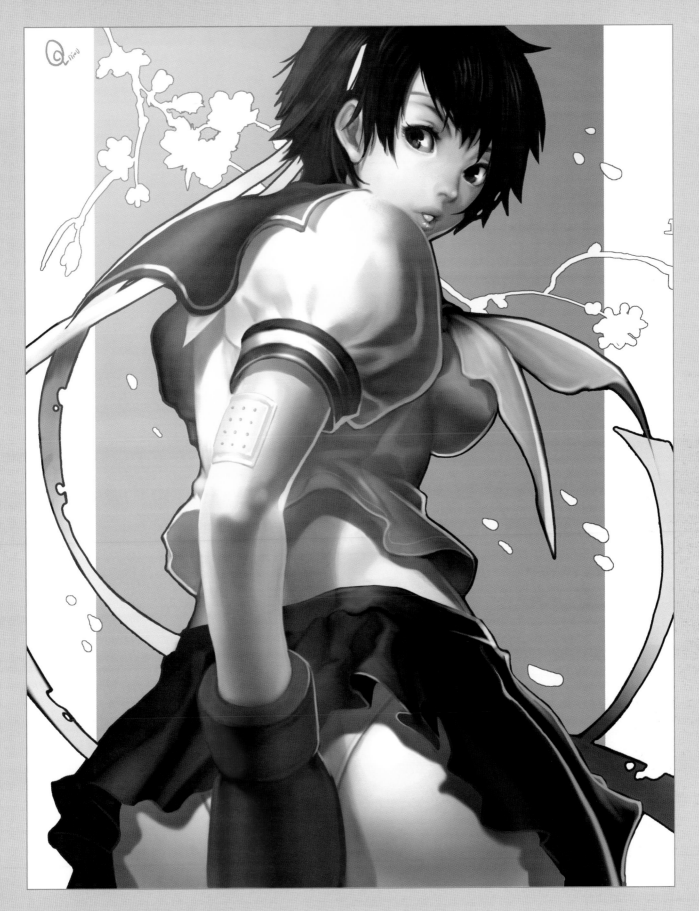

HWANG GEUN-HA [ONIOU]
SOUTH KOREA
BLOG.NAVER.COM/HGHGUY444
ILLUSTRATOR

JEN CHAN

The first time I ever played Street Fighter II, I chose Chun-Li because she was the only girl in the line up at that time.

I still look back upon the memory of my button-mashed victory fondly.

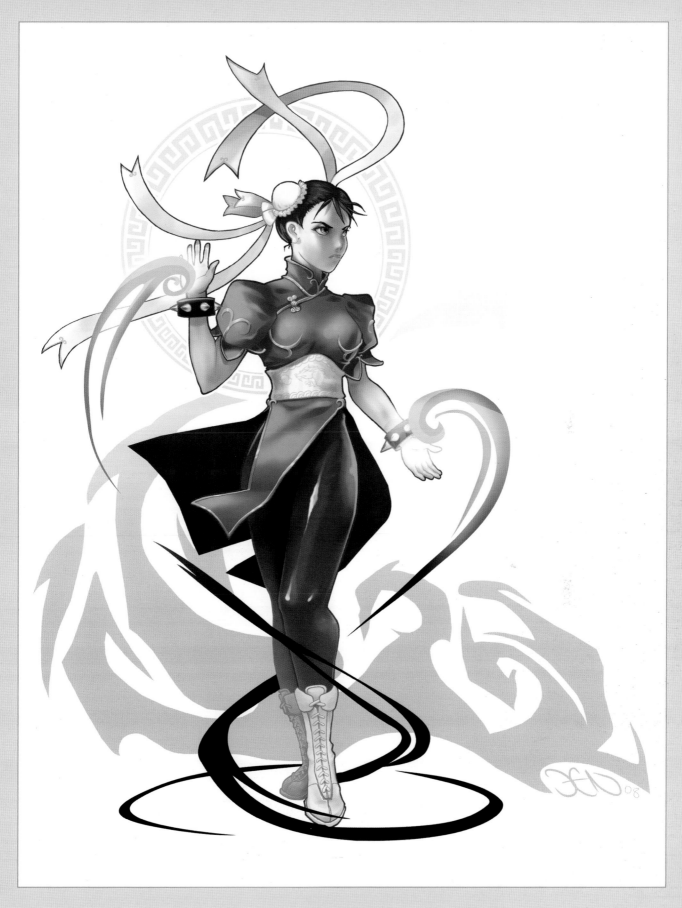

JEN CHAN
TORONTO, ONTARIO, CANADA
WWW.SKRATCH-PAD.COM

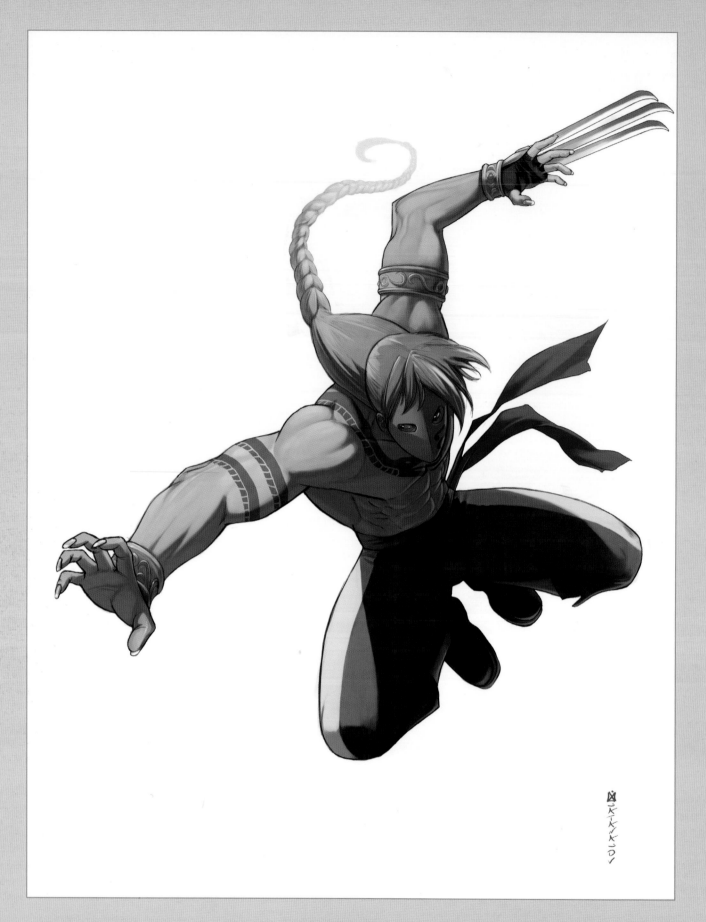

SATANASOV
BULGARIA
WWW.SATANASOV.COM
SATANASOV.DEVIANTART.COM
MANGA-KA

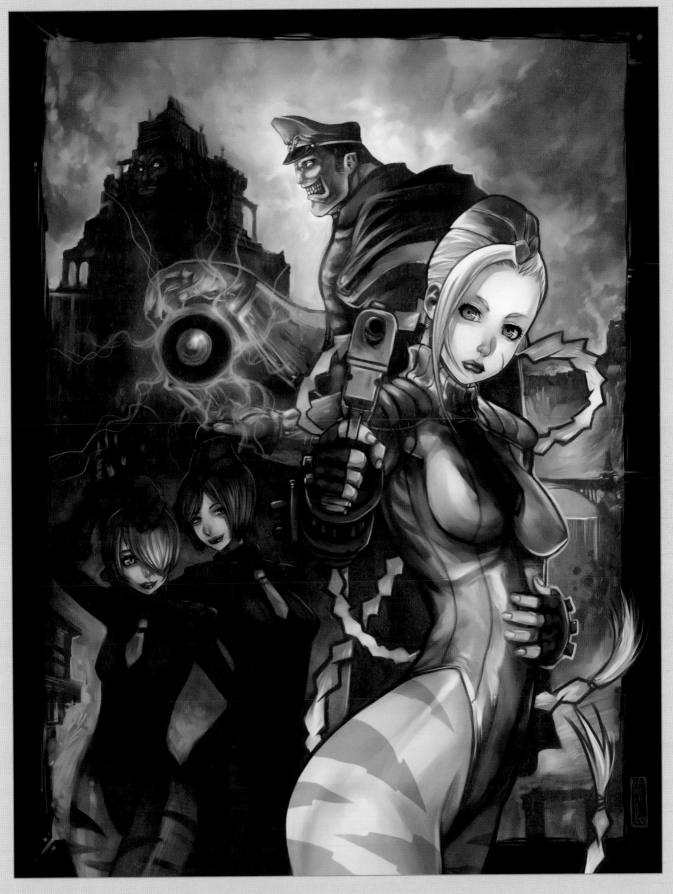

HECTOR SEVILLA LUJAN [ELSEVILLA]
ELSEVILLA.DEVIANTART.COM
ILLUSTRATOR

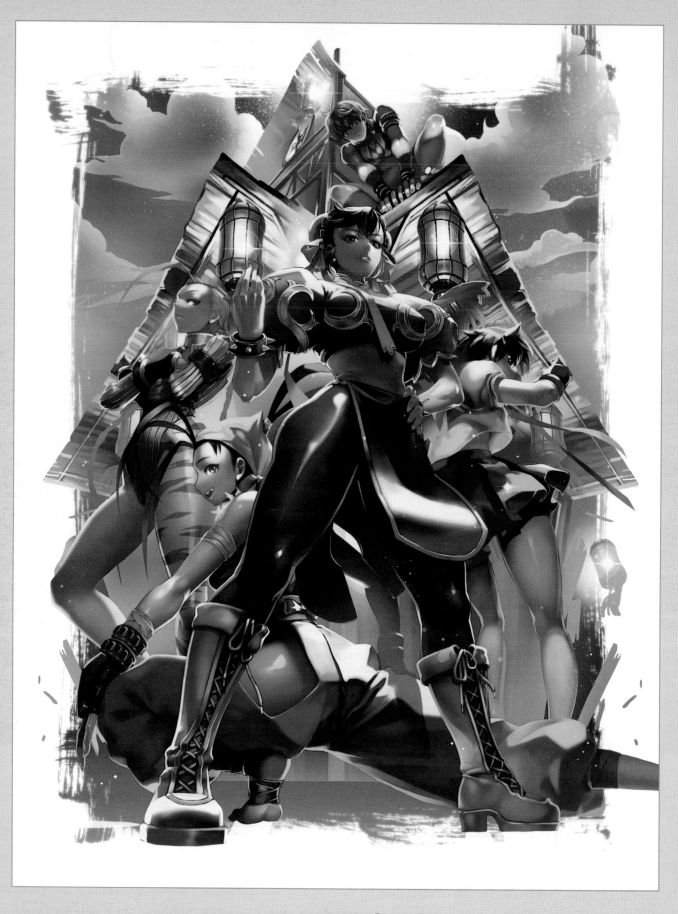

AN SU-JEONG [NOX]
SOUTH KOREA
NOX.NEW21.NET
ILLUSTRATOR

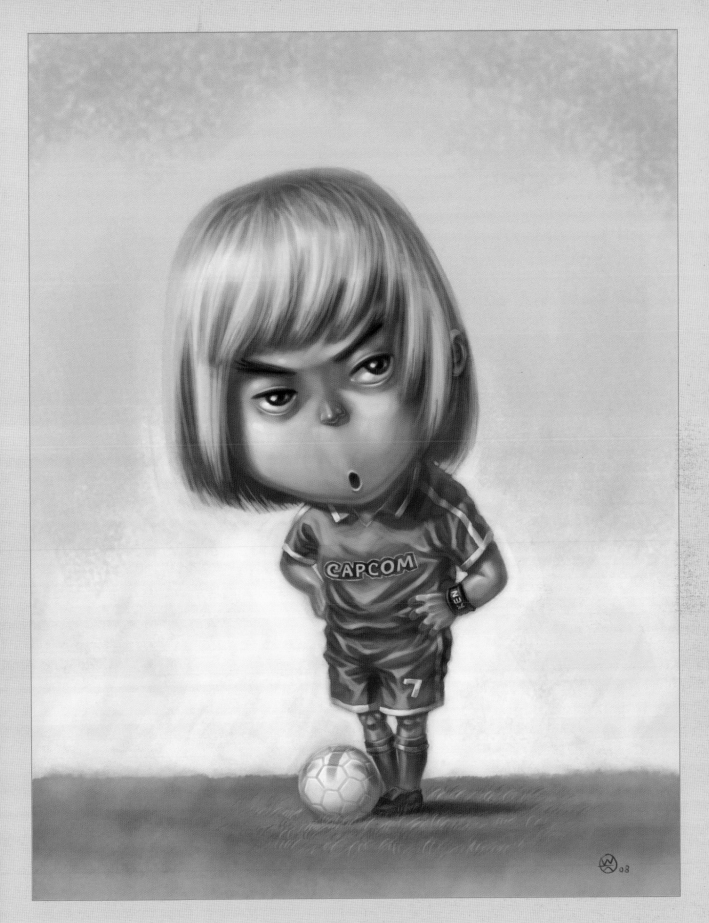

SEAN LEE CHUN HING
KUALA LUMPUR, MALAYSIA
SEANZ.DEVIANTART.COM
ILLUSTRATOR, COMIC COLORIST

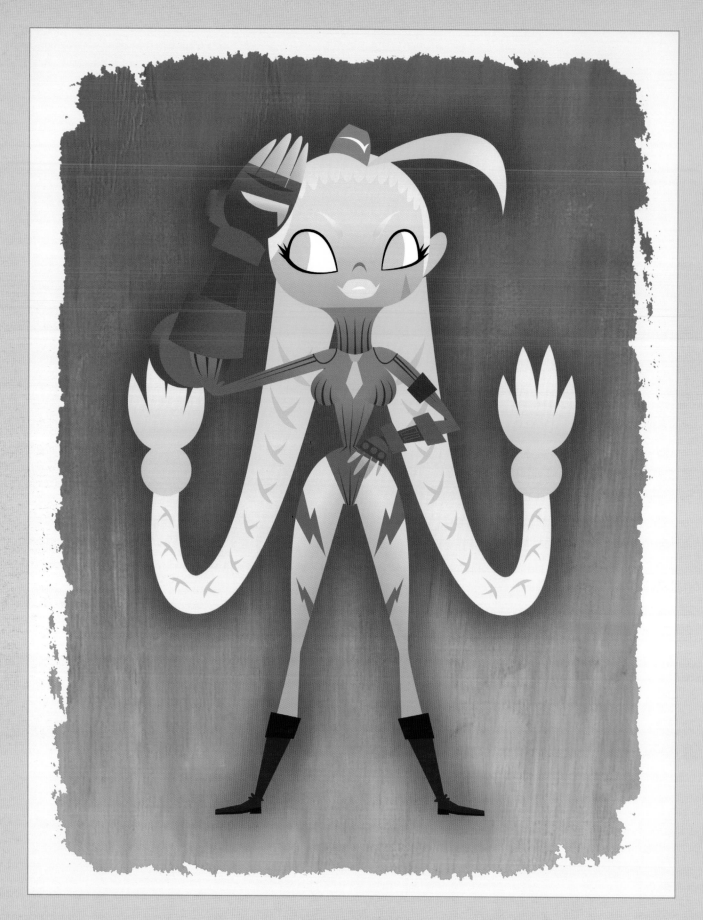

ROBOTSODA
TIJUANA, MEXICO
WWW.ROBOTSODA.COM
ILLUSTRATOR

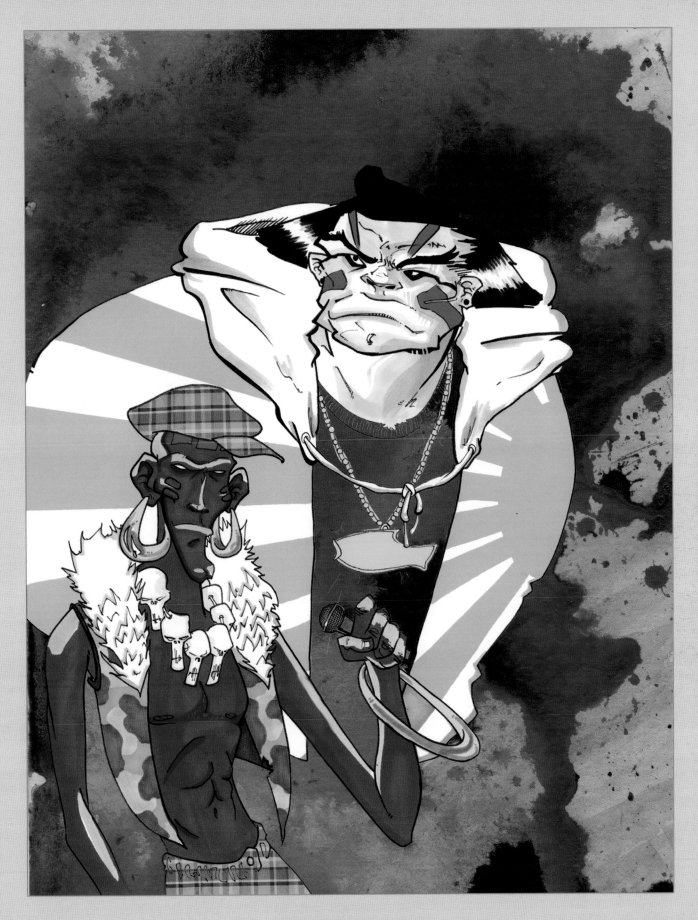

JEREMY NGUYEN
SAVANNAH, GEORGIA, USA
1000WORDS.BLOGSPOT.COM
STUDENT
[SAVANNAH COLLEGE OF ART AND DESIGN]

SAEJIN OH

Anyone who grew up in the 80's can tell you Street Fighter has been a significant part of their life. It definitely was for me. Despite the misconception parents had about arcades at the time, that smoky, dark room glittering with cathode ray-tubes and faint echoes of Ryu's Hadoken was nothing short of a wonder. Countless hours and coins were spent to prolong that ecstasy. Rivalry was born and victors arose. Kids, at their best attempt to emulate their favorite game, shouted countless variations of the hero's war cry (most notoriously Hurricane Kick and Sonic Boom) usually accompanied with poorly mimicked hand gestures (some got creative as to finding a suitable object to propel at the time of impact).

I still remember the incredible feeling of seeing M. Bison as a selectable character for the first time in Champion Edition and recal being deeply annoyed by my friend's overly skilful use of Skullomania. I still ponder what caused a man to perform a move like the Indra Bash (I always attributed its effects to some kind of hallucination caused by pharmaceutical products) and feel overwhelmed with glee when I successfully land a Shinryuken.

Arcades came and went. Now, the only place we can see our favorite game is in our living room. It's not quite the same, I know. But the wonderful memories of Street Fighter will be with us for the rest of our lives.

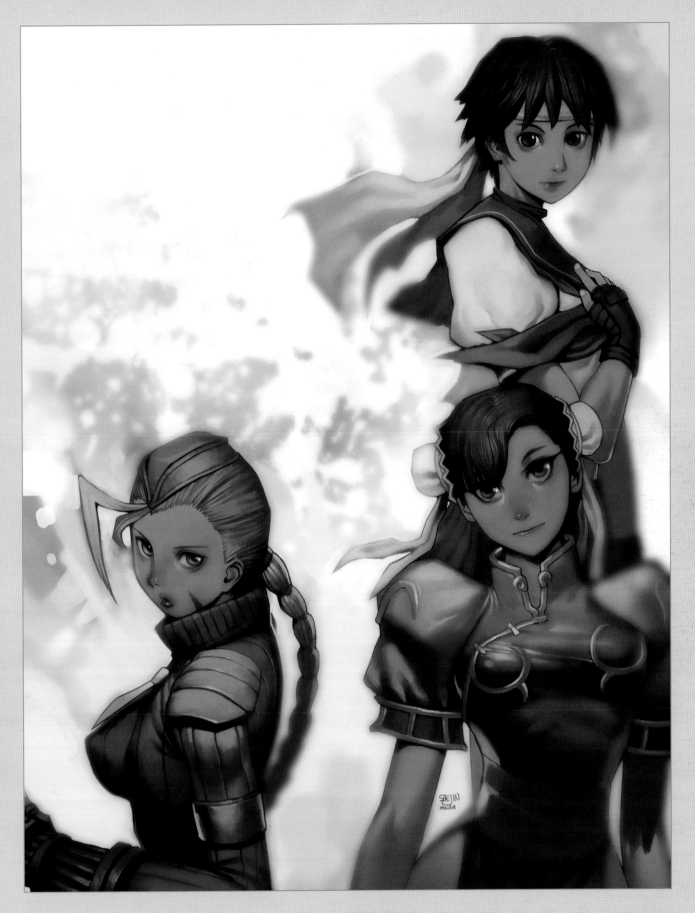

SAEJIN OH
TORONTO, ONTARIO, CANADA
SAEJINOH.DEVIANTART.COM
ILLUSTRATOR
[UDON- DUNGEONS & DRAGONS, EXALTED, STAR WARS RPG]

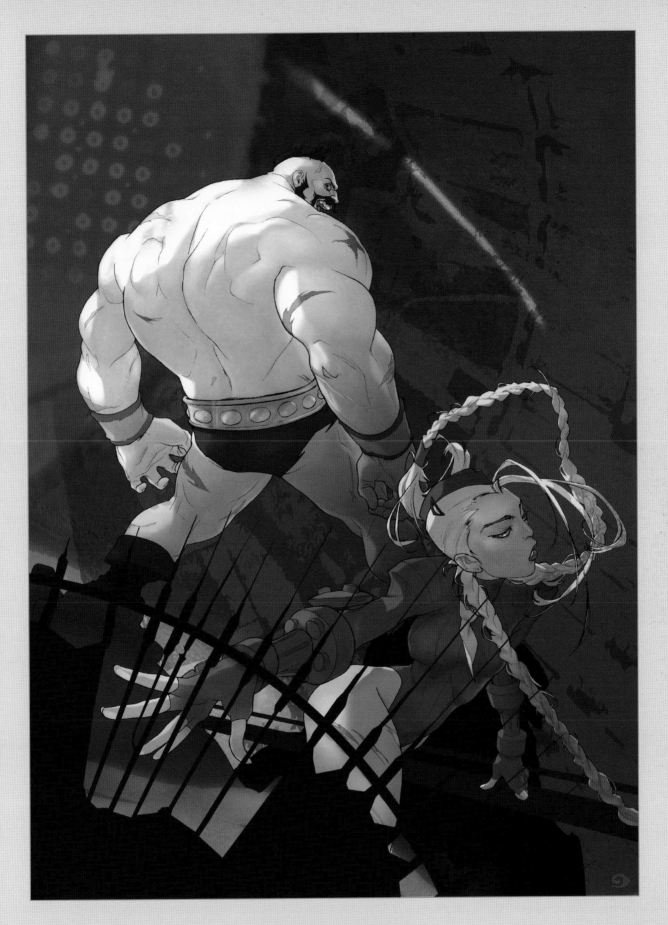

ALINA URUSOV
TORONTO, ONTARIO, CANADA
CLOUDYPOOL.BLOGSPOT.COM
COMIC ARTIST
[WONDERLOST, YOUNG AVENGERS]

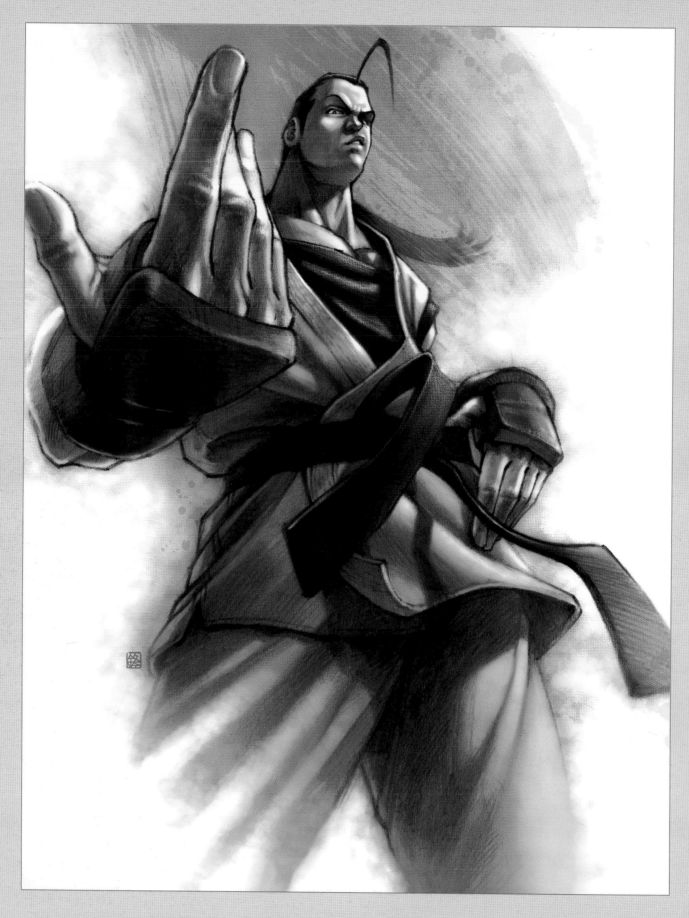

WANG LIANG FENG
KUALA LUMPUR, MALAYSIA
WLFENG.DEVIANTART.COM
ILLUSTRATOR

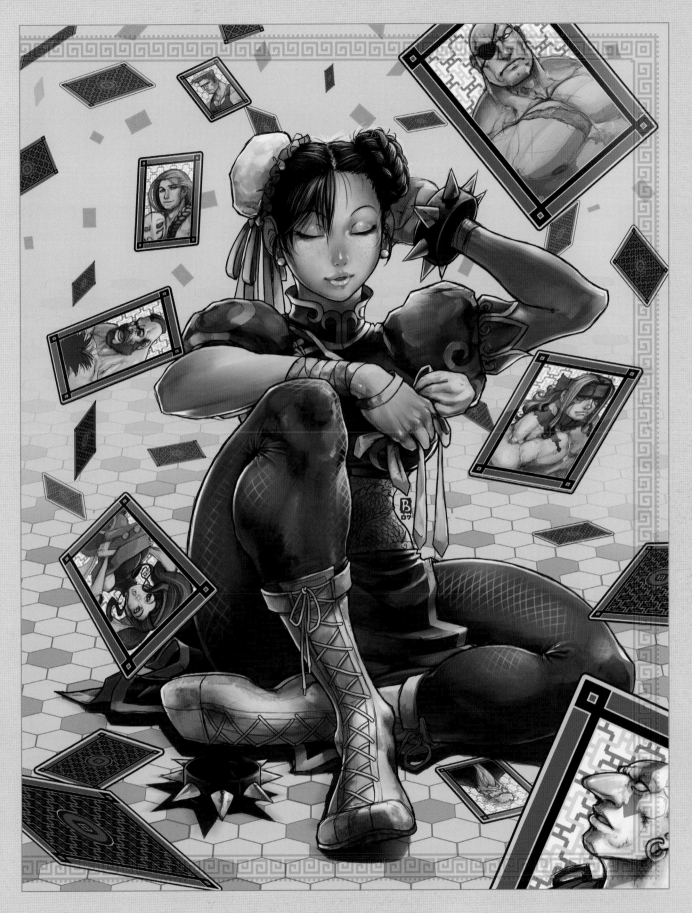

FELIPE GALLARDO
CALI, COLOMBIA
BLUEBERSERKER.DEVIANTART.COM
ILLUSTRATOR

GABE

Street Fighter was actually an important game in my life - Obviously it was one I played a lot of but beyond just enjoying the game, it was one of the first that really inspired me artistically.

As a young man I used to spend hours pouring over the illustrations in the manuals for Street Fighter II Turbo, and this was back when Anime was still called Japanimation and most people had no idea what it was. The manuals that came with the Street Fighter games provided me with an artistic counterpoint to all the American comic books I was reading at the time, and I had simply never seen anything like it before and it just blew me away. To me the manuals for these games and the artwork they contained represented a door to a secret world of art that no one else knew about. While my friends were drawing Superman and Batman I was drawing Ken and Ryu.

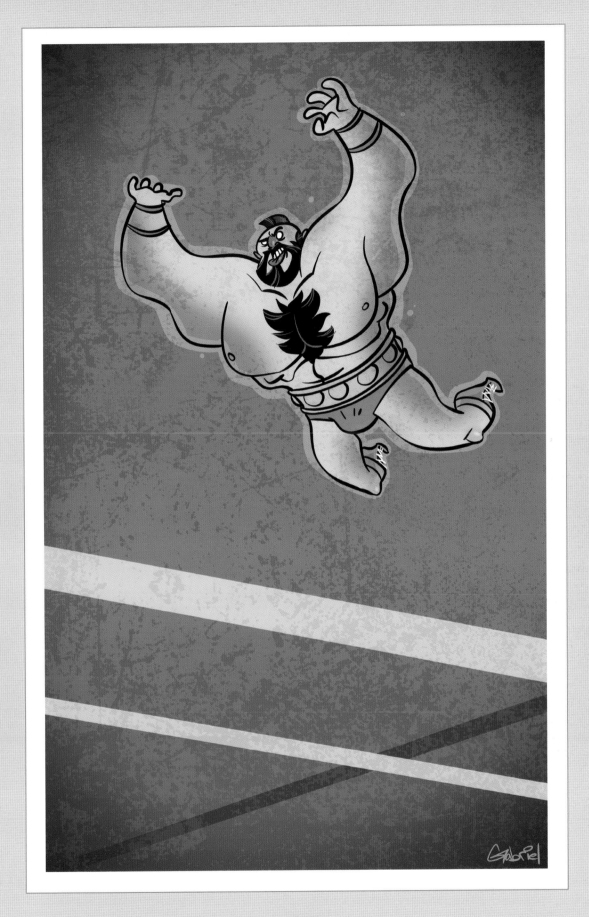

GABE
SEATTLE, WASHINGTON, USA
WWW.PENNY-ARCADE.COM
CARTOONIST
[PENNY ARCADE]

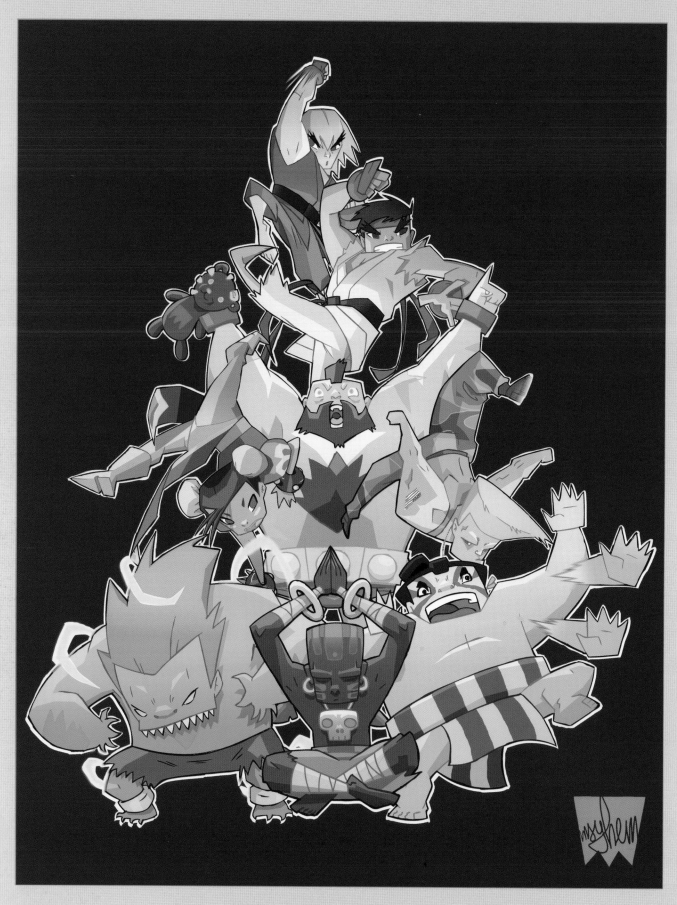

MAY WA LENG [MAYHEM]
SYDNEY, AUSTRALIA
VOTEMAYHEM.BLOGSPOT.COM
CONCEPT/CHARACTER DESIGNER, ANIMATOR
[DISNEYTOON STUDIOS SYDNEY, STUDIO B VANCOUVER, SNEAKER FREAKER MELBOURNE]

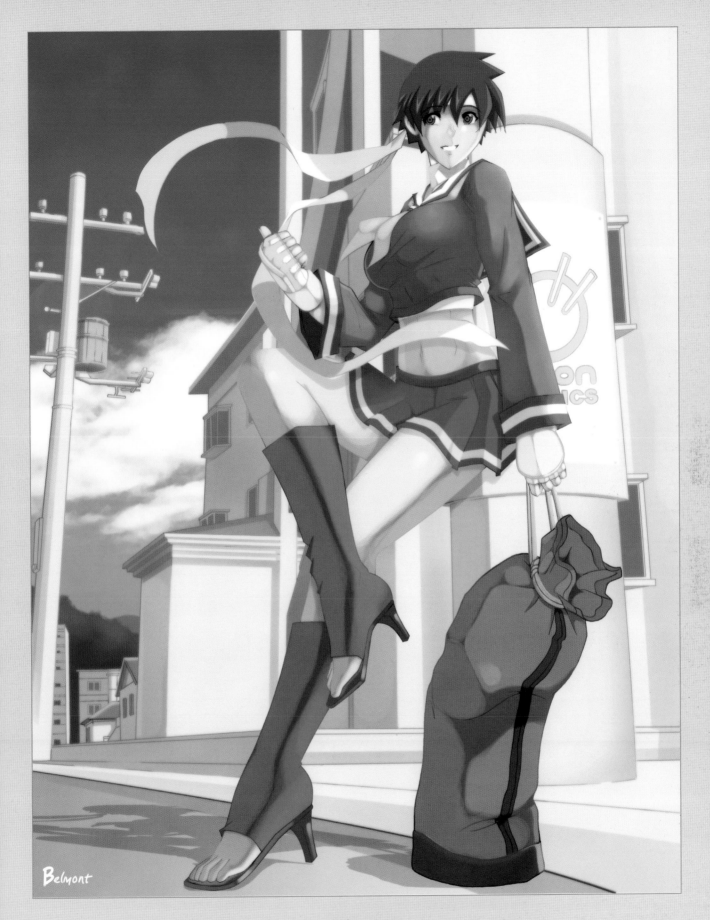

JL BELMONT
DF. MEXICO.
JOSELUISBELMONT.DEVIANTART.COM
CONCEPT ARTIST / CHARACTER DESIGNER [EVOGA/PLAYMORE- RAGE OF THE DRAGON]
COMIC & MAGAZINE ILLUSTRATOR

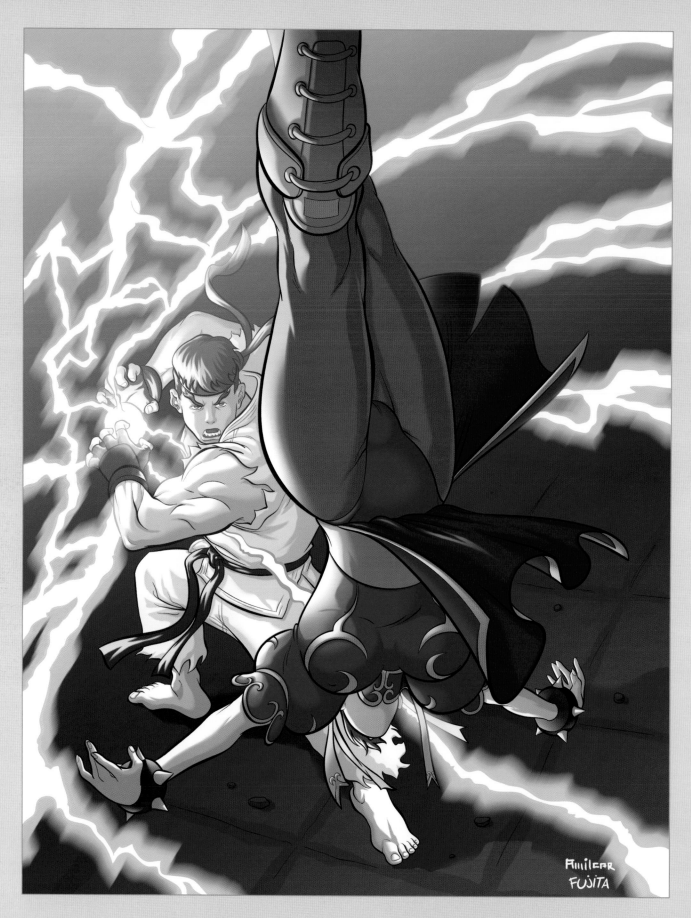

AMILCAR PINNA
SAO PAULO, BRAZIL
WWW.AMILCARPINNA.BLOGSPOT.COM
COMIC ARTIST

ARTUR FUJITA
SAO PAULO, BRAZIL
WWW.ARTURFUJITA.BLOGSPOT.COM
COMIC ARTIST

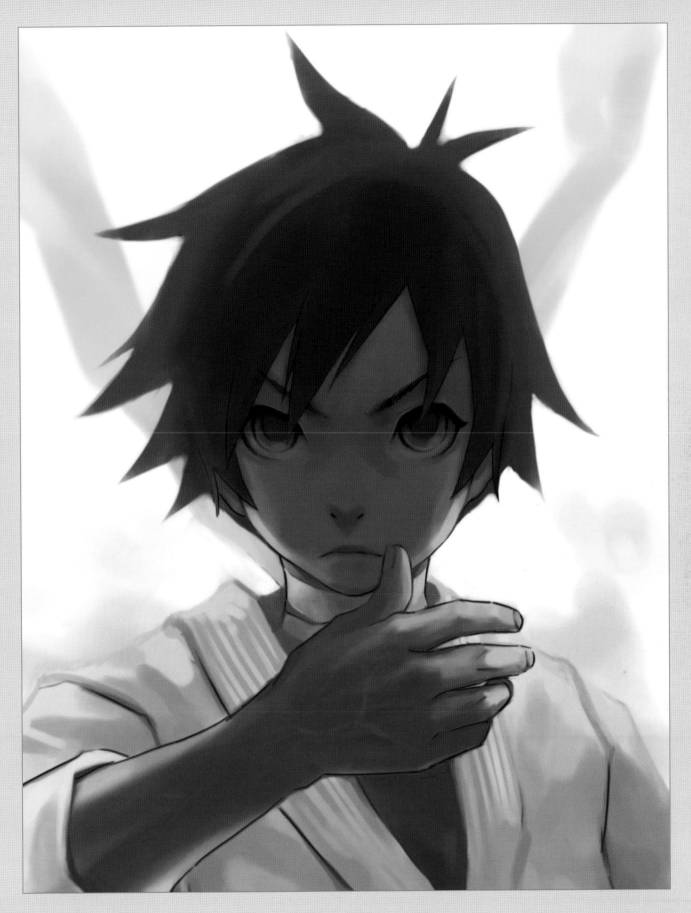

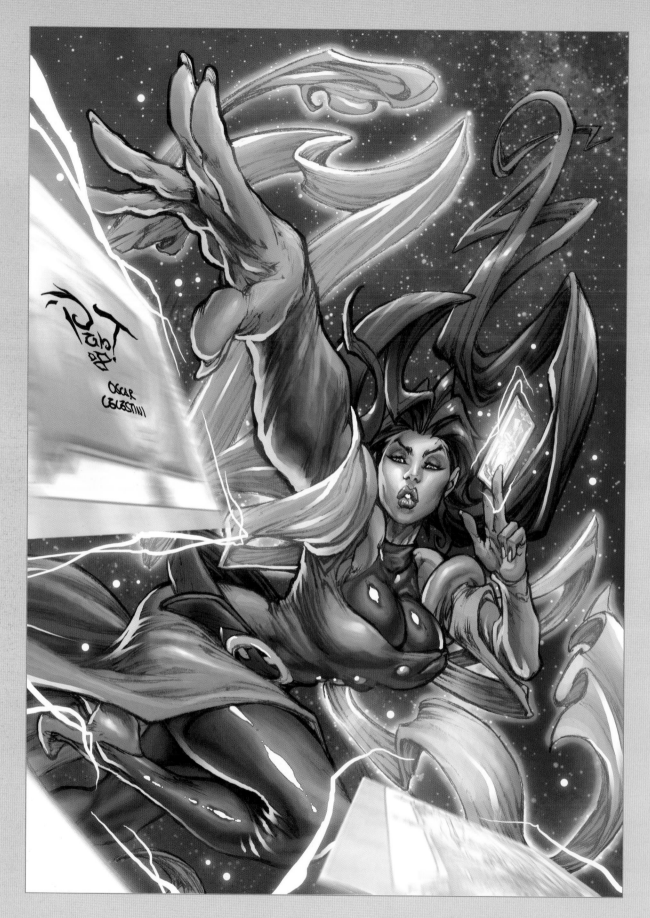

PAOLO PANTALENA
SALERNO, ITALY
PAOLOPANTALENA.BLOGSPOT.COM
PANT.DEVIANTART.COM
PENCILER
[ZENESCOPE ENTERTAINMENT'S 1001 ARABIAN NIGHTS]

OSCAR CELESTINI
COLORIST

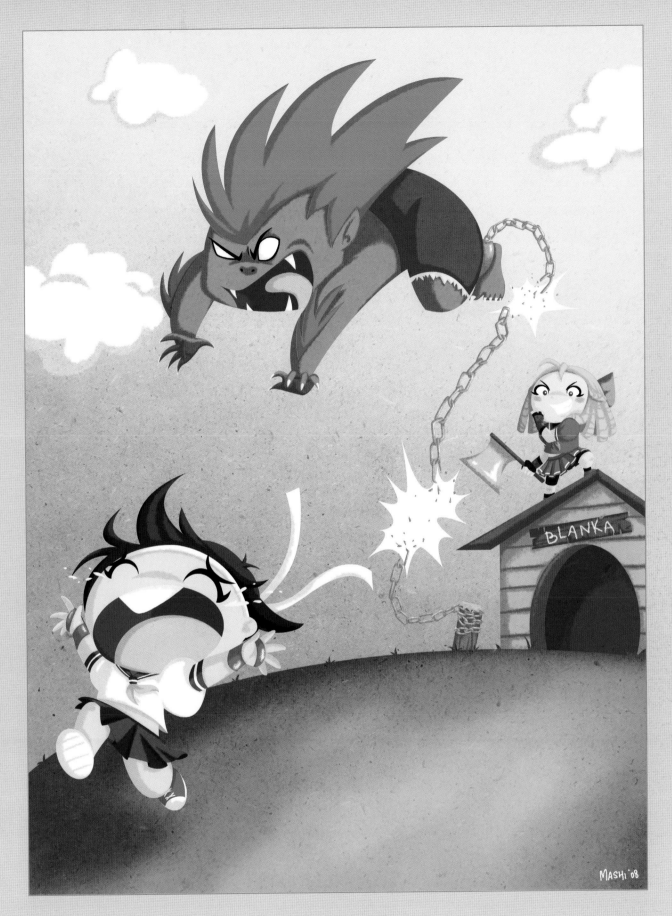

WENDY CHEW
SINGAPORE
MASHI.DEVIANTART.COM
FREELANCE ILLUSTRATOR

ADAM VEHIGE

When Street Fighter II first came to the arcades I was just a young boy. At the time it was the coolest game ever made... crowds would gather around to watch and play! I remember riding my bike for miles to the local QuickTrip so I could spend time with it. I have fond memories of hours spent in the gas station with microwave burritos and Blanka. He was my favorite by far, out of a cast of humans he was the only real "monster". For a beginner he was my first choice, I loved his devastating heavy attacks; his special moves were so easy to pull off, all you had to do was tap the button fast for lightning.

I wanted to capture Blanka's animal ferocity and power with this piece.

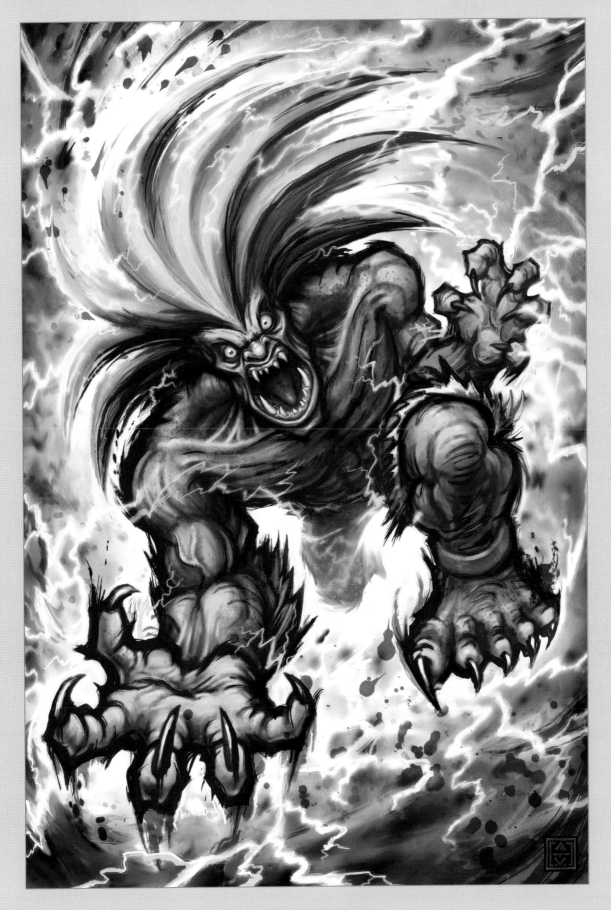

ADAM VEHIGE
WASHINGTON, MISSOURI, USA
VEGASMIKE.DEVIANTART.COM
FREELANCE ILLUSTRATOR

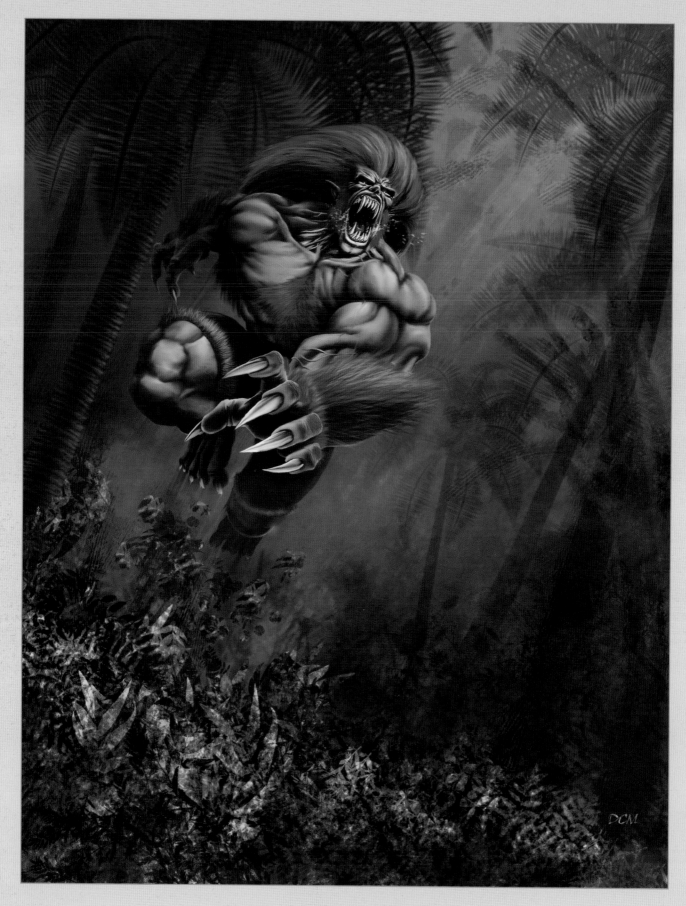

DANIEL CASTELLÓ MUÑIZ
BISCAY, SPAIN
WWW.DCM-ILUSTRADOR.ES
ILLUSTRATOR / CONCEPT ARTIST / GRAPHIC DESIGNER

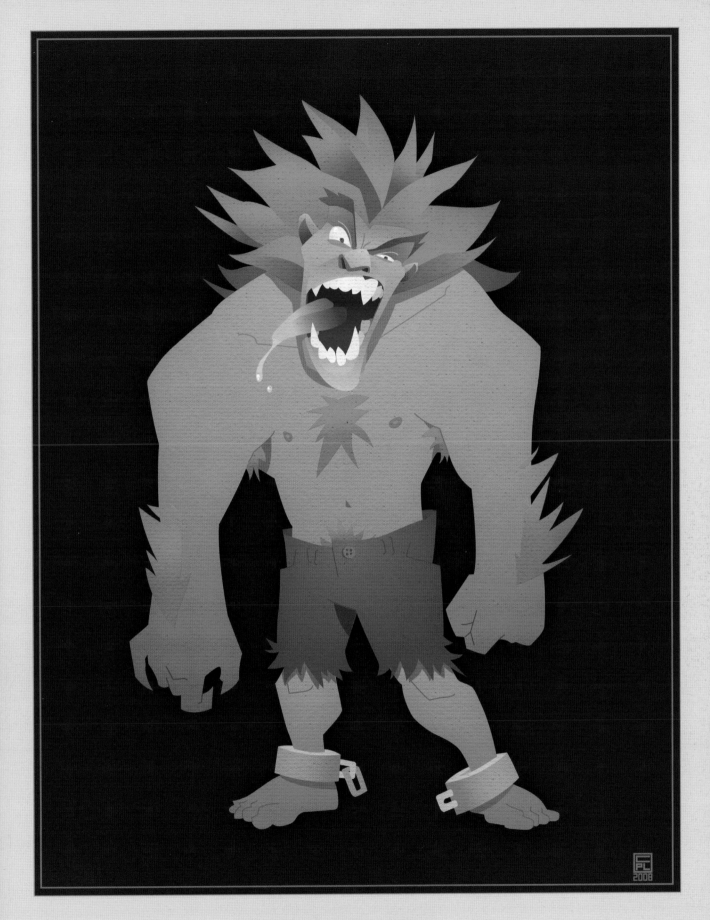

CHARLIE LAYTON
PHILADELPHIA, PENNSYLVANIA, USA
WWW.CHARLIELAYTON.COM

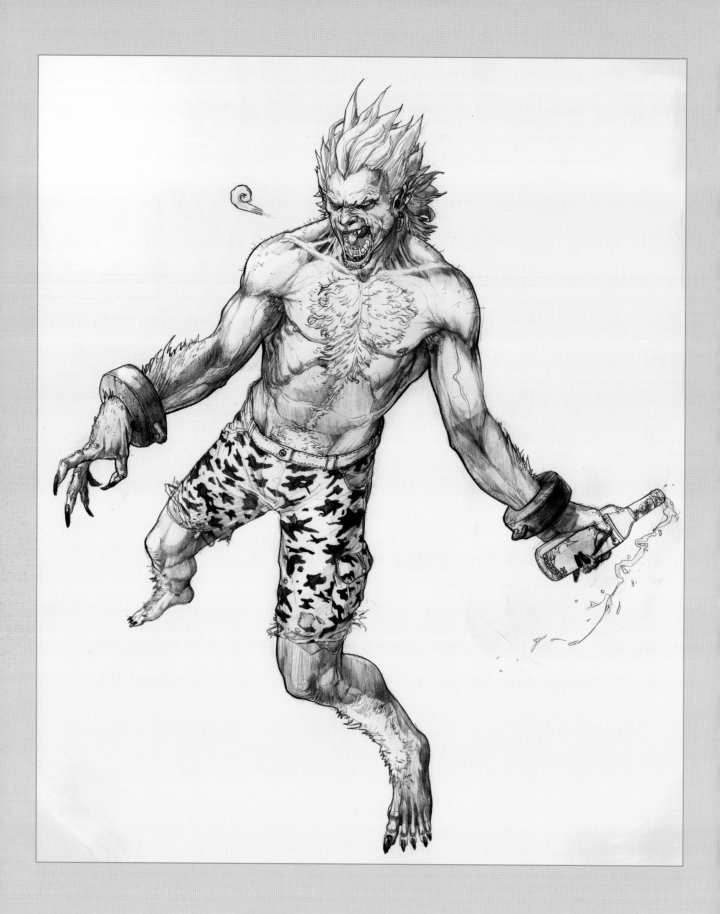

ALEXANDER PASCENKO
GERMANY
COROFLOT.COM/ALEXXX
CHARACTER DESIGNER

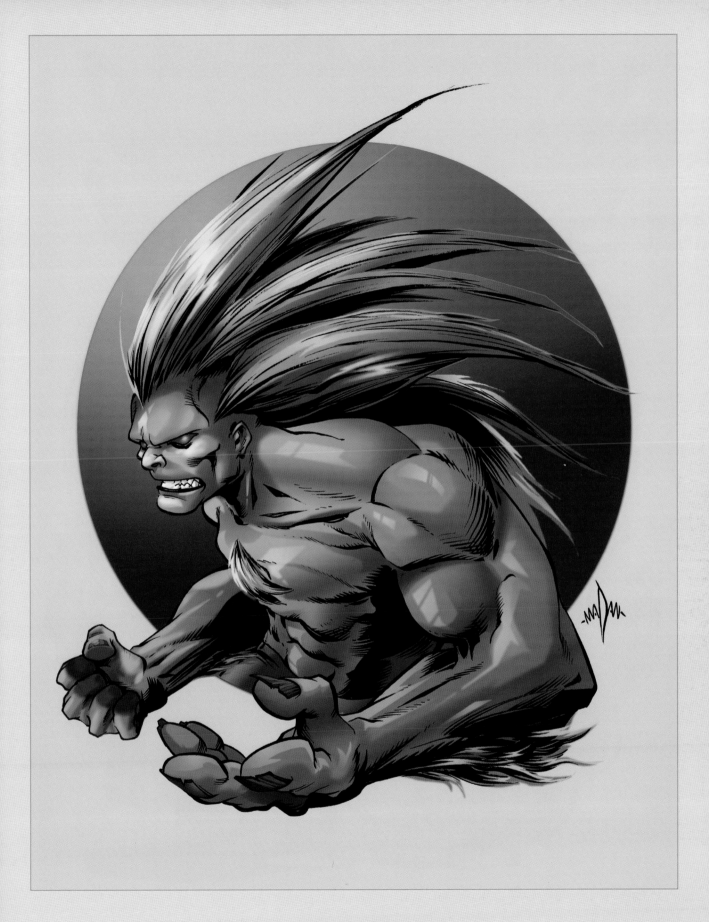

DEV MADAN
SEATTLE, WASHINGTON, USA
ILLUSTRATOR

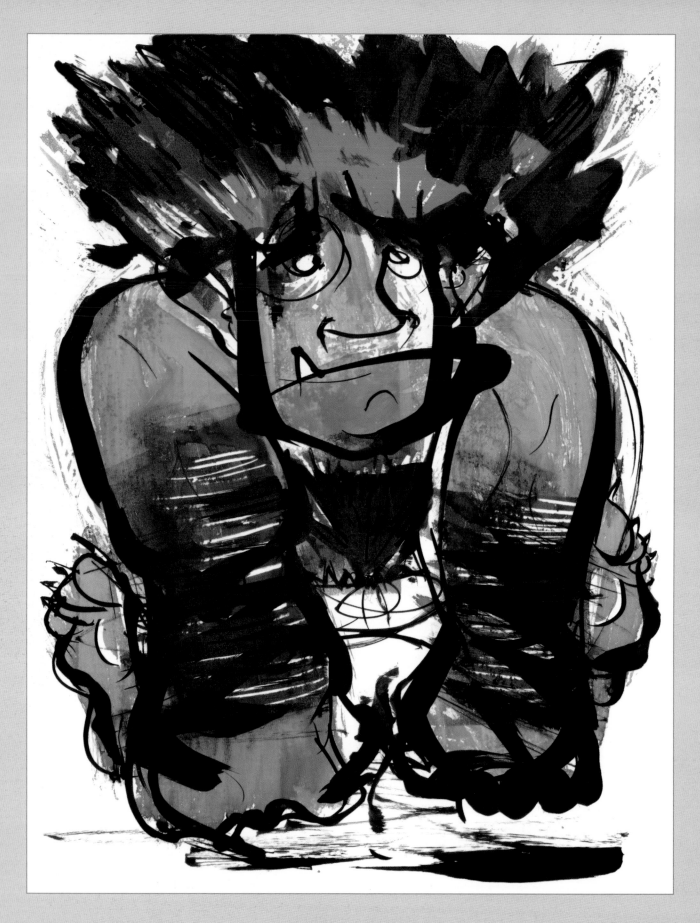

CHAD COVINO
WILLIAMSTOWN, VERMONT, USA
WWW.CHADCOVINO.COM
ILLUSTRATOR

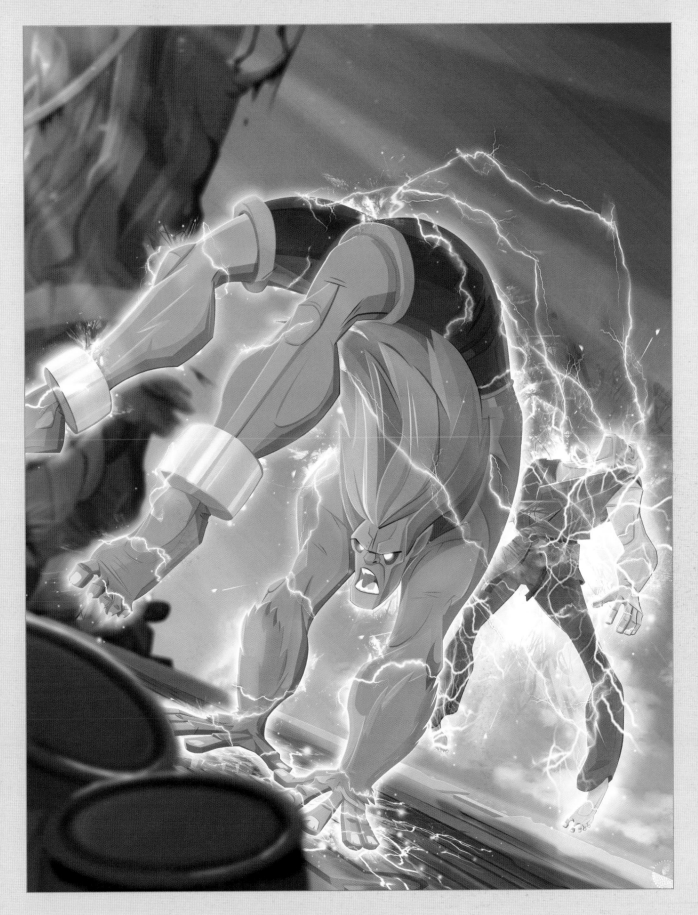

"DAPPER" DAN SCHOENING
VICY, BRITISH COLUMBIA, CANADA
DAPPERDANS.BLOGSPOT.COM
ANIMATOR/ILLUSTRATOR
[DC COMICS, MONSTEROLOGY]

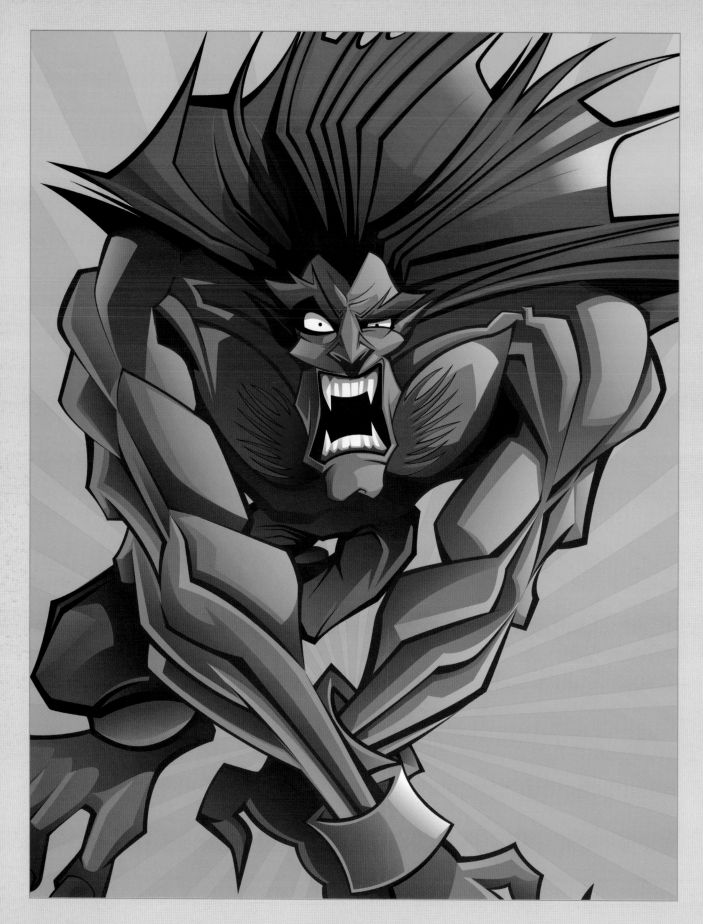

CRISVECTOR
SÃO PAULO, BRAZIL
WWW.CRISVECTOR.COM

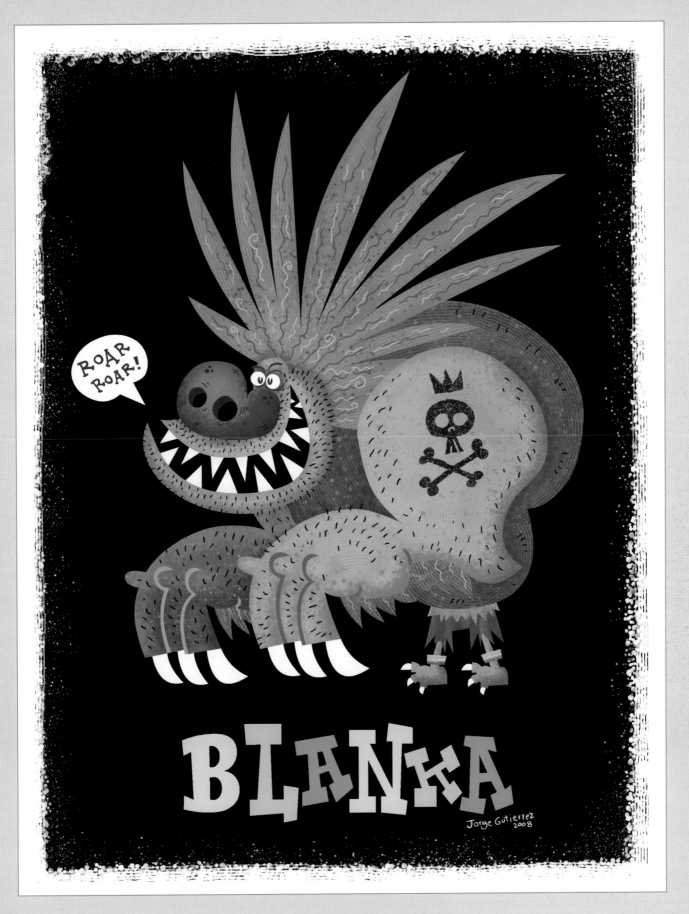

JORGE R. GUTIERREZ
TIJUANA, MEXICO
WWW.SUPER-MACHO.COM
CREATOR
[EL TIGRE, THE ADVENTURES OF MANNY RIVERA FOR NICKELODEON]

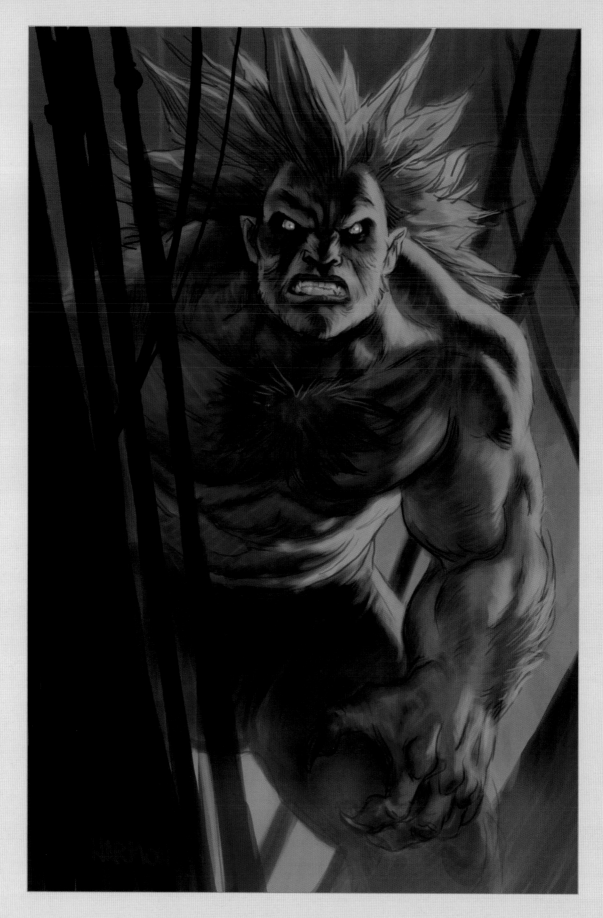

PAUL HARMON
LOS ANGELES, CALIFORNIA, USA
WWW.DOGMEATSAUSAGE.COM - DOGMEATSAUSAGE.BLOGSPOT.COM
COMIC ARTIST [MORA, FLIGHT, TALES OF TMNT]
ANIMATION ARTIST [HELLBOY ANIMATED, SPECTACULAR SPIDER-MAN]

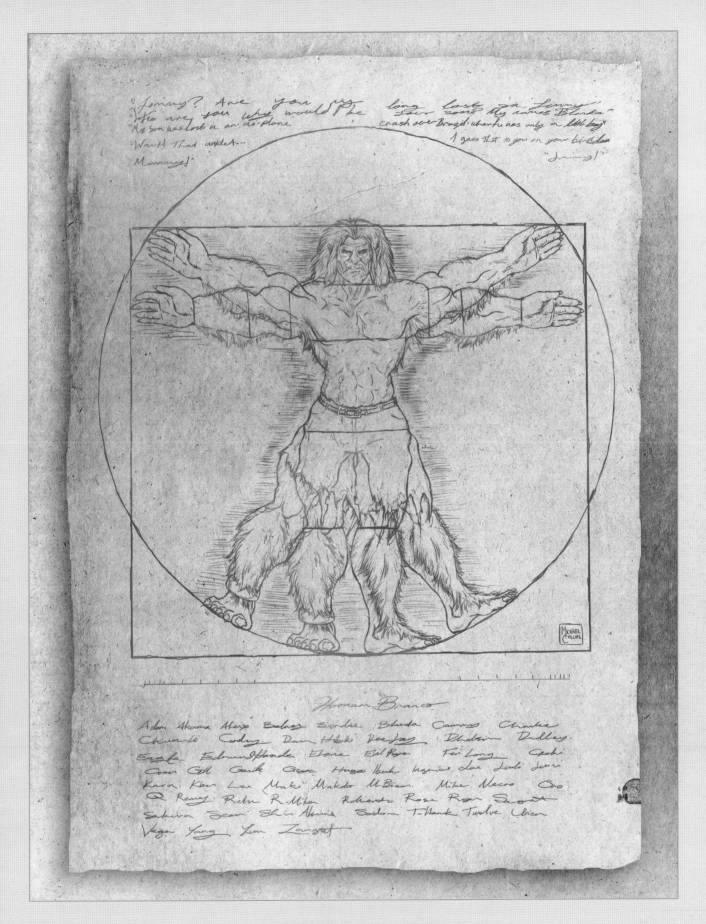

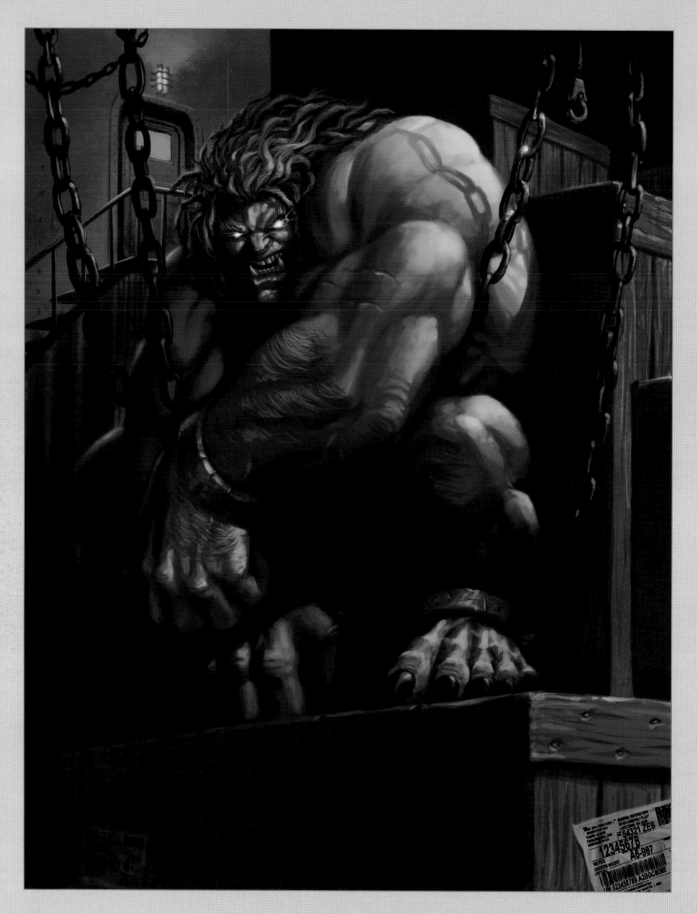

MARTIN ORONÁ
BUENOS AIRES, ARGENTINA
MARTINORONA.DEVIANTART.COM
ILLUSTRATOR / CONCEPT ARTIST

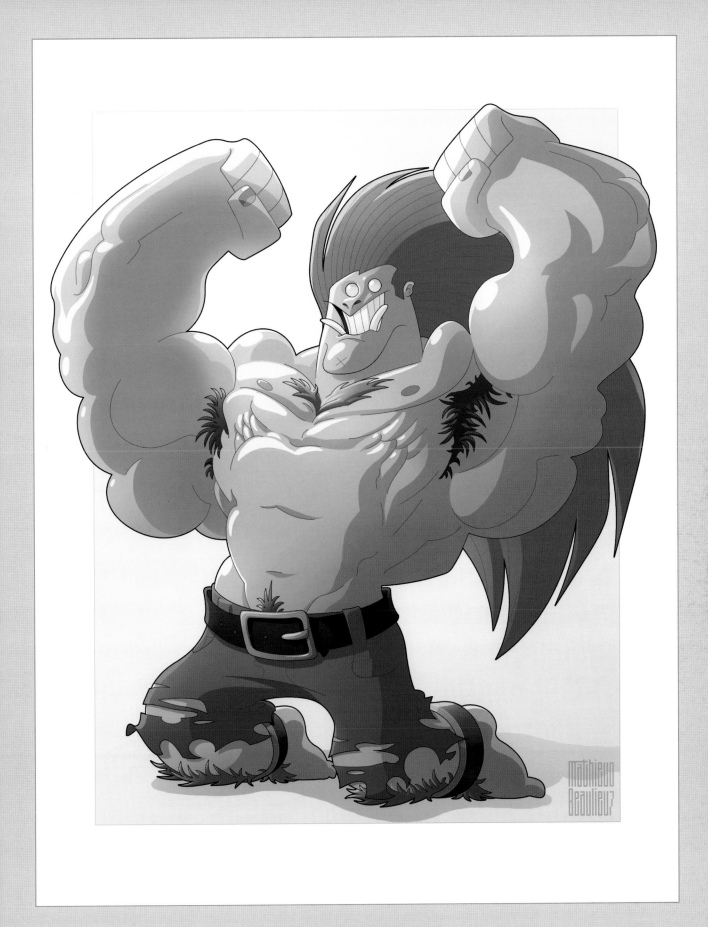

MATHIEU BEAULIEU
MONTRÉAL, QUÉBEC, CANADA
MATHIEU-BEAULIEU.BLOGSPOT.COM
ILLUSTRATOR

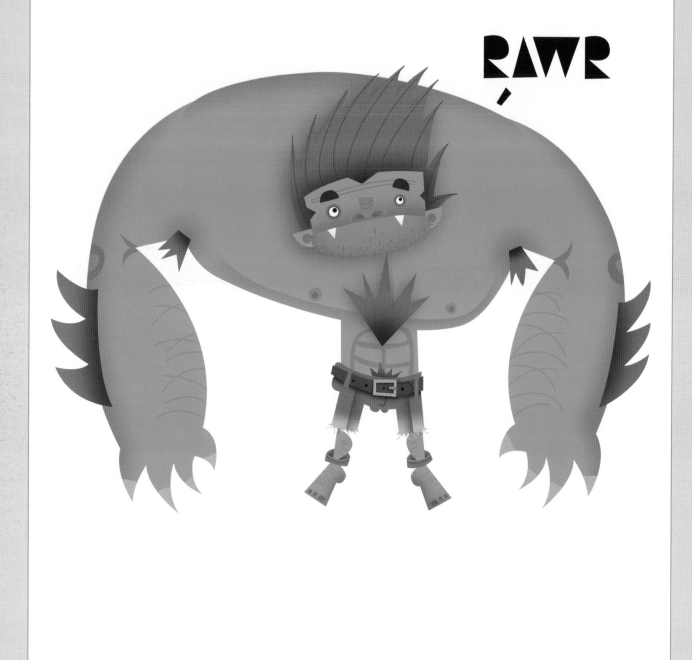

RAWR

WAYNE HARRIS
CARDIFF WALES, UK
WWW.WAYNE-HARRIS.COM

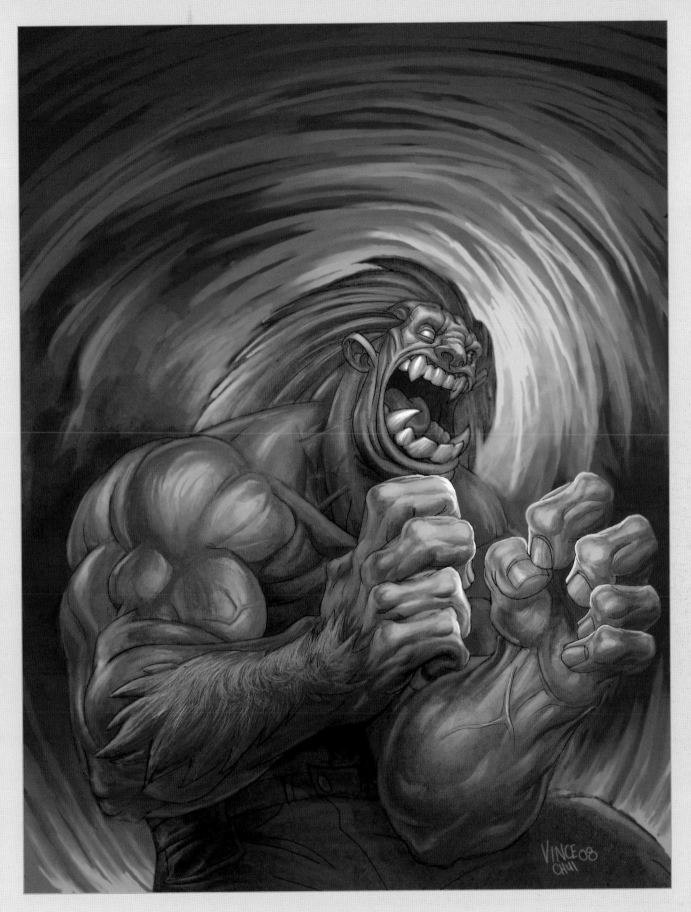

VINCE CHUI [KIDCHUCKLE]
PICKERING, ONTARIO, CANADA
WWW.KIDCHUCKLE.COM
ILLUSTRATOR/CONCEPT ARTIST
[CEL DAMAGE, FULL AUTO, FULL AUTO 2]

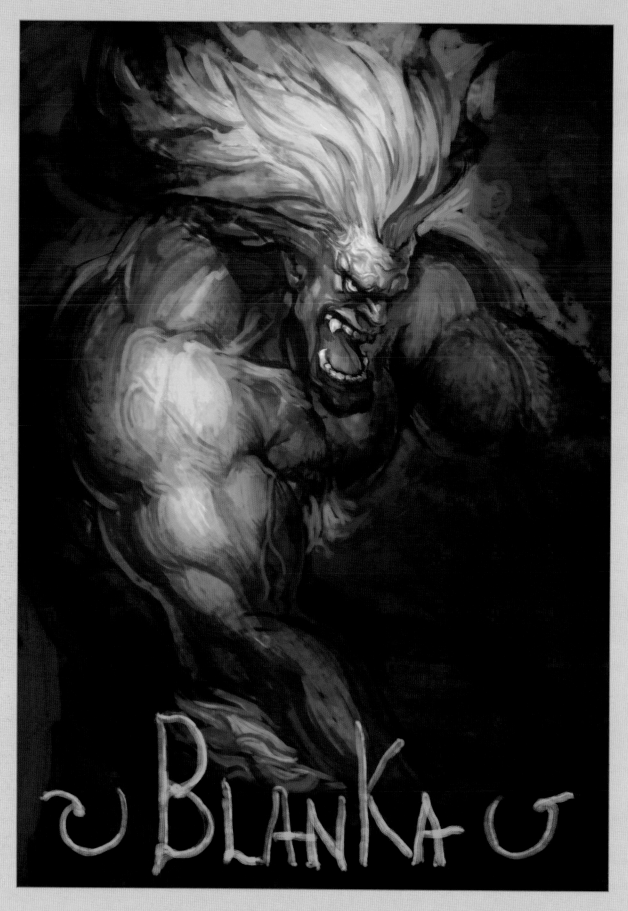

LEE MIN-HO [JUDAPRING]
SOUTH KOREA
JUDAPRING.COM
CONCEPT ARTIST
[XLGAMES]

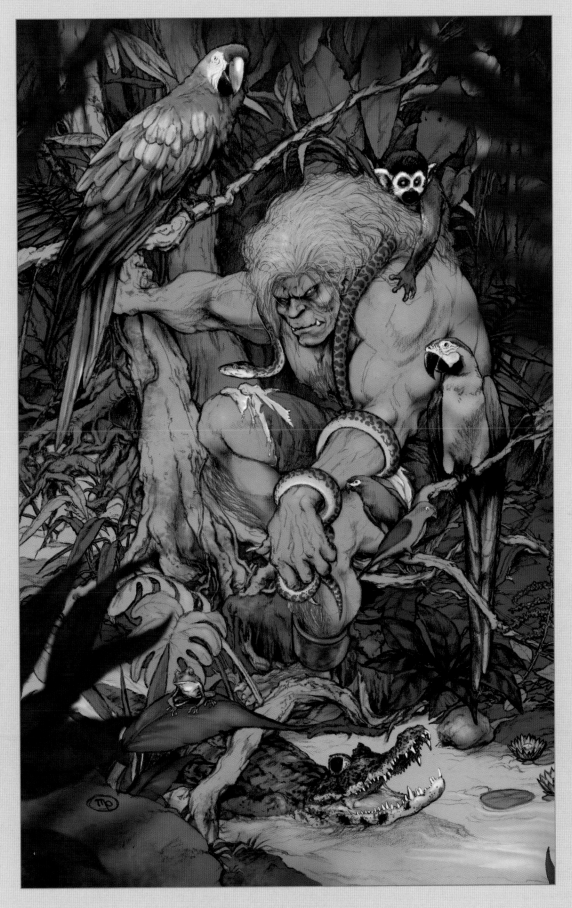

MARCUS PARCUS
SAN FRANCISCO, CALIFORNIA, USA
THEMONKEYMIND.LIVEJOURNAL.COM

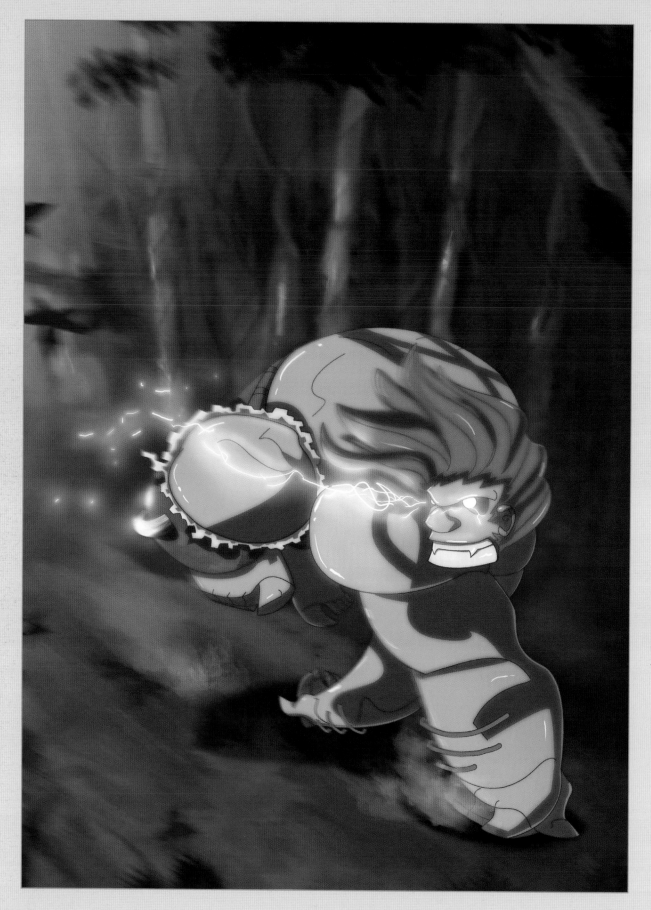

JOHNNY CHEUNG LIANG
CARTAGO, COSTA RICA
CHEUNGKINMEN.DEVIANTART.COM

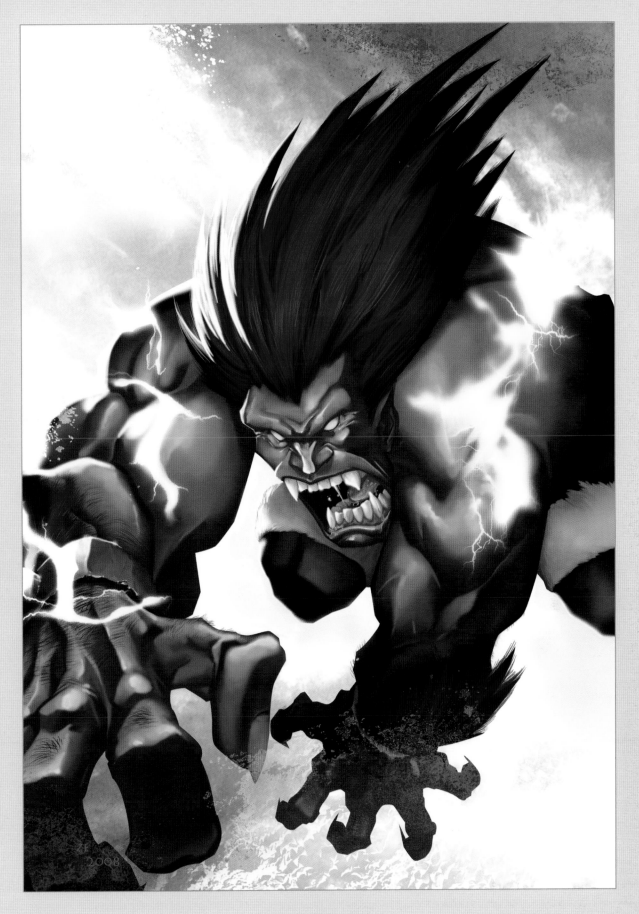

ZE CARLOS
SAO PAULO, BRAZIL
ZECARLOS.DEVIANTART.COM
CONCEPT ARTIST

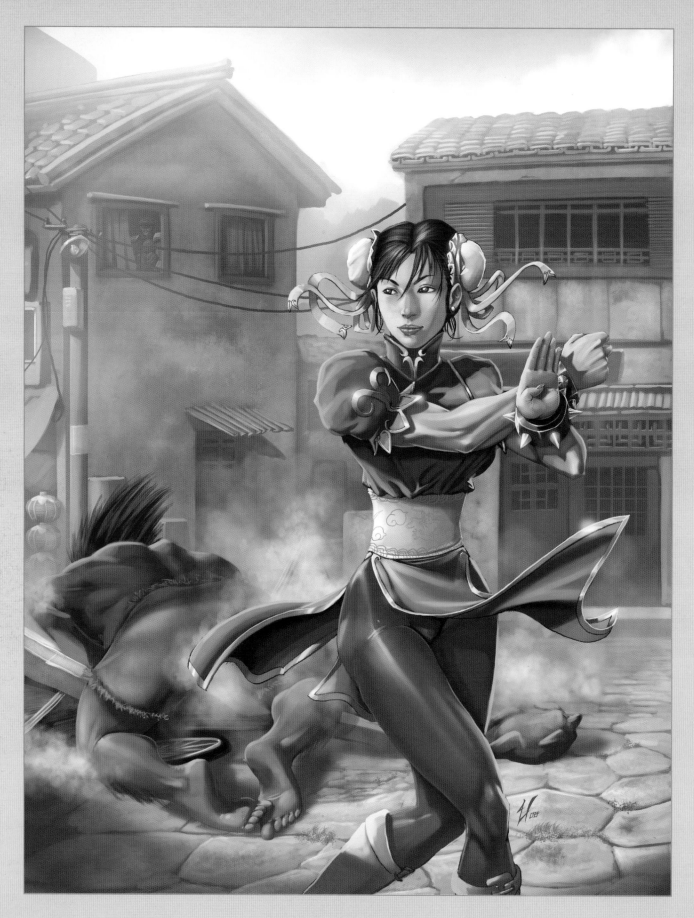

ULISES ARREOLA
GUADALAJARA, MEXICO
ULISESARREOLA.BLOGSPOT.COM
COLORIST
[LULLABY, MARVEL ADVENTURES: AVENGERS, BIONICLE, MARVEL ADVENTURES: IRON MAN]

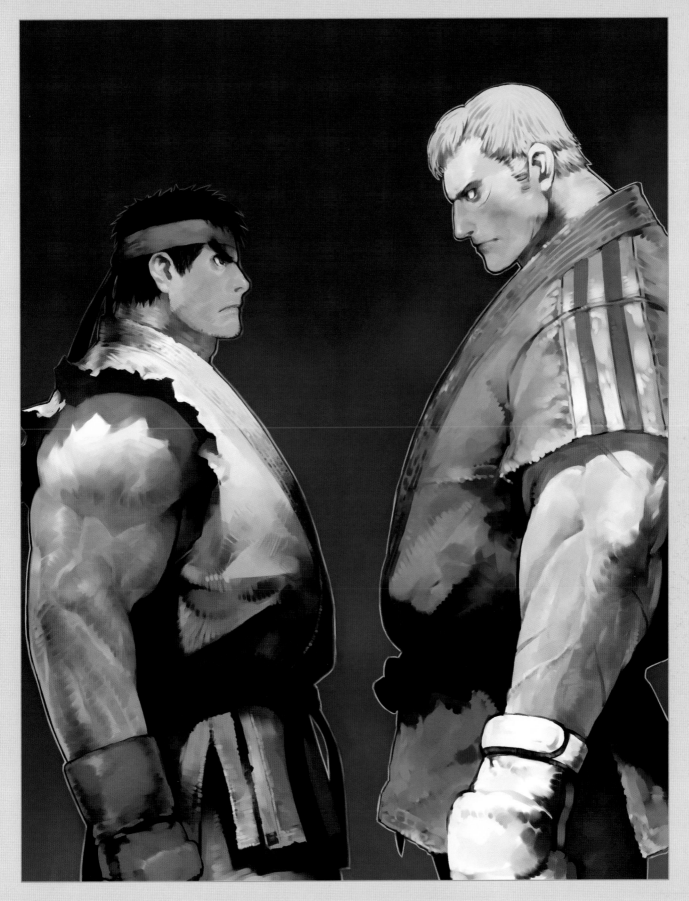

LEE SANG-BURN [GAEJABLEE]
SOUTH KOREA
DHRDHR.EGLOOS.COM
ILLUSTRATOR
[FORGOTTEN SAGA ONLINE, LINEAGE POSTER, DRAGON NEST]

BRYAN LEE O'MALLEY

Street Fighter was the reason I got a job when I turned 14. The first thing I bought with my own money was a Sega Genesis, a six-button controller and Super Street Fighter II so I could play it at home. The Street Fighter and VS series have been a huge influence on everything I've done ever since.

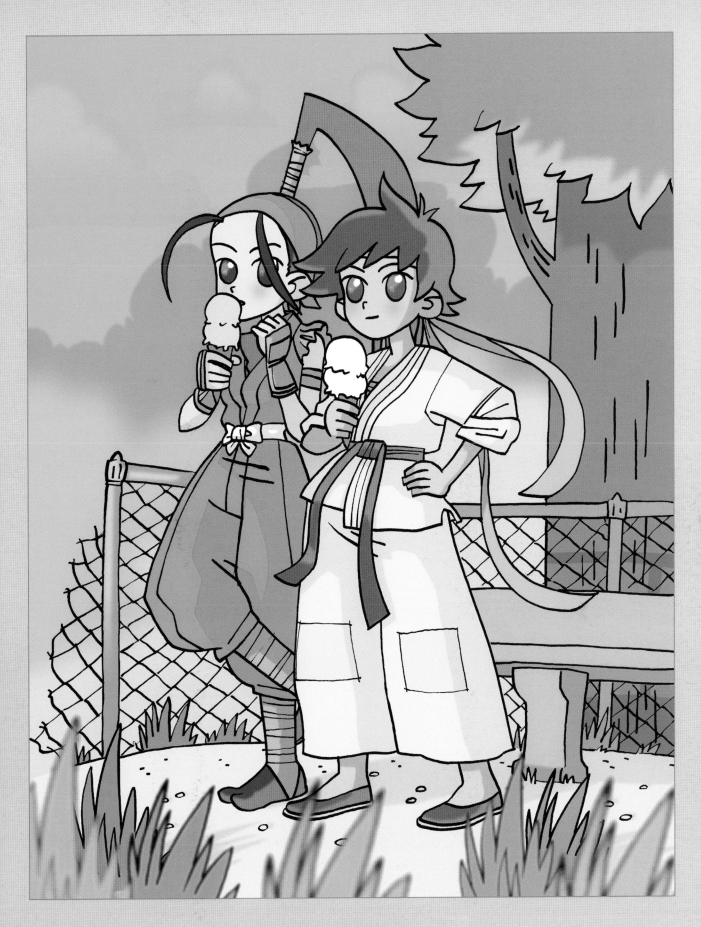

BRYAN LEE O'MALLEY
ASHEVILLE, NORTH CAROLINA, USA
WWW.RADIOMARU.COM
WRITER/ARTIST
[SCOTT PILGRIM]

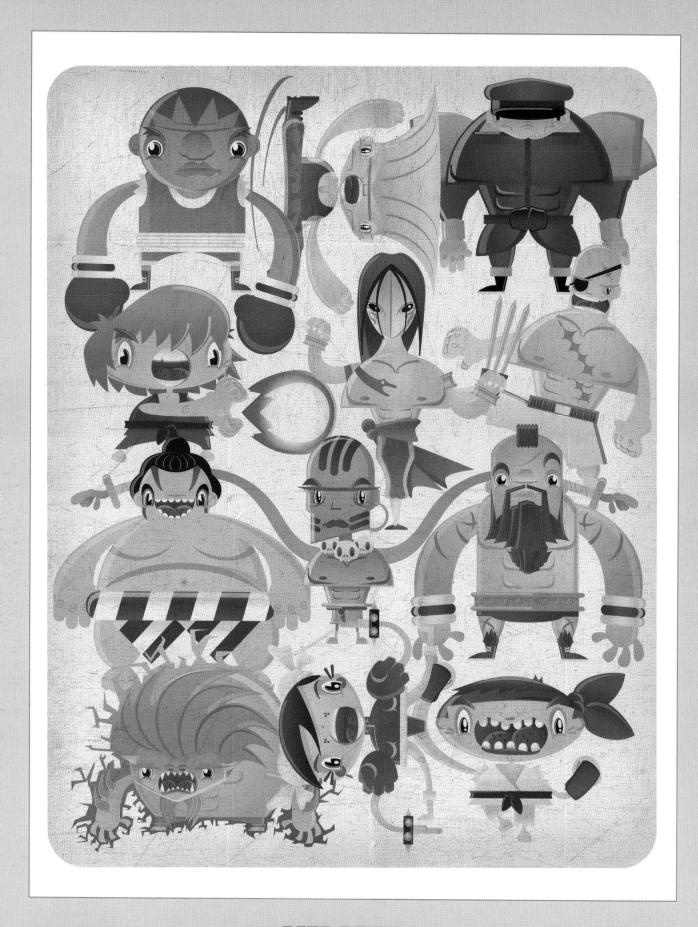

PETE MCEVOY
DUBLIN, IRELAND
WWW.PMCGRAPHICS.COM

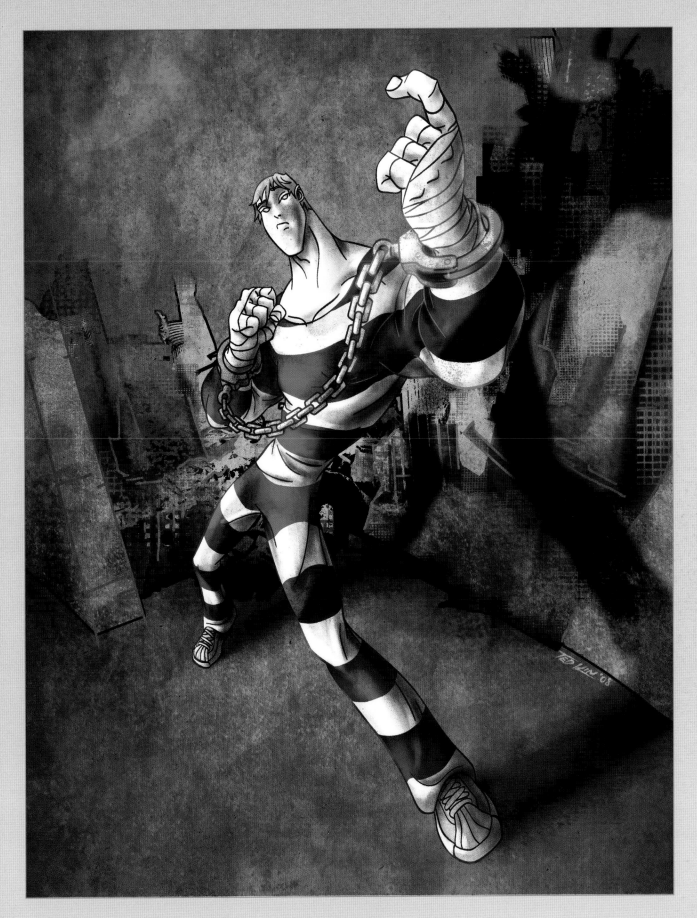

TED KIM
TORONTO, CANADA
WWW.TEDKIMCHEE.COM - SEOULMANTED.DEVIANTART.COM
CONCEPT ARTIST
CEL DAMAGE, FULL AUTO, FULL AUTO 2: BATTLELINES]

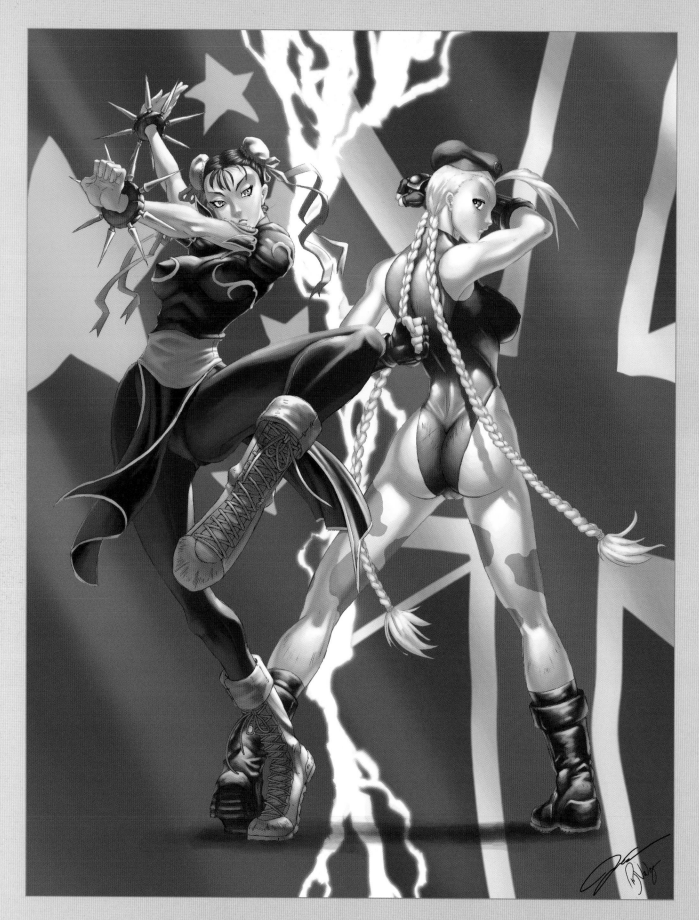

IAN CANG
MANILA, PHILIPPINES
WWW.GROUNDBREAKERS.COM.PH
SENIOR CREATIVE DIRECTOR [MANGAHOLIX]
CO-CREATOR/ARTIST [CHRONICLES OF HAORAN: KRAUST -
TEN ROARS OF THE HEAVENS]

BRIAN VALEZA
MANILA, PHILIPPINES
WWW.GROUNDBREAKERS.COM.PH
SENIOR COLORIST [MANGAHOLIX]
COLORIST [CHRONICLES OF HAORAN: KRAUST -
TEN ROARS OF THE HEAVENS]

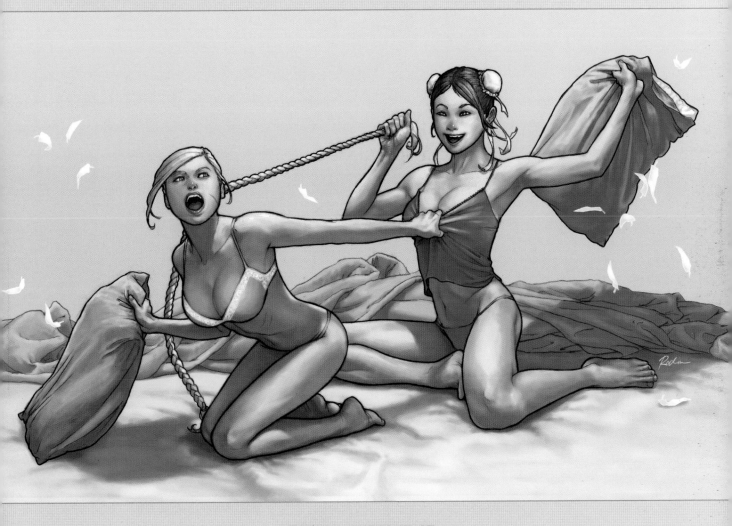

RODIN ESQUEJO
SAN MATEO, CALIFORNIA, USA
CAKES.DEVIANTART.COM
ILLUSTRATOR

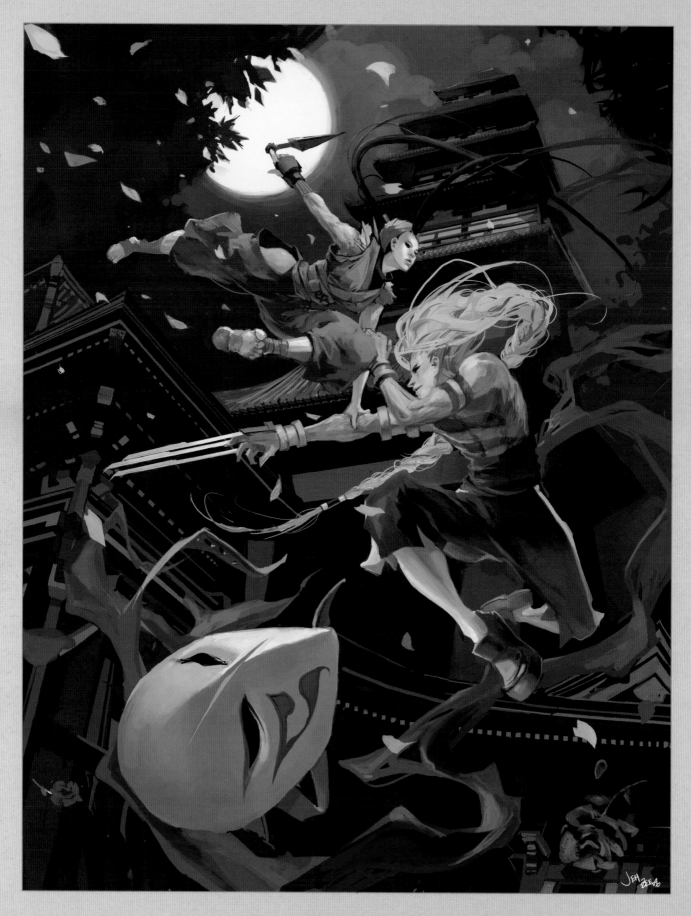

JEN ZEE
WWW.GAIAONLINE.COM
CONCEPT ARTIST
[GAIA ONLINE]

ALPHA GIRLS

RYAN COAXE
TORONTO, ONTARIO, CANADA
WWW.WOBBLY-POP.COM
CARTOONIST

KENDRICK LIM

I was instantly drawn to Q's mystery. He was slow, with clumsy-looking moves, yet intimidatingly powerful. The fact that he was a less popular character made me even more interested in mastering him.

I learned from the very best (via youtube, of course), Mr. Kuroda. Therefore this piece is also an homage to Kuroda, the best Q player in the world!

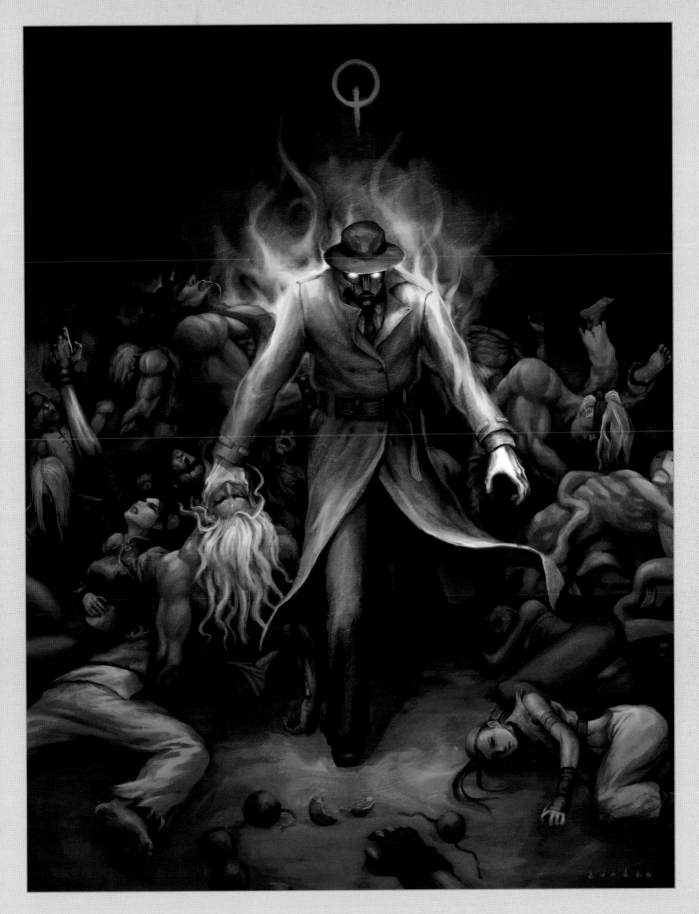

KENDRICK LIM
SINGAPORE
KUNKKA.DEVIANTART.COM

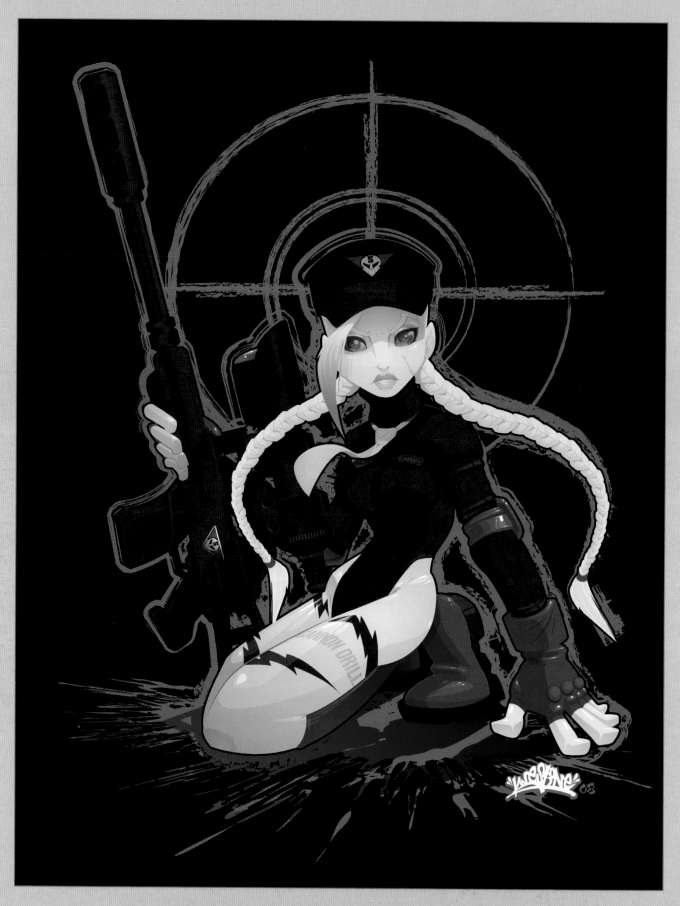

CHITO ARELLANO [KWESTONE]
LONG BEACH, CALIFORNIA, USA
ILLUSTRATOR AND TOY DESIGNER
[SPIN MASTER INC., TECH DECK DUDES]

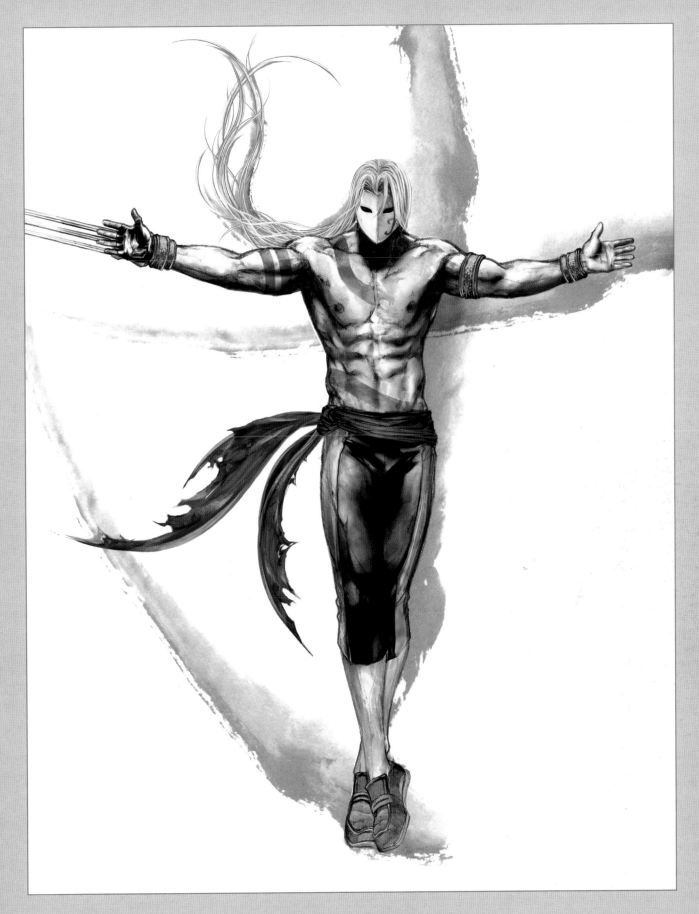

RUBEN M. SIMON
BANDUNG, INDONESIA
YUESHENGSHI.DEVIANTART.COM - WWW.ACOLYTECOMICS.COM
ILLUSTRATOR
[ACOLYTE INC.]

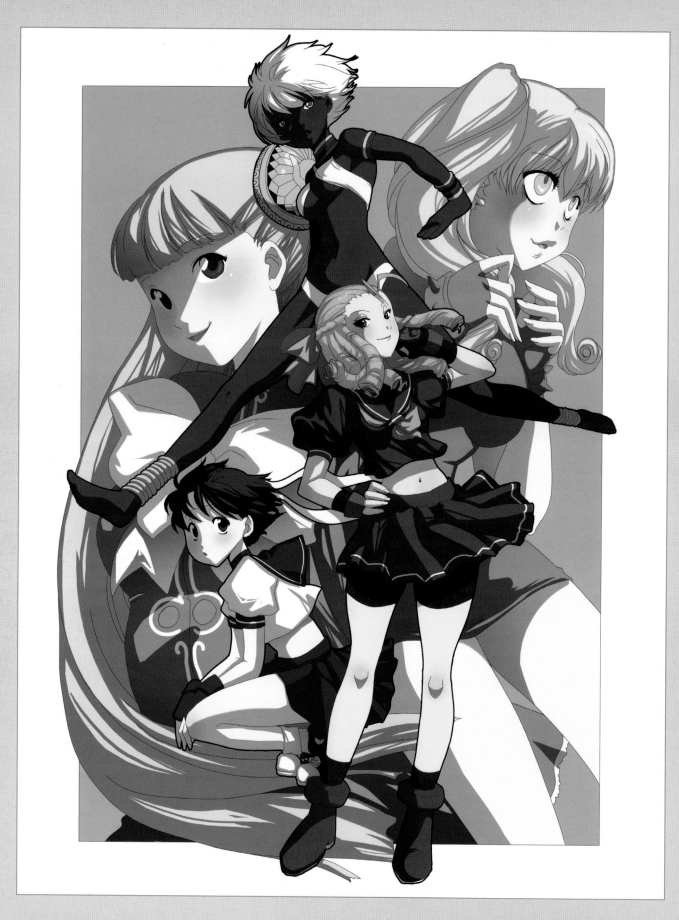

ERICA ORTIZ
ZAMBI.DEVIANTART.COM
ILLUSTRATOR

CHRIS ABEDELMASSIEH
LONDON, UK
WWW.CHEESYNIBLETS.CO.UK
CHEESYNIBLETS.DEVIANTART.COM
3D ARTIST
[CRASH TWINSANITY, SUPER MONKEY BALL ADVENTURE]

LEE CHIN HORNG
SELANGO, MALAYSIA
BRAMLEECH.DEVIANTART.COM - BRAMLEECH.CGSOCIETY.ORG/GALLERY
DIGITAL ANIMATION STUDENT, FREELANCE COMIC ARTIST
[ORZSOME!!!]

GARRETT HANNA
OTTAWA, ONTARIO, CANADA
SHERIDAN ANIMATION

ERIC KIM

My first memory of Street Fighter is at a go-kart track in Brampton. I was at the arcade there after a track meet, and saw Ryu in all his (former) red-haired glory. At that point I just knew I had to play! It was the first and last time that I'd see it (until it came out for NEC's Turbografx-16 later on).

When Street Fighter II came out, I was immediately drawn to Chun-Li. Who wouldn't be? We ended up being partners, taking on the best from Rexdale, Chinatown and a couple of shopping malls around Toronto. I'd meet my match later on in San Diego though, and would gracefully retire.

Now, me and Elena are looking to take on all comers! The future burns bright for fighters who want to be the best of the best...

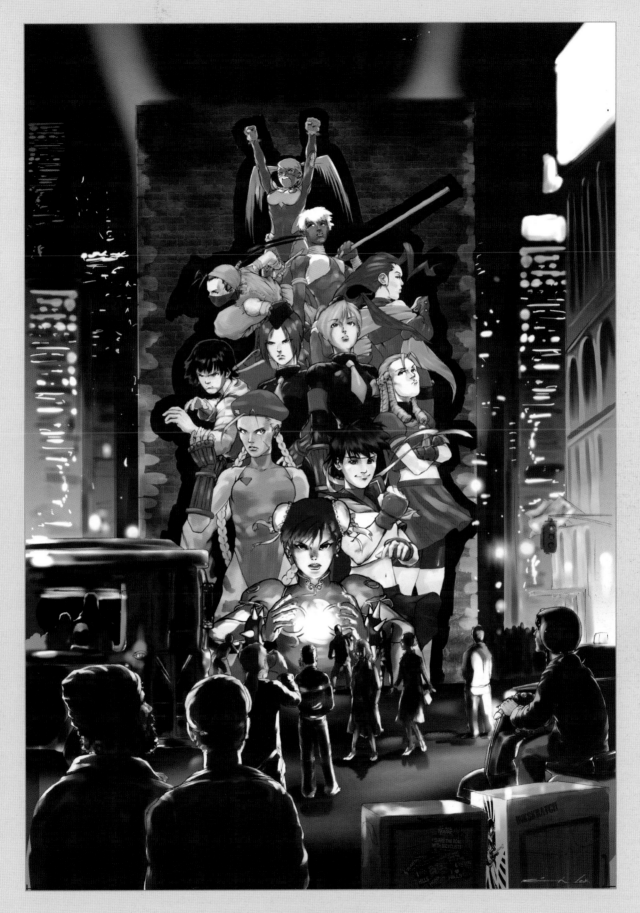

ERIC KIM
TORONTO, ONTARIO, CANADA
WWW.INKSKRATCH.COM
COMIC ARTIST
[LOVE AS A FOREIGN LANGUAGE, DEGRASSI: EXTRA CREDIT VOL. 3, OWL MAGAZINE]

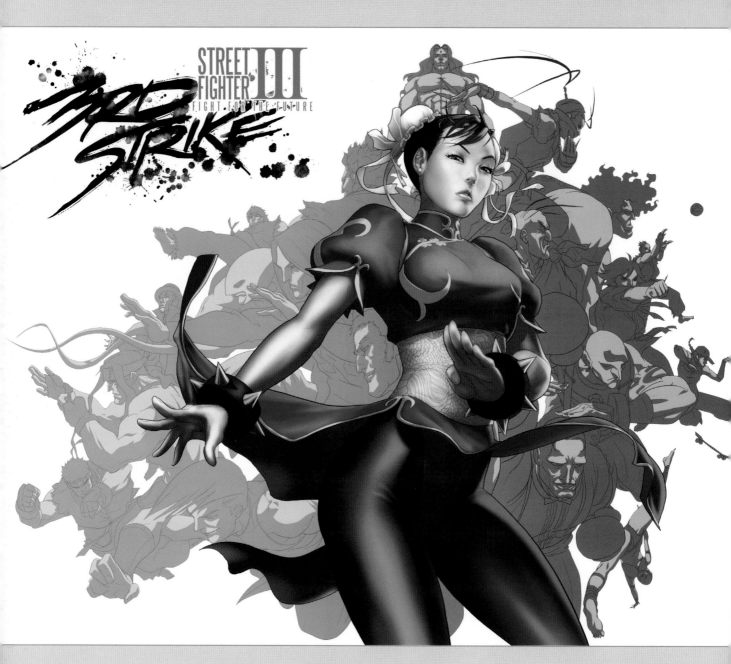

CHESTER OCAMPO
MANILA, PHILIPPINES
ELPINOY.DEVIANTART.COM
ART DIRECTOR
[IMAGINARY FRIENDS STUDIOS]

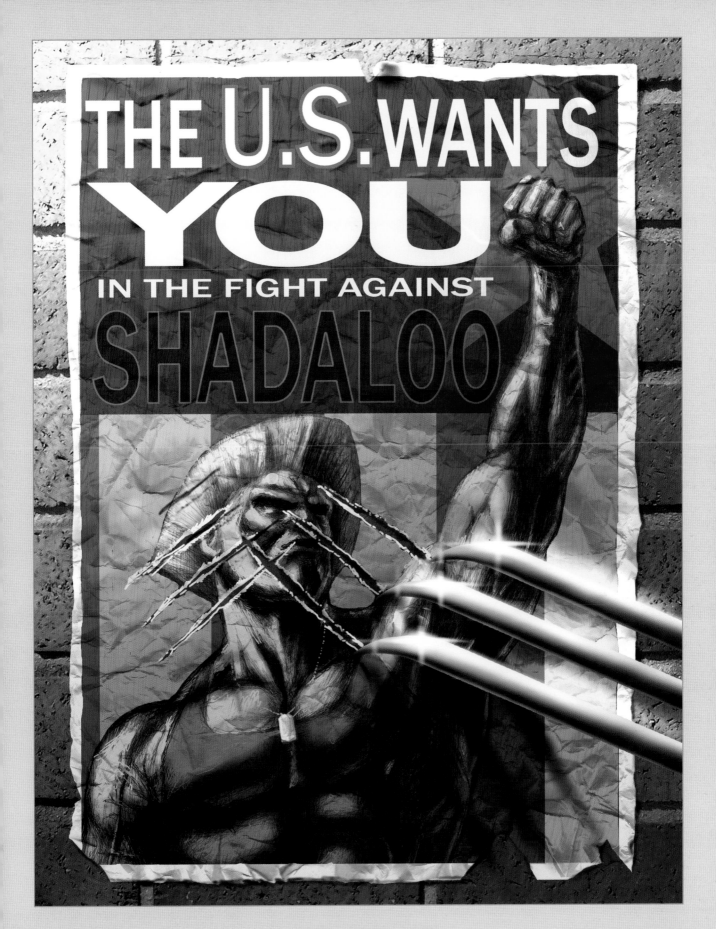

DERIC PHILLIPS
KINSTON, NORTH CAROLINA, USA
MALLAARD.DEVIANTART.COM

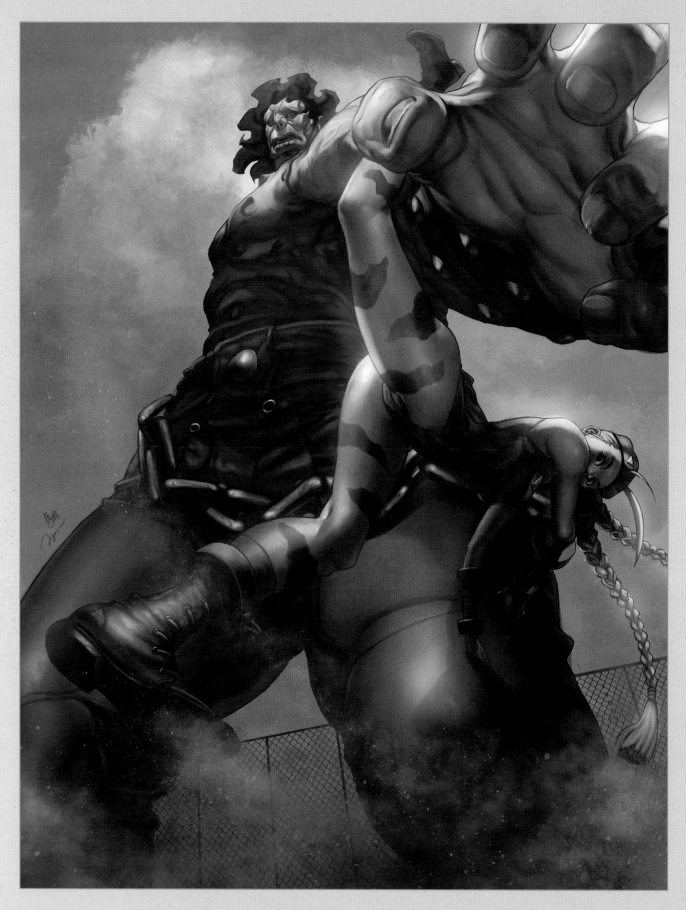

FAITH ERIN HICKS
HALIFAX, NOVA SCOTIA, CANADA
WWW.FAITHERINHICKS.COM
CARTOONIST
[ZOMBIES CALLING, ICE, DEMONOLOGY 101]

RODOLFO VELADO
SAN SALVADOR, EL SALVADOR
WWW.RODOLFOVELADO.COM
GRAPHIC DESIGNER / ILLUSTRATOR

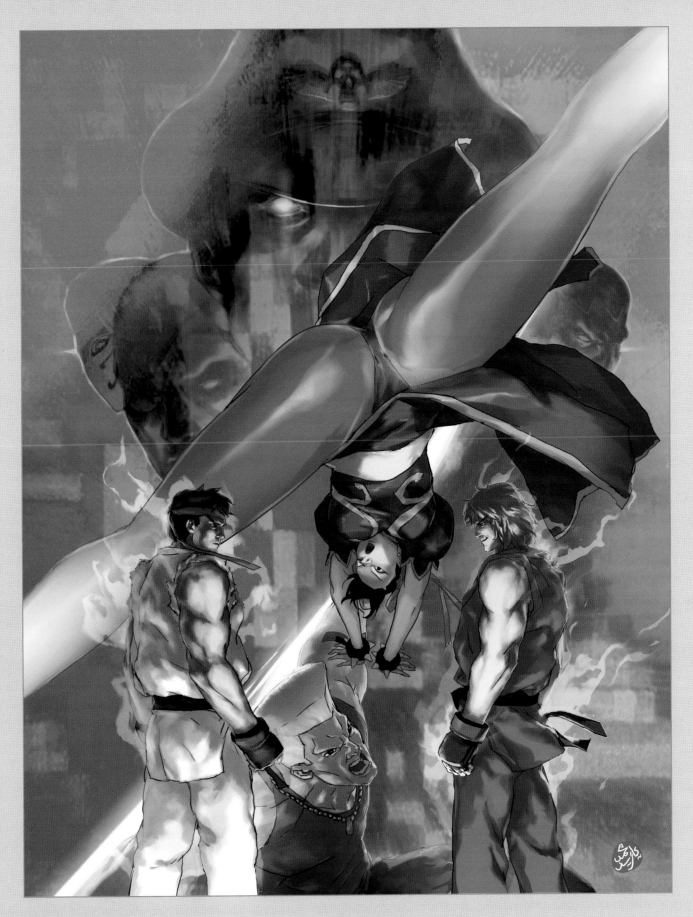

ZID
WWW.MOHAMMADYAZID.COM
SENIOR ARTIST
[IMAGINARY FRIENDS STUDIOS]

MATT MOYLAN

Originally, I didn't learn to play Street Fighter with an arcade stick, or even a game controller. I learned to play it on a keyboard of all things. We didn't have an arcade in my small town, and I didn't get a 16-bit console until the end of the SNES' run. So the only version of Street Fighter I owned when I was a kid was Street Fighter II for my 386 PC.

It ran pretty slow and some of the sound effects were pretty wonky. Also, for some reason, in this version of the game Dhalsim was unstoppable. My little brother and I even had a rule when we played each other that you were not allowed to pick Dhalsim, he was just too strong.

The game still got played a lot though, and it was largely responsible for wearing out the 'enter' key on that early 1990's keyboard. To this day I still have a habit of reaching for the backup 'enter' on the number pad.

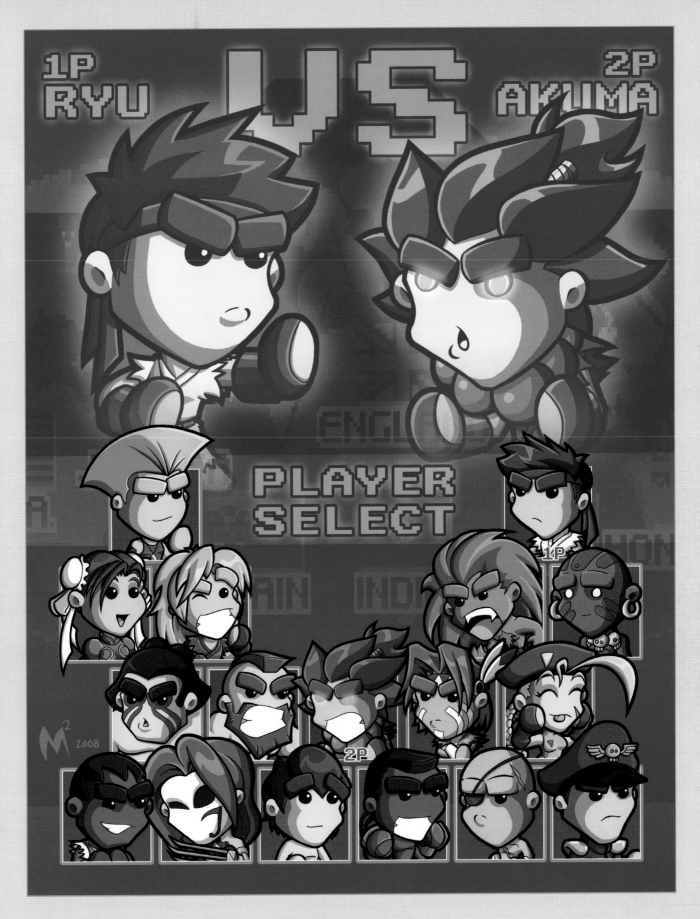

MATT MOYLAN
TORONTO, ONTARIO, CANADA
WWW.LILFORMERS.COM - MATTMOYLAN.DEVIANTART.COM
CARTOONIST [LIL FORMERS]
MARKETING MANAGER [UDON]

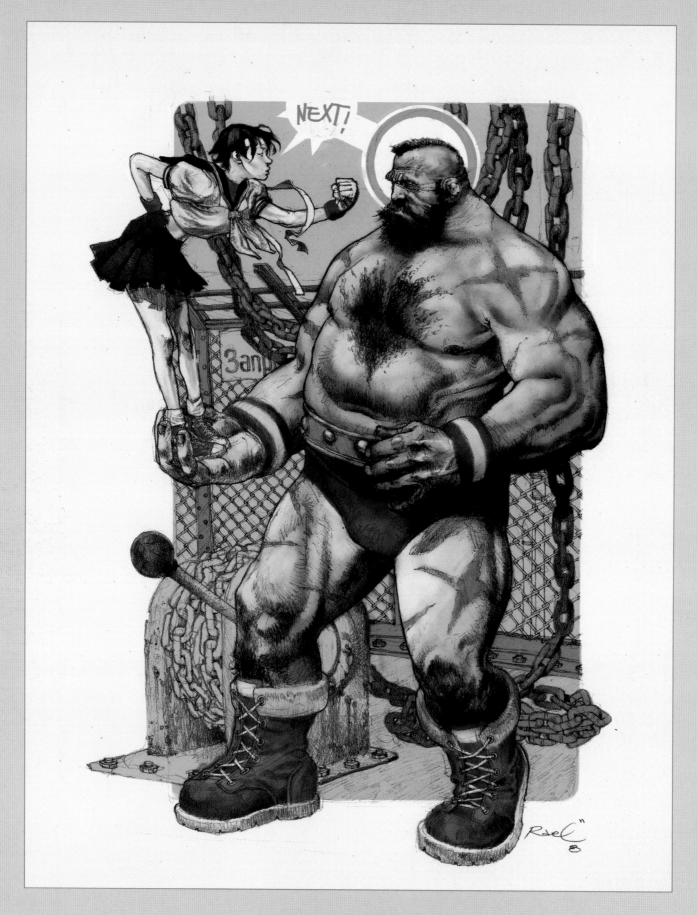

RAEL LYRA
OLINDA, BRAZIL
RAELLYRA.BLOGSPOT.COM
CONCEPT ARTIST / COMIC ARTIST
[JEREMIAH HARM]

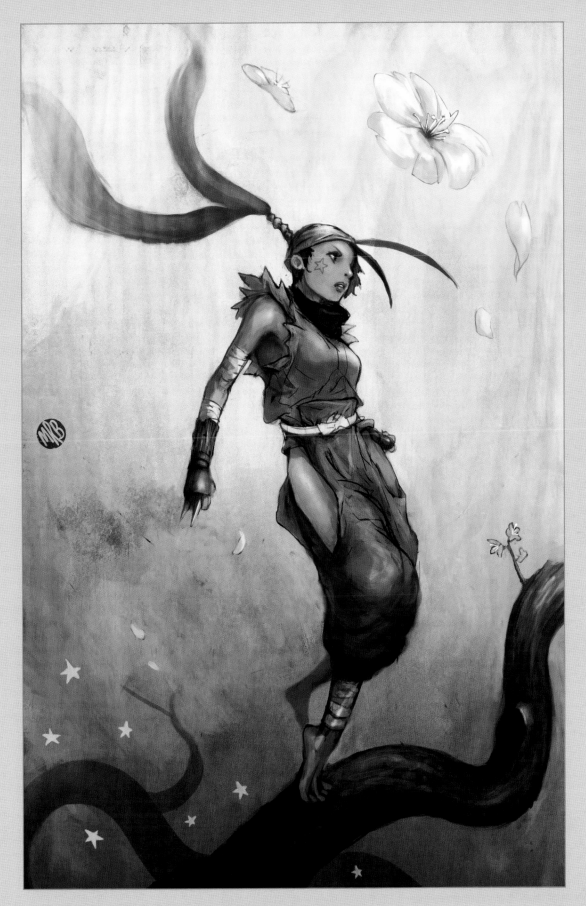

BEN QWEK [MR.B]
SINGAPORE
BENQWEK.DEVIANTART.COM
SENIOR ARTIST
[IMAGINARY FRIENDS STUDIOS]

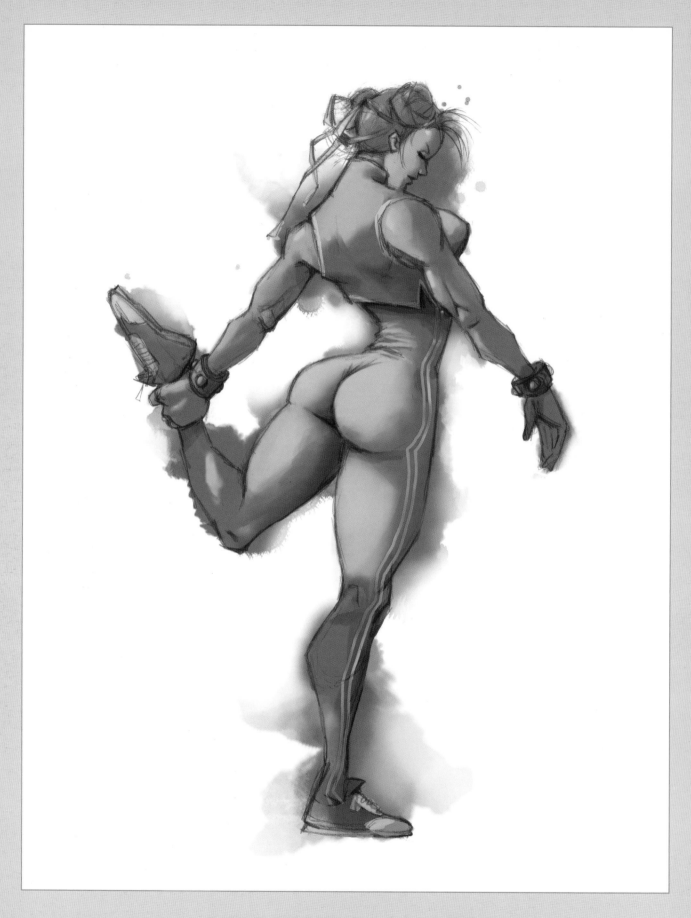

CARLO CESAR NEIRA ECHAVE
LIMA, PERU
LICARTO.DEVIANTART.COM

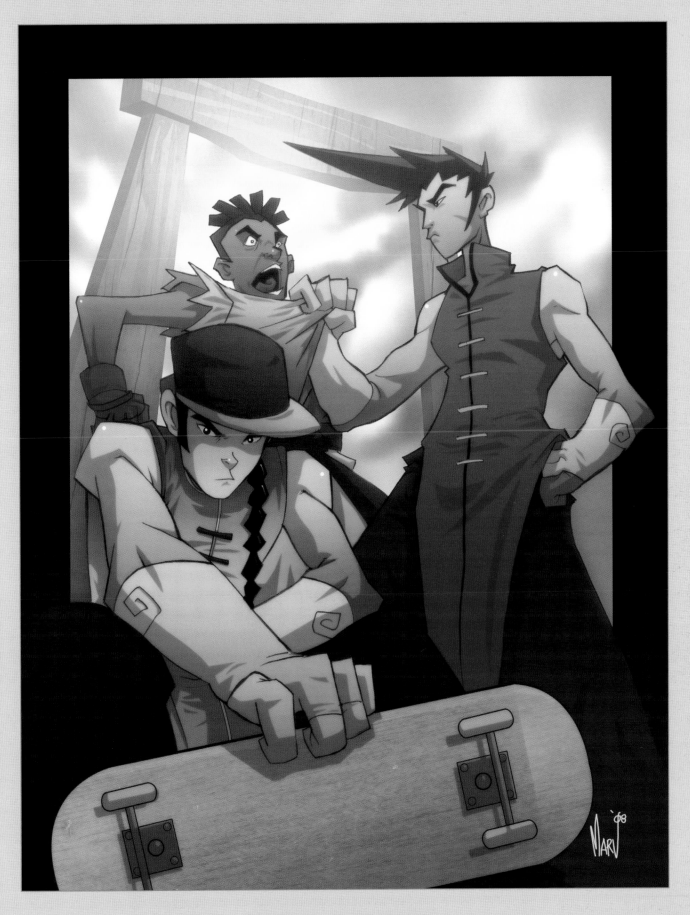

MARVIN DEL MUNDO
LAS PIÑAS CITY, PHILIPPINES
PARANOIDVIN.DEVIANTART.COM
DIGITAL ARTIST

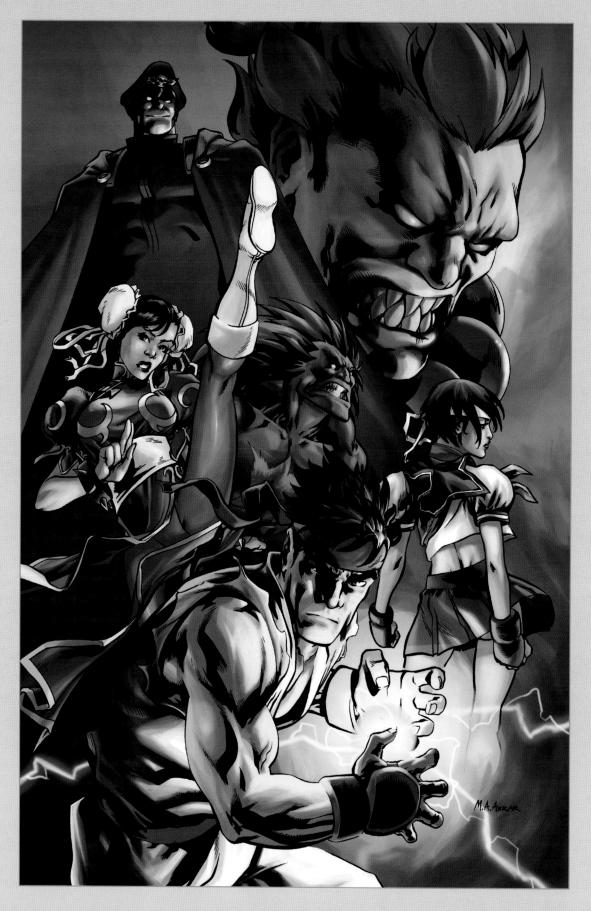

MAHMUD A. ASRAR
WWW.MAHMUDASRAR.COM
COMIC BOOK ARTIST
[DYNAMO 5, NOVA]

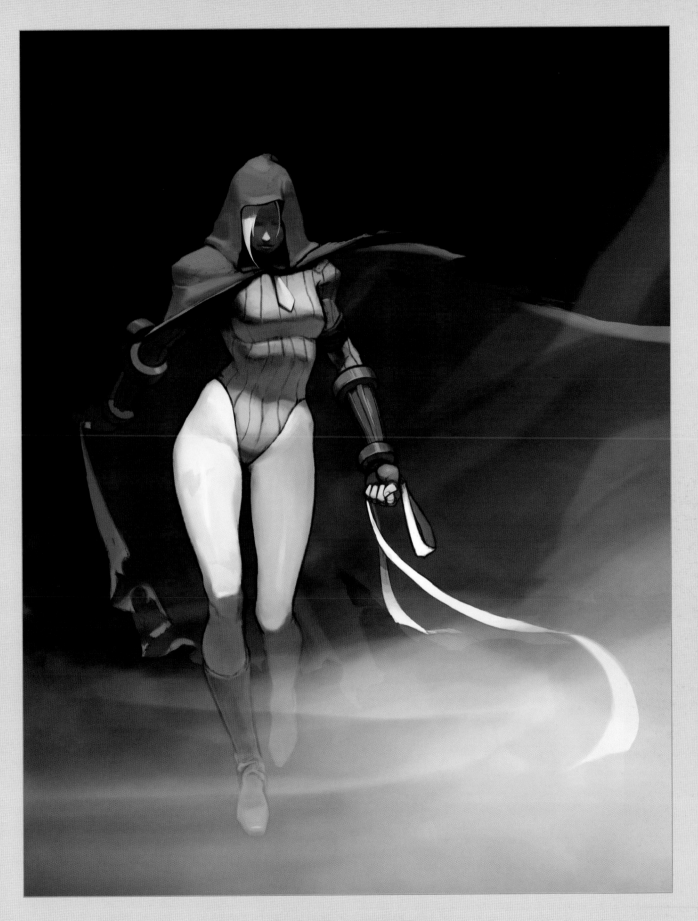

PHONG NGUYEN
ARLINGTON, TEXAS, USA
LEMONLIPS.BLOGSPOT.COM
ILLUSTRATOR

LONG VO

Oh, Street Fighter... the first game that ever intimidated me at the arcades.

Why can't people just leave me alone and let me learn how to throw a fireball? Nope, they had to just put their quarter in and kick my ass before I learned anything. Good thing one of my best friends was pretty good at Street Fighter II back in the day, so he acted as my videogame bodyguard. Once I started learning moves and combos, it was like bring it on! Holy crap, I'm shooting a projectile!

What really struck me about the game was that there were these really cool iconic characters whose sprites were massive for back then. They each had their own backgrounds, stories and character, something a lot of games just didn't have. It was truly revolutionary for its time and its effect on gamers everywhere still holds today.

While I played in the arcades when it first came out, I really learned on the SNES control pad when it hit the home systems. I spent summers playing it over and over again. My favorite version of Street Fighter is probably SFZ Alpha Gold for one single reason -- Ryu and Ken VS M. Bison at the SAME TIME! O_O

My tribute to Street Fighter is what happens when the good guys finally win -- They steal the bad guys' outfits and wear them! Enjoy!

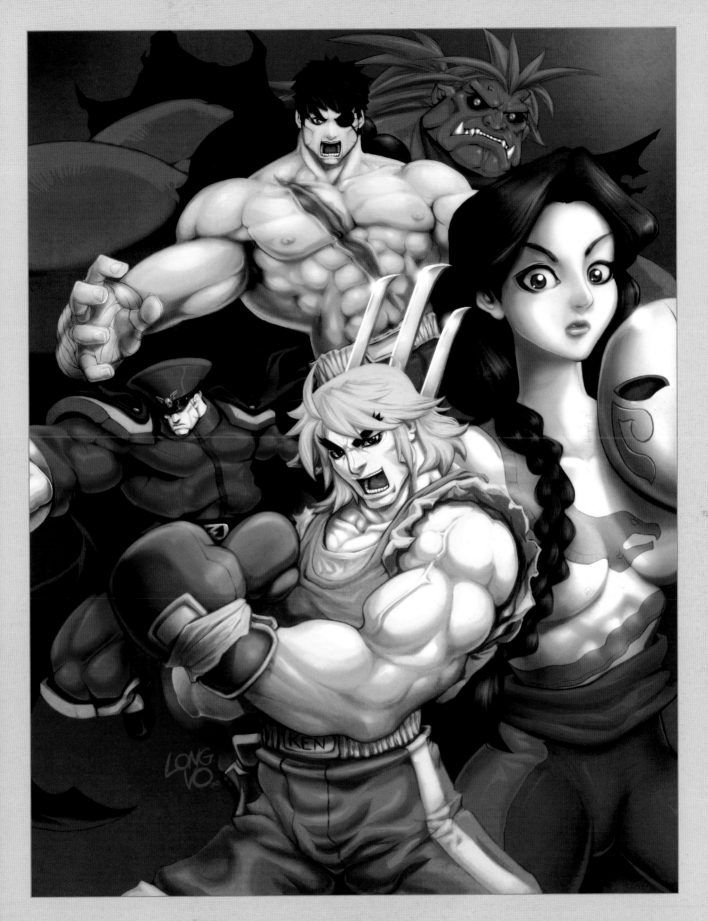

LONG VO
SANTA CLARA, CALIFORNIA, USA
WWW.VOSTALGIC.COM
LEAD SPRITE DESIGNER
[SUPER STREET FIGHTER II TURBO HD REMIX]

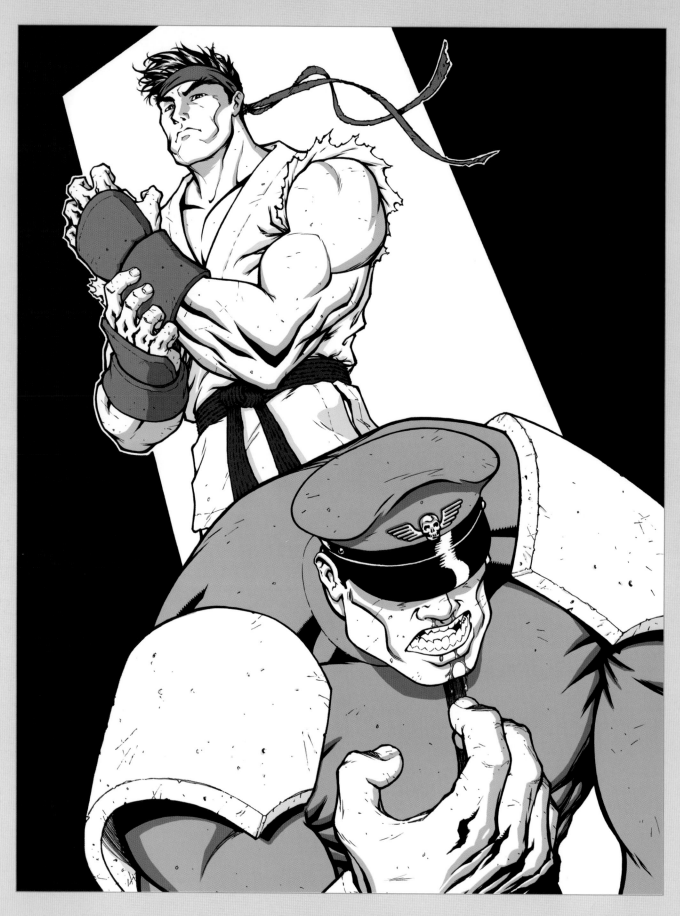

ALEX CHUNG
TORONTO, ONTARIO, CANADA
ILLUSTRATOR

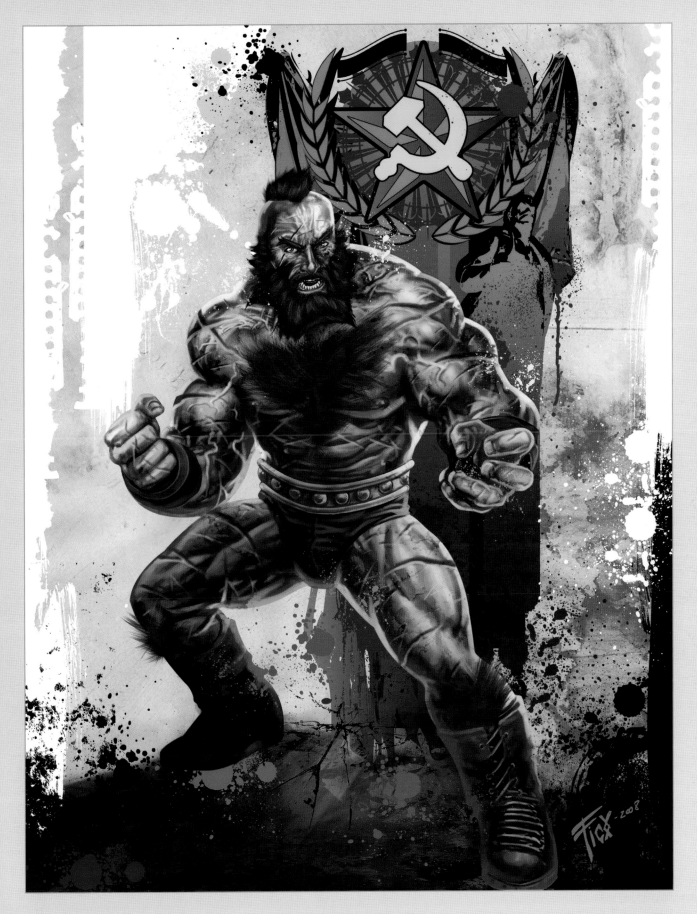

FEDERICO OSSIO
BUENOS AIRES, ARGENTINA
FIKKORO.DEVIANTART.COM
ILLUSTRATOR
[SELF-PROCLAIMED VIKING!]

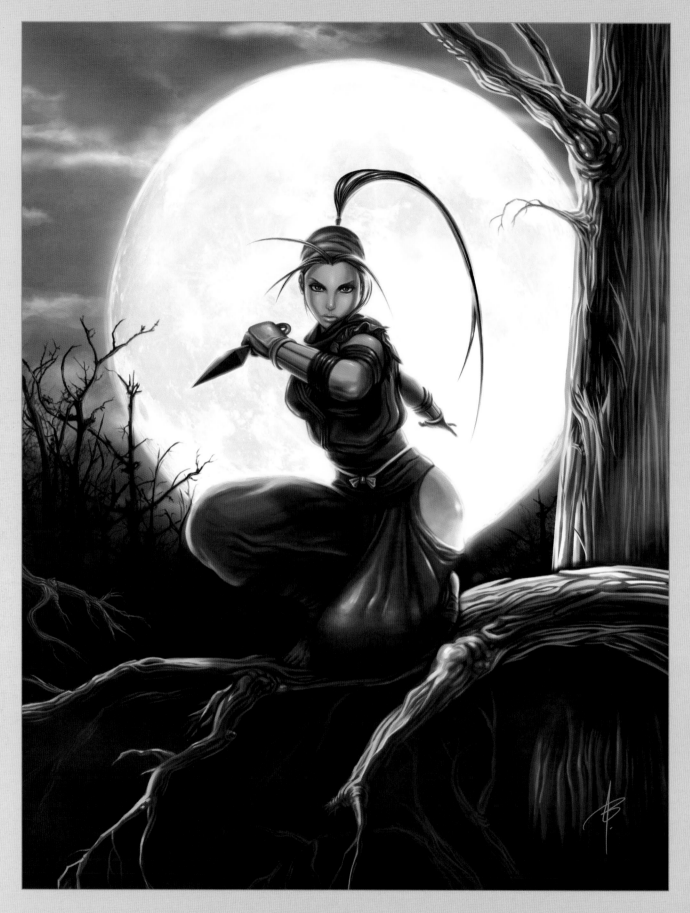

BENJAMIN ANG
SINGAPORE
WWW.BENJAMINANG.COM
COMIC ARTIST
[MAMMOTH BOOK OF BEST NEW MANGA 2, STRUM]

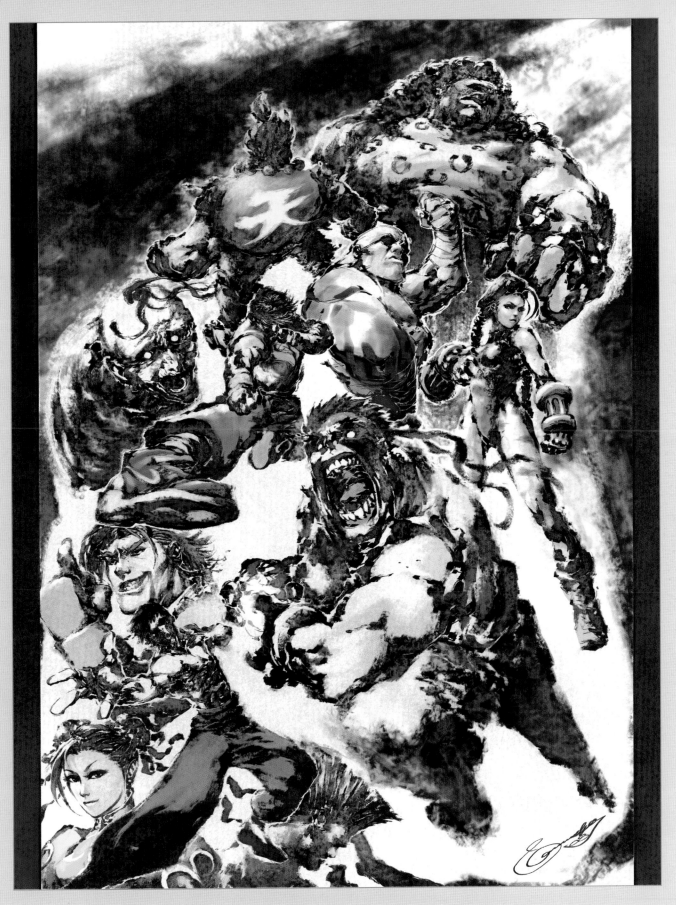

KENNETH LOH SOON HOCK [SCABROUSPENCIL]
SINGAPORE
SCABROUSPENCIL.DEVIANTART.COM
COMIC ARTIST

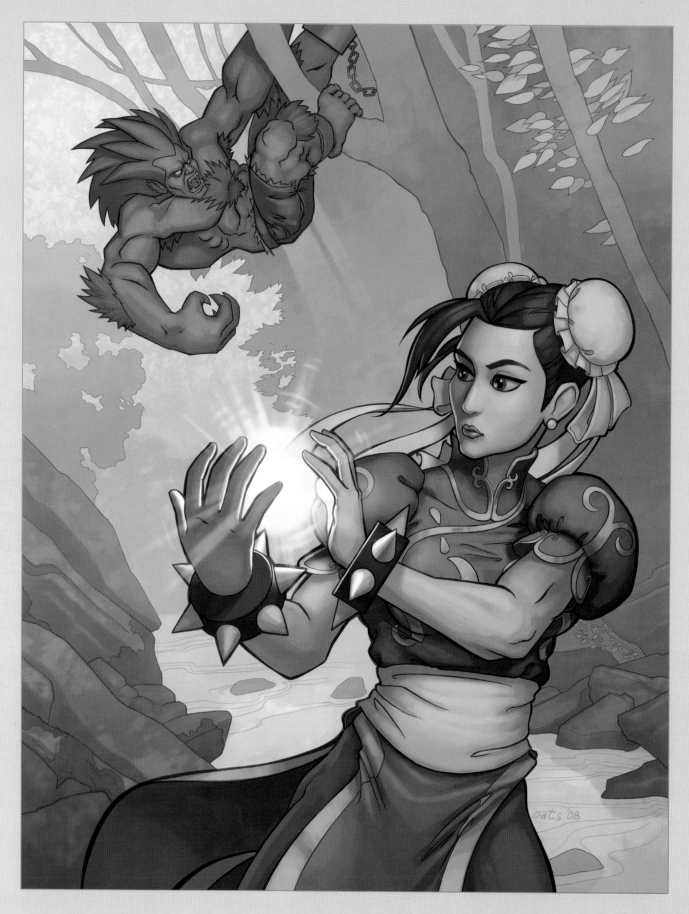

CHRIS OATLEY
COLUMBUS, OHIO, USA
WWW.CHRISOATLEY.COM
VISUAL DEVELOPMENT ARTIST

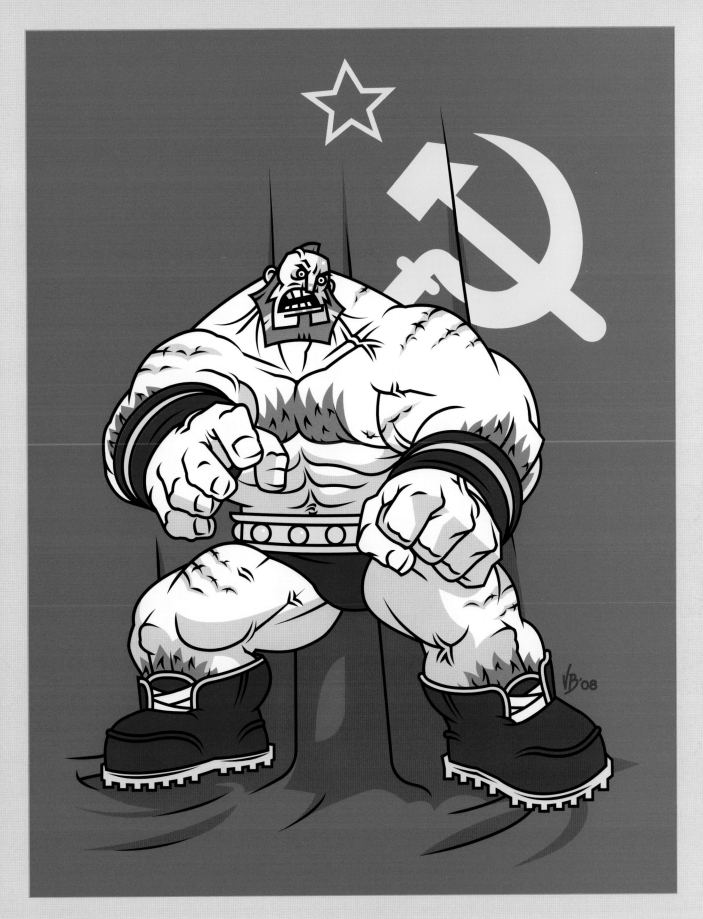

VANBEATER
G-VILLE, USA
WWW.VANBEATER.COM

SEAN GALLOWAY

Man, I remember the good old days going to the bowling alley and scurrying off to the arcade area while my parents would bowl in their league. I had a ton of favorite games but one of them would always eat my quarters and keep me coming back to it. That game, of course, was Street Fighter.

What I loved about Street Fighter was the awesome selection of characters. At such a young age I was hooked on the way they looked and moved and I even loved the background/incidental characters. Another appealing thing for me were the vibrant colors and amazing backgrounds. I actually wanted to live in some of those backgrounds.

Thank goodness for that game because it made want to draw.

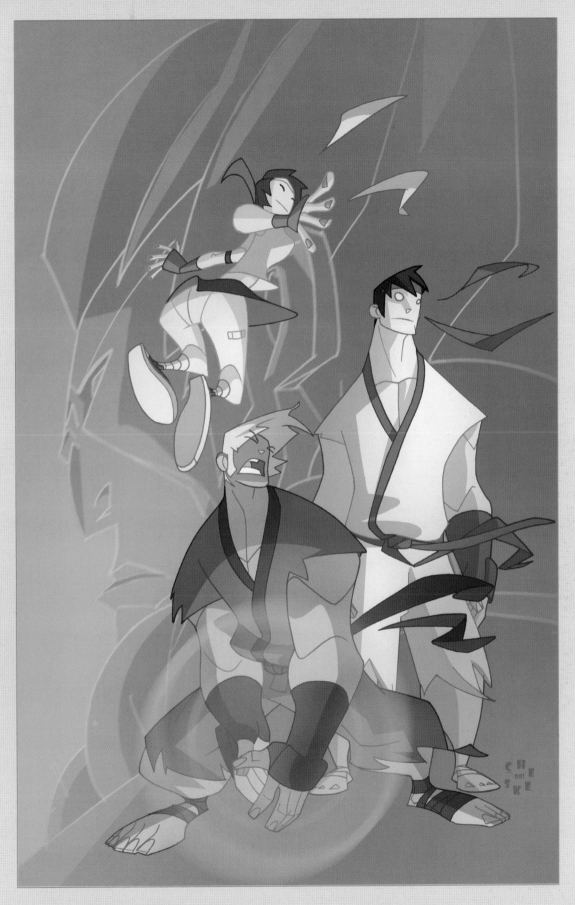

SEAN GALLOWAY [CHEEKS]
SAN DIEGO, CALIFORNIA, USA
GOTCHEEKS.BLOGSPOT.COM
CHARACTER DESIGNER [HELLBOY ANIMATED, SPECTACULAR SPIDER-MAN]
COVER ARTIST [TEEN TITANS GO!]

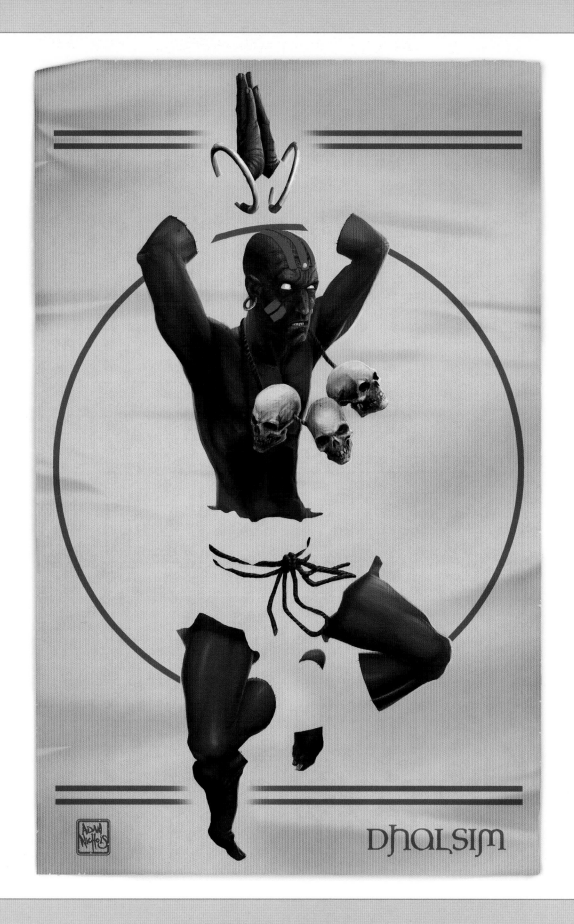

DHALSIM

ADAM NICHOLS
BRISBANE, AUSTRALIA
WWW.ADAMNICHOLSARTWORK.COM
LEAD CONCEPT ARTIST AT KROME STUDIOS
[STAR WARS: THE FORCE UNLEASHED, HELLBOY: THE SCIENCE OF EVIL]

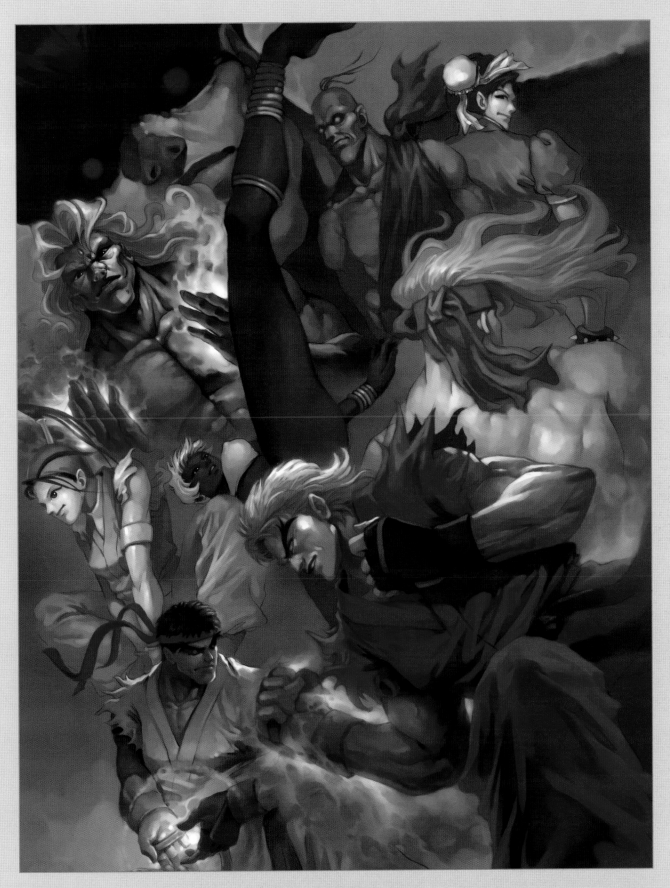

KACHEONG LIEW
KUALA LUMPUR, MALAYSIA
MASKEDRIDERKC.DEVIANTART.COM

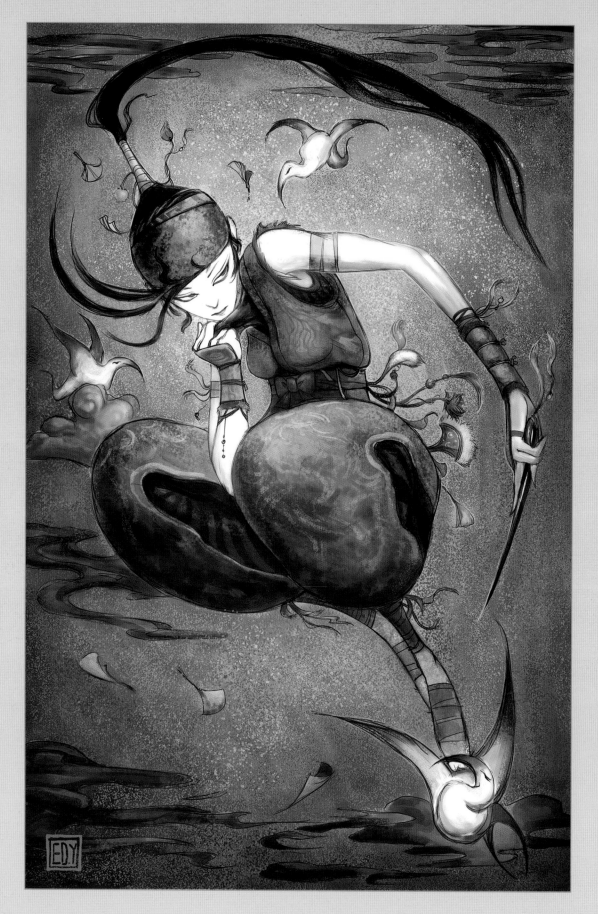

EDISON YAN
VANCOUVER, BRITISH COLUMBIA, CANADA
WWW.EDISONYAN.COM
CONCEPT ARTIST

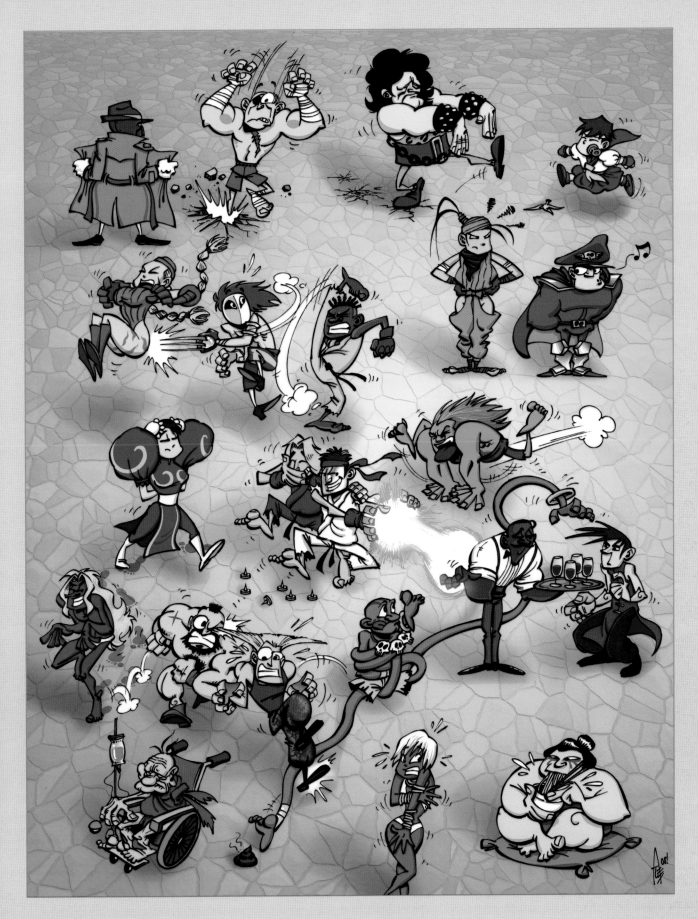

ALEX GALLEGO
BARCELONA, SPAIN
WWW.ALEXGALLEGO.COM
ILLUSTRATOR, CARTOONIST, DESIGNER
[DISNEY CHANNEL, ESPN, BRITISH TELECOM, VODAFONE, INT. BARCELONA COMICON]

NOI SACKDA

I actually hated Street Fighter as a child. I remember my brother would always pick Ryu and totally own me.

HADOKEN! HADOKEN! HADOKEN!... SHORYUKEN!

Yeah he's one of those guys.

What I like most about the Street Fighter universe is the dynamic characters. In my opinion it's the first game to really treat character design as a priority. Thank you Capcom and all the amazing artists for inspiring us to constantly perfect our craft.

SALLY SEIRIKI

It's hard to say exactly when I got introduced to Street Fighter, but I can remember when I first walked into the arcades at Fairview Mall it was hard to resist the urge to play the game. The great graphics and flashy moves were mind boggling.

The best part was playing one character through to the end to see their unique ending. My favorite was Blanka's story, because he's a vicious and angry fighter, but at the end of it all he's just a lonely guy and not a monster. He had all this angst because he was tortured and had been separated from his Mom. It made me realize that Blanka could be a goofball and cute sometimes too.

So don't be mad at Jimmy, aka Blanka, he just needs some love.

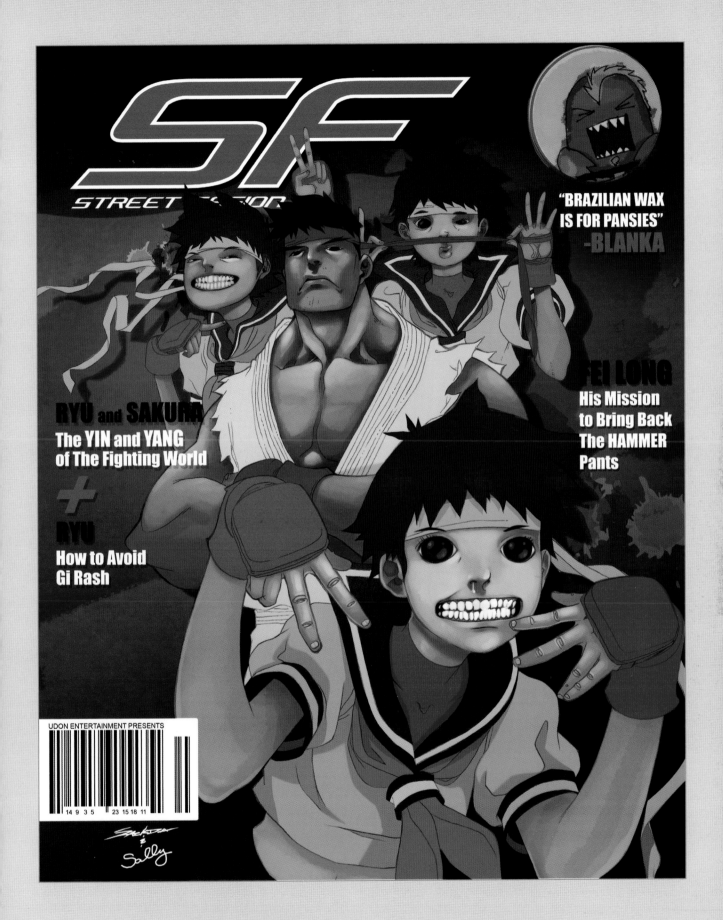

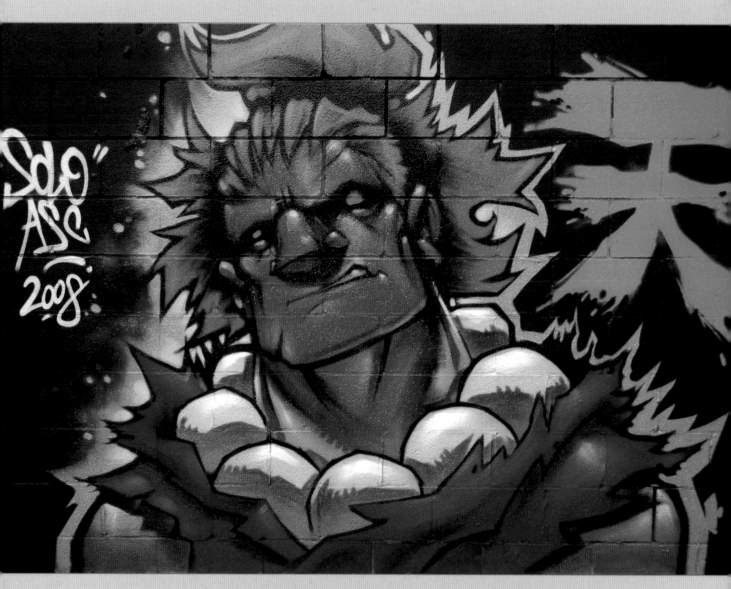

RODRIGO MIRELES [SOLO]
WWW.AREMPIRE.COM
CHARACTER/CONCEPT ARTIST
[TAO FENG, FIGHT NIGHT ROUND 3, DEF JAM ICON]

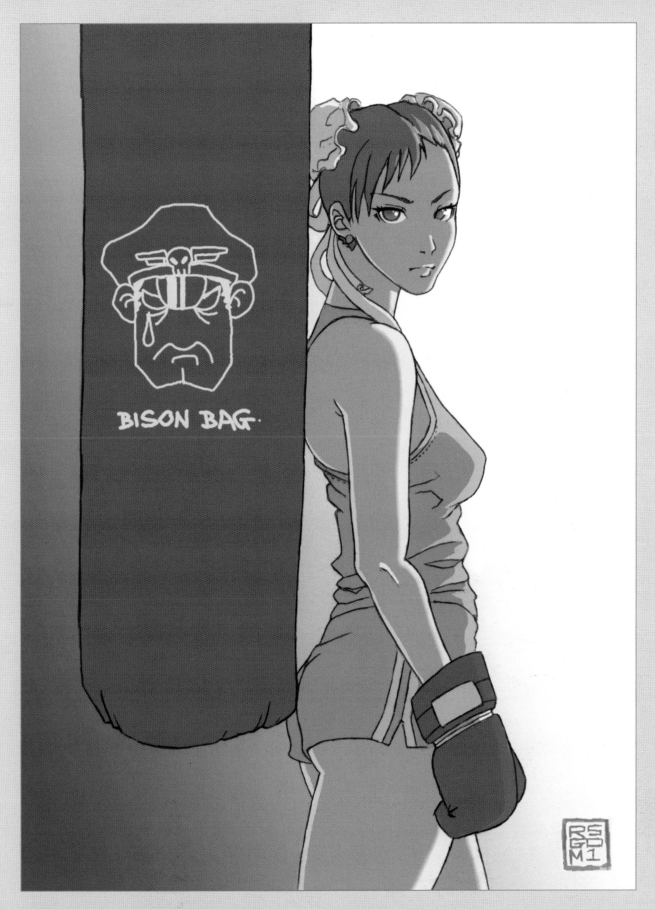

BISON BAG.

ROBERT MELLIS [RGM 501]
MELBOURNE, VICTORIA, AUSTRALIA
RGMS01.DEVIANTART.COM

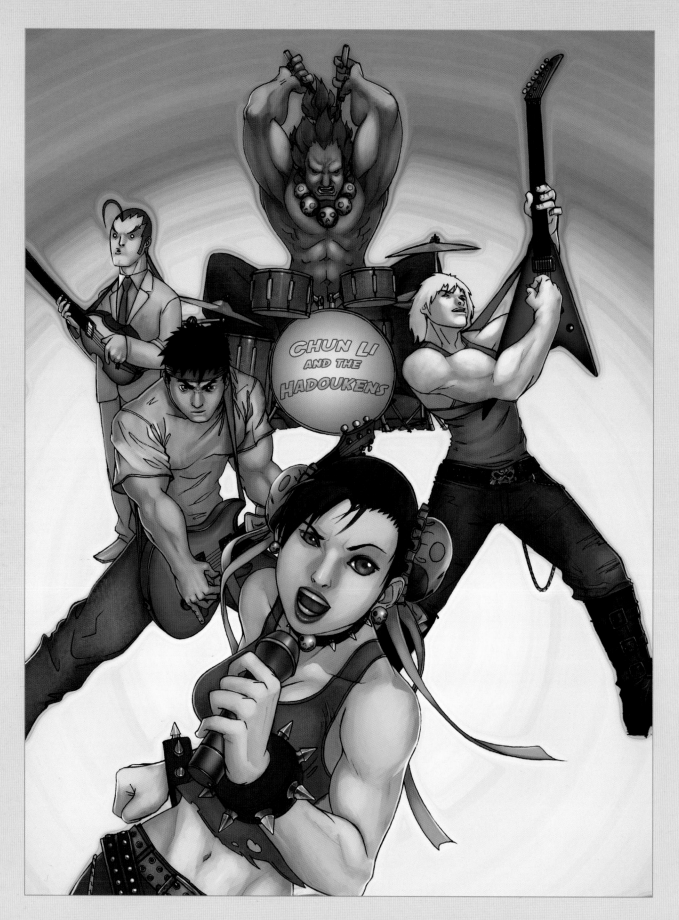

JAMIE NOGUCHI
WASHINGTON, D.C., USA
WWW.JAMIHN.COM - ANGRYZENMASTER.DEVIANTART.COM
ILLUSTRATOR/COLORIST
[ERFWORLD (WWW.ERFWORLD.COM), ICANDY, SPIDER-GIRL]

CHOE JUN-HYEOK
SOUTH KOREA
BLOG.NAVER.COM/CORY777
ILLUSTRATOR

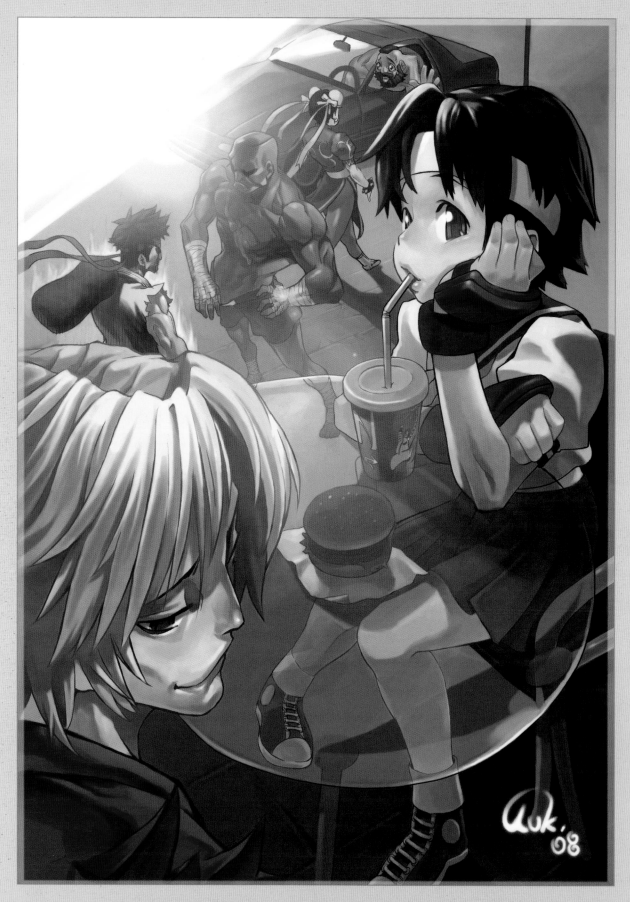

HAN GOO-UWK [KUKS]
SOUTH KOREA
BLOG.NAVER.COM/HAN626292
ILLUSTRATOR
[RZBZ, PARPET, NEW PORTLIS]

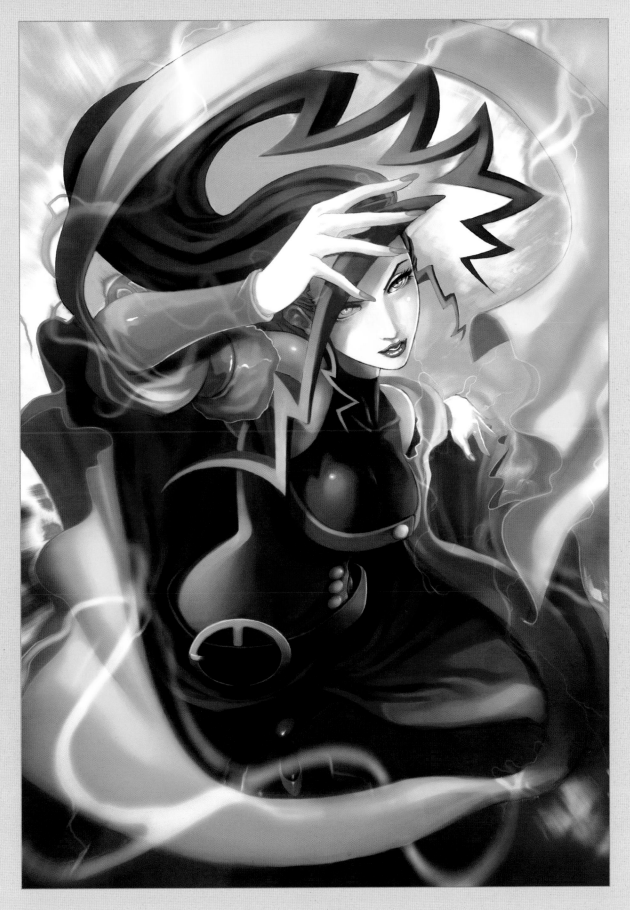

ERU
JAKARTA, INDONESIA
ERUFAN.DEVIANTART.COM

MARK SINCLAIR

The first time I heard about Street Fighter II as a kid, I didn't believe it until I saw it. The first thing I remember was how each character was so unique from each other. Each one had a different feel to them and a different background, from their visual design and special moves to their story and nationality.

I especially admired the natural paintings of Street Fighter characters and would stare endlessly at them. With that in mind, I tried to incorporate the traditional, personal and intimate aspects of a Street Fighter character into my illustration.

For many people Street Fighter isn't just a game, it's sort of like a tradition. It feels like we've seen these characters for so long that we almost know them on a personal level. The Capcom artists have done an amazing job bringing them to life for us.

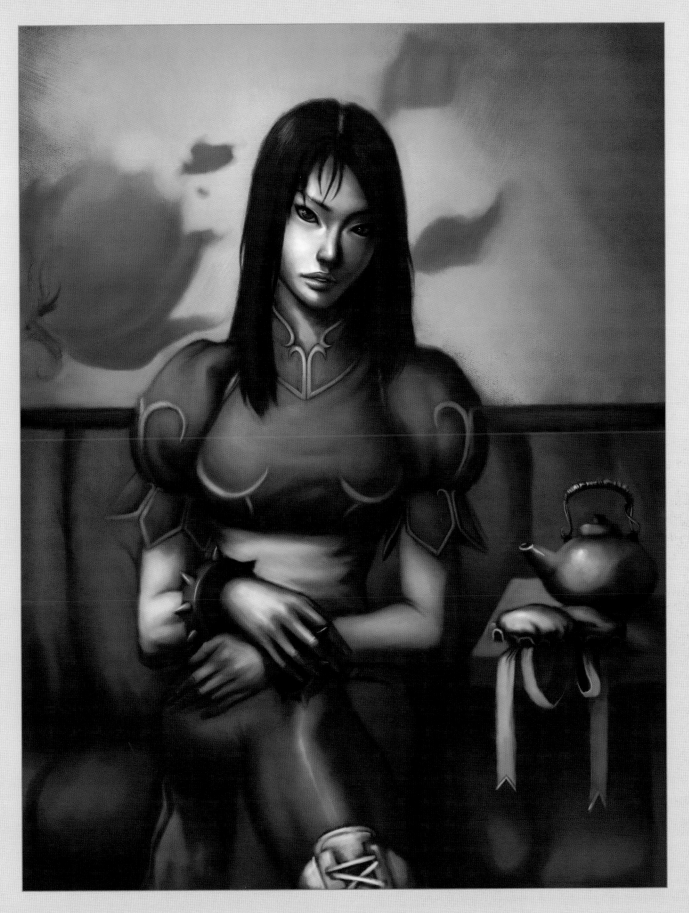

MARK SINCLAIR
TORONTO, ONTARIO, CANADA
WWW.MARKSINCLAIRART.COM
ILLUSTRATOR / PAINTER

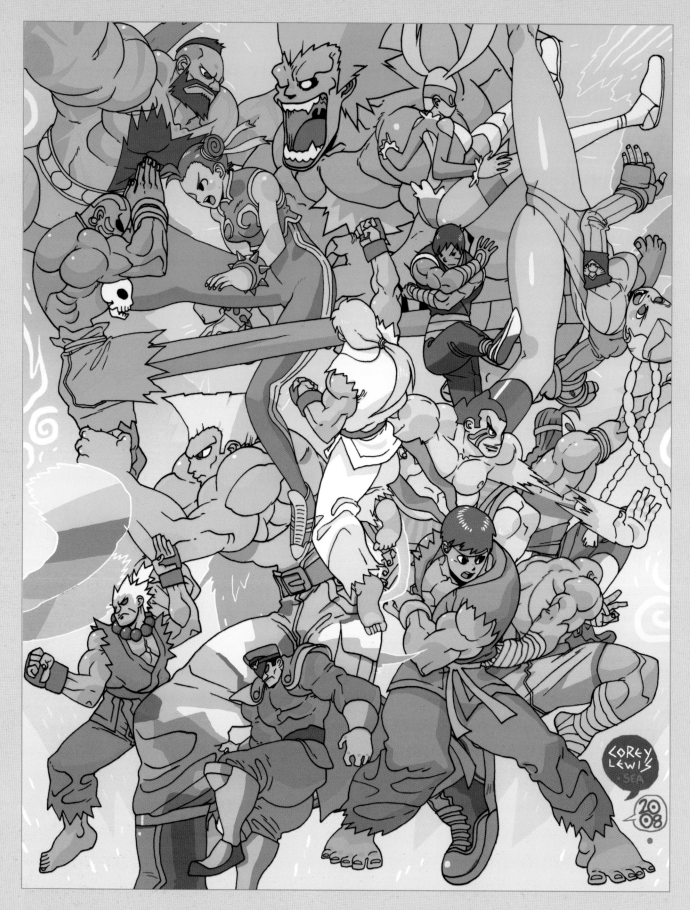

COREY LEWIS [REY]
SEATTLE, WASHINGTON, USA
WWW.REYYY.COM
ILLUSTRATOR [SHARKNIFE, PENG, CAPCOM MINI, RIVAL SCHOOLS]

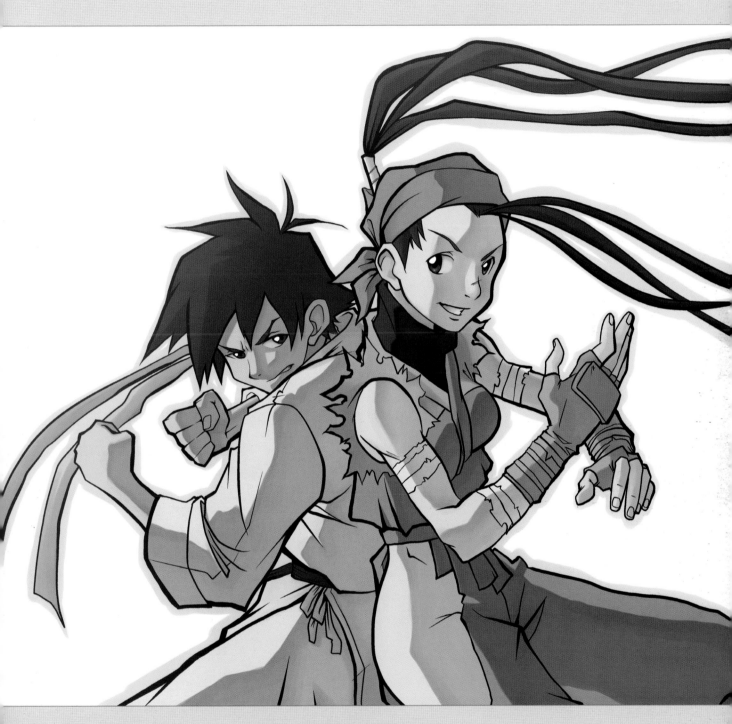

WILLIAM RUZICKA
RESEDA, CALIFORNIA, USA
RYUSUKE.DEVIANTART.COM
ILLUSTRATOR
[GAGAKU BERCEUSE - TOKYOPOP'S RSOM 7]

STREET
FIGHTER

JIM RUGG
PITTSBURG, PENNSYLVANIA
STREETANGELCOMICS.COM / JIMRUGG.LIVEJOURNAL.COM

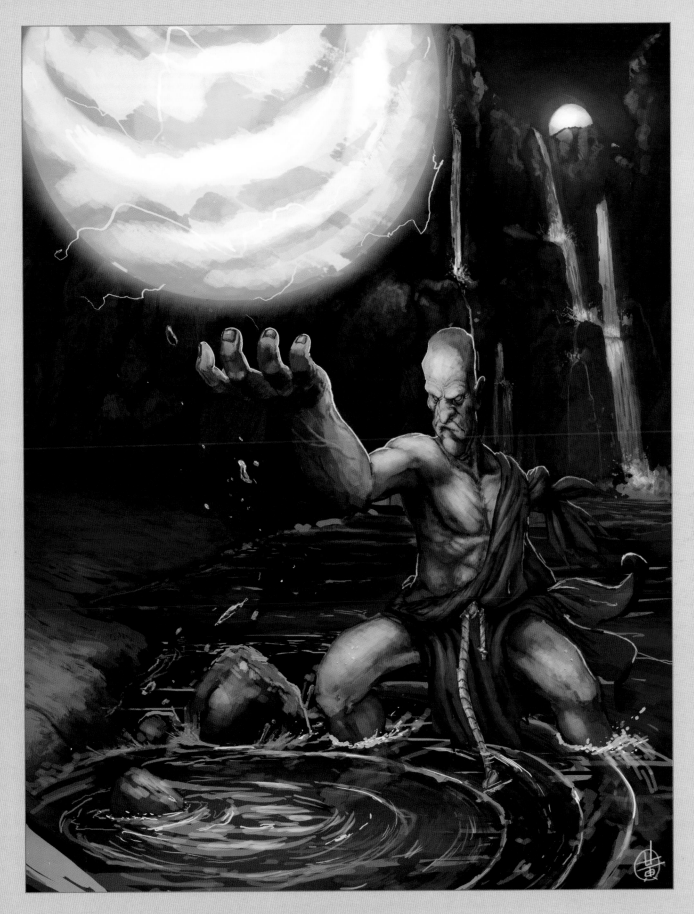

JUSTIN WONG
WWW.GAIAONLINE.COM
CONCEPT ARTIST
[GAIA ONLINE]

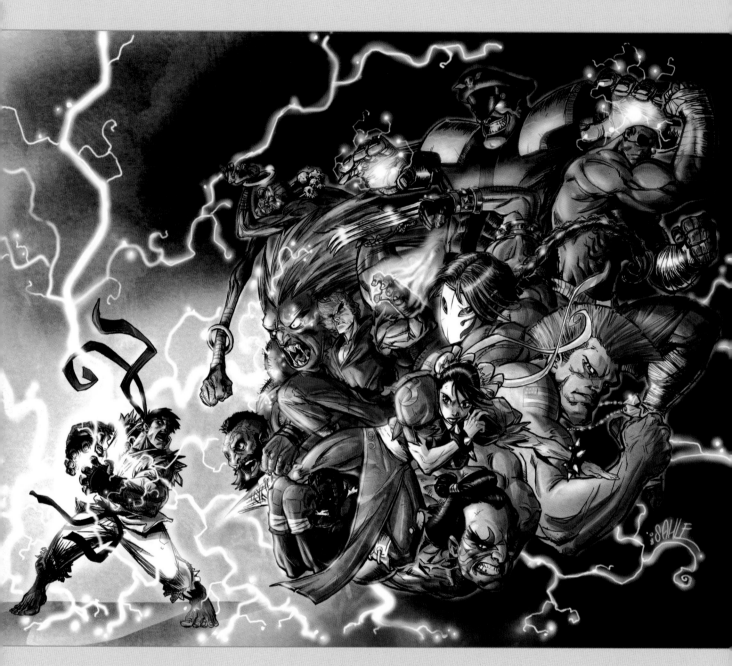

SAHLE ROBINSON
TORONTO, ONTARIO, CANADA
FLYINLION.BLOGSPOT.COM
STORY ARTIST & MAKER OF FRESHNESS

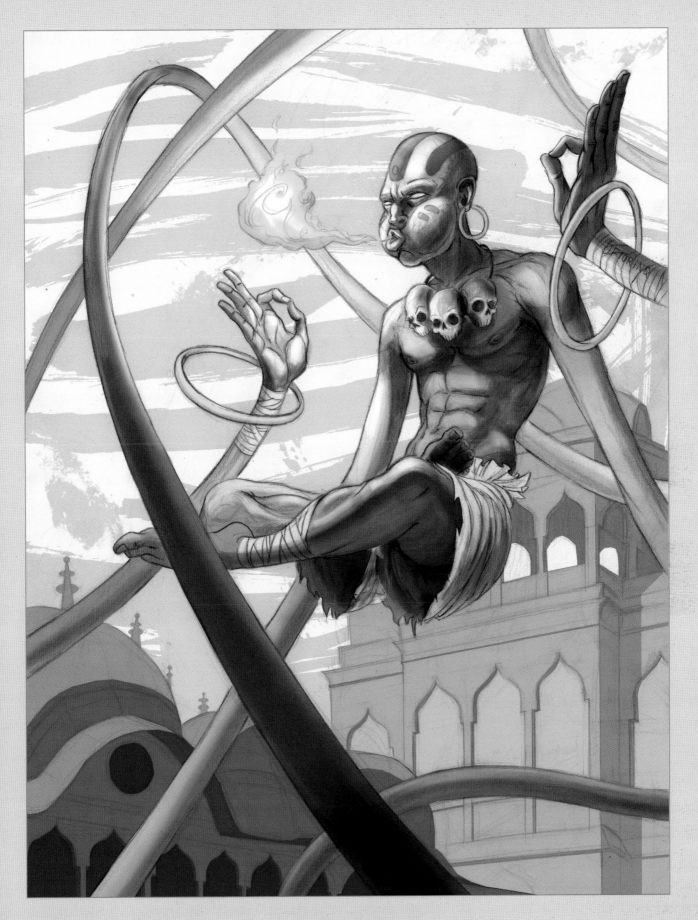

JARED FIORINO
SARASOTA, FLORIDA, USA
JAREDFIORINO.BLOGSPOT.COM
ILLUSTRATOR

BOICHI

When I started as a mangaka, one of my first professional projects was a Street Fighter II-themed illustration for a Korean gaming magazine. I drew the line art of Cammy and an animator friend of mine colored it up in an anime style.

When I received the message about this Street Fighter Tribute project, I was happy to contribute. There's a nice feeling of karma to it. My first professional project in Korea was Street Fighter and now my first professional artwork for North America is also Street Fighter.

Thanks for this great opportunity.

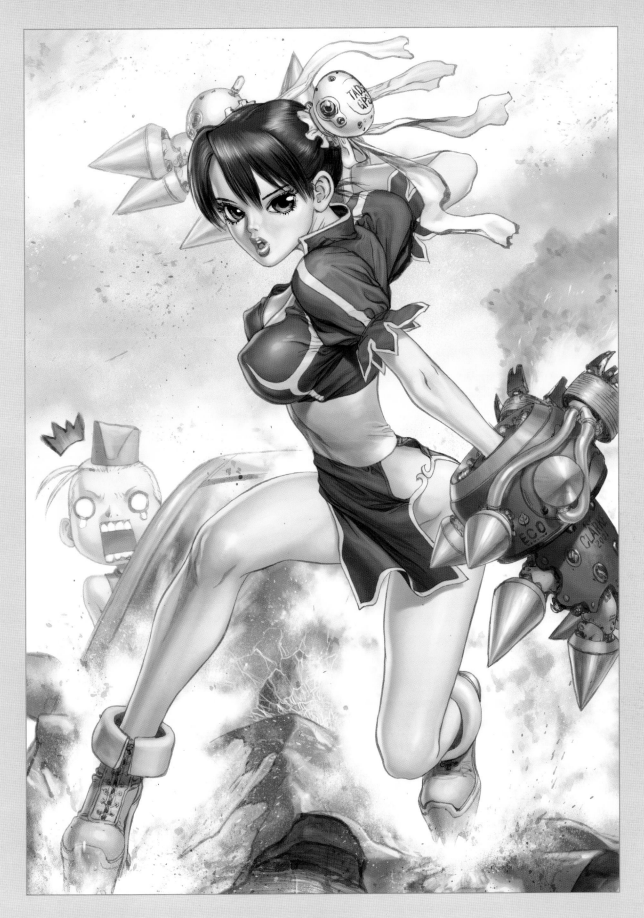

BOICHI
KOREA
WWW.BOICHI.COM
MANGAKA
[SUN-KEN ROCK, HOTEL, PRESENT]

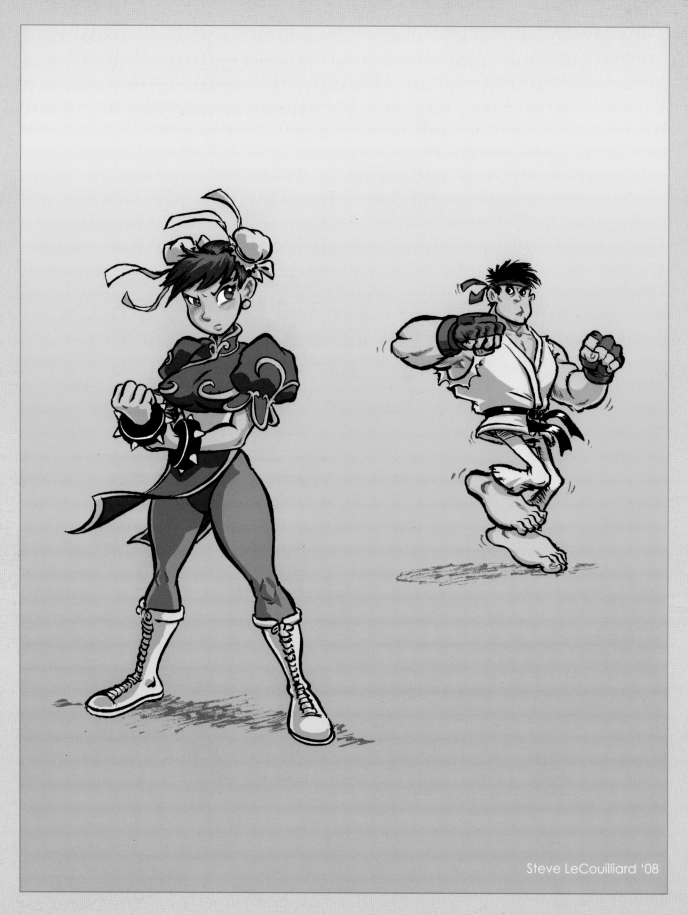

Steve LeCouilliard '08

STEVE LECOUILLIARD
COQUITLAM, BRITISH COLUMBIA, CANADA
STEVELEC.VIP.WARPED.COM
COMIC ARTIST [FEARLESS OF DICK]
STORYBOARD ARTIST [ED, EDD, N' EDDY, GEORGE OF THE JUNGLE]

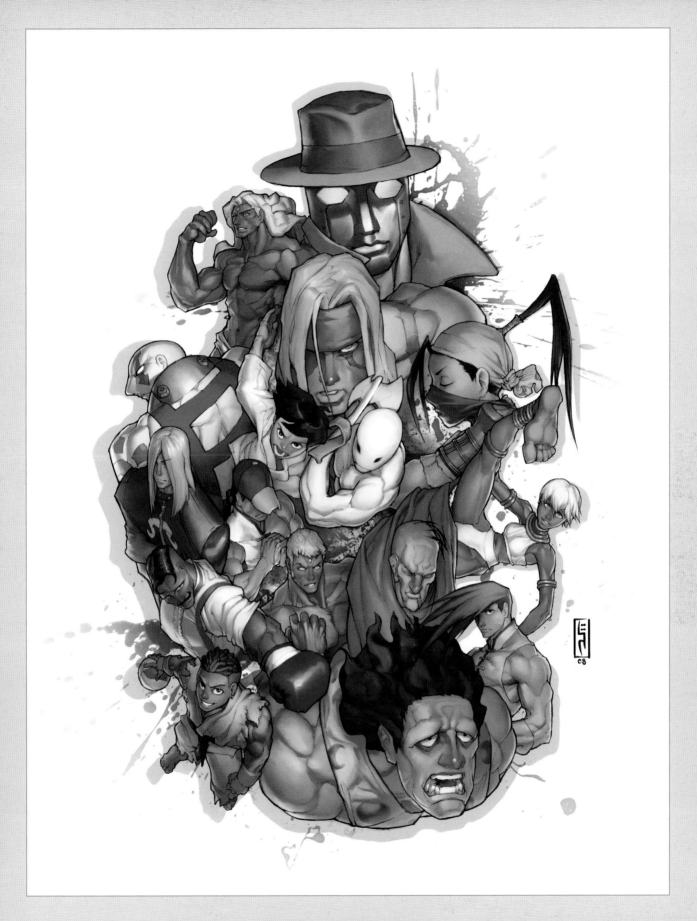

SETH DAVID JONES
SHEPHERDSVILLE, KENTUCKY, USA
SALAMANDROS.DEVIANTART.COM

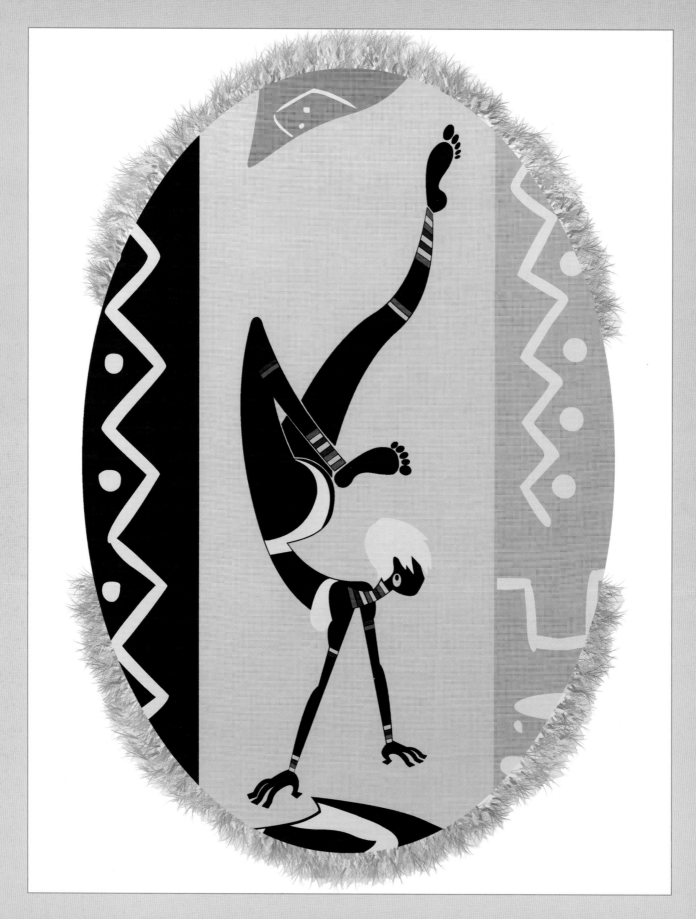

BRYAN NEWTON
LOS ANGELES, CALIFORNIA, UNITED STATES
BANONDORF.DEVIANTART.COM
ANIMATOR AND ARTIST
[OUT OF JIMMY'S HEAD, TODDWORLD, GROWING UP CREEPIE]

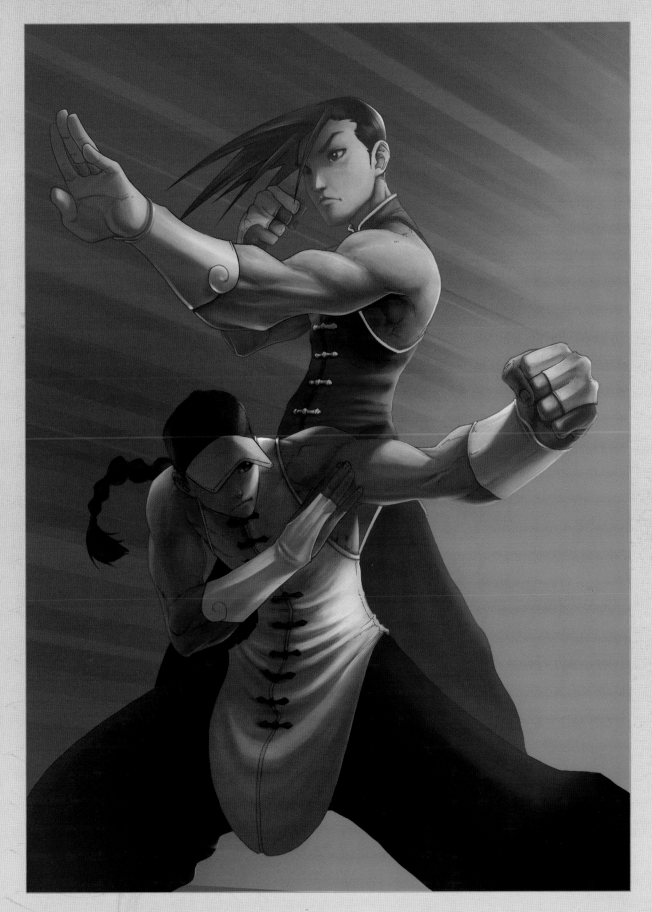

ANTHONY SOUTHERLAND
SEATTLE, WASHINGTON, USA
FOORAY.DEVIANTART.COM
PENCIL ARTIST

YANNICK DE SMET
MALDEGEM, BELGIUM
WWW.DESIGNSTABLES.COM
FREELANCE PAINTER

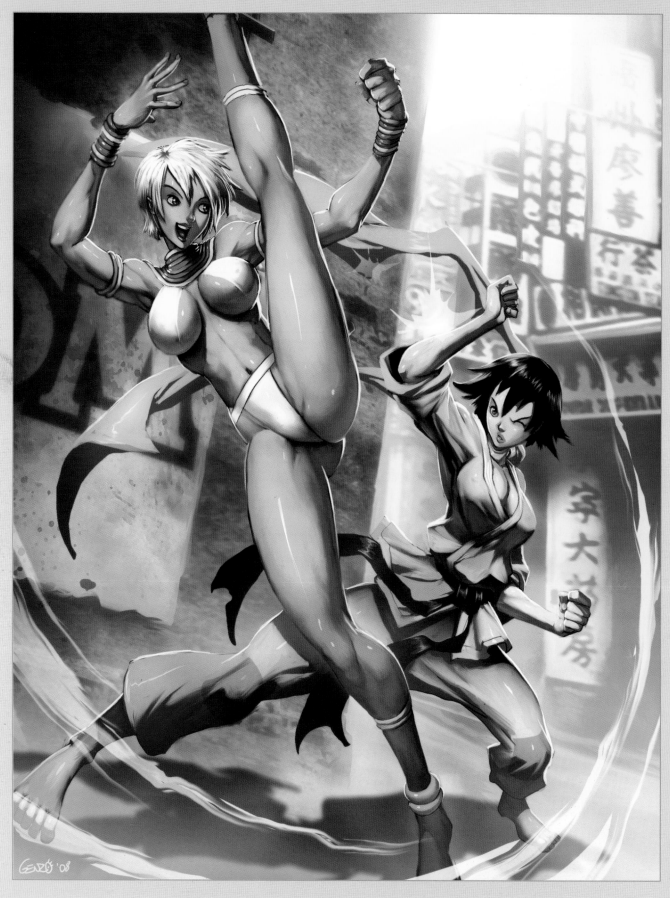

GONZALO ORDOÑEZ [GENZOMAN]
SANTIAGO, CHILE
GENZOMAN.DEVIANTART.COM
FREELANCE ILLUSTRATOR
[MYTHS & LEGENDS TCG, WORLD OF WARCRAFT TCG]

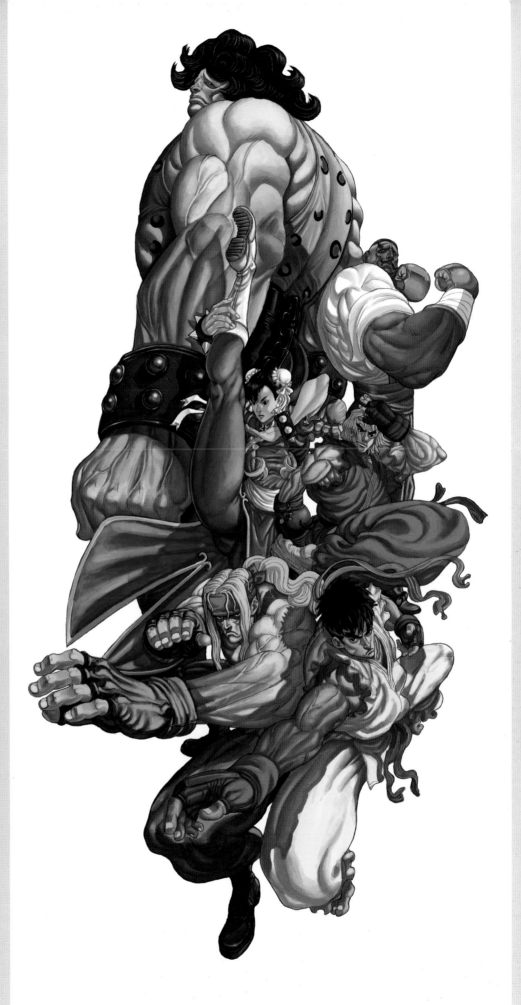

VAN-ANDY
PREVALUS
MIAMI, FLORIDA, USA
VPREVALUS.BLOGSPOT.COM
ILLUSTRATOR
CONCEPT ARTIST

JOE NG

All characters that withstand the test of time must have equally strong antagonists to compliment them. With Street Fighter, it's no different. Each of the villains in the game are so varied in look, personality and motive, I thought they would make a perfect composition of everything that makes Street Fighter so great.

When I was a kid growing up, I was never any good at playing the game, but I always tagged along with my older brother when he and his friends went to the arcade to play Street Fighter. I was always amazed at how they could memorize what button combo would activate the moves. While most people were either using Ryu, Ken or Chun-Li, I was a big fan of Guile because his moves were pretty simple to memorize and I loved his crazy hair. I remember when one of our friends' parents opened up a donut shop and they installed a Super Street Fighter II Turbo machine. We were so excited because it meant free games!

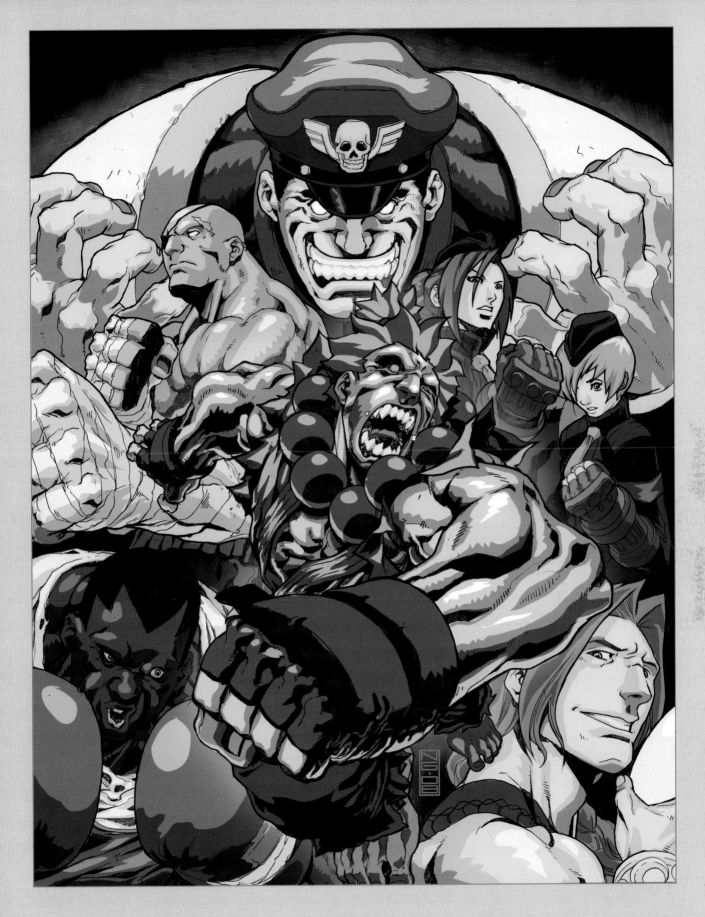

JOE NG
BURLINGTON, ONTARIO, CANADA
NGBOY.DEVIANTART.COM
COMIC ARTIST [TRANSFORMERS, SONJA GOES EAST, STREET FIGHTER III]
ILLUSTRATOR [SUPER STREET FIGHTER II TURBO HD-REMIX]

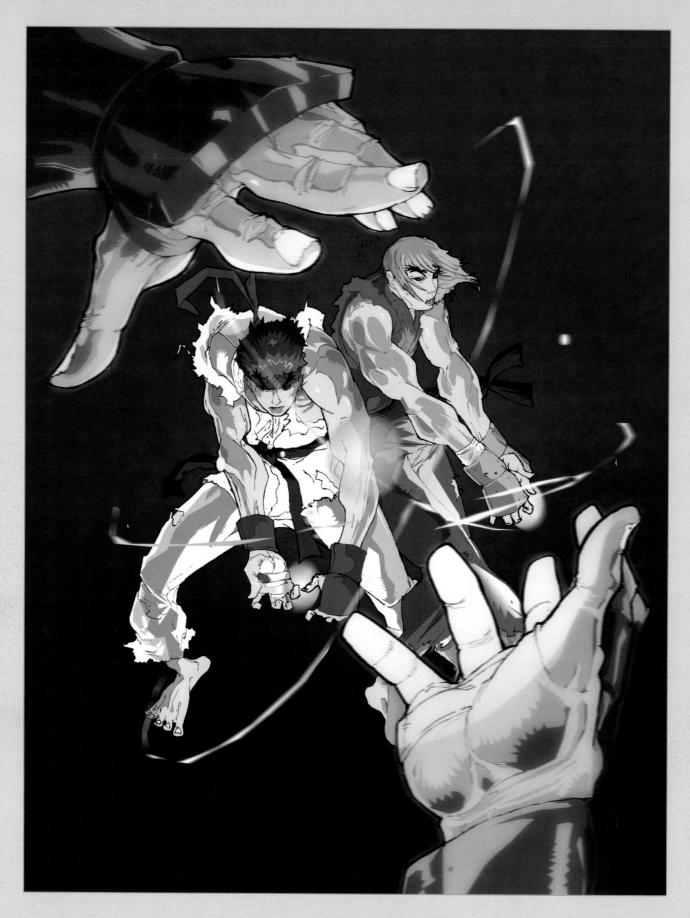

ISAAC RICHARDSON III
HILLSIDE, NEW JERSEY, USA
THOMAS-ANDERSON.DEVIANTART.COM
COMIC ARTIST / ILLUSTRATOR

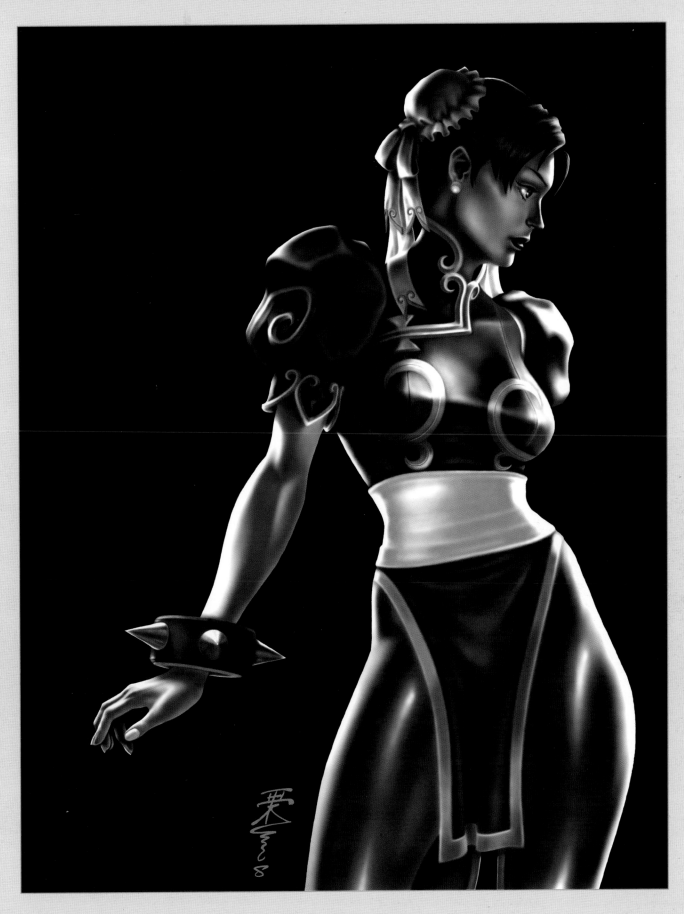

EAN KEAT ONG
KUALA LUMPUR, MALAYSIA
ANIMATOR

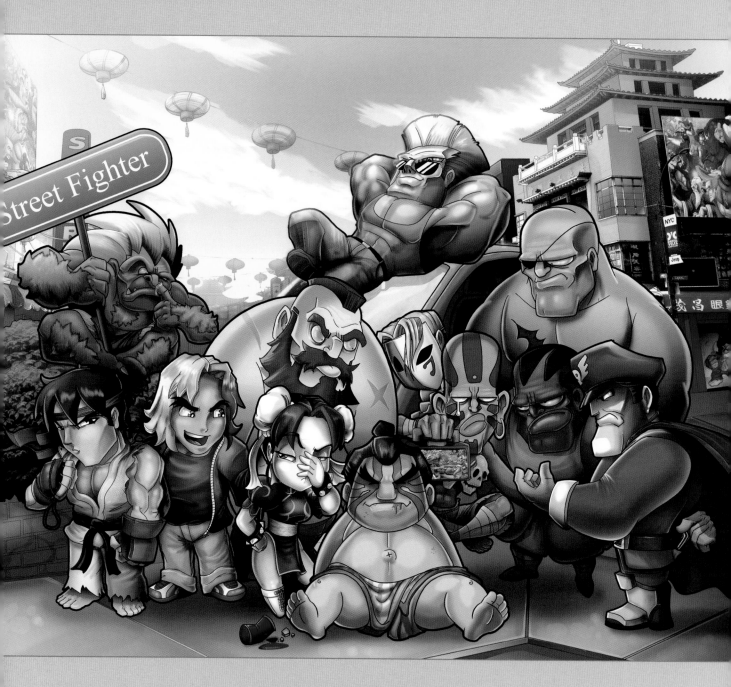

DANIEL VELEZ CARVAJAL
MEDELLIN, COLOMBIA
DANIEL-VELEZ.DEVIANTART.COM
CONCEPT ARTIST / ANIMATOR

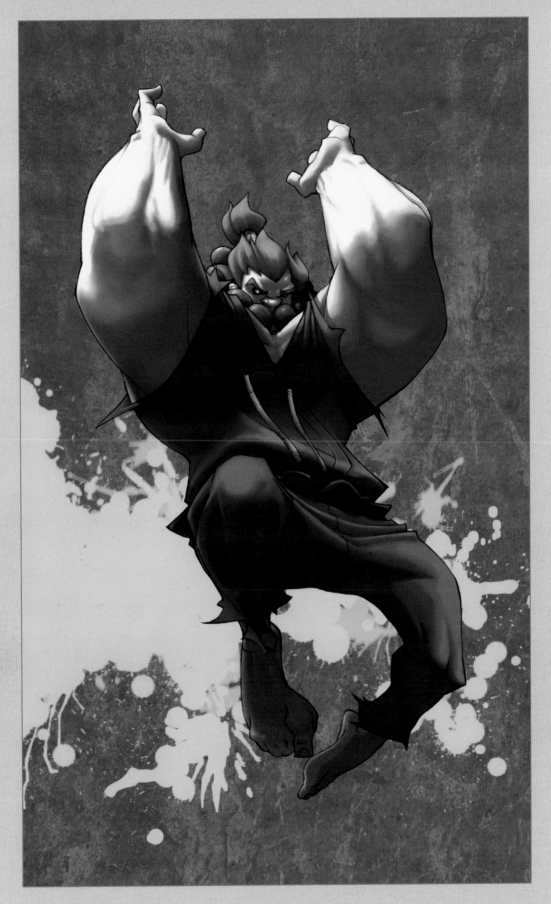

TIEN WEI HEE
WELLINGTON, NEW ZEALAND
T-WEI.DEVIANTART.COM
FREELANCE ARTIST

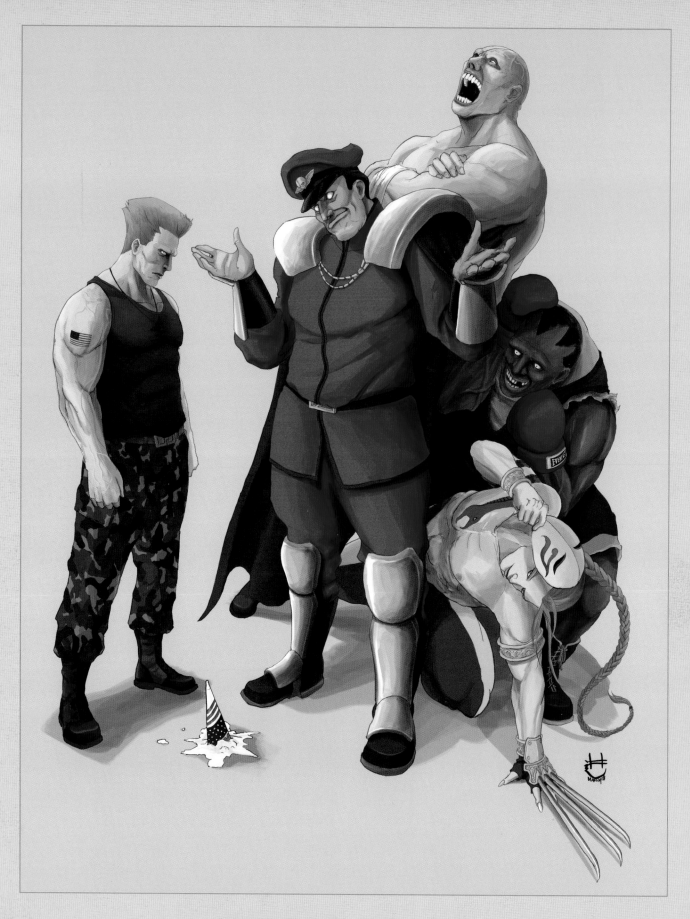

DAN MATANSKI
REDMOND, WASHINGTON, USA
MOTORFISH.DEVIANTART.COM
DESIGNER / ILLUSTRATOR
[ZIPPER INTERACTIVE, LOOKING GLASS STUDIOS, ANTARCTIC PRESS]

AFTERWORD

When I pitched the idea for the Street Fighter Tribute book during Capcom's Licensing summit in November of 2007, I didn't know if the idea would fly. I envisioned a high quality art book celebrating Street Fighter as a pop culture video game icon. Seeing it evolve into that very thing and much more is a pleasure I can hardly describe.

When we unveiled our Tribute Contest online and allowed open submissions, we weren't sure what we'd get. Internally at the studio, we guessed that we'd get a couple hundred submissions and might be able to pick 50 pieces that would show well in the book. Instead, we were flooded with over 1300 entries, showcasing a startling amount of skill and creativity from artists all over the globe. As we sorted the submissions, it quickly became clear that this book was going to be bigger and more incredible than any of us had anticipated. Whittling down the pieces to the ones showcased here was unbelievably difficult. I wish we had double the page count to show you even more.

Inspiration is a wonderful thing. It drives us to bring out the best in ourselves and reminds us of the things we value most. Having a video game as a source of inspiration may seem a bit silly, yet the results are just as impressive and engaging when that energy is turned back towards its source in tribute. It creates a wonderful paradox — mainstream commercial-inspired fine art.

Thank you for making Street Fighter Tribute such a satisfying experience.

Fight on!

Jim Zubkavich
Street Fighter Tribute Editor
April 13th, 2008

EDITOR
JIM ZUBKAVICH

LAYOUT AND DESIGN
MATT MOYLAN

COVER ARTIST/LOGO DESIGN
ARNOLD TSANG

PAGE 1 ARTWORK
OMAR DOGAN
JEFFREY "CHAMBA" CRUZ
JOE NG

CREDIT PAGE ARTWORK
OMAR DOGAN

UDON STAFF
UDON CHIEF - ERIK KO
PROJECT MANAGER - JIM ZUBKAVICH
MARKETING MANAGER - MATT MOYLAN

FOR CAPCOM LICENSING:
TOSHI TOKUMARU & TAKI ENOMOTO
OF CAPCOM CO. LTD.
GERMAINE GIOIA, JUNTA SAITO,
JOSH AUSTIN, & FRANCIS MAO
OF CAPCOM ENTERTAINMENT, INC.
MARC MOSTMAN OF MOST MANAGEMENT

WWW.CAPCOMCOMICS.COM
WWW.UDONENTERTAINMENT.COM

Published by UDON Entertainment Corp.
P.O.Box 32662, P.O. Village Gate,
Richmond Hill, Ontario, L4X 0A2, Canada

First Printing: August 2008
ISBN-13: 978-1-897376-98-0
ISBN-10: 1-897376-98-7

Printed in Hong Kong